3

The Treasury of
Basel Cathedral

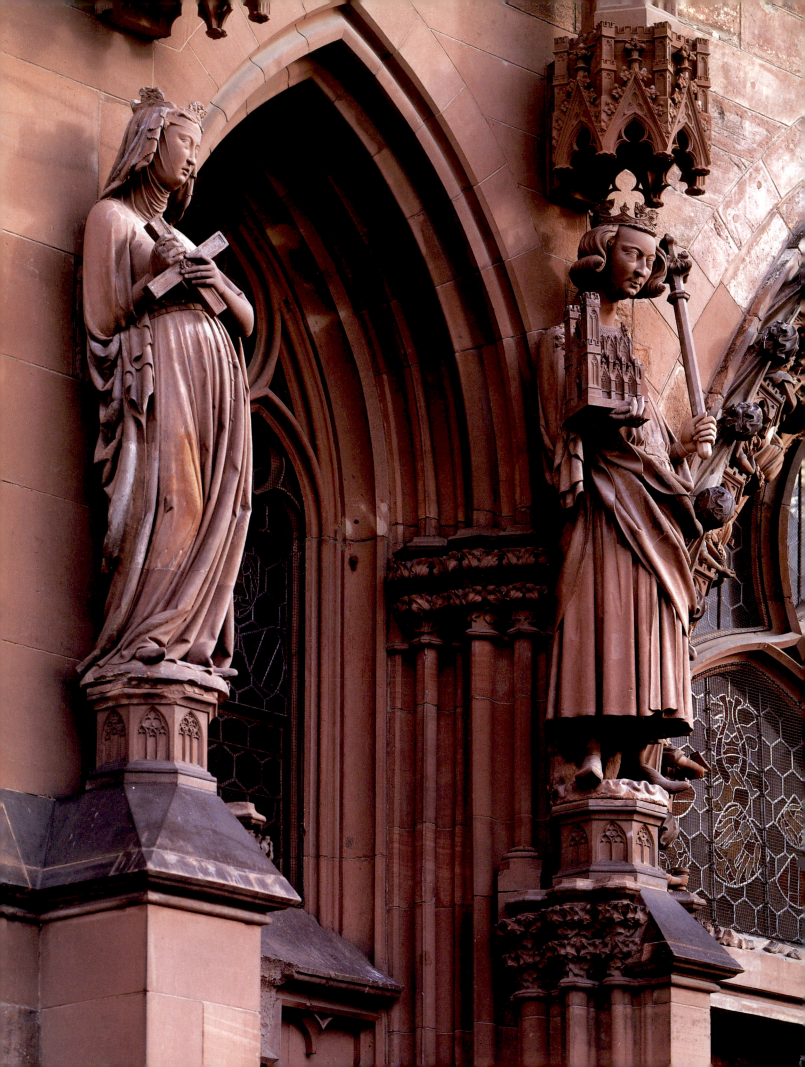

THE TREASURY OF
BASEL CATHEDRAL

Timothy Husband

with contributions by

Julien Chapuis

THE METROPOLITAN MUSEUM OF ART

YALE UNIVERSITY PRESS

This volume has been published in conjunction with the exhibition "The Treasury of Basel Cathedral,"
held at The Metropolitan Museum of Art, New York, February 28–May 27, 2001.

The exhibition is made possible in part by the William Randolph Hearst Foundation.
Additional support has been provided by Pro Helvetia, Arts Council of Switzerland.

The exhibition has been organized by The Metropolitan Museum of Art, New York,
and the Historisches Museum Basel, Switzerland.

An indemnity has been granted by the Federal Council on the Arts and the Humanities.

The exhibition catalogue is made possible by The Andrew W. Mellon Foundation.

Published by The Metropolitan Museum of Art, New York
John P. O'Neill, Editor in Chief
Ellen Shultz, Editor
Bruce Campbell, Designer
Sally Van Devanter, Production Manager

All objects in the Historisches Museum Basel, as well as nos. 5, 23, 24, 33, 45a, 46, xvi, and 47,
photographed by Peter Portner, Basel; fig. 11, courtesy of the Historisches Museum Basel;
nos. 2 and 55, courtesy of the Réunion des Musées Nationaux, Paris; frontispiece, no. iii, and no. xvii,
by Erik Schmidt, Basel; all other photographs supplied by the owners.

Endpapers: Instructions for displaying the Treasury on the high altar of
Basel Cathedral on major feast days. See fig. 6

Jacket: *Statuette of Saint Christopher.* See no. 37
Frontispiece: *Empress Kunigunde and Emperor Heinrich II.* About 1290.
Sandstone, over life-size. West façade, Basel Cathedral

Library of Congress Cataloging-in-Publication Data
Timothy Husband, 1945–
The Treasury of Basel Cathedral / Timothy Husband with contributions by Julien Chapuis.
p. cm.
Catalogue of an exhibition held at The Metropolitan Museum of Art from
February 28 through May 27 and at the Historisches Museum Basel from July 13 through October 31, 2001.
Includes bibliographical references and index.
ISBN 0-87099-976-1 (The Metropolitan Museum of Art)
ISBN 0-300-08849-3 (Yale University Press)
1. Reliquaries—Switzerland—Basel—Exhibitions. 2. Liturgical objects—Switzerland—Basel—
Exhibitions. 3. Basel Cathedral—Exhibitions. 4. Basel (Switzerland)—Religious life and customs.
I. Chapuis, Julien. II. The Metropolitan Museum of Art (New York, N.Y.). III. Historisches Museum Basel.
IV. Title.
NK7215.H87 2001
704'.9482'0949432074—dc21 00-066836

Printed in Spain

FOR

WILLIAM D. WIXOM

Curator, Scholar, and Mentor

❦

Contents

Director's Foreword

Although medieval churches often are austere and monochromatic in appearance today, in the Middle Ages they abounded with glittering objects in precious materials that were central to the religious experience. Eucharistic vessels, censers, crosses, monstrances, and reliquaries made of gold and silver played an integral role in the Mass and in the numerous processions that marked the liturgical calendar. Central to the development of church treasuries was the belief that the more splendid the materials, the better suited they were to honor God, the creator of all things. In the course of history, the intrinsic value of these church treasuries caused them to be pillaged and often their contents were even melted down into bullion.

The Treasury of Basel Cathedral—formed over five centuries, from the consecration of the restored cathedral building by Emperor Heinrich II in 1019 to the adoption of the Protestant Reformation in 1529—was among the most celebrated in Europe. It miraculously endured, despite an earthquake, wars, Iconoclasm, and religious zealotry, only to be dispersed in the early nineteenth century as a result of political division. The exhibition at the Metropolitan Museum is an attempt to re-create the splendor of the original Treasury by reuniting most of the surviving opulent church furnishings that served the liturgy and the cult of the saints on the high altar of Basel Cathedral from the eleventh to the sixteenth century. Among the masterpieces borrowed from European public collections and churches are numerous examples of Ottonian, Romanesque, and Gothic metalwork that have never before traveled to the United States.

Over half of the objects from the Treasury usually are housed in the Historisches Museum Basel—the co-organizer of the current exhibition—whose director, Dr. Burkard von Roda, has generously enabled the Metropolitan Museum to share in the presentation of this magnificent ensemble of treasures. Timothy Husband, Curator in the Department of Medieval Art and The Cloisters, is responsible for the concept of the exhibition in its New York venue, and is also the principal author of this catalogue. His excellent scholarship and keen understanding of the material provide a sensitive and enlivened introduction to Basel Cathedral's formidable Treasury. Throughout, he has been most ably assisted by Julien Chapuis, Assistant Curator in the Department of Medieval Art and The Cloisters.

Our profound thanks are extended to the many lenders who have kindly agreed to part with those significant works in their care, in order to make this remarkable event possible. Colleagues in museums, libraries, archives, and churches have responded with extreme generosity to our loan requests. The Metropolitan Museum is grateful to the William Randolph Hearst Foundation for its generous assistance in the realization of this project. We also wish to thank Pro Helvetia, Arts Council of Switzerland, for its contribution toward the exhibition, as well as the Consulate General of Switzerland in New York. The exhibition is further supported by an indemnity granted by the Federal Council on the Arts and the Humanities. Finally, the Museum wishes to acknowledge with deep appreciation the support provided by The Andrew W. Mellon Foundation toward the publication of this handsome catalogue.

Philippe de Montebello
Director, The Metropolitan Museum of Art

Lenders to the Exhibition

Bayerisches Nationalmuseum, Munich: 3

Benediktinerkloster Mariastein: 45a, 46, 47

Bibliothèque Cantonale Jurassienne, Porrentruy: x, xii

Bibliothèque de la Ville de Colmar: ix

Chorherrenstift Sankt Michael, Beromünster: xvi

Evangelisch-Reformierte Kirche Basel-Stadt: model of Basel
 Cathedral (not in catalogue)

Generallandesarchiv Karlsruhe: viii, xv

Haus der Bayerischen Geschichte, Augsburg: 62

Hausfideikommiß, Markgräflich Badische Hauptverwaltung
 Salem: xv

Historisches Museum Basel: 1, 6, 7, 8, 12, 13, 15, xiii, 17,
 18, 19, 20, 22, 23, 24, 25, 26, 27, 28, 29, 30, 31, 32, 34,
 35, 37, 38, 39, 41, 45b, 49, 50, 51, xviii, 52, 53, 54, xix,
 xx, 63, 64, 65, 67, 68, 69, 70, 71, 72, 73, 74, 75, 76, 78

Kunsthistorisches Museum, Kunstkammer, Vienna: 59

The Metropolitan Museum of Art, New York: 16, xiv, 43

Musée Jurassien d'Art et d'Histoire, Delémont: ii

Museum Kleines Klingental, Basel: iii, xvii

National Gallery of Art, Washington, D.C.: i

Rijksmuseum, Amsterdam: 40

Römisch-Katholische Kirche Basel-Stadt (Sankt Clara): 5, 23,
 24, 33

Schweizerisches Landesmuseum, Zürich: 44

Staatliche Museen zu Berlin, Kunstgewerbemuseum: 61, 66, 77

Staatsarchiv des Kantons Basel-Stadt: iv, v, vi, vii, xxi

The State Hermitage Museum, Saint Petersburg: 10, 36, 42

Trustees of the British Museum, London: 9

Universitätsbibliothek Basel: xi

Victoria and Albert Museum, London: 11, 14, 56, 57, 60

Acknowledgments

Medieval art history, out of necessity, is often focused on *membra disjecta*—works of art that are separated from their original contexts, frequently are displaced, and are thus but fragmentary survivors. Rare are the monuments or assemblages that have come down to us intact. The Treasury of Basel Cathedral, however, is an exception. Almost all of the extraordinary objects in use on the high altar until 1529 can be accounted for, and are reunited in this exhibition. Over half of them are in the collection of the museum in Basel, which, since the nineteenth century, has made the study of the Basel Cathedral Treasury one of its main missions. The director of the Historisches Museum Basel, Dr. Burkard von Roda, first envisioned reconstituting the Treasury to mark the five hundredth anniversary of Basel's entry into the Swiss Confederation on July 13, 2001; without his energetic and unstinting efforts, this exhibition could never have come to New York. I am most grateful to him and to the director of the Metropolitan Museum, Philippe de Montebello, for their support and determination to bring this exhibition to fruition.

Those Treasury objects not in the Historisches Museum Basel are housed in churches and institutional collections in and around Basel, as well as in major museums elsewhere in Europe. We are deeply indebted to the keepers of these objects for their generous loans: His Royal Highness Bernhard, Prince of Baden; Renate Eikelmann and Rainer Kahsnitz at the Bayerisches Nationalmuseum, Munich; Abbot Lukas Schenker at the Benediktinerkloster Mariastein; Benoît Girard at the Bibliothèque Cantonale Jurassienne, Porrentruy; Francis Gueth at the Bibliothèque de la Ville de Colmar; Pastor Georg Vischer and Peter Breisinger at the Evangelisch-Reformierte Kirche Basel-Stadt; Volker Rödel at the Generallandesarchiv Karlsruhe; Josef Kirmeier at the Haus der Bayerischen Geschichte, Augsburg; Manfred Leithe-Jasper and Rudolf Distelberger at the Kunsthistorisches Museum, Vienna; Sarah Stekoffer and Pierre Philippe at the Musée Jurassien d'Art et d'Histoire, Delémont; Dorothea Schwinn Schürmann and Alexander Schlatter at the Museum Kleines Klingental, Basel; Earl A. Powell III and Andrew Robison at the National Gallery of Art, Washington, D.C.; Ronald de Leeuw, Jan Piet Filedt Kok, Rainier Baarsen, and Jan Rudolph de Lorm at the Rijksmuseum, Amsterdam; Gabrielle Manetsch and Father André Duplain at the Römisch-Katholische Kirche Basel-Stadt; Andreas Furger and Hanspeter Lanz at the Schweizerisches Landesmuseum, Zürich; Barbara Mundt and Lothar Lambacher at the Staatliche Museen zu Berlin, Kunstgewerbemuseum; Josef Zwicker at the Staatsarchiv des Kantons Basel-Stadt; Mikhail Piotrovsky and Marta Kryzanovskaya at The State Hermitage Museum, Saint Petersburg; Father Josef Ignaz Suter at the Chorherrenstift Sankt Michael, Beromünster; John Cherry at the British Museum, London; Martin Steinmann at the Universitätsbibliothek Basel; and Alan Borg and Marian Campbell at the Victoria and Albert Museum, London.

The New York presentation of the exhibition would not have been possible without the extraordinary support of the staff of the Historisches Museum Basel: Dr. Marie-Claire Berkemeier-Favre, Curator, offered wise counsel and sage direction on all aspects of the project; without her constant efforts and participation, this exhibition would have been vastly diminished. I would also like to thank Benno Schubiger, who was involved in the early planning stages, as well as Anna Bartl, Anne Becker, Bernhard Graf, Alfred Jäggi, Esther Keller, Roger Keller, Gertrud Lütolf, Brigitte Meles, Elisabeth Pamberg, Walter Pannike, Therese Schmassmann, Catherine Schneider, Ruth Schweri, Alwin Seiler, Ralph Stoian, Sandra Suhr, and Eliane Tschudin.

This volume, which aims at introducing a broad audience to the Basel Cathedral Treasury, complements the

Historisches Museum Basel's exhaustive scholarly catalogue. My valued colleague Julien Chapuis, who contributed two thought-provoking and engaging essays to the present publication and was involved in all aspects of its preparation, joins me in acknowledging with deep appreciation the invaluable contributions of Marie-Claire Berkemeier-Favre. Archival research, bibliographic references, linguistic clarification, interpretation of documents, guidance through the arcana of Basel's history, as well as critical readings of our texts, were all offered up with unflagging enthusiasm, impressive energy, and considerable knowledge. I am also very grateful to Martin Sauter, whose knowledge and expertise in the material and technical aspects of metalwork, graciously shared, has found its way into many entries in the present catalogue.

I would like to express my sincere gratitude to the authors of the Basel catalogue, who agreed to let us read their texts—whether essays or catalogue entries—before publication. Our volume has benefited greatly from the scholarship that they have so generously shared: Anne Becker, Marie-Claire Berkemeier-Favre, Nicoletta Brentano-Motta, Lucas Burkart, Philippe Büttner, John Cherry, Wolfgang Cortjaens, Rudolf Distelberger, Katharina Eder Matt, Dorothee Eggenberger-Billerbeck, Franz Egger, Brigitta Falk, Regine Fellmann, Johann Michael Fritz, Valentin Groebner, Sabine Häberli, Peter Habicht, Simone Husemann, Romain Jurot, Anja Kalinowski, Marta Kryzanovskaya, Lothar Lambacher, Hans Rudolf Meier, Thomas Meier, Achatz von Müller, Christine Ochsner, Claude Rebetez, Margret Ribbert, Burkard von Roda, Lukas Schenker, Regula Schorta, Gude Suckale-Redlefsen, Benno Schubiger, Andrea Vokner, Dominik Wunderlin, and Monika Zutter. For her efforts in providing us with these texts in a timely fashion, I am grateful to Brigitte Meles. Much needed assistance also was furnished by Therese Wollmann and further information by Sabine Häberli and Ines Braun-Balzer. The magnificent new photography of the Basel objects is the work of Peter Portner. A welcome guest at the Historisches Museum, Ulrich Barth, Archivist of the City of Basel, offered much advice.

This publication would not have been realized without the tireless dedication of the Editorial Department at the Metropolitan Museum, headed by John P. O'Neill. I would especially like to thank Gwen Roginsky for her support; Ellen Shultz, who edited the text with her usual tact and precision; Bruce Campbell, who conceived the handsome design; as well as Peter Antony, Sally Van Devanter, and Robert Weisberg, who ensured the production of the book under difficult time constraints. Richard Gallin proofread the manuscript, Christine Kitzlinger and Tiffany Sprague assisted with the bibliography and footnotes, and Kathleen Friello compiled the index. Ann Lucke offered administrative assistance and Connie Harper exercised budgetary expertise. It was a pleasure to work with all of them.

Many other colleagues at the Metropolitan provided invaluable encouragement throughout the various stages of the exhibition. For her commitment to this project and her guidance, I am greatly indebted to Mahrukh Tarapor, and I am grateful, too, for the assistance of Martha Deese. I would also like to thank Doralynn Pines, Kent Lydecker, and Harold Holzer for their support. The efforts of Emily Rafferty, Kerstin M. Larsen, Sarah Higby, and Rosyn Anderson secured essential funding. Sharon H. Cott offered expert counsel. Linda M. Sylling handled countless logistical issues. Herbert M. Moskowitz enabled the smooth transfer of objects. Sensitive conservation issues were admirably managed by Mechthild Baumeister, Kathrin Colburn, Pete Dandridge, Michele D. Marincola, and Margaret Lawson. Jeffrey W. Perhacs and Nancy S. Reynolds skillfully performed their wizardry in realizing the installation and Michael C. Batista deserves praise for its elegance. Our thanks go to Barbara Weiss for the handsome graphics and Zack Zanolli for the sensitive lighting. I also would like to thank Pamela T. Barr, Chad Beer, Barbara Bridgers, Joe Coscia, Taylor Miller, Stella Paul, Linda Seckelson, Franz Schmidt, Jean Sorabella, Sian Wetherill, and Egle Žygas for their contributions. The following individuals have figured in different ways in the success of the exhibition: Michael Bock, David Courvoisier, Mariane Droux, Peter Hanhart, Henry Hänni, Werner Henssler, Lore Kiefert, Karol Kolecsany, Gregor Mahrer, François Maurer-Kuhn, Enrico Meneghetti, Wolfgang Pohl, Erik Schmidt, Heini Sörensen, and

Gabriele Wüst. Anthony Blumka, upholding family tradition, has been especially generous and supportive.

Peter Barnet, Curator-in-Charge of the Department of Medieval Art and The Cloisters, gave the exhibition his enthusiastic backing. Julien Chapuis was a vital collaborator in every facet of this project, and I am enormously grateful for all his help; indeed, the exhibition and the catalogue have profited immeasurably from his participation. I would also like to extend thanks to Christina Alphonso, Barbara Drake Boehm, Christine E. Brennan, Helen C. Evans, Melanie Holcomb, Charles T. Little, Theo Margelony, Thom Morin, José Ortiz, Tom Vinton, and Nancy Wu, my other colleagues in the Medieval Department and at The Cloisters, and—finally—to Nicholas, for his patience and support.

Timothy Husband
Curator, Department of Medieval Art and The Cloisters

Note to the Reader

This volume is not intended as an exhaustive catalogue of the Basel Cathedral Treasury—for that is being produced by the Historisches Museum Basel—but rather as a concise, informative overview with appeal for all readers. In matters of date and attribution we have relied on the scholarship of the Basel catalogue authors, and the resultant consistency in the heading material will allow, it is hoped, the two publications to complement each other.

In the catalogue section, Arabic numbers designate objects that were, or were thought to be, part of the Treasury; items with Roman numerals, while not part of the Treasury proper, directly relate to it, further informing us of the function and significance of its many components.

Unless otherwise noted, all cited inventory passages are drawn from the transcriptions published in Burckhardt 1933, pages 359–82.

The bibliography is highly selective, limiting references to the more recent, accessible, and informative literature; a comprehensive bibliography appears in the catalogue of the Historisches Museum Basel.

Numbers 2, 4, 21, 48, and 55 are not exhibited in New York.

THE TREASURY OF
BASEL CATHEDRAL

·BASILEA·

A BRIEF HISTORY OF BASEL
UP TO THE REFORMATION

JULIEN CHAPUIS

The Sienese Aeneas Silvius Piccolomini, better known as Pope Pius II, described the political situation in Basel in 1433 in the following words: "Basel once answered to its bishop also in temporal matters; he wielded the power of the sword and he judged criminals. Afterwards, I am not sure why, he let go of his rights. . . . The people of Basel wanted independence. . . . A democratic government now rules the city."[1] The formation of the Basel Cathedral Treasury should be seen in the context of the growth and decline of episcopal power in the Middle Ages.[2]

The land that comprises Basel was inhabited, from the second century B.C., by the Rauraci, a Celtic tribe. After Julius Caesar defeated the Helvetii at Bibracte in 58 B.C., the Romans established a fortified camp on the hill on which the cathedral would later be built, and a settlement grew around it.[3] The name Basilia was first recorded in 374, when Emperor Valentinian I visited the area.[4]

While archaeological finds document the presence of Christians in the region from the early fourth century on, it is only from about 740 that bishops resided continuously in Basel. Haito (r. about 805–23), was the first leader of the diocese about whom we know more than just his name. He had been made bishop of Basel by Charlemagne, to whom he retained a strong connection throughout his tenure, and in 811, he was one of eleven bishops to sign the will of the emperor. Charlemagne entrusted him in the same year with a mission to the imperial court in Constantinople. Bishop Haito erected the first cathedral on the hill overlooking the Rhine, but the building was ravaged in 917, when Basel was sacked by the Hungarians. An inscription on the sarcophagus of the then bishop records the event tersely: "Bishop Rudolph, killed by the pagans on 20 July."

Holy Roman Emperor Heinrich II acquired the city in 1006 from his uncle, King Rudolph III of Burgundy, aware of its political and economic significance. Straddling a bend in the Rhine from where the river is navigable all the way to the North Sea, Basel lay at the intersection of roads that led over the Jura Mountains to Burgundy and France and over the Alps to Italy. Heinrich increased the power of the bishop through privileges, making him effectively the temporal as well as the religious ruler. He also fostered the speedy reconstruction of the cathedral, which became a symbol of his hold over Basel. On October 11, 1019, the emperor attended the consecration of the cathedral, on which he bestowed important gifts. Later chosen as a patron saint of Basel, Heinrich eventually achieved mythical status in the imagination of the city.

The period beginning with the entry of Basel in the Holy Roman Empire up to the middle of the thirteenth century is characterized by the increasing power of the bishops. From successive emperors they received the rights to mint coinage, to levy taxes on transiting goods, to hold markets and fairs, and to dispense justice. The favorable conditions for commerce and industry attracted many merchants and craftsmen, and the population more than quadrupled between 1006 and 1250, from about 2,000 to over 8,000 inhabitants. Among the bishops deserving mention is Burkhard von Fenis (r. 1072–1107), who erected a stone wall around Basel and who founded the first monastery there, that of Saint Alban, when he invited a group of monks from Cluny to his city. The monks' contribution to the local economy was the excavation of canals that provided power for several industries and, in the fifteenth century, for paper mills. Bishop Heinrich II. von Thun (r. 1216–38)

Plate 1. *View of Basel* (detail), from the *Liber chronicarum*. See no. 1

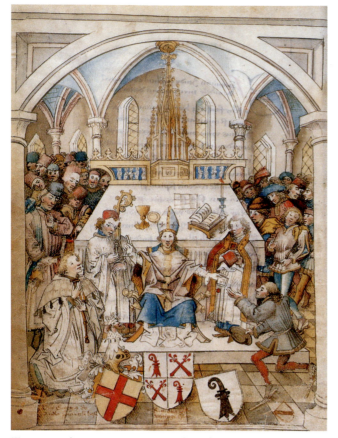

Figure 1. *Johann von Venningen, Bishop of Basel, in the Cathedral, Inaugurating Basel University, on April 4, 1460.* Illuminated manuscript on vellum (from the Basel *Matrikelbuch,* Universitätsbibliothek, Basel)

is remembered as the builder of the first bridge over the Rhine in about 1225, which allowed the development of the right bank of the river; known as Small- or Klein-Basel, this part of the city belonged to the diocese of Constance. He also summoned to Basel members of the newly founded mendicant orders, the Franciscans and the Dominicans.

The gradual emancipation of the burghers at the expense of episcopal power began in 1226, when Bishop Heinrich affixed his seal to the foundation charter of the guild of tanners, the first craftsmen to organize themselves as a corporation. About 1263, Bishop Henri III de Neuchâtel (r. 1262/66–74) sanctioned the election every year of a mayor and of a municipal council—which, at that time, consisted only of members of noble families and rich merchants. He also approved the charters of several other guilds, such as those of the goldsmiths, the gardeners, the weavers, and the construction workers.

The chronic debts of the Basel bishops in the fourteenth century forced them to make repeated concessions to the burghers. A charter of 1337 specified that the municipal council should be made up of a representative of each of the fifteen guilds, in addition to four noblemen and eight men from prominent families. After 1382, the leaders of all the guilds (*Zunftmeister*) sat on the council. The bishops, who often spent more time in their residences at Porrentruy and Delémont than in Basel, were forced to sell their prerogatives to the municipal council between 1360 and 1390, in part because of the strain put on the episcopal finances by the reconstruction of the city after the earthquake of 1356. Declaring bankruptcy on March 12, 1373, Bishop Jean de Vienne (r. 1365–82), for example, mortgaged his two most lucrative privileges—the rights to levy taxes on transiting goods and to issue currency—to the city of Basel for 12,500 and 4,000 gold gulden, respectively. In 1386, the municipality purchased the status of "Free Imperial City" from Emperor Wenzel, which made Basel accountable to him directly. In 1392, the city acquired Klein-Basel from the bishop, and, from that time on, his role was mostly ceremonial.

Basel's newly acquired independence and its position on the border of several states contributed to its choice by Pope Martin V (r. 1417–31) as the site of the seventeenth ecumenical council, or gathering of the Church. From 1431 until 1448, prelates and dignitaries from all over Europe convened in Basel. Of its three objectives—the fight against the Hussites, the establishment of a durable peace between England and France, and the reform of the Church—the council achieved some success only with the first. A major hurdle was the issue of the primacy of the council over the pope, which Eugenius IV (r. 1431–47) rejected. The council declared itself superior to the pontiff, deposed him, and elected an antipope in 1439, thus leading to a schism in the Church.

Among the participants in the council was Aeneas Silvius Piccolomini, who served in Basel from 1432 until 1442 as secretary to an Italian bishop. After his election as Pope Pius II, a group of Basel burghers requested from him the privilege to found a university, which the pontiff granted on November 12, 1459. The new statutes corresponded to those of Erfurt, and placed the university under the authority of the bishop.[5] On April 4, 1460, in Basel Cathedral, Johann von Venningen (r. 1458–78)

inaugurated the university and named Provost Georg von Andlau (about 1390–1466) its first rector (fig. 1).

Another consequence of the council was the production of paper to meet its needs for record keeping; the first paper mill opened in 1433. The availability of paper, in turn, was a prerequisite for the establishment of publishing houses. Printers settled in Basel in the 1450s, soon after Gutenberg's invention in Mainz of the press with movable type. With some twenty publishing houses by 1500, Basel was a leading center of book production. The printers Johannes Amerbach, Johann Froben, and Thomas Platter issued editions of the Bible, the writings of the Church Fathers and of classical authors, as well as the works of humanists such as Erasmus of Rotterdam, who was a longtime resident of the city. Albrecht Dürer and Hans Holbein the Younger were among the artists who illustrated these volumes.

Books published in Basel were important tools for the Reformation. A new interpretation of the Bible, especially of Saint Paul's epistles, led to a rejection of many Church dogmas in favor of the primacy of the Word. For this, the availability of the Scriptures in the vernacular was indispensable. Erasmus's edition of the New Testament in Greek and Latin, published by Froben in 1516, served as the basis for Martin Luther's translation of the Bible into German. Several of Luther's writings were printed in Basel by Adam Petri as early as 1518, and his theses found rapid acceptance. At the Corpus Christi procession of 1522, the parish priest of Saint Alban carried a Bible instead of a reliquary and proclaimed, "This is the true salvation; the others are just bones."[6]

The Reformation in Basel had strong social components as well. The municipal council abolished patrician privileges in 1515, and in 1521 officially rejected the dominion of the bishop over the city. This marked a formal break with tradition, since the bishop had *de facto* lost his jurisdiction over the city when Basel joined the Swiss Confederation in 1501. In 1525, members of the clergy were made burghers so that they could be taxed. The monasteries and their possessions gradually were placed under the authority of the council, which also began to appoint university professors. Events escalated in 1529, when the people of Basel besieged the Town Hall in an attempt to force the council to formally adopt the Reformation. The members of the council who were reticent to abandon Catholicism were forced to leave the city. On February 9, to hasten the council's decision, some two hundred men marched to the cathedral and to other churches, where they destroyed the altarpieces, paintings, and sculptures that were considered idolatrous. On April 1, 1529, the city formally adopted the Reformation, and the bishop left Basel for good.

1. As cited in Bonjour 1959, p. 30.
2. Unless otherwise specified, the historical account given here is based on Teuteberg 1988, and Alioth, Barth, and Huber 1981. I would like to thank Dr. Ulrich Barth, Archivist of the City of Basel, for his critical reading of an earlier draft of this text.
3. On the early growth of the city see d'Aujourd'hui 1986.
4. See Fellmann 1981, p. 47.
5. See Egger 1991.
6. See Wackernagel 1924, p. 329.

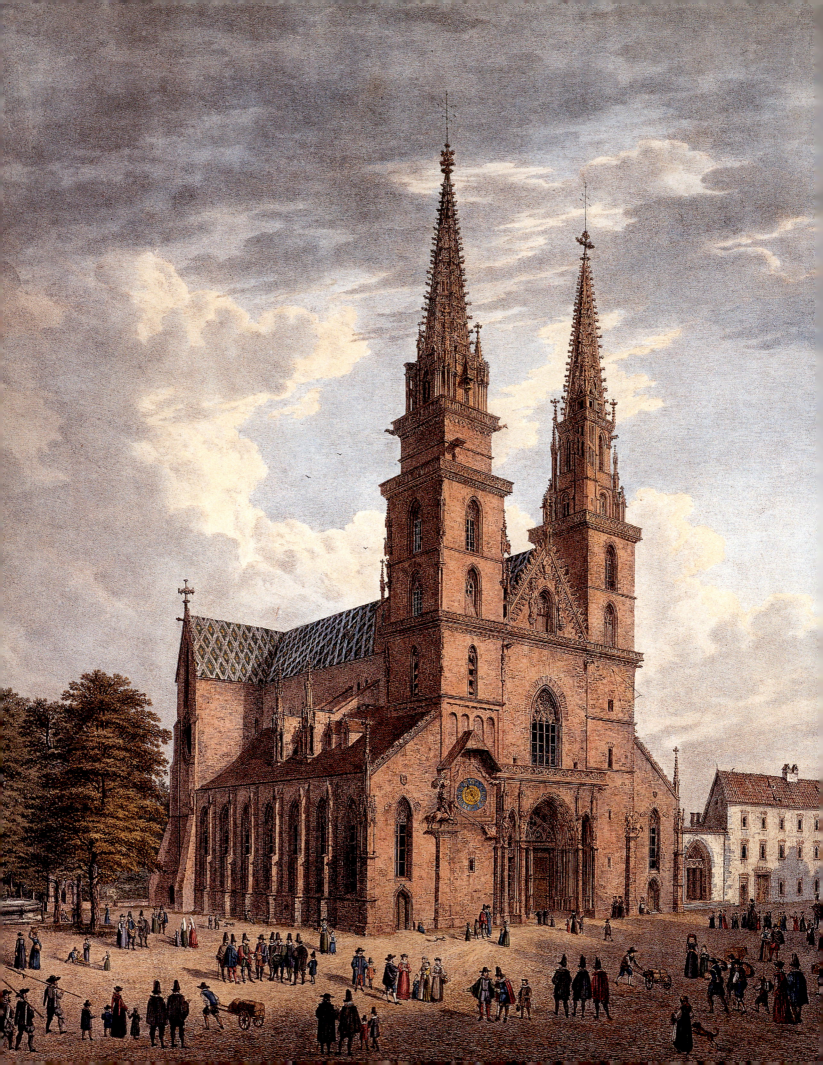

THE CONSTRUCTION OF BASEL CATHEDRAL: AN OVERVIEW

TIMOTHY HUSBAND

The Cathedral of Basel, situated on a high bluff overlooking the Rhine from its left bank, dominates a strategic site that has been occupied for over two thousand years. This promontory, in the middle of the bend where the widening Rhine begins its northerly flow, was fortified by the Celts in the first century B.C., and the layout of the main streets within the defensive walls (*Murus Gallicus*) was largely followed by successive inhabitants.[1] The Romans arrived soon after, and the settlement was expanded by a complex of buildings whose principal structure determined the orientation of the earliest church foundations. The extended fortifications defined the precinct of the holy sanctuary within which later bishops would claim immunity. Commanding views over the city and the Rhine, this precinct, encompassing the cathedral and its cloisters, the bishop's palace, the housing of the dean and chapter, the chapels of saints John and Ulrich, the Augustinian monastery, and the Parish Church of Saint Martin, was the heart of the city throughout the Middle Ages.

The Early Medieval bishops filled the governmental vacuum left by the departing Roman legions, and assuredly made use of their building foundations as well. A bishop by the name of Justinianus apparently was established in the area in the middle of the fourth century, but it is not certain whether he resided in Basel or in Kaiseraugst. At the beginning of the seventh century, a certain Ragnachar, formerly a monk at Luxeuil, became head of the Basel church, although again it is unclear whether the seat had as yet been transferred from Kaiseraugst to Basel. A Walaus and then a Baldobert were bishops in the eighth century, and a bishop named Waldo ruled about 800; nothing, however, is known of the church structures during this period.

In the first half of the ninth century, a large Carolingian church was constructed under the direction of Bishop Haito (r. about 805–23), an abbot from Reichenau, near Constance. Archaeological evidence suggests that it was a long, single-hall structure with an apse over a crypt at the east end and flanking towers at the west. The extended ground plan of the church forced the realignment of streets in a manner that, in part, prevails to this day. It remains uncertain how much of Haito's church had been destroyed by invading Hungarians in 917.

Soon after the turn of the millennium, Bishop Adalbero II (r. 999–1025) erected a new and enlarged cathedral. The two arcades that separated the nave from the side aisles rose above the outer foundations of Haito's church. The eastern crypt, with its vaulting and expanded choir above, incorporated much of the earlier structure, and is the most prominent feature to survive from the pre-Romanesque building campaigns. It was probably also during this period that the eastern towers at the juncture of the transepts and the choir were begun, if not completed. The cathedral was dedicated in 1019, with great ceremony and festivity, to Saint John the Baptist, the apostles, and, above all, to the Virgin Mary, apparently in the presence of Emperor Heinrich II (r. 1014–24). Heinrich had shown great favor to the city of Basel since it was pledged to him in 1006, along with the kingdom of Burgundy, by his uncle Rudolph III, who died without issue in 1032.

A number of structural features of Adalbero's cathedral dictated the design of future construction: The transepts projected only slightly beyond the side aisles, and these truncated extensions were retained in the Romanesque cathedral, as were the length and overall width of the nave, the width of the side and central

Plate 2. *View of Basel Cathedral from the Northwest* (detail). See no. iv

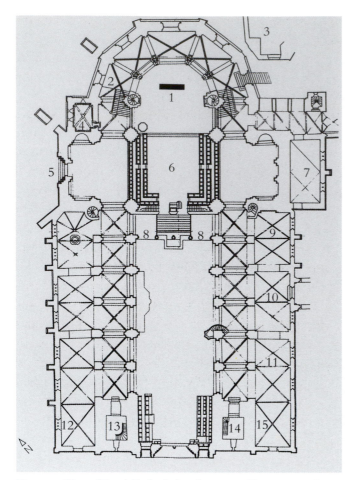

Figure 2. Plan of Basel Cathedral, as it appeared between 1381 and 1851: 1. High altar; 2. Tomb of Queen Anna von Habsburg; 3. Chapel of Saint Nicholas; 4. Sacristy; 5. Gallus Portal; 6. Choir stalls; 7. Chapel of Saint Catherine; 8. Choir screen; 9. Fröweler Chapel; 10. Gebwiler Chapel; 11. Tegernau Chapel; 12. Münch Chapel; 13. Tower of Saint George; 14. Tower of Saint Martin; 15. Bebelnheim Chapel (from *Basler Münster Bilder*)

aisles, and the placement of many of the supporting piers. Although it is less certain, the side aisles seem to have extended to the east, forming an ambulatory in the eastern hemicycle. While part of the foundations appear to date from Adalbero's time, construction of the Tower of Saint George, which we see today at the north corner of the west façade, seems to have begun toward the end of the eleventh century.

It is said that when Bishop Lütold von Aarburg (r. 1191–1213) pawned his ring and chalice, the campaign to build the Romanesque cathedral formally began,[2] but, in fact, he needed money to cover the expenses incurred by the visit, in 1212, of the emperor Friedrich II (1199–1250). Construction of the Roman-

esque cathedral, in all probability, had commenced under Lütold's predecessor, Bishop Heinrich I (r. 1180–90), after a fire in 1185, and continued until about 1220 or 1230. Reusing stone from the earlier church, the main body of the cathedral was enlarged, the nave arcades and the outer walls were rebuilt, the side aisles widened, and the crypt—along with the ambulatory overhead—either was constructed or reconstructed. This work probably was completed during the tenure of Bishop Lütold; having committed to the Fourth Crusade—his immediate predecessor had died in the Third Crusade—he had good reason to address his own mortality. Indeed, by 1193, an altar dedicated to the Virgin Mary was in use: This may have been either the high altar or the one located in the axial chapel of the ambulatory; the rededication of this altar in 1202, less than a decade later, undoubtedly was occasioned by the completion of the bishop's funeral monument. In addition, the dedication of the altar in the Magdalene Chapel in 1190 indicates that the large cloister was well under construction by this time.

Soon after the completion of the Late Romanesque cathedral, perhaps following a fire in 1258, the western end was altered extensively to incorporate a triple-arched narthex with a gallery above housing the altar of Saint Michael, which was completed in 1289 at the latest. A succession of bishops and members of the dean and chapter had secured prominent sites within the cathedral to erect their burial monuments, and the continual need for suitable locations provided impetus for new construction; funeral chapels were added beginning at least with the tenure of Bishop Henri III de Neuchâtel (r. 1262/66–74). Toward the end of the thirteenth century, the great tracery window was installed in the west gallery and the lower levels of the Tower of Saint Martin on the southwest corner were constructed. Early in the fourteenth century, Bishop Peter von Aspelt (r. 1297–1306) began a chapel of grander scale and format, thereby establishing the model followed by future bishops that resulted in the outer-aisle Gothic chapels flanking the Romanesque inner aisles. The last of these, the Bebelnheim Chapel, finished in 1346 and mirrored by the Münch Chapel in the northwest corner, conjoined the outer, southern aisle chapels with the now-completed Tower of Saint Martin (see fig. 2).

The devastating earthquake that struck Basel in 1356 toppled the upper stages of all four corner towers, and caused the collapse of the crossing tower, the choir, and, perhaps, other vaults in the nave and double side aisles, as well as damage to the crypt. During the energetic reign of Bishop Johann Senn von Münsingen (1335–65), rebuilding was rapidly begun under the direction of the master architect Johannes Parler of Gmünd, a member of the famed family of master builders responsible for the Cathedral of Saint Vitus in Prague as well as for numerous other churches across southern Germany. However, the eastern corner towers and the crossing tower never were rebuilt, and much of the reconstruction preserved the cathedral's Romanesque character. The conspicuous exception was Johannes Parler's Gothic choir: This soaring, narrow structure, the walls of which are dematerialized by expansive tracery windows, rises from the platform of the lower Romanesque elevation (see no. v). Element by element, the Gothic choir engages in a dialogue with its earlier substructure to which it is logically and coherently conjoined, window over corresponding window, and buttress connecting to corresponding buttress.

The high altar was rededicated in 1363, and the vaults of the crossing, transepts, and possibly those of the nave were reconstructed about 1400 or 1420. By this time, the west façade had been repaired and the damaged sculptures had been repositioned (see frontispiece). In 1381, the foundations of the choir screen were laid by Bishop Jean de Vienne (r. 1365–82). However, the upper elevations of the west towers remained unrealized by the beginning of the fifteenth century. In 1414, Ulrich von Ensingen, the famed master builder of Strasbourg, designed the upper elevations of the tower of Saint George; its execution, undertaken between 1421 and 1428/29, was entrusted to Johannes Cun, a master builder from Ulm, and Hans Böfferlin. The lower levels of the Tower of Saint Martin were reinforced by Vincenz Ensinger, who was the master builder of Constance Cathedral, and Hans von Nussdorf supervised the erection of the upper stages. On July 23, 1500, the finial of the Tower of Saint Martin was put in place, bringing to a conclusion the construction of Basel Cathedral five hundred years after it began (see nos. i, iv).

With 1529 came the rampages of the Iconoclasts and the advent of the Reformation. From this point onward, the cathedral was maintained as a parish church by the Basel city council, which assumed responsibility for upkeep of the fabric; restoration programs were undertaken in 1597, 1701, 1733–34, 1751, 1761–73, and 1785–87, although relatively little change was made to the building's exterior appearance. The interior changes were more conspicuous and none greater than those incurred from 1852 to 1857. Organs had been silenced by the Reformation, but they became an integral part of evangelical church life in the nineteenth century; in 1855, a new organ replaced one from the sixteenth century and, to support it, the choir screen was resituated in the west end of the cathedral, which, from then on, served as the organ loft. Concurrent alterations included leveling the crypt below the crossing, moving the pulpit forward to the pier against which one end of the choir screen had been attached, slightly raising the nave floor, and, most drastically, demolishing the westernmost reaches of the floor of the ambulatory. As this last modification eliminated access to the then empty upper sacristy where the Basel Treasury had been kept for three centuries, the door was sealed with masonry; today, this chamber can be reached only by ladder from the lower sacristy through a trapdoor in the floor above.

In an extensive restoration program, undertaken between 1880 and 1890, deteriorated masonry was renewed while compromised figural and architectural sculpture was removed, much of it eventually transferred to the Museum Kleines Klingental and the originals replaced with copies. Excavations between 1963 and 1974 yielded new archaeological information, and, in 1975, an interior renovation reversed some of the interventions of the 1852–57 restoration program. In response to the continuing need for the conservation and maintennance of the cathedral fabric, a new workshop, in operation since 1985, has repaired extensive areas of the masonry, substituted both casts and copies in stone for many of the deteriorated sculptures and architectural elements, retiled the roof of the Chapel of Saint Nicholas, and conserved and restored the Gallus Portal.[3] Repairs and conservation efforts continue to this day.

1. This essay is based largely on Schwinn Schürmann 2000; Maurer-Kuhn 1984; and Beck et al. 1982.
2. Beck et al. 1982, p. 91.
3. See Basel 1990, esp. pp. 38–73.

potunt de punasis demonstraturt inneq bisse octis di
est romanis corpale pstetur Juramentum sic esse
staturum traturus sf signo notarii pu gstetetar et ni
Qiunquagesimo nono Pontiftis dm Innocentij j
tus vir dns Petrus olim de Raspona et nic
mris sue et saf mf gsatter et asef boa n

A TREASURY IN BASEL

JULIEN CHAPUIS

Johann Senn von Münsingen, Bishop of Basel, was remembered at his death in 1365 as a reformer who had worked for the good of his diocese.[1] His thirty-year rule ensured Basel's peaceful relationship with both the pope and the emperor, and his financial reforms alleviated the burden of debts incurred by his predecessors. The two most traumatic events of his episcopate were the plague that ravaged Basel in 1349, killing a third of the population,[2] and a violent earthquake that struck the city on October 18, 1356. The quake destroyed the choir, the vaulting of the nave, and the great bell tower of the cathedral, as well as most of the houses in the city, which were built of wood and burned in the fire that followed.[3] With the help of neighboring towns such as Colmar, Strasbourg, and Freiburg, Bishop Johann initiated the repairs to the cathedral, and on June 25, 1363, he consecrated the new high altar in the rebuilt choir.

The reconstruction of the bishop's church certainly was aided by donations resulting from the veneration of the relics that Johann Senn von Münsingen had obtained from Rome after the earthquake. Indeed, it is as a benefactor of the Cathedral Treasury that Bishop Johann is portrayed in the historiated initial on a document of April 25, 1360 (plate 3 and no. xxi).[4] Kneeling in the center of the image, with the insignia of his office—the crosier and the miter—Johann Senn von Münsingen receives from Saint Paul a tooth, which he offers, now encased in an elaborate tower-shaped monstrance, to the Virgin Mary and the Christ Child. The text relates how Bishop Johann acquired for Basel relics of saints Paul, Cecilia, Pancras, Fabian, Sebastian, Agnes, Dorothy, Urban, Petronella, George, and Lucy, as well as of the Holy Innocents and the 10,000 Martyrs. The Virgin Mary in the miniature personifies the Cathedral of Basel, which was dedicated to her. Sewn to the parchment are two later texts, one, of May 23, 1360, and the other, of January 19, 1361—each promising an indulgence

(the remission of temporal punishment in purgatory) of forty days for the veneration of the relics.

This document offers an exceptional insight into the mentality that informed the development and use of a medieval church treasury—an ensemble of precious objects, ordinarily assembled over a long period of time, that served the cult. In one category were items used in the liturgy: chalices, patens, cruets, pyxes, and other vessels for the Eucharistic bread and wine; books, often with elaborate covers, containing the order of the Mass, the Psalms, the Bible, or the Gospels; censers, to burn incense; and elaborate vestments, such as albs, chasubles, copes, and miters, whose different colors reflected the liturgical calendar. In another category were the often-elaborate receptacles for relics, believed to be the bodily remains of Christ, the Virgin, or the saints, or objects that had come in contact with them.

The practice of endowing churches with precious objects for the liturgy or the veneration of the saints was widespread in western Europe by the time of Charlemagne. The emperor himself made important donations not only to his palace chapel at Aachen but also to places farther away, such as the Abbey of Saint-Maurice d'Agaune, a site in present-day Switzerland where a cult had developed around the tomb of an Early Christian martyr. Donations expressed the piety of the benefactor and his station in society, elevated the status of a place or of a cult, and, in turn, attracted other gifts.

Governing the formation of treasuries was the thought that because God created all things, the more precious the materials with which his churches were adorned, the better suited they were to honor him. Gold, silver, and gems were seen as particularly desirable for the decoration of liturgical vessels, book covers, or reliquaries, since they came in contact with the Body and Blood of Christ, the sacred texts, and the remains of the saints. The twelfth-century Cistercian abbot Bernard

Plate 3. *Johann Senn von Münsingen, Bishop of Basel, Receiving a Tooth from Saint Paul and Presenting It to the Virgin, Patroness of the Cathedral, in a Monstrance* (detail). See no. xxi

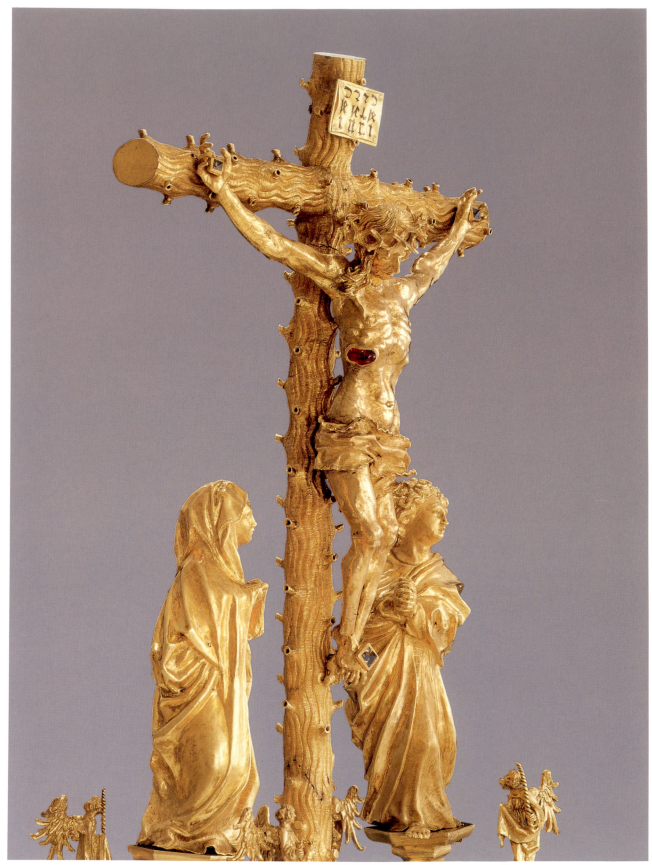

Figure 3. *Hallwyl Reliquary* (detail). See no. 34

of Clairvaux was one of the few to object that the richness of the materials was a hindrance rather than an aid to devotion, and that the sight of a golden reliquary prompted most people to admire the costly metal instead of venerating the saint. Bernard's contemporary, Abbot Suger—who, in 1122, began the remodeling of the Abbey Church of Saint-Denis, near Paris—expressed the opposite view: The opulent vessels that he had added to the Treasury were more appropriate to honor the saints, for they made visible the spiritual value of the relics. The Book of Revelation, which describes the heavenly Jerusalem as a city made of gold and gems, legitimized Suger's lavish use of precious materials.[5]

The value of their holdings is the main reason why so few church treasuries have survived. Since gold and silver can be reused countless times, ancient vessels frequently were destroyed to create new objects. More often than not, treasuries were pillaged during wars or revolutions. Their contents were melted down into ingots to finance mercenaries or to feed populations during famines. Much liturgical silver and gold also was destroyed during the Protestant Reformation, when the primacy of the Word supplanted the dogma that Christ is present in the Eucharist. In most cases, it is only through inventories that one can gain an impression of the cathedral treasuries of such cities as Lausanne or Magdeburg. Basel is one of the rare sites, along with Saint-Maurice d'Agaune, Aachen, Venice, and Halberstadt, to have retained a large portion of its medieval treasury. The survival of the treasuries of Basel and Halberstadt is all the more remarkable since these towns became Protestant in the sixteenth century.

Central to any treasury—because they are intimately linked to the identity of a church and often of a city, as well—were relics and the precious receptacles that housed them. Their veneration brought with it the hope that the saints would offer favors and intercede with God for the salvation of mankind. The more important the person of which the relic was a part, the greater its perceived power and, therefore, the prestige it brought to its owner. Cologne, for example, placed itself under the protection of the Magi, whose remains were kept in the cathedral. Likewise, Basel chose Heinrich as its patron saint after acquiring his relics in 1347. The search for relics was driven by the belief that owning the remains of as many saints as possible would result

in their cumulative protection. Johann Senn von Münsingen's purchase in 1360 of a multitude of relics from Rome certainly was governed by a desire to comfort a city whose confidence had been shaken by the plague and the earthquake, and to shield it against future calamity.

Through the honor they conferred on their guardians, relics often were an embodiment of political power. After acquiring the remains of Saint Mark from Alexandria in 828, Venice rivaled Rome in having the complete body of an apostle. In 926 or 935, Emperor Heinrich I obtained from King Rudolph II of Burgundy the spear believed to have pierced Christ's side at the Crucifixion. The price he paid for the highly desirable relic was considerable: Basel, and a sizable part of Swabia.[6]

Relics were also an important source of income since they attracted donations from the faithful. Pilgrims traveled long distances to sites where important relics could be viewed, such as those of Saint Foy at Conques in central France, or of Saint James at Compostela in northern Spain. Not only did the churches receive gifts but the local economy benefited from the sale of souvenirs and pious images as well as from feeding and housing the faithful. In Basel, on Sundays, Mondays, and Fridays, as well as on feast days, a cleric stood in front of the choir screen, encouraging donations with the following words: "Help maintain the cathedral, which is inhabited by God, Our Lady, the heavenly emperor Saint Heinrich, and all the saints. Take part in the grace and salvation of God. . . . Anyone in possession of money found, acquired through gambling, usury, or not legally inherited, should give it to the house of Our Lady and so be free of sin." The petition, known in German as a *Bitt*, contributed an estimated 140 pounds annually to the cathedral. As a reward for their donations, the devout were blessed either with the large cross given by Emperor Heinrich II in 1019 (no. 4), containing the two most precious relics of the Treasury—the blood of Christ and a splinter of the True Cross—or with another reliquary.[7]

Often described as rarer than gold and gems, relics were thought to be even more valuable than the receptacles that housed them. A thirteenth-century poem refers to the splinter of the True Cross and the blood of Christ in the Heinrich Cross as the most precious possessions of Basel but does not mention the cross itself, which is made of gold, silver, and gems.[8] Likewise, in

the fourteenth century, thieves stole the splinter of the True Cross but left the Heinrich Cross otherwise intact. When the relic was returned in 1381 by Greda zem guldin Ringe, the Cathedral Chapter promised her a memorial Mass each year after her death.[9]

Integral to the cult of relics was the belief that the saints were present in them: The relics thus are proof positive of the existence of a person or the occurrence of an event. Indeed, in the 1360 miniature, Johann Senn von Münsingen receives Saint Paul's tooth from the apostle himself. Further evidence of a relic's power of mediation is given by a particular display during the Council of Basel. After Pope Eugenius IV refused to recognize the council's primacy over him, the councillors met in the choir of Basel Cathedral on June 25, 1439, to declare the pope a heretic and to depose him. On this occasion Cardinal Louis Aleman of Arles, president of the council, ordered that reliquaries from the Basel Treasury be placed on the seats of the absent bishops, so that the saints themselves would attend the gathering and sanction its proceedings.[10]

HEINRICH II: FOUNDER AND PROTECTOR OF THE TREASURY

The defining figure in the history of the Basel Cathedral Treasury is Emperor Heinrich II, who was its earliest and principal benefactor, and who, himself, became the object of a cult. Heinrich II had inherited Basel in 1006 from his uncle King Rudolph III of Burgundy, who had remained childless. This acquisition was a politically significant act, since Basel controlled the access routes from the Rhine to the Kingdom of Burgundy (*Hochburgund*), which, at the time, was situated in present-day western Switzerland. Through gifts and privileges, Heinrich elevated the hitherto modest diocese to a position of prominence. He strengthened the economic power of Bishop Adalbero II (r. 999–1025) by allowing him to mint his own currency. He gave Basel several forests rich in game, which provided a plentiful supply of meat for the episcopal household.[11] He also fostered the speedy reconstruction of the cathedral, which the Hungarians had destroyed in 917; whatever precious objects the cathedral contained must have disappeared by then. Only a single relic, the foot of one of the Innocents given by the sixth-century Irish monk

Columban, remained in the Treasury (see nos. 44, 47).[12] The new building was consecrated by Bishop Adalbero on October 11, 1019, in the presence of the emperor.

The exceptional nature of Heinrich's gifts to the cathedral ensured that he would be remembered in Basel throughout the Middle Ages. The most precious objects in the Treasury, they featured prominently in major cultual and civic events. Heinrich donated several highly important relics, including some associated with Christ, the Virgin, and John the Baptist, as well as with the apostles Peter, Paul, Andrew, and Thomas, and with many other saints.[13] To confer adequate prominence on the high altar, which housed them, Heinrich donated a sumptuous antependium made of gold (no. 2)—that is, a large relief with Christ and saints Benedict, Michael, Gabriel, and Raphael, which was placed in front of the altar on solemn occasions. Among his other gifts were the large reliquary cross, discussed above; a golden censer; a book described in documents as a "plenarium sumptuosum," containing a complete set of liturgical writings in a binding of gold and precious stones, with the emperor's image; a cope embroidered in gold (see no. xv); a large gilded-silver chandelier in the shape of a crown that hung in the choir in front of the high altar; and a throne decorated with gold, silver, and ivory. In addition, the Basel Breviary of 1515 (no. ii) makes reference to "many other precious objects" presented by the emperor.[14]

While the bodily remains of the saints on the high altar necessarily were hidden from view, the particles of the True Cross given by Heinrich II were plainly visible behind the crystal cabochons of the cross-shaped reliquary. The relics associated with Christ's Passion were singled out by writers as early as the thirteenth century as the most precious in Basel,[15] and the Heinrich Cross not surprisingly became the principal focus of the Treasury. Together with the *plenarium*, it was carried in procession several times a year, and remained at the center of cultual life in Basel until the Reformation. On Palm Sunday, for example, a procession marched through the Cathedral Square after the consecration of the palms. The Heinrich Cross and the *plenarium* were laid out on a silk cushion on a stone column, in front of the bishop's throne, against the north wall of the cathedral. The celebrant stood before the cross, and, responding to the choir by singing "O cross hail to thee, our only hope," he threw himself to the ground, where he lay prostrate.

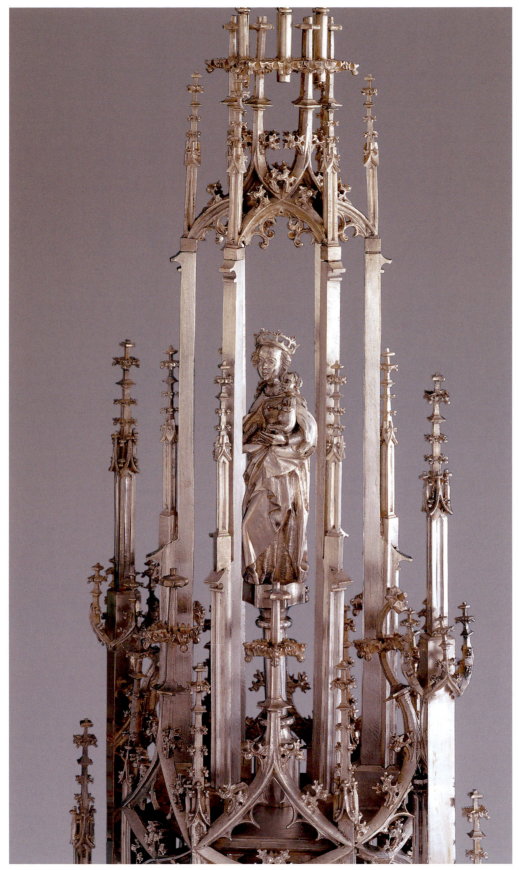

Figure 4. *Münch Monstrance* (detail). See no. 72

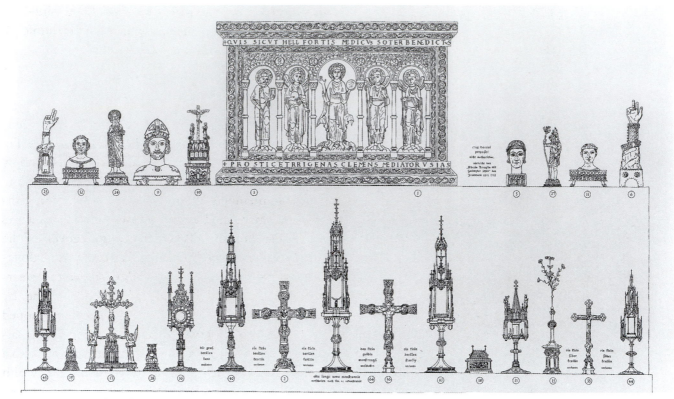

Figure 5. Diagram of the display of Treasury objects on the high altar of Basel Cathedral on major feast days in the later Middle Ages (from Burckhardt 1933)

He then touched the cross with a palm, after which the clergy and all the people present followed suit.

The Good Friday liturgy allowed for an even closer contact with the cross. Wrapped in a golden cloth, the cross was placed on a silk cushion on the steps of the choir and held upright. The celebrant—barefoot, as a sign of humility—raised the cross three times, unveiling it in the process as he called out, "This is the wood of the cross." The adoration proper followed. Beginning with the bishop, members of the clergy knelt and approached the cross in order to kiss it. Once the clergy had returned to their seats, members of the municipal council entered the choir with candles, and worshiped the cross in similar fashion. At the end of the liturgy, the cross, together with the Eucharist, was placed in the holy sepulcher that had been installed in the choir.[16]

The cross was thought to bring protection, comfort, and health, and popular piety naturally grafted these miraculous virtues on to Heinrich II himself. The precious objects, which were of considerable importance because they had been given by an emperor, became doubly so after Heinrich was declared a saint in 1146. The

emperor's canonization had been promoted by the diocese of Bamberg, which Heinrich had founded in 1007, and in whose cathedral he lay buried along with his wife, Kunigunde. A *vita* was drafted and various miracles ascribed to the imperial couple. A cult of Heinrich rapidly developed in southern Germany, and by the early thirteenth century the pietistic reverence in which Heinrich was held in Basel gave way to liturgical veneration. The significance of the imperial couple for the diocese was spelled out in stone at the end of the thirteenth century, when monumental effigies of Heinrich and Kunigunde were installed on the west façade of Basel Cathedral (see frontispiece).[17]

The cult of Heinrich received official sanction from Bishop Johann Senn von Münsingen on July 28, 1347, when he declared July 13 the saint's annual feast day. Cathedral chaplain Johannes von Landser, who, as subdeacon of the chapter, was responsible for the safekeeping and maintenance of the Treasury, was the first to express the desire for relics of the emperor and his wife to be sent to Basel: The bishop, Cathedral Chapter, mayor, council, and burghers all agreed to formally ask Bamberg for bodily

16

Figure 6. Instructions for displaying the Treasury on the high altar of the cathedral on major feast days. About 1500. Pen and ink on paper. Staatsarchiv des Kantons Basel-Stadt

that it was on his feast day in 1501 that Basel joined the Swiss Confederation, effectively marking the municipal council's break from the authority of the bishop.

THE GROWTH OF THE TREASURY

The Basel Cathedral Treasury grew over the five centuries from the consecration of the restored cathedral in 1019 to the adoption of the Protestant Reformation by the city in 1529. It increased through commissions and gifts from members of Basel's Cathedral Chapter, bishops, noblemen, and burghers, as well as from dignitaries outside the diocese. Different motivations governed the gift of a precious object to a church treasury. The donation was first of all an act of piety: It expressed the veneration of an individual for a saint, Christ, or the Virgin. By providing, say, a receptacle for a relic, the donor hoped for the protection of that particular saint and for the salvation of his or her own soul. The costly gift was also a statement about the donor's actual or perceived wealth and station in society. Equally important, the gift perpetuated the memory of that individual long after death. Donors were aware that Emperor Heinrich's gifts had kept his name alive in Basel centuries after any recollections of his actual person had faded. In fact, many objects in the Basel Cathedral Treasury announce the identity of their donors through armorial shields or inscriptions.

The development of the Treasury, in which growth followed a period of stagnation, reflects the changing political situation in Basel. Carried in procession and displayed on the high altar of the cathedral, the contents of the Treasury were tangible embodiments of episcopal power. As long as that power was strong, there was no need to increase its signs of expression. From the early eleventh until the mid-thirteenth century, almost nothing was added to the Treasury; the gifts of Heinrich II were sufficient to make visible the bishop's genuine authority as a worldly and religious ruler, whose prerogatives were sanctioned by the emperor and his successors.

By the late thirteenth century, however, the bishops began to lose their hold over Basel and more objects were added to the Treasury. About 1263, Henri III de Neuchâtel approved the yearly election of a municipal council, and he authorized the foundation of several guilds, which, a century later, would effectively rule the city. In 1270, he obtained from Cologne the skull of

remains. The official request sent by Bishop Johann Senn von Münsingen praised Heinrich for having restored the Basel church after the damage inflicted by the pagans. The Bamberg Chapter sent fragments of the right arms of the emperor and the empress, which arrived in Basel on November 4 amid great celebration. The bishop in full regalia, the clergy, and all the burghers—carrying crosses, reliquaries, and candles—hastened to the gates of the city, and, to the sound of church bells, accompanied the relics to the cathedral,[18] where they were placed in a tower-shaped monstrance, within a crystal cylinder flanked by statuettes of the imperial couple (no. 65).

Heinrich had now become the third patron saint of Basel, after the Virgin and Pantalus, and he gradually surpassed them as the principal bearer of communal identity. The relics were shown to the people, along with the Heinrich Cross and the *plenarium*, in a procession that meandered through the city every year on July 13, uniting the chapter, the council, and the burghers of Basel. By the Late Middle Ages, the figure of Heinrich was so allied with the identity of the city

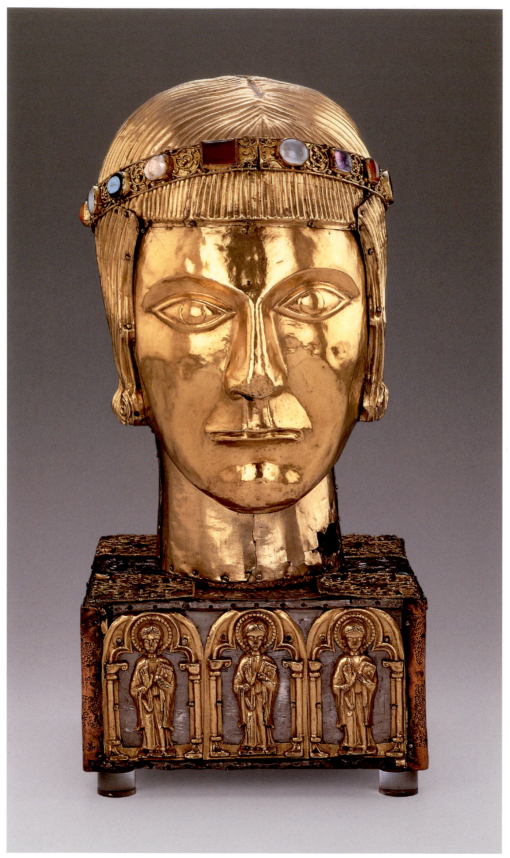

Figure 7. *Reliquary Head of Saint Eustace.* See no. 9

Saint Pantalus, the legendary first bishop of Basel, said to have accompanied Ursula and her 11,000 Virgins to Cologne, where they were martyred in 451. In an affirmation of his own authority, Bishop Henri elevated Pantalus to second patron saint of the diocese, after the Virgin Mary, and he commissioned an imposing reliquary bust of the saint in full episcopal regalia (no. 39). When they saw the bust carried in procession, many naturally would link the reliquary to the bishop himself.[19] That the commissioning of the Pantalus reliquary was not free of political connotations is confirmed by the case of Saint Ursula, whose relics were received from Cologne in 1254, but it was not until the early fourteenth century that a reliquary bust was made (no. 41).

In 1386, the municipality of Basel purchased the status of "Free Imperial City" from Emperor Wenzel, which made the city accountable only to him. Ironically, more goldsmiths' work entered the Treasury from this time, when the bishop's authority became essentially ceremonial, until 1529, when the Reformation was adopted, than in the four centuries following the consecration of the restored cathedral in 1019. A parallel can be found for this situation in sixteenth-century Venice. While it was at its zenith as a maritime power, the Serenissima had little need for visual glorification, but in the sixteenth century, when its supremacy was long gone, Tintoretto was commissioned to paint vast allegories in an attempt to convince visitors to the Ducal Palace that the authority of Venice was stronger than ever. Likewise, in Basel the lavish commissions of the decades preceding the Reformation reflected an episcopal power that had ceased to exist.

The desire for an imposing display of metalwork went hand in hand with what one might term an inflation of relics. In 1450, the foot of one of the Innocents was placed in a newly manufactured reliquary (no. 44). Shortly afterward, the chapter commissioned a large cross, the so-called Sunday Cross (no. 33), so close in form and dimensions to the Heinrich Cross that when seen in a procession most people would have mistaken the new cross for the one given by the emperor. In 1470, the chapter acquired from Rudolf V. von Hallwyl a particularly precious reliquary (see fig. 3 and no. 34) with figures made of solid gold for those relics of the True Cross and the blood of Christ that had been in Basel for centuries. The last major group of objects to enter the Treasury is an ensemble of six extremely tall tower-shaped monstrances, created in the last decade of the fifteenth and the first decade of the sixteenth century. With the exception of one monstrance, commissioned to house relics of Saint Theodulus given by the diocese of Sion in 1490 (no. 74), these new receptacles were manufactured for relics that already had reliquaries. The relics of Heinrich and Kunigunde were divided and placed in three of these (see fig. 4 and nos. 72, 77, 78), in order to increase the visibility of the imperial couple as well as to strengthen the bishop's claim that he was a territorial ruler. The chapter financed part of the commissions; noble families involved with the cathedral paid for the others.

A particular feature of the Basel Cathedral Treasury is that reliquaries comprise the preponderance of its holdings. Of the few liturgical vessels to have entered the Treasury, many seem to have taken the place of earlier ones that were either damaged or lost. The pair of silver censers from about 1200 (no. 7), for example, are thought to have replaced the golden censer given by Heinrich II, which had become worn out by two centuries of use, while the chalice presented by Gottfried von Eptingen a few decades later (no. 8) was a substitute for a golden chalice, mentioned in documents, which had been sold by Bishop Lütold von Aarburg (r. 1191–1213). Because relics were associated with prestige and protection, it must have been easier for the Cathedral Chapter to find donors willing to finance the manufacture of elaborate receptacles for them rather than to pay for other objects of lesser significance.

The reliquaries in the Treasury fall into four categories. Shaped like the remains that they contain, the busts of saints Eustace, Pantalus, Thecla, and Ursula (nos. 9, 39, 40, 41), the arms of saints Walpert and Valentine (nos. 10, 43), or the Foot Reliquary (no. 44) are often called talking reliquaries; these vessels make the relic vividly present by rendering it in precious metal. Monstrances, of which the Apostles Monstrance (no. 64) of 1330–40 is an outstanding example, dramatically display a relic or a consecrated Host in their center, behind a crystal window or cylinder. Full-length figure reliquaries, such as the statuettes of saints John the Baptist and Christopher (nos. 36, 37), are narrative, anecdotal depictions of each saint. These three types contrast with the casket reliquaries (nos. 30, 31), whose forms provide no indication of their contents.

While a few objects in the Treasury were produced elsewhere, such as Avignon (no. 55) or Strasbourg (no. 34), most objects in the Basel Cathedral Treasury are thought to be of local manufacture. Goldsmiths in Basel, along with coin minters and money changers, were members of the guild "zu Hausgenossen," so called because the master of the mint originally was a member of the episcopal household.[20] First recorded in Basel in 1267, goldsmiths varied in number. By 1280 there were four masters working concurrently in the city. In the first decades of the fourteenth century, by contrast, there seems to have been only one master goldsmith active at a time in Basel. After the earthquake of 1356, several goldsmiths settled in the city, and in 1363, thirteen of them purchased a house together. From 1400 until 1529, the number of workshops fluctuated between ten and fifteen, with the exception of the 1430s and 1440s, when the council met in Basel and there were as many as twenty-six masters.[21]

Medieval goldsmiths in Basel did not sign their works and very few objects can be ascribed to specific craftsmen. One exception was Hans Rutenzwig from Augsburg, who was active in Basel from 1453 until 1486. It is likely that he received the commission from the Cathedral Chapter for the *Agnus Dei* Monstrance (no. 66) in 1460, since he is referred to in documents as "the goldsmith of the cathedral" ("aurifabro fabrice").[22]

Like Rutenzwig, several goldsmiths came to Basel from other centers—some close, such as Colmar and Strasbourg, other farther away, such as Nuremberg and Zwickau.[23] The mobility of artists contributed to the dissemination of styles, and several works in the Basel Cathedral Treasury bear witness to the goldsmiths' knowledge of art from other regions. A case in point is the mid-fourteenth-century reliquary known as the Chapel Cross (*Kapellenkreuz*) (no. 58)—in Berlin until its disappearance in World War II—whose graceful, elongated figures reflect contemporary French work.

DISPLAY AND ACCESSIBILITY OF THE TREASURY

From the eleventh to the sixteenth century, the presentation of the Treasury was highly regulated by liturgy and protocol. When not on view, which was most of the time, it was deposited in the upper story of the Romanesque sacristy for safekeeping (see fig. 2 and nos. v, vii). This secure space, adjacent to the north transept, was approachable only from the cathedral itself. Most objects were locked up in a large cabinet with heavy doors blocking off the west vault of the chamber (no. 1). The Golden Altar Frontal of Heinrich II and one of the Late Gothic monstrances had their own receptacles in the same room.[24] Liturgical vestments and books were stored in two other sacristies, located above the Chapel of Saint Catherine on the south side of the cathedral.

At least seven times a year—at Christmas, Easter, Pentecost, and Corpus Christi, and on Saint Heinrich's day and the feasts of the Ascension and All Saints—the major objects were installed in two registers on the high altar, with the Golden Frontal in the center; on less important feast days the Altar Frontal was not included.[25] Surviving instruction sheets for the placement of individual objects reveal a symmetrical arrangement (figs. 5, 6). Although these plans date from about 1500, a time when the Treasury was at its most extensive, it is fair to assume that the display of the reliquaries was codified gradually over the centuries. Indeed, the commissioning of certain works as pendants for others, such as the arms of saints Valentine and Walpert, the busts of Ursula and Thecla, and the reliquaries of saints Christopher and John the Baptist, suggests that symmetry had been a governing principle in the formation of the Treasury, from an early stage.

The distance normally maintained between the population and the precious objects must have intensified their impact. When on the high altar, the Treasury was first and foremost visible to members of the Cathedral Chapter, who enjoyed an unencumbered view from their seats on the tribune. A choir screen, erected in 1381, separated the choir from the nave. Lay people, who neither had access to the sacristy nor to the choir, could only catch a glimpse of the shimmering reliquaries and crosses in the distance, through the two central openings in the screen, over the stairs that led to the tribune and to the high altar beyond.

Individual elements of the Treasury were much more accessible during the thirty-odd processions that punctuated the liturgical year. Varying in importance, itinerary, and number of participants, some meandered through the cathedral to one of its approximately forty-five altars, others proceeded through one or both cloisters,

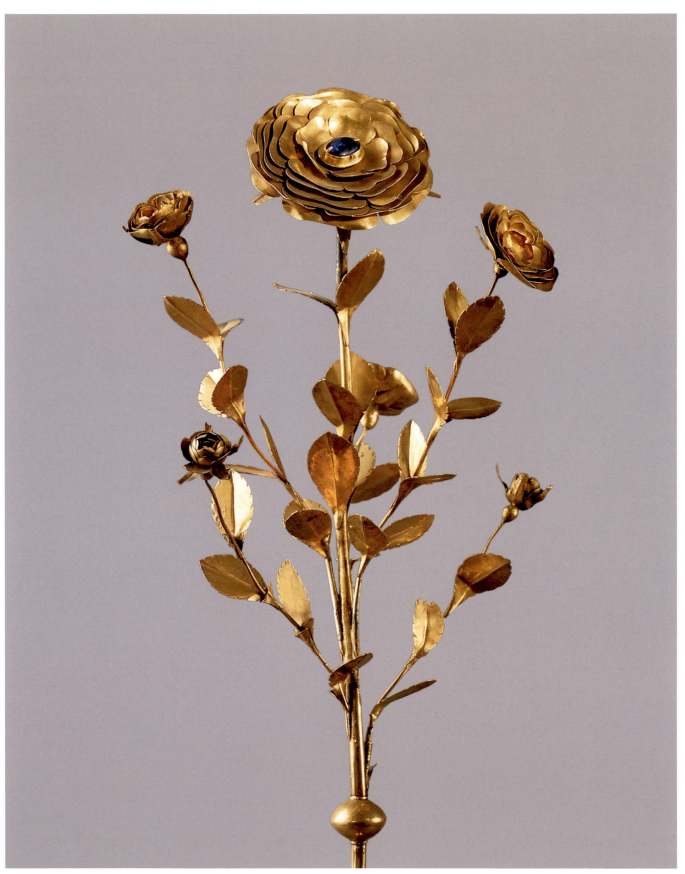

Figure 8. *Golden Rose Branch* (detail). See no. 55

and still others crossed the Cathedral Square. The Reliquary Head of Saint Eustace (fig. 7 and no. 9), for example, was carried through the cathedral on November 2, the feast day of the saint,[26] as was the Foot Reliquary (no. 44), on December 29, the feast of the Innocents.[27] To commemorate John the Baptist's birth, the large monstrance containing his finger (no. 75) was taken across the Cathedral Square to the Chapel of Saint John on June 24.[28] On the fourth Sunday in Lent, the Golden Rose Branch given in 1330 by Pope John XXII to Rodolphe III de Nidau (fig. 8 and no. 55)[29] was carried onto the Cathedral Square by a celebrant, preceded by two choir boys with candles, the whole choir, the pupils of the cathedral, the bell ringer with the veiled cross, and a subdeacon with a Gospel book; the procession did not stop, returning directly to the cathedral.[30]

Once a year, on the Feast of Corpus Christi, the Treasury featured prominently in a celebration that united the clergy and population of Basel.[31] After Mass, the master of the ceremonies, carrying his staff (no. 29), led a long cortège out of the cathedral. Two acolytes with banners, two chaplains with the Sunday Cross (no. 33) and a Gospel book, and the pupils from the parishes of Saint Martin, Saint Peter, Saint Leonard, and the cathedral headed the march. Then came the clergy: the Franciscans, the Dominicans, the Augustinians, and the canons of Saint Martin, Saint Peter, Saint Leonard, and Saint Alban, each with their own crosses, banners, and candles. They were followed by members of the guilds with candles, two acolytes with church banners, the deputy custodian with the Heinrich Cross (no. 4), a deacon with the golden *plenarium*, the cathedral chaplains with the reliquaries, the principal chaplains, the canons, and the prelates. Then came the mayor, preceded by his officials; behind him marched the senior guild master; and after them, the organist, singers, and pupils of the cathedral, carrying candles, small bells (nos. 25, 26), flowers, and perfume. The master of the innkeepers' guild, holding a candle, was followed, in turn, by a burgher, who scattered roses in front of the monstrance with the consecrated Host. A priest, with two acolytes, a deacon, and a subdeacon in tow, carried the monstrance under a canopy held by four vassals of the bishop. Another priest remained nearby with a stand on which the heavy object could be set from time to time to afford the priest carrying it a rest. Then, all the candle-bearing members of the merchants' guild, and the men and women of Basel, assembled according to their station, joined the procession, which wound its way across town and, after several hours, returned to the cathedral.

The arrivals of dignitaries in Basel were other occasions on which the Cathedral Treasury served as the focus of communal identity. On September 3, 1473, for example, the Bishop of Basel and all the clergy and burghers of the city, carrying reliquaries and candles, walked to the bridge on the Wiese River (an affluent of the Rhine) to meet Emperor Friedrich III and to accompany him, under a canopy, to the cathedral.[32] More often than not, however, the objects in the Treasury became symbols of the bishop's ebbing dominion over Basel, which was superseded by the power of the newly elected leaders of the municipal council, who, nevertheless, pledged allegiance to the bishop every year, once on the golden *plenarium* and a second time on the Heinrich Cross.[33]

The Protestant Reformation, adopted by Basel on April 1, 1529, effectively put an end to the use and expansion of the Treasury. The leaders of the new faith abolished the cult of relics and the commerce of indulgences that accompanied it, and they rejected the doctrine of transubstantiation—that is to say, the dogma that Christ is present in the consecrated bread and wine—giving primacy instead to the Word of God. The reliquaries, monstrances, and liturgical vessels, which, for centuries, had marked the rhythm of the Church calendar, suddenly lost their function. The citizens of Basel, however, did not melt down the greater part of the Treasure but kept it in recognition of its importance to their collective memory.[34]

It is tempting to draw a parallel between this act of *pietas* and the reverence with which the city buried Erasmus of Rotterdam a few years later. Convinced that, although necessary, a reform would ultimately tear the Church apart, Erasmus left Basel in 1529 for Freiburg-im-Breisgau. Lonesome for his friends and in ailing health, he returned to Basel in May 1535, and died during the night on July 12, 1536. The students and professors at the university, as well as most members of the municipal council, attended the funeral of the

humanist at the cathedral the following day, even though he had remained a Catholic.[35] Erasmus was interred in the nave and a marble slab with an inscription celebrating his virtues was erected against a pillar, directly in front of the pulpit from where the new doctrine was preached. The Treasury, which for five hundred years had defined the identity of the city, was only a few yards away.

1. On Bishop Johann Senn von Münsingen see Wackernagel 1907, pp. 249–75; Stückelberg 1907, caption to pl. 17; Bruckner 1972, pp. 187–88.
2. Some 4,000 inhabitants died in the epidemics out of an estimated population of 12,000; see Teuteberg 1988, p. 146.
3. See Wackernagel 1907, pp. 270–71.
4. Staatsarchiv des Kantons Basel-Stadt, Domstift Urkunde, no. 119.
5. On the use of precious material in church treasuries, its political implications, and Saint Bernard's and Abbot Suger's views on the subject, see the essay entitled "'Das Herz des Königs ist im Schatz': Der Kirchenschatz als politisches Zeichensystem (11.–16. Jh.)," in the catalogue of the Basel venue of this exhibition, by Achatz von Müller, whom I would like to thank for making his text available to me before publication.
6. See Pfaff 1963, p. 11.
7. For a more thorough discussion of the Bitt, and for the original quote in Middle High German, see the essay entitled "Reliquien und Reliquiaren, ihre Aufbewahrung und ihre Funktion im Leben der Bischofstadt Basel," in the catalogue of the Basel venue of this exhibition, by Marie-Claire Berkemeier-Favre, from which this paragraph is drawn. I would like to thank Dr. Berkemeier-Favre for kindly allowing me to read her manuscript before publication and for generously providing me with information.
8. See Meyer-Hofmann 1973, pp. 25, 31.
9. See Wackernagel 1916, p. 772. The episode is described by Berkemeier-Favre.
10. See Wackernagel 1907, p. 519.
11. See Pfaff 1963, pp. 17–18.
12. See Burckhardt 1933, p. 3.
13. See Pfaff 1963, p. 36.
14. On the now lost gifts of Heinrich II to the cathedral see Burckhardt 1933, pp. 52–56.
15. See Meyer-Hofmann 1973, pp. 25, 31.
16. On the different uses of the Heinrich Cross see Pfaff 1963, pp. 40–42.
17. See Pfaff 1963, p. 68.
18. Ibid., pp. 68–70.
19. See von Müller in note 5, above.
20. See Barth 1989, vol. 1, p. XI.
21. See Barth 1978, pp. 106–7.
22. See Burckhardt 1933, p. 232, n. 3; Basel 1989, vol. 3, p. 12. The document is in the Staatsarchiv des Kantons Basel-Stadt, Domstift NN 1470/71, p. 55. I would like to thank Dr. Berkemeier-Favre for the citation.
23. See Barth 1989, vol. 3, pp. 5–16.
24. See Stückelberg 1922, pp. 58–60; Burckhardt 1933, pp. 221–22.
25. On the display of the Treasury on the high altar see Burckhardt 1933, pp. 15–21, 353–58.
26. See Burckhardt 1933, p. 68.
27. Ibid., p. 220.
28. Ibid., p. 288.
29. See Taburet-Delahaye 1989, pp. 168–69.
30. See Hieronimus Brilinger, Ceremoniale Basiliensis episcopatus 1517, in Hieronimus 1938, pp. 146–47.
31. Ibid., pp. 218–25.
32. This episode is described by Marie-Claire Berkemeier-Favre.
33. See Burckhardt 1933, p. 46, and Berkemeier-Favre, in note 7, above.
34. Only the goldsmiths' work from the high altar of the cathedral was saved from destruction, however. In 1532, the municipal council ordered the liturgical silver from other churches to be melted down; likewise, in 1590, a silver image of the Virgin and Child, four monstrances, forty-four chalices, and forty-eight patens, mostly used for Mass on altars in the cathedral other than the high altar, were melted down, as was the golden plenarium of Heinrich II, and the proceeds used for the care of the poor; see Burckhardt 1933, p. 22.
35. See Teuteberg 1986, pp. 191–92.

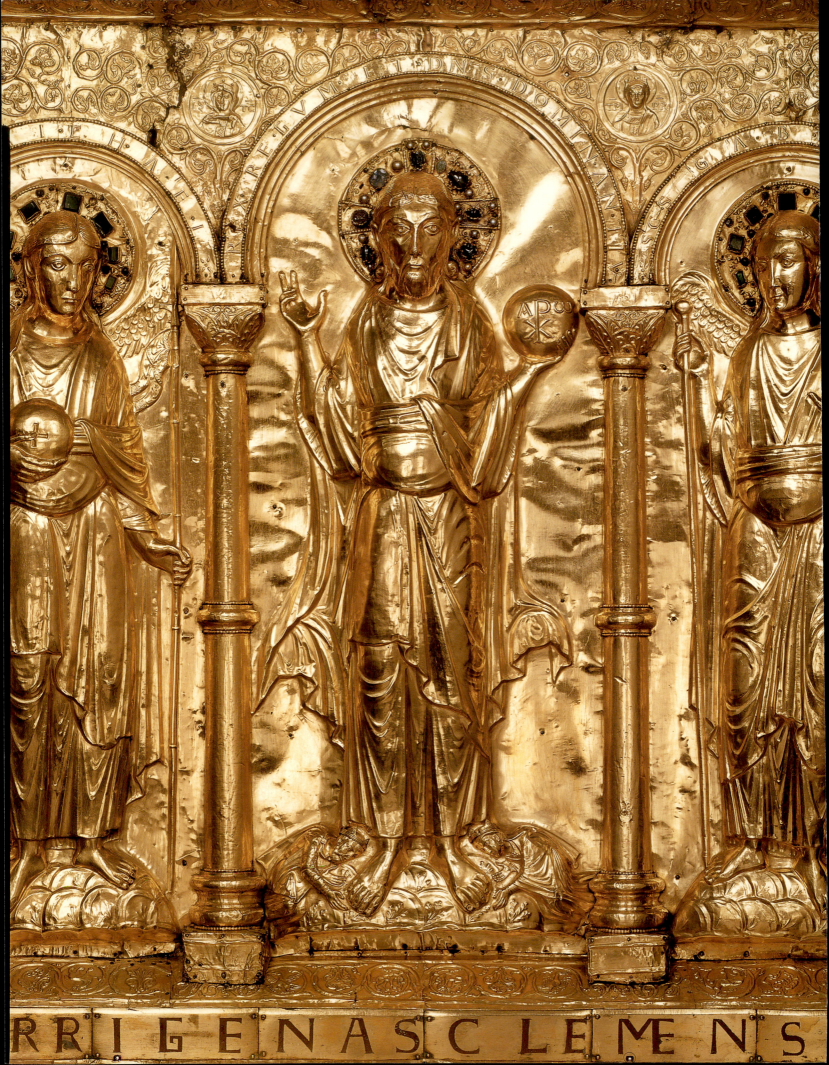

DORMANT THEN DIVIDED, DISPERSED AND REUNITED

TIMOTHY HUSBAND

Early on the morning of February 9, 1529, an indecisive Basel city council once again assembled to debate its course through the ever-intensifying storm of religious controversy. For too long, the council had sought a path of moderation; hesitant to espouse reformation, reluctant to reject it, the council, embracing a spirit of tolerance, favored a policy of personal freedom of belief. However, in the wake of the Peasants' Revolt and in the current climate of open defiance to the Church, the issue had become too polarized, and the citizenry was divided into two implacable camps. While the humanists, for example, preferred a gradual reform of the Church, the guilds would settle for nothing less than the definitive expulsion of the adherents of the "old faith."[1] From the pulpit of the Church of Saint Martin, Johannes Oekolampad (1482–1531) formulated and expounded his brand of evangelism, and, in a more radical fashion than that envisaged by Martin Luther (1483–1546), preached that only the Bible was the true Word of God; through faith alone man could achieve redemption and a state of grace. Correctly sensing that the religious controversy would unleash underlying social, political, and economic upheaval as well, the council hesitated all the more.

Armed citizens congregated in the Market Square, in front of the Town Hall, awaiting word of a decision from the city council; as deliberations lingered on into the early afternoon, the crowd became ever more aggravated and impatient. A group broke away and headed toward the Cathedral Square to take a "stroll" through the cathedral. One of the iconoclasts attacked an image, sparking a confrontation with the Catholics. Word got back to the Market Square and a mob headed for the cathedral; the secured door of the central portal was broken down and a wave of destruction was unleashed within the building.[2] Before the outbreak of Iconoclasm, there were sixty-four altars in the cathedral, chapels, and cloisters, most of which must have had an altarpiece; the walls of the chapels, crypt, nave, and transepts undoubtedly were further embellished with devotional imagery in stone and wood, panel painting, and stained glass. Effigies, epitaphs, and funerary monuments occupied sites in the many chapels and throughout the two cloisters. Stone sculptures were smashed, stained-glass windows shattered, altarpieces dismantled, and panel paintings and wood sculptures cleaved apart and dragged into open squares; what was not burned publicly was taken home for fuel. The great crucifix suspended over the cathedral choir screen was taken down, dragged to the Market Square, and burned. Not a single wood sculpture or painted panel from the cathedral complex appears to have survived this orgy of destruction, which spread to churches throughout Large- or Gross-Basel, Small- or Klein-Basel across the river, and the surrounding countryside, continuing into the next day. Wrath was directed at imagery alone, however, and, amid such frenzied violence, it is remarkable that all manner of Treasury objects, mostly works in gold and silver, were left undamaged (". . . allein, was von golt, silber und andre kleinotter was, das ward ungeschediget und wol behalten . . .").[3]

The city council appears to have viewed the iconoclastic outbreak as a public referendum on the reformation question. Ordinances were instituted and the former inclination toward tolerance evaporated: Basel was a reformed city; the cathedral became the city parish church; the bishop fled to Porrentruy, the canons to Freiburg-im-Breisgau, and all those who were not

Plate 4. *Golden Altar Frontal* (detail). See no. 2

Figure 9. Ludwig Kelterborn (1811–1878). "How Saint George Lances the Dragon and Thereby Brings Many Rare Treasures to Light." Lithograph, 1834. Historisches Museum Basel

prepared to embrace the new faith, likewise, were compelled to quit the city.[4]

Dormant then Divided

The Basel Treasury had been secured, as it customarily was for all but high feast days, in a cupboard (see no. 1) on the upper floor of the Romanesque sacristy, and, whether by oversight or out of preternatural deference, it escaped the ravages of February 9 and 10. No chances were taken afterward, however: The windows of the upper sacristy were fitted with bars and the entranceway sealed with a double-bolted iron door. The liturgical plate and altar furnishings of the many surrounding churches and monasteries, however, did not fare so well, and in 1532 they were gathered up and melted down, yielding some six thousand pounds of silver and gold, with the proceeds being donated to charity.[5] Again, the

Basel Treasury was left untouched, although most of the ecclesiastical vestments and paraments unfortunately were sold. A contract concluded in 1559 provided that the Treasury would remain locked up and that the bishop, the chapter, and the city council each would be provided with a key.[6] Subsequent and successive efforts of the bishops to recover the Treasury objects met with varying degrees of failure. In 1585, the city paid 200,000 gulden in compensation; hopes that this would bring the matter to a close were elusory, and although two years later restitution was agreed to by the city government, it was avoided by a veto of the city council. A resolution to stay any further discussion of recompense was approved by the city council in 1693. The Basel Treasury briefly was placed in serious jeopardy again in 1799 when General André Masséna, head of Napoleon's army in Switzerland, attempted to secure it as a forced loan.[7]

The Basel Treasury, properly speaking, comprises only those objects that were associated with the high altar and were kept in the Romanesque upper sacristy for safekeeping; it does not include the items required for the other sixty-three altars located throughout the cathedral complex, all of which were secured in the new sacristy situated over the Chapel of Saint Catherine, attached to the terminus of the east transept. The earliest surviving inventory of the Basel Treasury dates to 1477 and commences with seventy-one entries (no. viii); a further inventory of 1525, again in seventy-one entries, accounts for each of the objects employed on the high altar and also, in greater detail than in 1477, records those used on all other altars, requiring another 179 entries. Much of this material, including a silver image of the Virgin and Child, forty-four chalices, forty-eight patens, vestments, and even the *plenarium* of Heinrich II were sold by the church authorities in 1590;[8] income from the proceeds of the sale was used for alms.

At five o'clock in the morning on July 31, 1827, the Treasury was opened and a new inventory drawn up; the only other inspections of the contents since the Reformation appear to have been in conjunction with the inventories of 1585 and 1735. Some days later, on August 14, the Basel Treasury was moved from the cathedral to the Town Hall in the belief that it would be more secure there. A comparison of the previously compiled inventory with those of 1477 and 1525 indicates that virtually all the objects, other than those sold

in the late sixteenth century, could be accounted for. Thus, the Basel Treasury remained in the sacristy cupboard, essentially and miraculously untouched, for three centuries, rendering the consequences of subsequent political events all the more ironic.

The greatest crisis faced by the city of Basel since the Reformation was the revolution by inhabitants of the countryside of Canton Basel in the years 1830–33. In a futile effort to establish a more egalitarian balance between the poorer, discontented, agrarian citizens, who accounted for two-thirds of the population, with the richer, conservative, industrial, and mercantile city dwellers, those in the countryside sought constitutional redress. With no political solution in sight and with the residents of the countryside claiming measures of autonomy, the situation reached a crisis point with the defeat of an expeditionary force of eight hundred from the city, resulting in the death of sixty-five of its troops on August 3, 1833. Now at an irreconcilable impasse, the canton, through the arbitration conducted at a Confederation court hearing (*Tagsatzung*), was permanently divided, twenty-three days later, into Basel-City and Basel-Country.[9]

With the separation of the city from the country, all cantonal assets had to be distributed proportionately by population, or two-to-one in favor of the countryside. As the Basel Treasury was now housed in the city hall, it, too, was considered an asset of the canton, and therefore was subject to partition. A political cartoon of the period (fig. 9) expresses the jeopardy into which the division of the canton had placed the newly rediscovered Treasury: Based on the sculptures affixed to the cathedral tower that bears his name, Saint George, depicted on horseback, with the coarse features associated with peasants, attacks the basilisk—the symbol of Basel, which holds the armorial shield of the city—and struggles to protect the now-exposed Treasury amid the ruins of the cathedral in the background. To achieve an equitable allotment of the Treasury holdings, three goldsmiths were selected: Johann Jakob Pfaff of Liestal and Bernhard Schnyder of Sursee represented Basel-Country, and Johann Jakob III. Handmann represented Basel-City. The Treasury objects, excepting the Golden Altar Frontal (no. 2), were evaluated individually and then divided equally into three lots; lots I and II were ceded to Basel-Country and lot III to Basel-City.[10] Before

the partage of the Treasury, the city government ordered that every relic, along with its authenticating parchment identifications, be removed from all the reliquaries and monstrances, and then turned over to the Basel archivist Johann Krug for destruction. Finding himself incapable of disposing of items steeped in spiritual and historical significance, he carefully inventoried the relics and arranged for their transfer to the Benedictine monastery at Mariastein, about twenty kilometers southwest of Basel, on January 8, 1834 (see no. 47).[11] In the same year, the Basel city government elected to give four objects from its share of the Treasury to the Roman Catholic Church of Saint Clara in Klein-Basel: a copper-alloy Romanesque base for a cross (no. 5), a processional cross and staff (nos. 23, 24), and the Sunday Cross (no. 33).[12]

In a transaction that appears to have been more of an indirect subsidy than an equitable trade, the city government, in 1837, also chose to exchange the Reliquary Bust of Saint Thecla (no. 40), the Arm Reliquary of Saint Valentine (no. 43), and the Golden Rose Branch (no. 55) for the Hüglin Monstrance (no. 75), then in the possession of the Academic Society of Basel. The Society, in turn, sold these three objects (now in Amsterdam, New York, and Paris, respectively) in the following year, ironically, with the intention of using the proceeds to make a plaster cast of the Golden Altar Frontal.[13]

The Golden Altar Frontal (plate 4 and no. 2), in the partage of the Treasury, was not allotted to either half-canton; rather, it was decided that the frontal should be auctioned off between the interested parties. In decisions that later caused considerable regret, the city council decided it could not justify—given its drained resources—a subvention of 7,800 francs to purchase the Altar Frontal, or, for that matter, lots I and II, which had been offered for sale; thus, it relinquished all possibility of keeping the Treasury intact. While there was support for such an undertaking, higher priority was given to other needs, such as subventions for the university.[14] In the end, Basel-Country acquired the Altar Frontal for 8,875 francs and consigned it to auction in the town of Liestal, the capital of the new half-canton, along with all the other objects in their two allotments. A citizen of Liestal is said to have whispered to an attendee from Basel just before the sale: "We are as poor as church mice, and we cannot even pay our officials; thus, we are

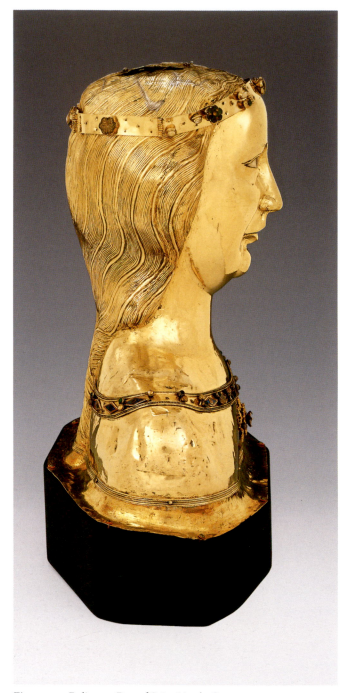

Figure 10. *Reliquary Bust of Saint Ursula.* See no. 41

given a limit of 9,200 francs; in case of a successful bid, the frontal was to be conveyed to Basel and placed on public exhibition at the university, in the collection of the Haus zur Mücke. What followed was a misapprehension of colossal proportions. As the auction progressed, Schreiber recognized his opposing bidder as Johann Handmann; assuming that his fellow citizen had only the interests of Basel at heart, Schreiber decided not to bid against him. No such altruism was at play, however, for Handmann, one of the three aforementioned appraisers of the Treasury, was buying strictly as an investment. He was successful at 9,050 francs, well below the Basel limit.[16] Thus, the most important object in the Basel Treasury came on the art market.

The intention to exhibit the Treasury objects belonging to Basel-City in the Haus zur Mücke proved to be untenable largely for reasons of security, and they languished until 1850, when they were installed in the newly opened museum on the Augustinergasse. In 1882, the objects were moved to the Chapel of Saint Nicholas adjoining the cathedral and incorporated into the Medieval Collection, which had been founded in 1856. They then were transferred to the Historisches Museum Basel, which was established in the Barfüsserkirche in 1894, where they remain today, shown much to their advantage in a recently redesigned installation. One of the early visitors to the museum on the Augustinergasse was a Colonel Jean-Jacques Ursin Victor Theubet (1787–1863), who had acquired the Golden Altar Frontal from Johann Handmann in 1838 and had been attempting to resell it advantageously since then. While visiting the building and the exhibition, he observed that it was unfortunate that the Altar Frontal was not on exhibition; due to his "modest means" ("l'exiguïté de ma fortune"), he could not donate the original work, but he wished to offer in its stead one of the two plaster casts he had had made (see no. 62), hoping that it would be displayed in the original cupboard (no. 1), which then formed an integral part of the installation.[17]

Dispersed . . .

With the deracination of the Golden Altar Frontal (no. 2), after an eight-hundred-year presence, Basel lost not only an artistic monument of the highest order but also a measure of its own history and identity. That the

obliged to auction these objects off."[15] The auction was scheduled for ten o'clock in the morning of May 23, 1836. Three days before the sale, the Commission of the Academic Society met and recommended the purchase of a major work; one of the members, Peter Vischer-Passavant (1779–1851), persuasively argued that that object should be the Golden Altar Frontal. An agent, Heinrich Schreiber, was engaged in the strictest confidence and

frontal was not of Basel origin nor, originally, even intended for Basel in no way mitigated the circumstances. Indeed, after the hapless events at the auction itself, the fact that the Golden Frontal was paraded about Europe by Colonel Theubet for years, in a vain search for a buyer, can only have compounded the later frustration over its needless loss, as well as that of many of the other Treasury objects. Furthermore, the profundity of this sense of loss continued to impress itself upon the communal consciousness, just as efforts to rationalize, reverse, replace, and, hopefully, recover the forfeited works prevail to the present day. The Heinrich Cross (no. 4), if less iconic, was, to an even greater degree than the Altar Frontal, inextricably woven into the fabric of the spiritual and secular life of medieval Basel, as it was processed *intra* and *extra muros* on high feast days, at the installations of high officials, and at the ceremonial entries of secular princes (see pp. 14, 16, 22). The collective identity exceeds any of its component parts, and loss of the least precious individual object geometrically diminishes the whole. The scholar Hans Reinhardt observed that the Cathedral Treasury existed for all the people of Basel, not just for the friends of history and art; it was an object of loving devotion, and the part that was lost 170 years ago remains throughout the city a wound that has not yet fully healed.[18]

The faltering initiatives of Peter Vischer-Passavant prior to the Liestal sale and the failure to acquire any of the objects purchased by the Basel goldsmiths proved an inauspicious beginning in the difficult and elusive task of reconstituting the greater part of the Treasury: The fourteen works bought by Johann Friedrich II. Burckhardt-Huber and the four bought by Johann Handmann all ended up in foreign collections. Since the middle of the nineteenth century, however, there has been a continuing and unabated effort to recoup lost objects individually.

Where the original has been lost or destroyed, or is otherwise unobtainable, surrogates in a variety of forms have served. These replicas, casts, copies, and inventions expand our knowledge and understanding of the Basel Treasury in multifarious ways. The replica of the Chain of the Order of Our Lady of the Swan (no. 61), for example, is now an invaluable document; the medieval example, given to the Cathedral Treasury by the widow of a mayor of Basel, Peter Rot (d. 1487), was acquired

after the Liestal sale by the Prussian king Friedrich Wilhelm III, only to be lost or destroyed in Berlin in 1945.

The superb replica of the Gothic censer (see no. xiv), raised out of sheet silver in the medieval manner by a highly competent goldsmith, was long unrecognized as an example of nineteenth-century workmanship; once unmasked, however, the object has emerged as something of an enigma, for there appears to be no compelling reason why Colonel Theubet, who bought the original in the 1836 auction, would have commissioned the copy. More mysterious is the case of the Covered Beaker of Ulrich zem Luft-Eberler (no. 60): The original was sold in Liestal in 1836 and, so it was thought, entered the collections of the Victoria and Albert Museum, London, in 1855, with the Sommesson and Prince Peter Soltykoff collections. Two other versions are known: One is a free variant made in the traditional fashion by the Basel goldsmith Ulrich Sauter in 1912 on commission from Rudolf Vischer-Burckhardt, a local ribbon manufacturer, and is inscribed, with laconic

Figure 11. Baron Bentinck, Ambassador of the Netherlands (right), officially presents the *Reliquary Bust of Saint Ursula* (see no. 41) to Professor Hans-Peter Tschudi, President of the Basel municipal council, September 17, 1955. The young women on the boat are all named Ursula

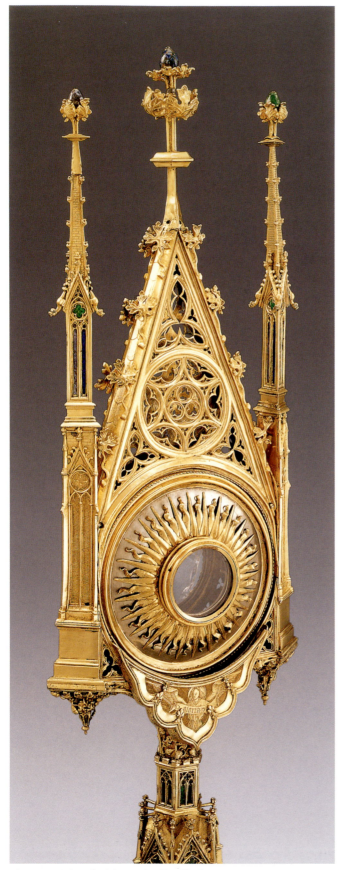

Figure 12. *Apostles Monstrance* (detail). See no. 64

irony as it turns out, "The direct way is the best way" ("Der gerade Weg ist der beste");[19] the second (no. xx) always has been considered to be an electrotype after the presumed original in London, made at the behest of the Victoria and Albert Museum as a gift for the Historisches Museum in appreciation for information shared concerning the beaker's theretofore unknown provenance. However, as was recently discovered, the beaker in London is itself a cast,[20] and the whereabouts of the original remains a total mystery.

The craftsmanship of Ulrich Sauter is also identifiable in a covered beaker now in the Historisches Museum Basel (no. 63). It inventively incorporates an original element, for only the kneeling knight, now serving as the cover finial, is medieval, while the entirety of the vessel, as though perpetuating the local tradition of goldsmith's work, is executed in medieval style. The knight, already divorced from its original context in the Liestal auction, was attached by a loop to a watch fob; this talismanic reuse is repeated on the Sauter beaker.

Another object that entered the Victoria and Albert Museum in 1862 was also the subject of a copy: The Branched Cross, with the Virgin and John the Evangelist (no. 14) was bought in 1836 at the Liestal sale by the Basel goldsmith Johann Friedrich II. Burckhardt-Huber and, after his death in 1844, was inherited by his son Samuel Burckhardt. Two years later, the younger Burckhardt made a precise copy of the Branched Cross out of *papier-mâché,* to which he applied colored foils, silver and gold leaf, and pearls. Inscribed on the bottom, "Executed in 1846 by Samuel Burckhardt after a silver cross" ("1846 von Samuel Burckhart verfertigt nach 1 silberen Kreuz"),[21] the function intended for this exceptional copy remains uncertain, but, remarkably accurate in all detail, it could well have served as a goldsmith's model.

Of all the replicas of objects from the Basel Treasury that have been made in the course of the last century and a half, none has quite the resonance as the after casts of the Golden Altar Frontal (no. 62). As mentioned above, Colonel Victor Theubet had two fabricated, one gilded and the other not. The latter, given to the Basel museum by Theubet, was exhibited from 1849 until the gilded copy was placed on loan and ultimately, in 1904, was bequeathed to the museum by Theubet's heirs; it has been on exhibition ever since, now prominently displayed in the recent reinstallation of the Treasury objects.

As Burkard von Roda, the director of the museum explains, the gilded copy is not merely a didactic substitute for a Romanesque work of art, but, rather, it is the symbol both of the unhappy vicissitudes of the entire Basel Treasury as well as of the uneasy reconciliation with its resultant losses. In this sense, the replica must be viewed as an object highly important to the Basel collections.[22] Indeed, because of its fragile condition, the Historisches Museum Basel would not allow the Theubet replica to travel to New York for the Metropolitan Museum's exhibition of objects from the Treasury, and, in its place, substituted a modern after cast of the ungilded Theubet cast fabricated for that purpose. This, the most recent of replicas, will be displayed in a special exhibition at Bamberg Cathedral; thus, a copy replaces the original that many believe left for Basel almost one thousand years ago.

. . . AND REUNITED

The repatriation of dispersed objects from the Treasury has long ranked as a high priority for the Historisches Museum Basel, and the missteps at the time and in the wake of the Liestal sale rarely have been repeated. Rudolf Burckhardt (1877–1964), a former director of the museum, was able, using a number of documentary aids, such as the watercolor drawings of Johann Friedrich II. Burckhardt-Huber (nos. xviii, xix), to track down thirteen of the twenty-three objects that disappeared after the Liestal auction. Since the Historisches Museum Basel opened in the Barfüsserkirche in 1894, eleven objects have been recovered, including the Statuette of Saint Christopher (no. 37), on loan from the Gottfried Keller Foundation; the Apostles Monstrance (no. 64); the Imperial Couple Monstrance (no. 65); and the Münch Monstrance (no. 72), a gift of Basel-Country.

Perhaps the most extraordinary of all restitutions was that of the Reliquary Bust of Saint Ursula (fig. 10 and no. 41), and the saga of its repatriation is not only a measure of the emotional investment of the community in the Basel Treasury but also is indicative of the labyrinthine routes by which some of the Treasury objects found their way back to Basel. In 1834, the reliquary bust was allotted to Basel-Country and was purchased by the Berlin art dealer Oppenheim for 261

francs. It subsequently entered the Löwenstein collection in Frankfurt, and was sold at auction, upon the death of its owner, by Christie's, London, on March 12, 1860. The successful bidder in that sale, at 90 pounds or about 2,160 francs, was Prince Peter Soltykoff; his collection was put up for sale a mere two years later, and this time the Bust of Saint Ursula was purchased by the Russian count Alexander P. Basilevsky, who also acquired other objects from the Basel Treasury—notably, the Arm Reliquary of Saint Walpert (no. 10), the statuettes of saints John the Baptist (no. 36) and Christopher (no. 37), the Reliquary Bust of Saint Thecla (no. 40), the Apostles Monstrance (no. 64), and the Reliquary Monstrance of the Imperial Couple (no. 65). The entire Basilevsky collection was purchased in 1884 for six million francs by Tsar Alexander III and installed in the Hermitage in Saint Petersburg. In 1932, the Soviet government sold many paintings and objects to various buyers, including the reliquary busts of saints Thecla and Ursula, which were purchased by the Amsterdam banker Fritz Mannheimer. The Nazis' rise to power was ruinous to Mannheimer's European business interests and, after his death in 1939, his collections were held as collateral against his debts by Dutch banks. Following the invasion of the Netherlands in 1940, both reliquary busts, along with numerous other works from the Mannheimer collection, ended up in Nazi hands, apparently destined for the Führermuseum in Linz. In 1945, the busts were recovered by the Allies from the depot in Altaussee, turned over to the Central Collecting Point in Munich, and eventually repatriated to the Netherlands, where they were deposited with the State Office for Dispersed Works of Art. Both busts were transferred to the Rijksmuseum, Amsterdam, in 1953. In the meantime, authorities in Basel had expressed a keen interest in repatriating their long-lost reliquaries; after certain legal questions were resolved and considerable discussion between museum officials and governmental representatives had ensued, the general director of the Rijksmuseum agreed, with a 200,000-guilder compensation, to relinquish the Reliquary Bust of Saint Ursula.[23]

Like Saint Ursula herself, and like the relics of the saint that were transferred to the Cathedral Treasury in the mid-thirteenth century, the Reliquary Bust of Saint Ursula made the journey from the Netherlands to Basel by boat, up the Rhine. On September 17, 1955, as the

ship approached, all the girls in Basel aged seven to four-teen, with the name of Ursula—a total of 426—boarded two other boats; as the conveyance with the saintly image approached, the multitude of namesakes drew up alongside it and offered a chorus of welcome. The ship landed near the Rheinbrücke and was greeted by a festive host of government officials, authorities of the shipping guild, members of various groups and societies all displaying their banners, as well as ordinary citizens. The Bust of Saint Ursula was officially handed over to the municipality of Basel by the ambassador of the Netherlands, placed at the head of a carriage, and con-veyed to the Historisches Museum Basel, where the reliquary was received by museum officials (fig. 11). All the proceedings, of course, were thoroughly reported by the press, radio, and television.[24]

On that February morning in 1529, over four hun-dred years earlier, the spiritual life of the Basel Treasury was extinguished. No longer serving a liturgical function, its holdings were, in an instant, transformed into mere artifacts, laid up for safekeeping in a cupboard, where they remained dormant for the next three centuries. Vessels that once contained relics were emptied of their holy contents and became relics themselves. For cen-turies, the Treasury had been a living entity, each object fulfilling a specific function in the liturgy and in all manner of sacred observance. Utilized according to the canonical hours of the day and the temporal and sanctoral cycles of the year, the Treasury objects became an integral part of the fixed rhythm of the Church calendar, and thus marked the spiritual heartbeat of everyday life.

As credo, dogma, liturgy, and fashion changed or evolved, individual objects were modified, altered, adapted, or otherwise transformed. One of the more fas-cinating aspects of the Basel Treasury has been the con-tinual transformation of objects, which can be charted over the course of their medieval history. A thirteenth-century paten and chalice, outmoded by changes in the liturgy, were converted with a goldsmith's hammer into a reliquary (no. 8), thus extending its useful life. The Apostles Monstrance (fig. 12 and no. 64) was reshaped to accommodate its varying sacred contents, although it is not entirely certain what these were. The Heinrich Cross (no. 4) was altered over the centuries to suit its expanded roles as a reliquary and as a processional

insignia in both spiritual and secular functions. The Foot Reliquary (no. 44), housing the relic of one of the Holy Innocents massacred on Herod's orders, said to have been given to the cathedral by Saint Columban (d. about 540), appears to be a Late Gothic reworking (1450) of a Romanesque reliquary, either incorporating actual ele-ments of an earlier work or using one as a model. An analogous situation is found regarding the Sunday Cross (no. 33), which is based on a much earlier model, the Heinrich Cross. Perhaps no object's appearance was transmogrified more over the centuries than the King David reliquary (fig. 13 and no. 35); with a core of thirteenth-century raised gold, and incorporating a sec-ond- or third-century cameo of a Gorgon's head, the figure was further enhanced with thirteenth-, fourteenth-, and fifteenth-century additions.

Far from mutilations, these alterations—which affected almost every major object in the Treasury—shed light on their individual functions and significance, while bringing the Treasury as a whole to life. Even the type of objects and the varying rates at which they entered the Treasury inform us of shifting political and economic fortunes. It appears, for example, that when the bishops enjoyed their greatest powers, little empha-sis was placed upon enriching the Treasury, but in times of crisis, such as the 1356 earthquake, or as their powers waned, toward the end of the Middle Ages, the bishops acquired growing numbers of relics and required even more vessels to house them, as though the divine power invested in them would compensate for the diminished authority of the episcopate (see pp. 13, 22).

As additional objects from the Basel Cathedral Trea-sury are rediscovered—some even making their way to their principal repository, the Historisches Museum Basel—our understanding of medieval treasuries, in general, increases. Each object is an episode, but collec-tively they weave a rich and complex narrative set within and without the cathedral walls of a major medieval city. When invested with spiritual value, they were indicators of both ecclesiastical and secular authority, as it was exercised in daily life. Since that fate-ful day in 1529, the destiny of the Treasury has been linked inextricably with the history of Basel itself: With each repatriated item, so a portion of the city's identity is retrieved as well, and a measure of loss expi-ated. The process, too, takes on a life of its own. In

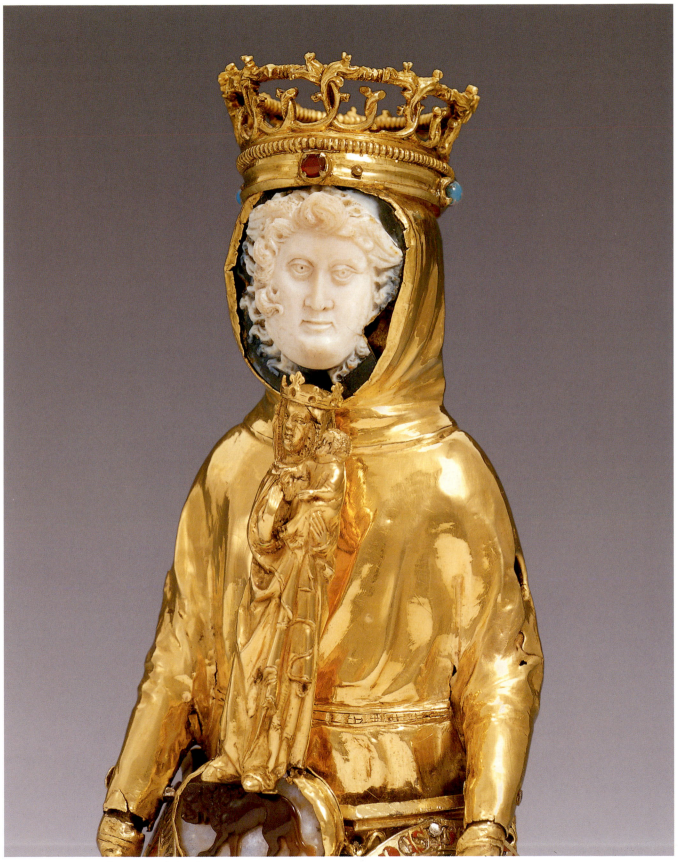

Figure 13. *Statuette of King David* (detail). See no. 35

1995, the theretofore unheard-of "left-hand section" of the Golden Altar Frontal, said to have been secreted in the Hermitage in Saint Petersburg, was offered to the Historisches Museum by an agent claiming authorization from the highest reaches of Russia's state government. Curiously, this agent seemed unaware of the three objects from the Basel Treasury that, in fact, are in the State Hermitage Museum (nos. 10, 36, 42).[25] Nonetheless, disastrous assumptions of the sort made by Heinrich Schreiber, the Basel agent in the Liestal auction, were resolved never to be repeated, and the offer was followed to its inevitable dead end. As the Historisches Museum's director, Burkard von Roda, remarked, the chimera hovered for ten days, then vanished.[26]

1. Alioth, Barth, and Huber 1981, pp. 57–58.
2. Luginbühl 1909, pp. 26–28.
3. Ibid., p. 27.
4. For further descriptions of iconoclastic rampages and the aftermath of reformation see Ryff, in *Basler Chroniken I*, 1872, esp. pp. 88–92.
5. Barth 1990, p. 5.
6. von Roda 1999, p. 20.
7. Barth 1990, p. 5.
8. Ibid., pp. 5–6.
9. For a detailed history of the cantonal separation see Teuteberg 1988, pp. 293–304.
10. Barth 1990, p. 6.
11. For the instruments of gift and the inventory of relics see Roth 1911, pp. 186–95.
12. Gasser 1978, p. 18.
13. I am grateful to Dr. Berkemeier-Favre for sharing with me her findings in the Staatsarchiv Basel.
14. Barth 1990, p. 7; von Roda 1999, p. 27.
15. Barth 1990, p. 7.
16. von Roda 1999, pp. 29–31.
17. The cast was installed in the Medieval Collection and is now in the Museum Kleines Klingental; the other cast, which had been gilded, remained in Theubet's family until 1904, when it was bequeathed to the Historisches Museum Basel, where it is now displayed in the recently redesigned installation (illustrated on p. 149).
18. Reinhardt 1956, p. 27.
19. von Roda, "Münsterschatz in Nachbildungen," in Basel 2001.
20. I am grateful to Martin Sauter of the Historisches Museum Basel, who examined the object in London and has kindly shared his discoveries with me.
21. von Roda, "Münsterschatz in Nachbildungen," in Basel 2001.
22. von Roda 1999, pp. 36–40.
23. Reinhardt 1956, pp. 28–29.
24. Ibid., p. 27.
25. von Roda 1999, pp. 43–44.
26. Ibid.

CATALOGUE

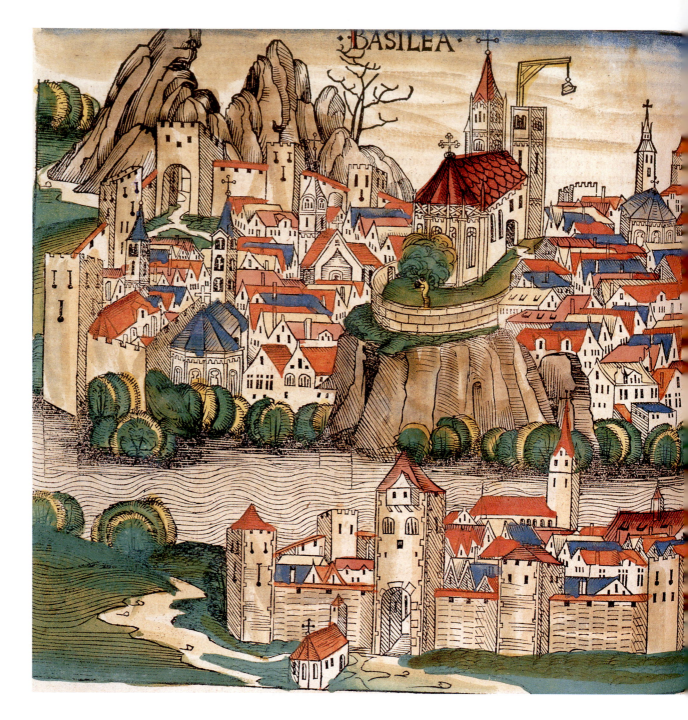

INTRODUCTION

i. Liber chronicarum

Hartmann Schedel, with woodcut illustrations by Michael Wolgemut and Wilhelm Pleydenwurff; published by Anton Koberger, Nuremberg, 1493. Incunabulum (paper): 47.5 x 34 cm.
Washington, D.C., National Gallery of Art, Gift of Paul Mellon in Honor of the 50th Anniversary of the National Gallery of Art, 1991 (1991.7.1./BV).

Published first in Latin as the *Liber chronicarum* on July 12, 1493, the expanded German edition, the *Weltchronik* (or *Chronicle of the World*), appeared in December of the same year, to be followed by further editions in 1496 and 1497. One of the most famous printed books of the Late Middle Ages, the *Nuremberg Chronicle*, as it is generally known, recounts the history of the world, divided into six ages, from the Creation to the year 1492. The eighteen hundred wood–

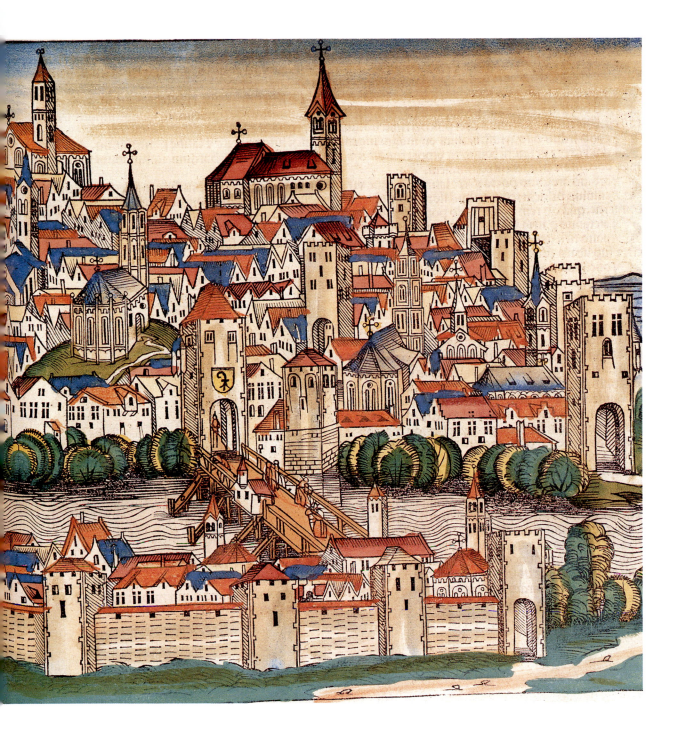

cuts include genealogical trees, maps, views of famous cities, and portraits of renowned personages. The city of Basel, *Basilea*, is depicted with reasonable accuracy over a two-page spread:[1] Small- or Klein-Basel is on the near side of the Rhine connected to Large- or Gross-Basel by a bridge leading to a tower gate with a large shield emblazoned with the head of a bishop's crosier—the arms of the city. The cathedral, rising from a bulwarked terrace high up on a rocky promontory over the river, is seen from the east or choir end. In this view the cathedral towers are reversed: The south tower, not the north, was still under construction when the *Liber chronicarum* was printed, and the finial of the spire was only put in place in 1500.

PROVENANCE: Raimund Fugger, Augsburg; 1960, acquired at auction in Paris.

1. Folios 243*v*–244.

ii. *Breviary of Basel*

Printed by Jakob von Pforzheim, with a woodcut illustration
after Urs Graf (1485–1528/29). Basel, 1515. 37.5 x 26.5 cm.
Delémont, Musée Jurassien d'Art et d'Histoire, MJ 1963.19.

A Breviary is a service book comprising hymns, Psalms, anthems, prayers, and other readings, used in the celebration of the daily offices of the canonical hours: Matins, Lauds, Prime, Terce, Sext, None, Vespers, and Compline. These services were in praise of Christ and the saints—not sacramental like the Mass—and generally were celebrated in the choir, not at an altar. After the Missal, the Breviary was the most important book required by a priest. The present Breviary, intended for use in the winter, was compiled specifically for Basel. The illustration on the title page depicts the three patron saints of Basel Cathedral: The Virgin flanked by Saint Heinrich, holding a model of the cathedral (see no. iii), and Saint Pantalus, the legendary first bishop of the cathedral, holding a crosier and a martyr's palm. The woodcut was designed by Urs Graf and bears his monogram and the date 1514.

PROVENANCE: 16th century, possibly in the library of the bishops of Basel; transferred to the parish church at Mervelier; since 1963, on deposit at the museum.

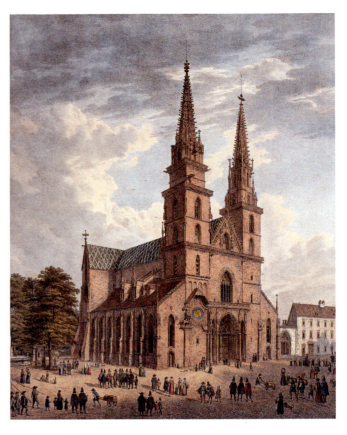

iii. *Hand of Heinrich II Holding a Model of Basel Cathedral*

Basel, about 1290. Sandstone: 45 x 26.5 x 23 cm.
Basel, Museum Kleines Klingental, 10425.

Statues of Heinrich II, as patron of the cathedral, and of his wife, Kunigunde, both carved about 1290, flank the north side door of the central portal on the building's west façade (see frontispiece). These statues toppled from an unknown location on the cathedral during the earthquake of 1356 and subsequently were placed in their current position. The present fragment representing Heinrich's right hand holding the model of the cathedral was broken off in the fall, and the corresponding portion now in place is a restoration dating from 1880–90. The model of the cathedral is executed entirely in the Gothic style, eliminating the Romanesque portions of the building, including the choir, ambulatory, and the Gallus Portal of the north transept. It does, however, give an impression of what the cathedral might have looked like prior to the completion of the west towers or the addition of the outer side aisles.

PROVENANCE: 1939, transferred from the cathedral to the museum.

BIBLIOGRAPHY: Schwinn Schürmann 1998, p. 27.

iv. *View of Basel Cathedral from the Northwest*

Domenico Quaglio. Basel, 1823. Colored lithograph: 68.5 x 54 cm.
Staatsarchiv des Kantons Basel-Stadt, Bild Falk B 6.

In this view of the west façade of the cathedral, seen from the northwest, the artist exaggerates the open expanse of the Cathedral Square and the verticality of the structure.

PROVENANCE: Hieronymous Falkeisen (1758–1838) collection, Basel; 1907, transferred to the Staatsarchiv des Kantons Basel-Stadt.

BIBLIOGRAPHY: Basel 1999, no. 12.

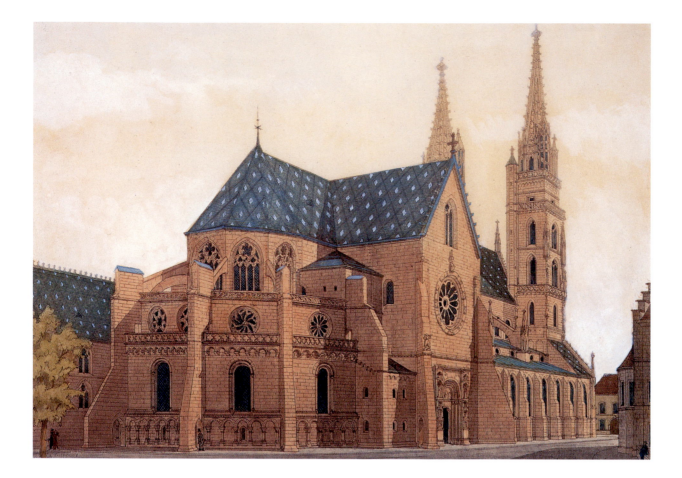

v. *View of Basel Cathedral from the Northeast*

Julius Kelterborn. Basel, 1885. Colored phototype: 17.2 x 24.1 cm.
Staatsarchiv des Kantons Basel-Stadt, Bild SMM/1972.9.

vi. *Interior View of Basel Cathedral*

Constantin Guise. Basel, 1852. Watercolor on cardboard:
25.9 x 19.9 cm.
Staatsarchiv des Kantons Basel-Stadt, Bild 6, 1654.

The monumentality of the Romanesque choir ambulatory and transept is evident in this view of the cathedral from the northeast. Nestled between the north lower-ambulatory bay and the east wall of the north transept is an austere two-storied structure, the east wall of which is actually a choir buttress; on the second floor of this structure, penetrated by three windows, is the upper sacristy, where the Basel Cathedral Treasury was held in safekeeping until it was removed to the Town Hall in 1827.

PROVENANCE: 1972, acquired by the Stadt- und Münstermuseum, Basel, from Galerie Fischer, Lucerne; 1997, transferred to the Staatsarchiv des Kantons Basel-Stadt.

BIBLIOGRAPHY: Basel 1999, no. 17.

Depicted here is a view of the nave as it appeared in 1852, looking east toward the choir screen and the stairs leading up to the high choir beyond. The pulpit can be seen against the second pier on the south side of the nave. During the renovations begun in the same year, the choir screen was moved to the west end of the nave, to be reused as an organ loft, and the pulpit was moved three piers to the east, where the screen originally was situated.

PROVENANCE: early 20th century, acquired by the Staatsarchiv des Kantons Basel-Stadt.

BIBLIOGRAPHY: Basel 1999, no. 38.

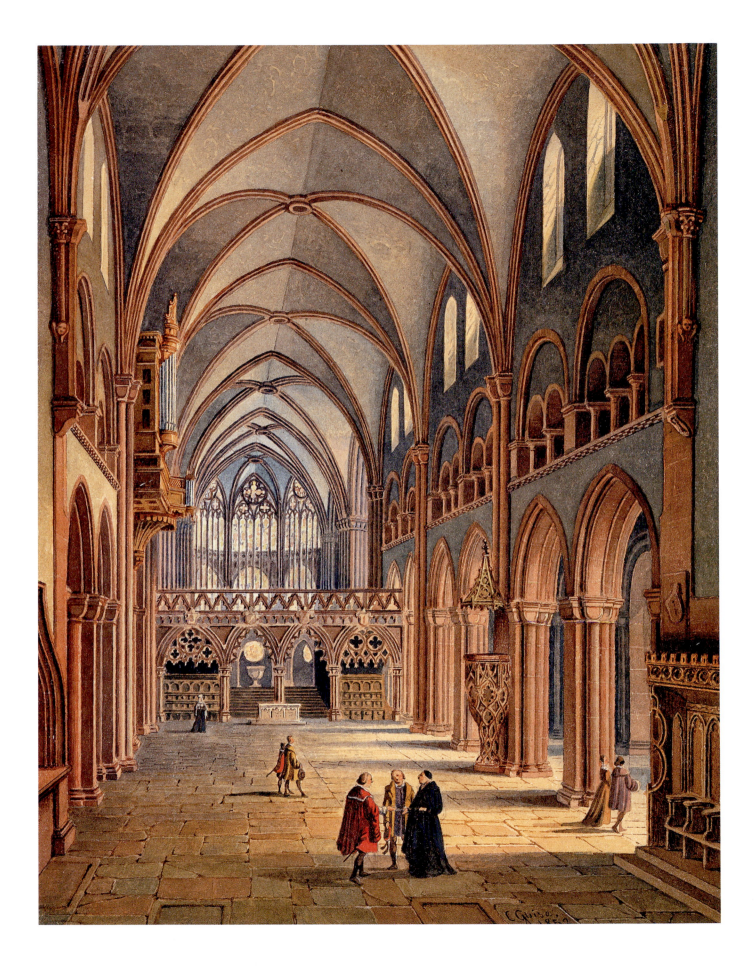

vii. *Interior View of Basel Cathedral*

Emanuel Büchel. Basel, 1773. Pen and ink, with wash over pencil: 58.5 x 72.6 cm.
Staatsarchiv des Kantons Basel-Stadt, Bild Falk B 5.

The view here is from the high choir looking westward toward the transept crossing, with the choir stalls, choir screen, nave, and west window visible in the distance. The baptismal font has been moved to where the high altar originally stood. To the right, just beyond a doorway with an inscription above, is an arched opening raised up several steps, which led to a door into the upper sacristy, where the Basel Treasury was kept. In later alterations, this passageway was eliminated and the door sealed; since then, access to the upper sacristy is possible only from the lower sacristy, through a trapdoor.

PROVENANCE: Hieronymous Falkeisen (1758–1838) collection, Basel; 1907, transferred to the Staatsarchiv des Kantons Basel-Stadt.

BIBLIOGRAPHY: Basel 1999, no. 39.

1. *Doors of the Treasury Cupboard*

Basel, about 1450. Lindenwood and tin-plated wrought iron, with modern colored backings for the openwork: 356 x 268 cm.
Historisches Museum Basel, 1904.375.

These imposing doors—two above and two below—filled the width of a shallow blind arcade on the west wall of the upper sacristy of the cathedral, effectively forming a massive cupboard. It was here that the Basel Treasury—specifically, the precious metalwork objects associated with the high altar—was held in safekeeping, from the time the cupboard was installed until 1827. Because of their scale, the Golden Altar Frontal (no. 2) and an outsized tower monstrance, now lost, were kept in individual cases in the same room. Impressive not only for their scale but also for the fine decorative carving, the doors were conceived more as appropriate housing for the contents rather than as an impregnable barrier; that was provided by the inaccessibility and the massive masonry walls of the sacristy itself. The outer border of the doors consists of elaborate leaf-and-tendril openwork, heavy with bunches of grapes and inhabited by animated birds. The arched crown terminates in

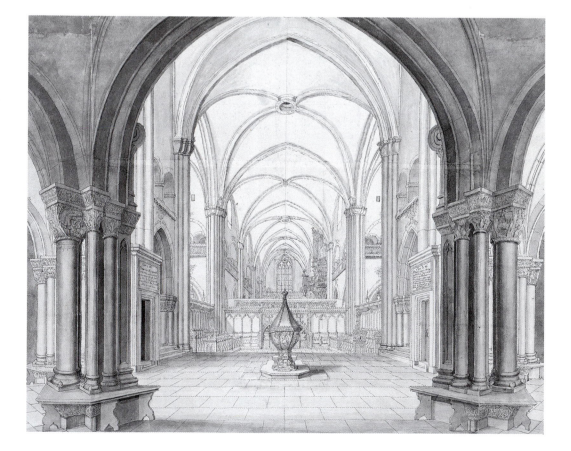

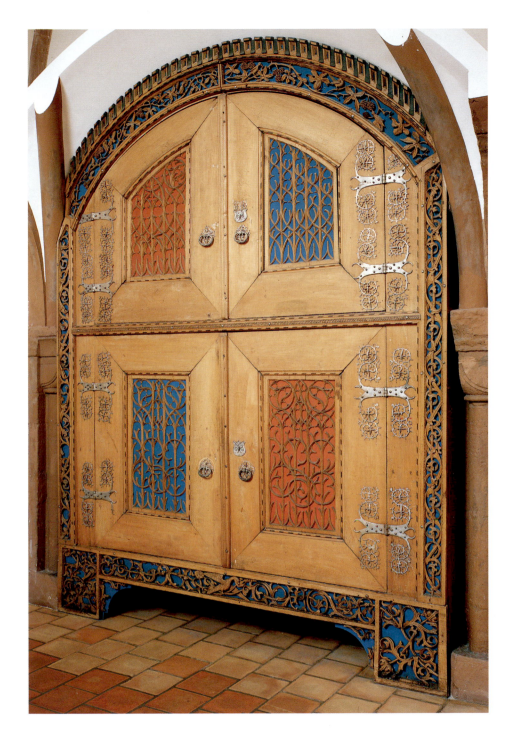

crenellation and the center field of each door panel is articulated with different patterns of dense and intricate open tracery, backed by alternating blue and red panels. The door pulls, lock plates, and hinges are fashioned in exceptionally fine and delicate detail from wrought and tinned iron, the bright surfaces of which set them off from the mellow tones of the supporting wood. According to the inventory of 1477, the "large new cupboard" ("grosse núwe kensterlin") was the donation of "Herr Hans Hanffstengel," identified as

the chaplain Johannes Hanffstengel, who died in 1452 and was buried in the Chapel of Saint Nicholas.[1]

PROVENANCE: 1849, transferred from Basel Cathedral to the museum on the Augustinergasse, Basel; 1894, transferred to the Historisches Museum Basel; 1904, accessioned by the museum.

BIBLIOGRAPHY: Burckhardt 1933, no. 29; "Münsterschatzschrankes" 2000, pp. 133–36.

1. Inventory 1477:2; see Burckhardt 1933, p. 222.

viii. *Inventory of the Basel Treasury*

Basel, 1477. Pen and ink on paper: (14 leaves), 29.5 x 11 cm.
Generallandesarchiv Karlsruhe, Abteilung 85, no. 155 (1).

Of the number of inventories of the Cathedral Treasury that
have survived, the present one, dated 1477, is the earliest. Its
seventy-one entries list all of the objects that were associated
with the high altar, and it is thus a key document in the
attempts to reconstruct the Basel Treasury. Written in hand-
some Late Gothic script, the inventory presents a methodi-
cal and concise account of the Treasury holdings, often
punctuated with episodic detail, noting the donor and men-
tioning an older item that the one at hand replaced, the
relics contained within, and other such relevant facts. The
compiler of the inventory even comments upon the value
or beauty of the object when it so moves him, as clearly was
the case in his expansive discussion of the Hallwyl Reliquary
(no. 34).

This inventory, as well as that of 1525, not only enumer-
ates each of the objects used on the high altar but also those
employed in conjunction with other altars and chapels
throughout the cathedral. These works, itemized in 179
additional entries, were stored in the new sacristy located
above the Chapel of Saint Catherine, which was attached to
the terminus of the south transept. The more detailed 1525
document is a dispiriting witness to a great loss, for all of
these objects, including forty-four chalices and, tragically,
the golden *plenarium* of Heinrich II, were sold in 1590 and
the proceeds of the sale given to charity.

PROVENANCE: during the French Revolution, transferred from the
archives of the Cathedral Chapter to Karlsruhe.

BIBLIOGRAPHY: Karlsruhe 1970, no. 248, pp. 275–76.

2. *Golden Altar Frontal*

Germany, probably Bamberg, 1015–19. Raised gold on a wax-resin compound and wood core, with opaque enamel, glass, pearls, bloodstone, carnelian, and other gemstones: 120 x 177.5 cm. Inscribed: (on the top frame) + QVIS SICVT HEL FORTIS MEDICVS SOTER BENEDICTVS; (on the lower frame) + PROSPICE TERRIGENAS CLEMENS MEDIATOR VSIAS; (over Christ, the middle figure) REX REGNUM ET DNS DOMINANTIU; (over the other arcaded figures, left to right) SC S BENEDICTVS ABB; + SC S MICHAEL; SC S GABRIEL; SC S RAFAEL; (over the roundels in the spandrels) P̅R̅ D̅E̅; I̅S̅ T̅C̅; T̅M̅ P̅R̅; F̅R̅ T̅T̅

Paris, Musée National du Moyen Âge, Thermes & Hôtel de Cluny, CI 2350.

3. *Head of an Archangel from the Golden Altar Frontal*

Germany, probably Bamberg, 1015–19. Wax-resin compound: 10 x 7 x 6 cm.
Munich, Bayerisches Nationalmuseum, MA 289. Gift of Jakob Heinrich von Hefner-Alteneck, 1867.

The Golden Altar Frontal ranks as one of the greatest treasures to have come down to us from the Middle Ages, and must be placed on the same level as the Golden Altar of San Ambrogio (about 900) in Milan, the Golden Ambo (about 1020) in the Cathedral of Aachen, and the famed Pala d'Oro (about 1005; altered in 1209 and 1342–45) in the Basilica of San Marco in Venice. The altar is the focal point of the Christian liturgy and, since Early Christian times, was provided with elaborate textile hangings, the richness of which reflected the very status of the church. Antependiums or frontals made of precious metals were donations of exceptional

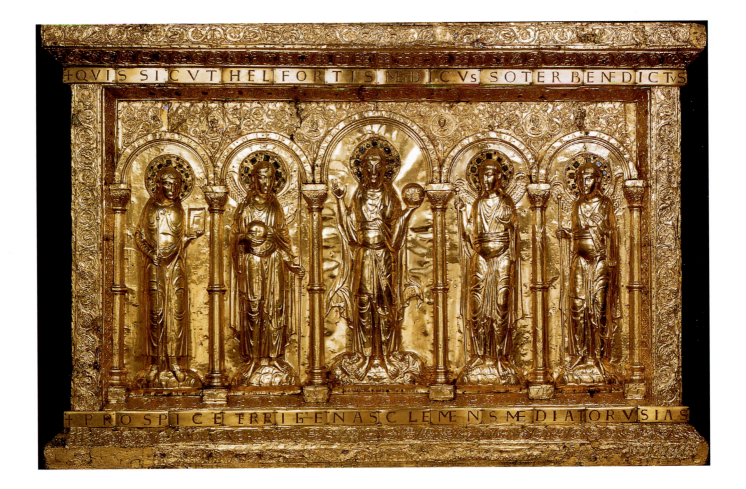

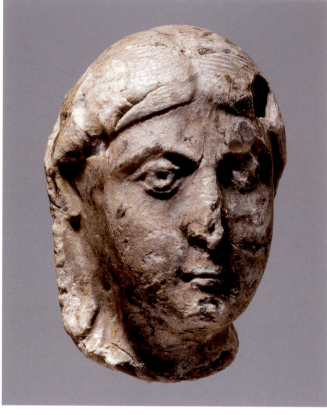

3

eminence reserved for the most venerable of ecclesiastical foundations. The Basel Golden Altar Frontal traditionally is held to be the gift of Emperor Heinrich II (r. 1014–24) for the consecration of the Romanesque cathedral, which occurred in the imperial presence on October 11, 1019. Heinrich had contributed to the rebuilding of the cathedral after it was sacked by the Hungarians in 917 and had incorporated Basel, formerly part of Burgundy, into the Holy Roman Empire in 1006. In addition to the Golden Altar Frontal, other gifts traditionally credited to Heinrich include reliquaries for the high altar, a golden censer, ecclesiastical vestments (see no. xv), a golden *plenarium*, a chandelier, a bishop's throne, and a reliquary cross (no. 4) that, along with the frontal, is the only surviving object from Heinrich's bounty. As the first written account did not appear until four centuries after the event, before 1461, the most compelling evidence of its veracity lies in the objects themselves—that is, the very existence of the Altar Frontal and the Heinrich Cross. It is generally believed that the small figures at the feet of Christ represent the imperial couple Heinrich and Kunigunde.

The frontal is conceived as an antique sarcophagus with arcades enframing standing figures: Christ, in the center, is flanked, on the left, by Saint Benedict and the archangel

Michael, and, on the right, by the archangels Gabriel and Raphael. The inscriptions on the arches identify the figures below; Christ is called "King of Kings, Lord of Lords," while the others are identified by their names. The four Cardinal Virtues—Prudence, Justice, Temperance, and Fortitude—appear in medallions over each spandrel. The large inscription in enamel above and below the arcaded figures, which appears to allude to Benedict as Intercessor, reads: "He who, like God, the powerful, the healer, the savior, and the blessed / Look with benevolence, merciful intercessor, upon the worldly creatures."

The origins of the Golden Altar Frontal are unknown but current scholarship views it as the product of an imperial workshop in Bamberg dating to between 1015 and 1019.[1] However, arguing against this proposal is the fact that Bamberg, at this point, only recently had been elevated to a bishopric, and thus it seems unlikely that there would have been established workshops capable of creating a work of art of this magnitude. Fulda, which enjoyed a rich artistic tradition, therefore has been proposed as an alternate place of origin. Likewise uncertain is the destination for which the Altar Frontal originally was intended. Because Monte Cassino was the primal Benedictine foundation, it has been thought to be a possibility by some. Yet, the emphasis placed on the archangels, as well as on Saint Benedict, has led many scholars to favor the Benedictine monastery on the Michaelsberg in Bamberg, founded by Heinrich and Kunigunde in 1015, which is referred to in period texts as the "monastery of Saint Michael," "mountain of angels," and "monastery of Saint Benedict" ("*monasterium sancti Michaelis,*" "*mons angelorum,*" and "*monasterium sancti Benedicti*").[2] In any case, the iconography of the Golden Altar Frontal suggests little connection with Basel, for its Romanesque cathedral was dedicated to the Virgin, Saint John the Baptist, and the apostles. The earliest mention of the Golden Frontal in the cathedral coincided with the erection of the new altar after the earthquake of 1356. The 1477 and 1511 inventories record that the Frontal was kept in the sacristy; no longer used in front of the altar, it was displayed on the altar along with other Treasury objects on high feast days, at least seven times a year.[3]

The main figures in high relief once contained a wax-resin composite core, suggesting that the Altar Frontal was dismantled at some point in its history. The Munich head, said to have been removed by Johann Jakob III. Handmann, the Basel goldsmith who bought the Golden Frontal at the Liestal auction, appears to be that of either Gabriel or Raphael, the archangels on the right side. Although the dimensions do not accord precisely with the cavity left in the relief—a difference possibly caused by subsequent shrinkage or distortion—the close correspondence of the facial features and the positioning

of the Munich head would indicate that it did, indeed, form part of the missing core of the Golden Altar Frontal.

PROVENANCE: (2) 1834, excluded from the allotment to Basel-City and Basel-Country, which were to resolve its disposition between them, and, as the city government could not justify the expense of the aquisition, the Altar Frontal devolved to Basel-Country; 1836, sold at auction in Liestal to the Basel goldsmith Johann Jakob III. Handmann; 1838, acquired by Colonel Jean-Jacques Ursin Victor Theubet, Porrentruy; 1852, placed on loan in the Musée de Cluny; 1854, purchased by the French government for the Musée de Cluny; (3) 1836, acquired with the Altar Frontal and subsequently removed; 1840, given to Jakob Heinrich von Hefner-Alteneck; 1867, presented by von Hefner-Alteneck to the Bayerisches Nationalmuseum.

BIBLIOGRAPHY: (2) Burckhardt 1933, no. 1; Schramm and Mütherich 1962, no. 138, p. 166, figs. pp. 359–61; Pfaff 1963, pp. 44 ff.; Reinhardt 1963, pp. 31–41; Wollasch 1980, pp. 383–407; Caillet 1985, no. 163, pp. 229–37; Reinle 1988, pp. 12, 14, fig. 4; Lasko 1994, pp. 105, 129, 130–31, 133, 135–36, 185, fig. 179; Suckale-Redlefsen 1995, pp. 129–75; von Roda 1999, esp. pp. 7–21; (3) Basel 1956, no. 65, p. 53; Caillet 1985, p. 229.

1. For a lengthy discussion of the origins of the Golden Altar Frontal see Caillet 1985, esp. pp. 233–35.
2. Ibid., p. 233.
3. von Roda 1999, pp. 9–21.

4. *Reliquary Cross, known as the Heinrich Cross*

Germany, 1000–1050, with extensive alterations and additions in the 14th, 15th, and 19th centuries. (Obverse): Raised gold and gold filigree, with silver pearls, glass cabochons, a chalcedony cameo, and glass, garnet, amethyst, carnelian, and rock-crystal cabochons; (Reverse and edges): Raised, engraved, and gilded silver, gilded copper, and glass and semi-precious cabochons, on a wood (oak) core, with iron armatures: 51.2 x 46.2 cm.
Staatliche Museen zu Berlin, Kunstgewerbemuseum, 1917,79.

Throughout the Middle Ages, elaborate gold crosses encrusted with filigree, gemstones, rock crystal, and cameos were conceived primarily as dazzling vessels for precious relics. The Heinrich Cross is a rare and particularly resplendent example from the Ottonian period. Arms of equal length extend from a central square upon which an imperial Roman cameo phalera, or military decoration, representing a male head encircled with an ivy wreath, is mounted; rock crystals set on circular expansions of the arms provide a view into the underlying housing for the relics of the sainted emperor Heinrich II ("S heinrici i[m]peratoris"), left and right, and fragments of the True Cross, above and below.

Like many Early Medieval examples of goldsmiths' work, the Heinrich Cross was altered extensively in the later Middle Ages; the reverse side with the crucifix and the circular medallions with symbols of the Evangelists, as well as the edges, were largely reworked in the fourteenth and fifteenth centuries. The missing symbol for Saint Matthew once placed on the circular expansion of the lower vertical arm apparently was removed to allow for the attachment of the corpus.

The cross is so named not only because it houses relics of the emperor Heinrich II (r. 1014–24) but also because it was thought to have been presented by him personally at the consecration of Basel Cathedral by Bishop Adalbero II (r. 999–1025) on October 11, 1019. Although praised for its important relics of the Holy Blood and of the True Cross in an anonymous thirteenth-century poem that appears in the *Weltchronik* (about 1250) of Rudolf von Ems, the cross is not associated with Heinrich II. Nor is he linked with the cross in the earliest surviving Basel Treasury inventory compiled in 1477 (no. viii); rather, it was referred to only as the "good cross" ("bona cruce" or "guote krútz") or the "good and precious cross" ("crux bona et preciosa" or "gût und koestlich crútz").[1] The first account associating a cross with Heinrich's donation, however, appears in the Breviary of Bishop Friedrich ze Rhin of Basel (no. xi), written between 1437 and 1439. Although the written record is unclear, the Berlin cross traditionally has been identified with the original donation of Heinrich II. It is unlikely that the relics of Heinrich II could have been incorporated into this cross prior to 1347, when relics of both Heinrich and his wife, Kunigunde, were translated from Bamberg to Basel, and the emperor became a patron saint of the cathedral. The devastating earthquake of 1356 may have occasioned a major repair and alteration of the cross. In the early sixteenth century, a relic of the Holy Blood must still have been associated with the cross, as it is described as an "exquisite cross in which the relic of the miraculous blood is contained" ("crucem preciosorem in qua sanguinis miraculosi reliquie sunt reconditi").[2] As relics were acquired, housing for them had to be found; sometimes this occasioned the fabrication of new reliquaries and, at other times, the reuse or the alteration of existing ones.

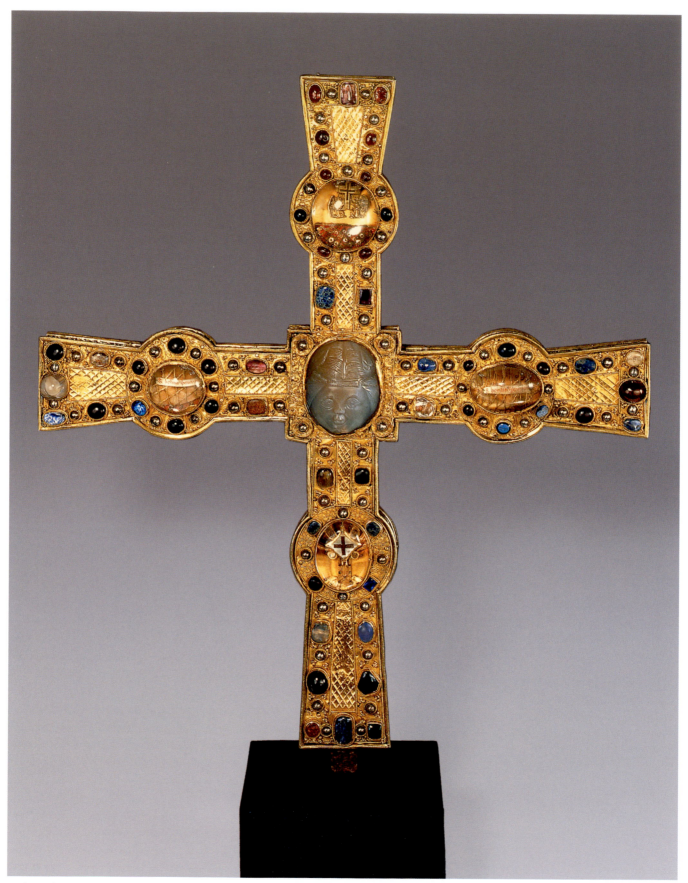

4: obverse

The Heinrich Cross played a special role in the spiritual life of Late Medieval Basel (see pp. 14, 16, 22). On Palm Sunday, it was placed on a silk cushion on a stone column in front of the bishop's throne and surrounded with blessed palm boughs, and on Good Friday the cross was prominently displayed in the choir; on such occasions, it was provided with a supporting base (no. 5). The cross, likewise, was employed in more politically oriented events—as, for example, the swearing in of newly elected city councillors and the welcoming ceremonies for princes of Church and State. During the 1493 entrance of King Maximilian into the city of Basel, the Heinrich Cross was elevated by a prelate for the future emperor on horseback to kiss. The cross was mounted on a processional staff (no. 21) for these events.

BIBLIOGRAPHY: Burckhardt 1933, no. 2; Schramm and Mütherich 1962, no. 139, pp. 166–67, fig. p. 362; Pfaff 1963, no. 58; Grimme 1972, p. 42; Reinhardt 1976, pp. 34–46; Arenhövel 1985; Jülich 1987, pp. 170–72, 214–16; Reinle 1988, p. 94; Hildesheim 1993, vol. 2, no. II-46, pp. 104–7; Basel 2001, no. 1.

1. Inventories 1477:63 and 1525:6, respectively.
2. Ceremoniale Basiliensis episcopatus (UBB, H.I.28, 31a); Lambacher, in Basel 2001, no. 1.

4: reverse

5. Footed Base for a Cross

Lower Rhineland or Valley of the Meuse, 1150–1200. Cast, chased, and gilded copper alloy, with traces of original gilding: Height, 14 cm.
Basel, Römisch-Katholische Kirche Basel-Stadt (Sankt Clara).

6. Base for a Cross

Lorraine or western Germany, 1150–1200. Cast, chased, gilded, and silvered copper alloy: Height, 16.4 cm.
Historisches Museum Basel, 1882.86.

Two bases for altar crosses have survived from the Romanesque Treasury. The first of these, the more elaborate and finely wrought ("reicher Kreuzfuss"), is supported by four paw feet over which are seated figures, presumably the Four Evangelists. Between the feet are representations of the Baptism of Christ, Christ in Majesty, the Trinity, and the enthroned Virgin and Child. Projecting upward from the center is a vertical support for a cross, on both sides of which an Atlas figure with upraised arms appears to hold up the cross above.

Compositional balance and formal clarity bring exceptional sculptural presence to this base. Its visual appeal may well be reflected in a later design for the seal of the cathedral, the composition of which is strikingly similar to that of the enthroned Virgin and Child. When the base entered the

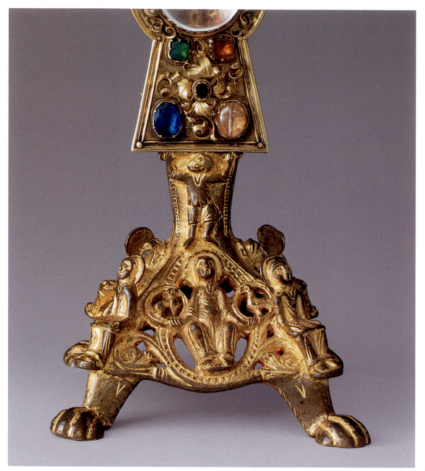

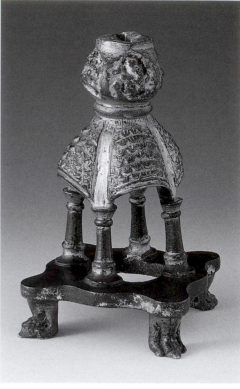

6

5: with Sunday Cross (no. 33)

Treasury and whether it was made or intended for a specific cross are unclear. The resemblance of the crosshatched patterns on the sides of the stem of the base to those on the obverse and edges of the Heinrich Cross (no. 4) may argue for more than a coincidental relationship.[1] At least in the fifteenth century, this base was associated with the Heinrich Cross, often referred to as the "good cross." Thus, in the 1477 inventory the base is itemized as "a foot for the good cross" ("ein fuoss zu dem guoten krútz"), and in the 1478 inventory it is mentioned as "a gilded foot for the good cross" ("ein vergült fuss pro bona cruce").[2] In the 1525 inventory, however, the base is identified with an entry reading "a gilded foot for the Sunday Cross" ("ein vergulter fůsz zů dem sonteglichen crutz"),[3] a connection perpetuated in 1834 when the Basel city government gave the Sunday Cross (no. 33) and this base to the Church of Saint Clara, where the two are displayed in a special case in the apse.

The second base for a cross, simpler in design ("einfacher Kreuzfuss"), is in the form of a ciborium on a platform surmounted by a knop into which a flange can be inserted; the style of the cupola suggests Byzantine influence. Unlike the first base, this one is not associated with a particular cross in the early inventories. Today, it is used as the support for the Reliquary Cross (no. 32). The opening in the bottom of this base appears too large to have accommodated a staff to support a cross in procession, and it has been suggested that the hole originally was fitted to hold the two phials of the "miraculous blood of Christ," now in the Benedictine monastery at Mariastein, that were brought back from Beirut by Bishop Ortlieb von Froburg in 1149.[4]

PROVENANCE: (5) 1834, allotted to Basel-City, then given with the Sunday Cross (no. 33), to the Catholic community of Basel and deposited at the Church of Sankt Clara; (6) 1834, allotted to Basel-City.

BIBLIOGRAPHY: (5) Burckhardt 1933, no. 3; Braun 1940, p. 484, fig. 571 a; Augsburg 1973, no. 90, p. 124; Springer 1981, no. 42, pp. 175–79, figs. K319–323; Reinle 1988, pp. 101, 104; Basel 2001, no. 21; (6) Burckhardt 1933, no. 4; Braun 1940, p. 484, fig. 571 b; Springer 1981, no. 30, pp. 153–55, figs. K258–261; Reinle 1988, p. 104; Falk 1993, p. 173; Basel 2001, no. 23.

1. Burckhardt 1933, p. 59.
2. Inventory 1477:63; see Burckhardt 1933, no. 63, p. 362.
3. Inventory 1525:54.
4. Berkemeier-Favre, in Basel 2001, no. 23.

7. *Pair of Censers*

Upper Rhineland, possibly Basel, about 1200. Raised,
pierced, and incised silver: Height: (overall, with chains)
(a) 56.6 cm (b) 59.8 cm; (vessel) (a) 13.1 cm (b) 13.4 cm.
Historisches Museum Basel, 1882.82 (a), 1916.516 (b).
Gift of C. Chr. Burckhardt-Schazmann.

The censers are each composed of two parts and suspended
from five chains, four for swinging the censer and the fifth
for lifting up the lid or upper section. Nearly identical, both
are worked of unusually thin silver, which has suffered
deformation and other damage with use. Romanesque
censers are generally made of a more durable cast copper
alloy or bronze; while examples fashioned in raised silver are
exceedingly rare—only two others are recorded—a surviv-
ing pair appears to be unique to Basel.[1] The purification of
the sanctuary was the principal role of censers, but the
swinging of the vessels gave a measured rhythm to the pro-
ceedings and the pungent aroma added further perceptual
dimension. Architectural edifices in miniature, the censers
take the form of a centrally planned cruciform church. The
vertical elevations of the upper sections are pierced with

numerous arched or circular windows through which the
incense smoke escaped, and the surfaces are worked in an
imbricated or fish-scale pattern resembling roofing tiles.
According to the presbyter known as Theophilus—who, in
the first half of the twelfth century, wrote an authoritative
treatise on the working methods of artists—the form of
censers was meant to imitate the heavenly Jerusalem.

PROVENANCE: (a) 1834, allotted to Basel-City; (b) 1834, allotted to
Basel-Country; 1836, sold at auction in Liestal; until 1916, C. Chr.
Burckhardt-Schazmann, Basel.

BIBLIOGRAPHY: Burckhardt 1933, no. 7; Reinle 1988, p. 92; Barth
1990, no. 1; Basel 2001, no. 44, 1 and 2.

1. Ribbert, in Basel 2001, no. 44.

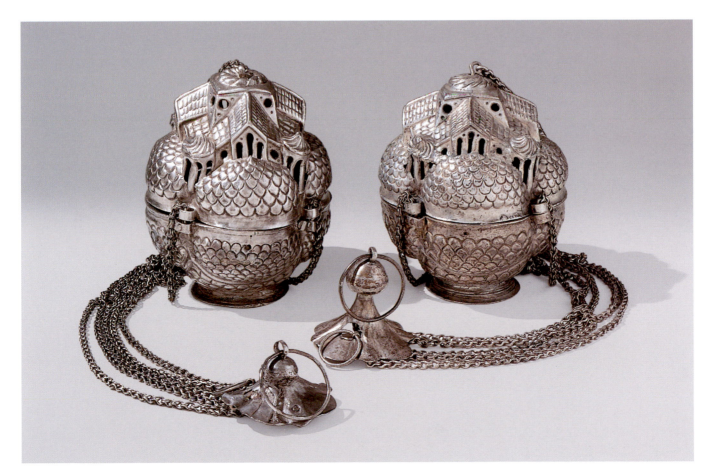

8. *Eptingen Chalice and Paten*

Basel, 1200–1225 (probably after 1213); altered in 1467.
Raised, engraved, gilded, and stippled silver, with filigree:
Height (chalice), 18.1 cm; (with cover), 33.7 cm.
Inscribed: + CALICEM ○ ISTVM ○ DEDIT ○ GOTFRIDVS ○ DE ○
EPTINGEN ○ BEATE ○ MARIE ○ +
Historisches Museum Basel, 1882.84.

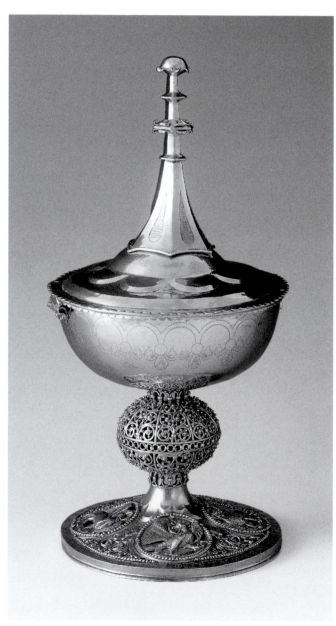

8: chalice with paten altered as lid

Relative to chalices of the Gothic period, few Late Romanesque examples have survived. The one belonging to the Treasury is distinguished by the generous but graceful proportions and the balance of its component parts. Engraved around the rim is a continuous arcade with pendentive fleurs-de-lis; the knop is constructed of reticulated and finely executed filigree through which the stem remains visible; and the foot is adorned with four medallions with symbols of the Evangelists, set among raised, symmetrical foliate decoration. The inscription encircling the rim of the foot informs us that the chalice was donated by Gottfried von Eptingen in honor of the Blessed Virgin Mary, to whom the cathedral originally was dedicated. The von Eptingen were a noble family from the vicinity of Basel; three thirteenth-century members of this family with the name Gottfried are recorded, but of these only the first two could have been the donor of this chalice in the first quarter of the century.[1] The donation may have been occasioned in 1213 when the impecunious bishop Lütold von Aarburg sold an earlier gold chalice.[2]

Like many objects in the Basel Treasury, the Eptingen Chalice was altered in the course of its medieval history; such reworkings and adaptations were propelled as much by changes in liturgy as in taste. In 1458, Bishop Arnold von Rotberg donated a chalice in the current Gothic style (no. 12), and the older Eptingen Chalice was withdrawn from use; rather than being melted down for cash or reuse, in 1467, according to cathedral records, the chalice was transformed into a reliquary. To accomplish this, the center of its original paten was raised into a dome onto which a separate and rather inelegantly proportioned spire with finials was summarily attached. This "lid" was fastened to the chalice by a hinge and a hasp. Only recently was an image of Christ Pantocrator flanked by the alpha and omega rediscovered on the obverse of the paten, the hammering of which had reduced the engraving to a palimpsest-like state.[3]

PROVENANCE: 1834, allotted to Basel-City.

BIBLIOGRAPHY: Burckhardt 1933, no. 8; Heuser 1974, pp. 100–101; Reinle 1988, p. 73; Barth 1990, no. 2; Basel 2001, no. 47.

1. Kalinowski, in Basel 2001, no. 47.
2. Barth 1990, p. 36.
3. I am grateful to Martin Sauter, who made this observation and pointed it out to me.

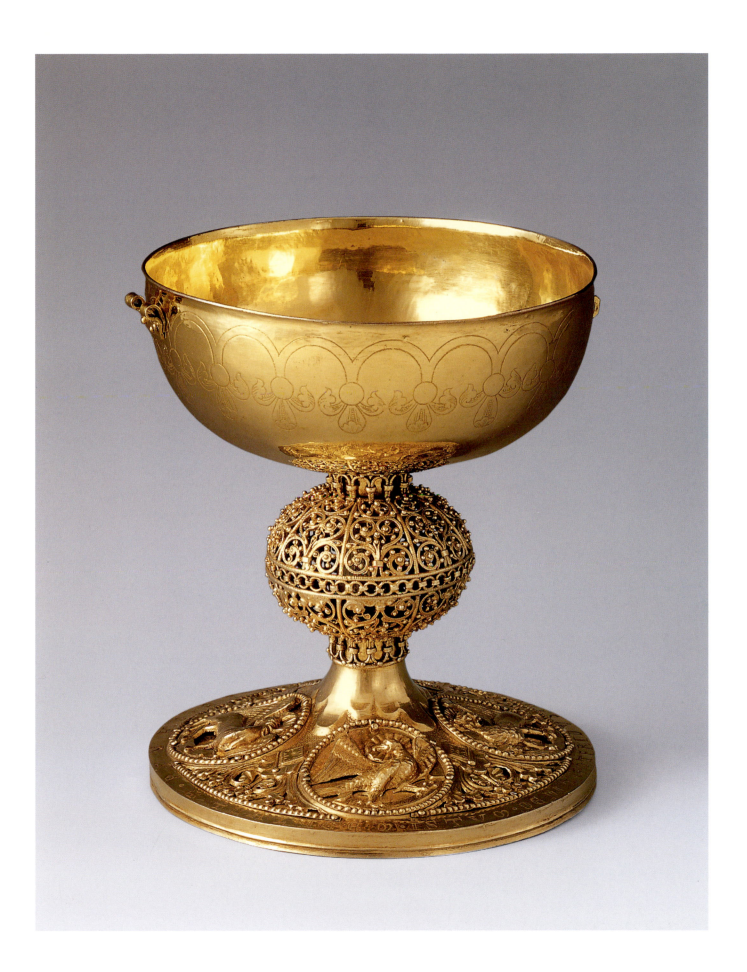

9. *Reliquary Head of Saint Eustace*

Upper Rhineland, possibly Basel, 1180–1200 (wood head and base), 1200–1220 (silver head and base). Raised, stamped, and partially gilded silver, with filigree, copper, glass, rock crystal, chalcedony, amethyst, mother-of-pearl, pearl, onyx, and carnelian, with fragments of silk: Height (silver head and base, overall), 33.5 cm; (wood core, overall), 32.8 cm. London, Trustees of the British Museum, MLA 50,11-27,1.

Saint Eustace was a Roman general who converted to Christianity and subsequently was martyred on the orders of Emperor Hadrian in 119. This austerely frontal depiction of the saint's head, with its straight hair curled at the ends and a jewel-beset fillet, is fixed to a small square base on each side of which three standing saints are placed within arcades. The silver sheets that encased the wood core were removed in 1955, revealing that this inner support consists of three pieces: the base, the head, and a removable skullcap that allows access to the interior cavity. Only after the relics were inserted was the sheathing of silver, comprising at least nine separate sheets, attached; how far apart the core and silver sheeting are in date is not clear.[1] Although the latter generally conforms to the modeling of the wood head, there are deviations: The surface of the fillet band on the wood head, for example, is flat and unarticulated, while, on the silver head, the contours of the hair continue under the applied strips of filigree. The relatively small size of the base and the fact that the four dowels projecting from the neck have no corresponding means of attachment in this base suggest that the two parts were not originally intended as a whole and that the ensemble was reworked considerably early in its history.

Although the inventories from 1477 onward consistently identify this head reliquary with Saint Eustace, there is no corroborating internal evidence. To the contrary, the cavity in the head was not designed to house a skull, as would be expected; rather, it serves as a container to hold numerous individual relics. These relics, each wrapped in a textile fragment ranging in date from the seventh through the twelfth century and labeled with an attached vellum strip, were placed in the head cavity in three layers: the top one held relics of saints Anthony the Confessor, Eucherius, Simeon, Anastasius, and Nicholas; the middle, of saints Benedict, Nicholas, and Jocunda, among others; and the bottom, nine fragments of an unlabeled skull. Like the textiles in which they are wrapped, the labels appear to be of various dates, from the seventh through the twelfth or early thirteenth century. As there were no indications that the reliquary had

ever been opened prior to the 1955 examination, the Head of Saint Eustace, like many other reliquaries in the Treasury, appears to have been altered at an early date under circumstances that are, in this case, entirely unclear.

PROVENANCE: 1834, allotted to Basel-Country; 1836, sold at auction in Liestal to Johann Friedrich II. Burckhardt-Huber; 1850, purchased from William Forrest by the British Museum.

BIBLIOGRAPHY: Burckhardt 1933, no. 5; Braun 1940, p. 413, fig. 477; Heuser 1974, p. 100; Falk 1993, no. 52, pp. 206–9; Basel 2001, no. 13.

1. Cherry, in Basel 2001, no. 13.

9: wood core

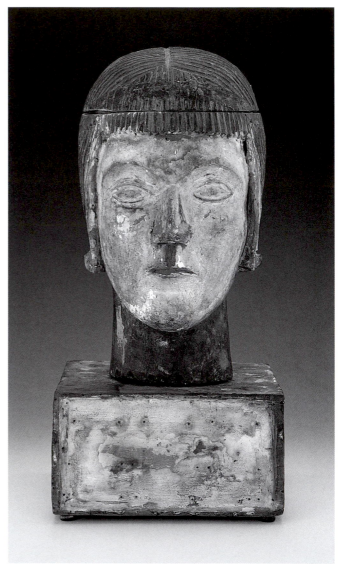

54

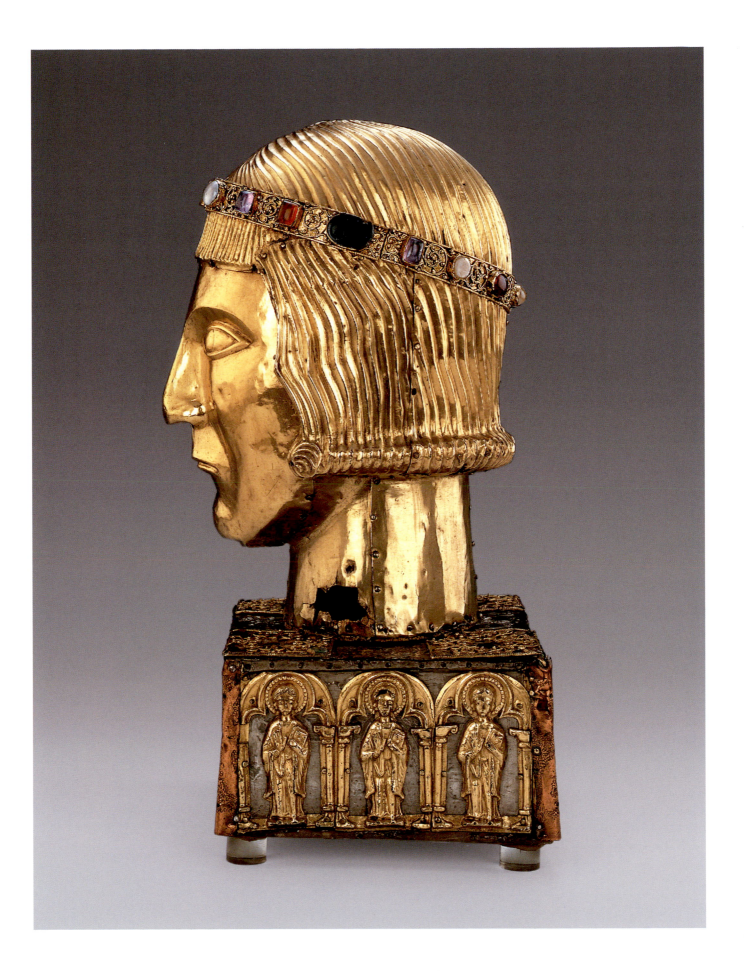

10. *Arm Reliquary of Saint Walpert*

Upper Rhineland, possibly Strasbourg, about 1250. Raised, stamped, engraved, and partially gilded silver, and gilded copper filigree, with glass, rock-crystal cabochons, jasper, a chalcedony cameo, onyx cameo, carnelian, and doublets, on a wood core: Height, 63.5 cm.
Saint Petersburg, The State Hermitage Museum, F-111.

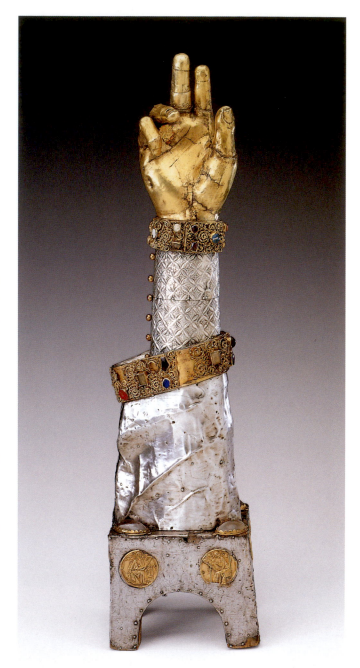

With the hand in a gesture of blessing, the upright, life-size right arm, clothed in a tight-fitting, patterned sleeve with simulated buttons down the wrist and an elaborated cuff, rises out of a second, loose sleeve with a similarly decorated hem. A ring with a glass intaglio of a female head adorns the middle finger. The whole is supported by a base with arched openings on each side. Raised medallions representing the Evangelists at their writing desks, along with their symbols, are attached to the base, two on the front side and one at either end, each flanked by two smaller medallions with the zoomorphs; the back is now blank, although there are indications of previous attachments. Large cabochon rock crystals are mounted on the upper corners of the base.

In spite of the many losses and repairs, this Late Romanesque arm reliquary retains much of its commanding presence. The carefully observed anatomical details of the hand are all the more striking in contrast to the stiff, geometric patterning of the forearm garment, which, in turn, is counterbalanced by the soft folds of the voluminous sleeve over the upper arm. The late date notwithstanding, the wood core and the completely encased relic are characteristic of Romanesque arm reliquaries, while their Gothic counterparts generally are fashioned from raised silver alone, without a core support, and almost always incorporate an aperture providing a view of the relic (see no. 43).

Like other reliquaries in the Treasury, there are no iconographic indications of whose relics the arm was intended to contain. The identification of this reliquary with the one itemized in the 1477 inventory as "an arm covered in silver of Saint Walpert the confessor" ("ein arm mit silber beslagen Sancti ualperti confessoris")[1]—a description that accords with those in the 1525 and 1827 inventories, although the latter adds the detail that the hand is gilded—is based on the correspondence of the materials listed, the size indicated, and the fact that this brachial reliquary was in the Soltykoff collection along with four other objects known to be from the Basel Treasury (nos. 14, 41, 56, 57).[2]

PROVENANCE: 1834, allotted to Basel-Country; 1836, sold at auction in Liestal; after 1836, acquired by Prince Peter Soltykoff, Paris; 1861,

sold at auction in Paris; before 1870, acquired by Baron Achille Seillière, Paris; 1878, acquired at auction by Alexander P. Basilevsky, Paris; 1884, entire Basilevsky collection acquired by Tsar Alexander III; 1885, with the Basilevsky collection, entered the Hermitage.

BIBLIOGRAPHY: Burckhardt 1933, no. 6; Braun 1940, pp. 390, 402, 407, fig. 451; Reinle 1988, p. 137; Basel 2001, no. 17.

1. Inventory 1477:9.
2. Kryzanovskaya, in Basel 2001, no. 17.

LITURGICAL OBJECTS

11. *Pair of Altar Cruets*

Upper Rhineland, possibly Basel, 1350–1400. Raised, stamped, and partially gilded silver: Height (each), 13.8 cm. Inscribed: (on the bottom of one) DOCTOR ARNALDVS; (on the bottom of the other) AR. zê. LVFT.
London, Victoria and Albert Museum, 1865-449, 450.

Primary liturgical vessels, altar cruets were used to mix the sacramental wine with water for the celebration of the Mass. Of balanced proportion and graceful profile, each example in this small pair has a single letter in Gothic majuscule attached to the lid that indicates the intended contents: an *a* for *aqua* (water) and a *v* for *vinum* (wine). The form of these vessels was widely favored over an extended period of time, making a precise date or localization difficult to determine.[1]

Inscriptions on the bottoms of the vessels record that they were given to the cathedral by Dr. Arnold zem Luft, a canon from 1474 until his death in 1516, who also donated a covered beaker (no. 60).[2]

PROVENANCE: 1834, allotted to Basel-Country; 1836, sold at auction in Liestal to Johann Friedrich II. Burckhardt-Huber, Basel; until 1861, Prince Peter Soltykoff, Paris, when they were sold at auction to van Cuyck; 1865, acquired by the Victoria and Albert Museum.

BIBLIOGRAPHY: Burckhardt 1933, no. 21; Fritz 1982, no. 615, pp. 272–73; Reinle 1988, p. 83; Basel 2001, no. 46, 1 and 2.

1. Fritz 1982, p. 272.
2. Burckhardt 1933, p. 171.

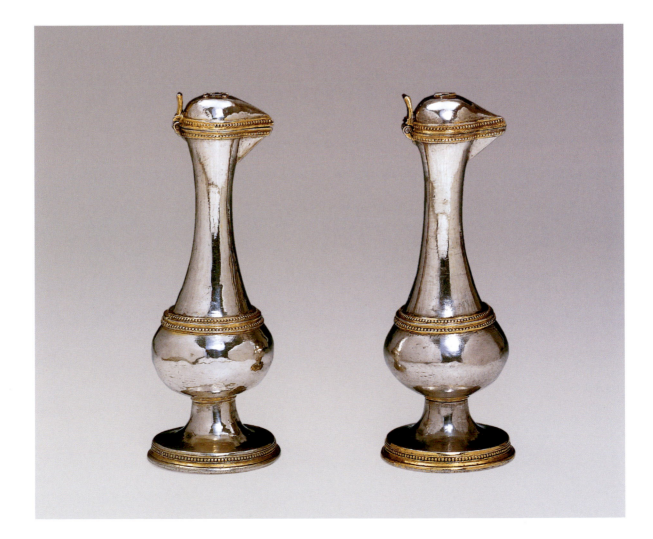

12. *Rotberg Chalice*

Basel, probably 1451–58. Raised, engraved, and gilded silver, with opaque *champlevé* enamel: Height, 21.6 cm. Historisches Museum Basel, 1894.346. Bequest of Felix Sarasin-Brunner.

Gracefully proportioned and restrained in ornament, this chalice, hexalobe in section from the base to the cup, may have been the work of Heinrich Schwitzer, a Basel gold-smith favored by the episcopacy. The apparent austerity belies the subtleties of design. The mass and weight of the chalice are relieved within each of its component parts: the foot, by the band of quatrefoil openwork; the knop, by the ungilded silver, inset lozenges that read almost as voids; and the cup, which appears to float out of its reflection on the knop below.

The entry for this chalice in the inventory of 1477 estab-lishes that it was bequeathed to the cathedral by Bishop Arnold von Rotberg, who died in 1458 (". . . ein grosser núwer kelch quem legavit dominus Arnoldus de Ratperg olim episcopus huius ecclesie")[1] and who may have ordered it early in his tenure.[2] The finely decorated Rotberg Room (*Rotbergstübchen*) in the former Bishops' Palace; the donation of a full array of sumptuous ecclesiastical vestments, all sold shortly after the Reformation was instituted; and the bounty of luxury vessels left to his beneficiaries attest to the bishop's ability to gratify his lavish tastes.[3] The enameled shields attached to the base are emblazoned with the black-on-gold arms of the Rotberg family and with the red crosier head on silver for the Bishopric of Basel.

PROVENANCE: 1834, allotted to Basel-Country; 1836, sold at auction in Liestal to Wilhelm Oser, Basel; until 1862, Felix Sarasin-Brunner, Basel, and then his widow, Rosalie Sarasin-Brunner; 1874, bequeathed to the Medieval Collection; 1894, transferred to the His-torisches Museum Basel.

BIBLIOGRAPHY: Burckhardt 1933, no. 30; Barth 1990, no. 12; Basel 2001, no. 48.

1. Inventory 1477:48.
2. Barth 1990, p. 58.
3. Burckhardt 1933, p. 225.

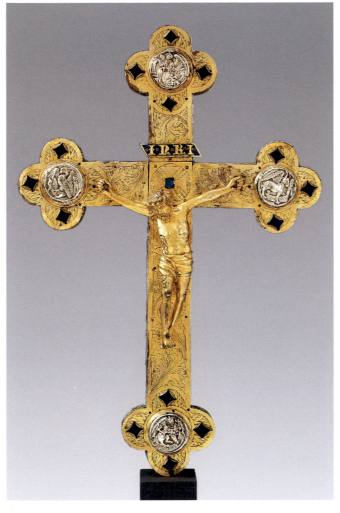

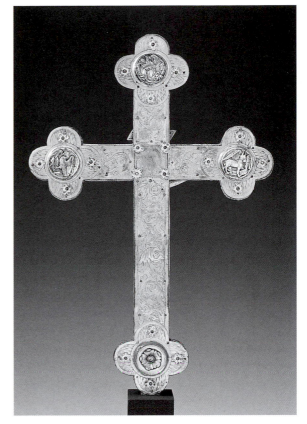

13. *Altar Cross*

Basel, 1440–60. Engraved, stamped, gilded, and silvered copper, on a wood core, with glass and traces of opaque *champlevé* enamel, and cast, chased, and gilded copper alloy (bronze): Height, 52 cm.
Historisches Museum Basel, 1893.379. On deposit from the Kirchgemeinde Allschwil.

The obverse and reverse of this much-altered cross are similarly treated: The fields of the arms, within a plain border, are engraved with a lush foliate pattern, and what appear to be trelobed termini—by the addition of an engraved lobe on the inner sides—are converted, in a visual conceit, to quatrelobed fields, all filled with emanating rays of light. On the obverse side, colored glass stones are centered within each lobe, surrounding stamped and silvered medallions representing the zoomorphic symbols of the Four Evangelists. The square plaque at the crossing is en-

graved with a cruciform halo for the attached figure of Christ. On the reverse, silver rosettes attached by nails surround raised medallions, again representing the Four Evangelists; that on the lower terminus is replaced with a large rosette. The central plaque is engraved with an image of the face of Christ. The edges of the cross are sheathed with pattern-stamped and silvered copper sheeting. An entry in the 1827 inventory cites a gilded-copper cross, probably a reference to this one, and rather overstates its compromised condition, declaring it to be "broken and without value" ("zerbrochen und ohne Werth").[1]

PROVENANCE: 1834, allotted to Basel-Country; 1836, sold at auction in Liestal to an Allschwil judge; since 1893, on deposit at the Historisches Museum Basel.

BIBLIOGRAPHY: Burckhardt 1933, no. 34; Fritz 1966, p. 42, fig. 18, no. 39, p. 448; Basel 2001, no. 50.

1. Inventory 1827:52.

14. *Branched Cross with the Virgin and Saint John the Evangelist*

Basel, 1350–1400 (cross); attributed to Hans Rutenzwig, Basel, before 1477 (base). Raised, cast, engraved, and gilded silver, with translucent *basse-taille* enamel, pearls, and red pigment (crucifix); raised, engraved, and partially gilded silver (base): Height (crucifix), 19 cm; (with base), 49.2 cm. London, Victoria and Albert Museum, 7939-1862.

A generation after its creation, the small and finely worked crucifix was provided with an elaborate base,[1] creating an ensemble of sufficient stature for public display. The large quatrelobe-on-square termini enlivened with brilliant purple and blue translucent enameling and pearls create a celestial surround for the diminutive but attenuated corpus, which is actually attached to a thin tubular cross superimposed on the larger one that thus serves more as a background than as a support. Red pigment marks the wound in Christ's side. The elaborate stand rests on an octalobed base out of which the stem supporting the crucifix rises; punctuated midway by a large knop with foliate decoration, the stem branches into two flanking stems with leafy ornament that support the Virgin on one side and John the Evangelist on the other. The mourning figures are so out of scale with the corpus that they appear as conduits to the contemplation of the significance of the scene rather than as witnesses to the event itself. Stylistically, the figures are sufficiently close to the standing figure of a Virgin by Hans Rutenzwig incorporated into a monstrance made by the Basel goldsmith Jörg Schongauer in 1488 and now in Porrentruy (Canton Jura) to support an attribution to Rutenzwig or his workshop.[2]

There is no record of the circumstances under which the crucifix entered the Treasury. The base, we know, was ordered by the Cathedral Chapter during the tenure of the curate and administrator Heinrich Gugelin, and was paid for by indulgences purchased by individuals who hoped to reduce their time spent in purgatory—a practice that was railed against by Church reformers. In an apparent alteration, the back panel of each arm of the cross can be opened to reveal a cavity that could have housed a relic.[3]

PROVENANCE: 1834, allotted to Basel-Country; 1836, sold at auction in Liestal and acquired by the Basel goldsmith Johann Friedrich II. Burckhardt-Huber; thereafter, acquired by Prince Peter Soltykoff, Paris; 1861, sold at auction in Paris to Webb, London; 1862, acquired by the South Kensington Museum, London, later the Victoria and Albert Museum.

BIBLIOGRAPHY: Burckhardt 1933, no. 32; Basel 2001, no. 24.

1. I am grateful to Martin Sauter, who shared his technical observations with me.
2. Karlsruhe 1970, no. 193, pp. 239–40, pl. 170.
3. This information was kindly provided by Martin Sauter.

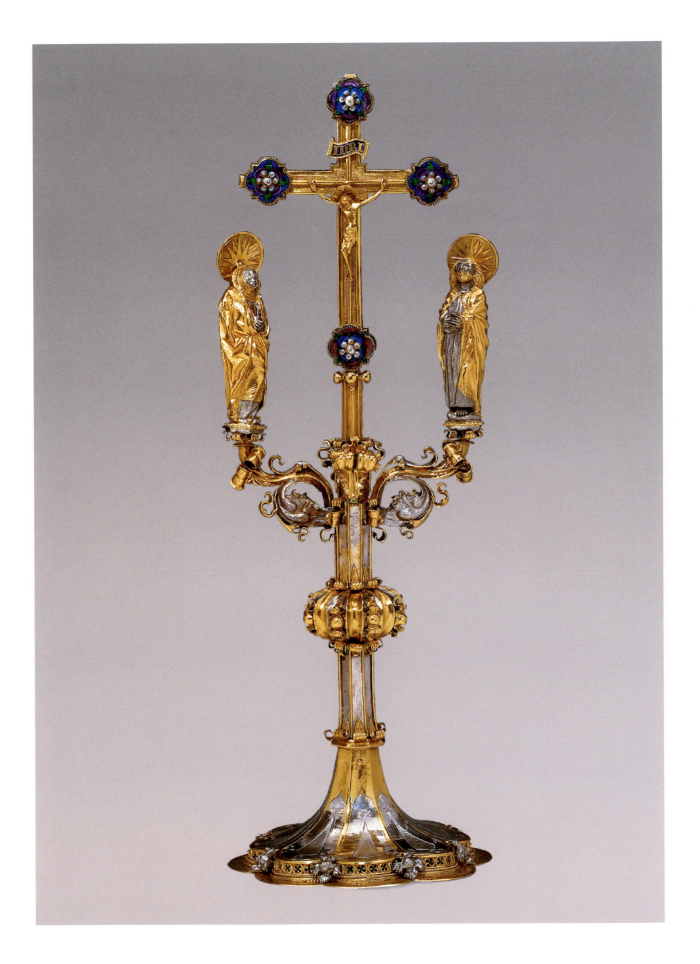

15. Small Footed Altar Cross

Basel, about 1493. Raised, engraved, and partially gilded silver, and cast and gilded silver, with a ruby: Height (overall), 26.8 cm.
Historisches Museum Basel, 1909.475. Purchased through the legacy of Carl Bachofen-Burckhardt.

The obverse of this diminutive but compelling altar cross is engraved with a continuous pattern of symmetrical doublet traceries against a grained background. In the trelobed termini are the winged zoomorphic symbols of the Four Evangelists, holding blank banderoles and rather uncomfortably arranged in their incommodious fields; the compositions

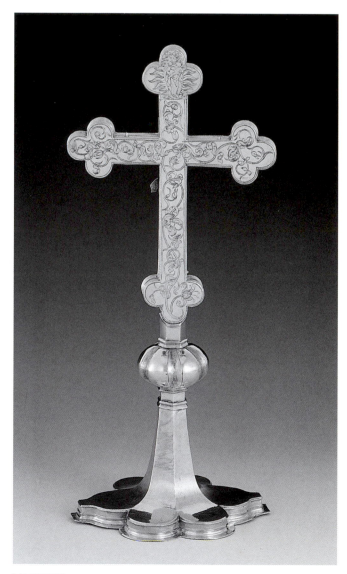

15: reverse

depend on the prints of the renowned Upper Rhenish engraver known only as the Master E.S. The reverse is entirely engraved with a leaf-and-tendril pattern that gracefully meanders along the length of the arms and expands into the lobes of each of the termini excepting the uppermost one, which is engraved with an image of the standing Virgin and Child in a radiating mandorla. Attached to the obverse is a corpus of Christ; fully dimensional, the modeling of the figure conveys both its corporeal presence and physical anguish, underscored by the limpid, deep-red ruby indicating the wound to Christ's side and signifying his death. Although to a lesser degree than that of the Hallwyl Reliquary (no. 34), the crucified Christ—in the tension of the form, the agitated drapery folds of the loincloth, and the suffering expression—reflects an awareness of the work of Niclaus Gerhaert von Leiden, a seminal sculptor of the 1460s and 1470s, who worked both in Strasbourg and in Vienna.

The cross is supported by a stand of nearly equal height, composed of an elongated hexalobed foot that rises in a tapering stem to a substantial knop with four projecting nodes and a short connector. The height and the reflective silver of the stem, which contrasts with the richer coloration of the gold surfaces, give the impression that the cross above, resting on the orb-like knop, is floating in space. The articulated volumes of the foot and knop, counterbalanced by the planar facets of the tall stem, imbue the stand with a volumetric rhythm that is repeated in the sculptural presence of the corpus, set against the flat, linear surface of the cross.

The Footed Altar Cross has been associated with the descriptions in both the 1511 and 1525 inventories of a small cross ("crutzlin") that Hans David had made (". . . hat her Hans Davit machen lassen . . .").[1] Johannes David, a cathedral chaplain, established and endowed a benefice for the Altar of the Holy Cross, which was reconsecrated as the Altar of the Fraternity of the Virgin Mary of the Cathedral Works in 1493. It is in this connection that Chaplain David, who died in 1502, is thought to have commissioned the present exceptional cross.[2]

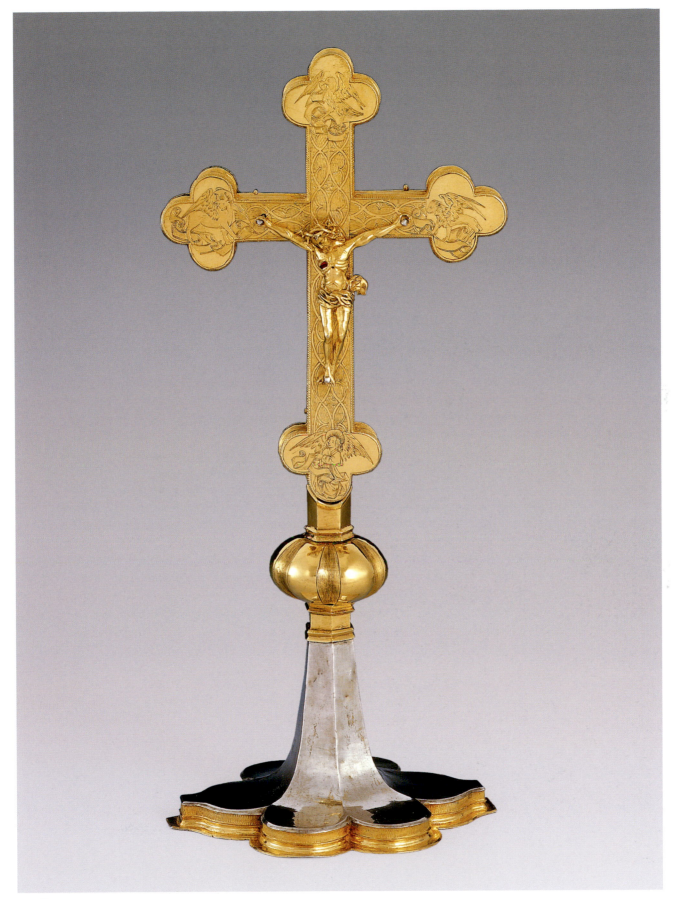

15: obverse

Later alterations to the structure of the cross—which can, with difficulty, be opened—make it unclear whether it was ever intended to serve as a reliquary.[3]

PROVENANCE: 1834, allotted to Basel-Country; 1836, sold at auction in Liestal; until 1909, private collection; acquired by the Historisches Museum Basel through a gift of the heirs of Carl Bachofen-Burckhardt.

BIBLIOGRAPHY: Burckhardt 1933, no. 37; Fritz 1966, pp. 42, 55, 199, fig. 20, no. 40, pp. 448–49; Barth 1990, no. 13; Basel 2001, no. 49.

1. Inventory 1525:18; see Büttner, in Basel 2001, no. 49.
2. Barth 1990, p. 60.
3. This observation is based on the examinations made by Martin Sauter.

ix. *Pontifical of the Bishopric of Basel*

Basel, 15th century. Manuscript on vellum, with marginal illustrations: (33 folios), 24.5 x 17.5 cm.
Bibliothèque de la Ville de Colmar, ms. 848.

A pontifical is a liturgical book that evolved into a manual of the forms for the sacraments and other non-Eucharistic rites performed solely by bishops. The contents were taken from older sacramentaries and from other *libelli*, or booklets, containing the texts for specific sacraments, such as the dedication of a church or the ordination of priests. Eventually, these writings were collected in a single volume, often including treatises on the liturgy, which could be easily consulted. The present example, written in a bold Gothic minuscule, was made for the use of a suffragan bishop—that is, a bishop who was subordinate to another prelate in the diocese and thus often acted as an assistant. The Colmar manuscript, which contains a manual for the sacrament of Consecration, is exceptional for the marginal drawings that illustrate, in a forthright but engaging hand, many of the liturgical implements required for the particular sacraments formulated in the accompanying text. Apparently, this manuscript was compiled before pontificals excluded the Mass and all other rites that could be performed by a priest, as a chalice, paten, and various Eucharistic vessels are clearly depicted on the verso of folio 8. The pair of altar cruets illustrated below the chalice is very similar in form to those from the Basel Treasury (no. 11).

PROVENANCE: formerly in the Antonine monastery, Isenheim; during the French Revolution, transferred to the library in Colmar.

BIBLIOGRAPHY: *Catalogue des Manuscrits* 1969, no. 300, p. 121.

parentur ampulle cū vino et aqua
pelvis · aqua cū suffono et manu ter
gium · que omnia sigillatim ordinandi
tangant · Dicente Episcopo · Vide
te auꝰ modi ministeriū vobis tra
ditur · ideo vos amoneo · vt ita vos
exhibeatis qꝫ deo placere possitis ·
Deinde epꝰ dicat prefacionem ·

Oremꝰ deū patrem omnipotente
ac dūm nrm fratres karissimi
vt super hos seruos suos · quos ad
subdyaconatꝰ officiū vocare dignatꝰ
ē · infundat benedictionē suā et gracā
vt in conspectu eius fideliter seruien
tes · predestinati sanctis pꝛima consequa
tur plane · Adiuuante dūo nro ihū
xᵖo · qui cū eo et spū sancto viuit et
regnat deus per omnia secula sᵉ Amen
Postea dicat epꝰ Oremꝰ ꝝ ꝰflecta ꝯ
Domine sancte pater omnīps eterne ds.

—

buᵗ ✝ dicere dignare hos famulos
tuos : quos ad subdyaconatꝰ officiū
eligere dignatus es : vt eos in sacra
rio tuo sancto strenuos sollicitosꝙ
celestis milicie militias exhibitores
sctisꝙ altaribꝰ tuis fideliter subminu
istrent · et requiescat super eos spūs
sapiencie et intellectꝰ : spūs ꝯsilii
et fortitudinis : spūs sciencie et pie
tatis · et repleas eos spū timoris tui
et eos in ministerio diuinoꝯ firmes
vt obedientes facto atꝙ dicto
parentes tuā gracā ꝯsequantꝛ Per
dūm nrm · ꝝ Amen · Sequitꝛ Rᵐ
interim epꝰ ꝯ
ponit amictū
singulꝰ dicens·
Regnū mun di Accipe amictū
ꝙ que designatꝛ casti gacio vocis in
nomīe pꝛis et filii et spūs scti Amen

x. *Pontifical of Archbishop Charles de Neuchâtel*

Besançon (?), 1463–98. Illuminated manuscript on
vellum: (212 folios), 14.5 x 10 cm.
Porrentruy, Bibliothèque Cantonale Jurassienne, ms. 10.

This unusually small pontifical was made for Charles de
Neuchâtel (r. 1463–98), Archbishop of Besançon, the arch-
diocese that included Basel. It is known that the archbishop
was an enthusiastic bibliophile, for other richly ornamented
liturgical manuscripts commissioned by him have survived.
Under unclear circumstances, this pontifical came into the
possession of Melchior von Lichtenfels (r. 1554–75), a later
bishop of Basel, whose coat of arms replaced that of the
original owner. The text, however, remained unaltered,
despite the pontifical's changed locality, undoubtedly because,
after the Reformation, the bishops resided in Porrentruy and
they played no active role in the Basel Cathedral.

Folio 23, shown here, depicts an archbishop with two
supporting clerics blessing a monstrance containing an *Agnus
Dei* or Eucharistic wafer (see no. 66).

PROVENANCE: until 1498, Charles de Neuchâtel; until 1575, Mel-
chior von Lichtenfels; 1795, inventoried; 19th century, library of the
cantonal school, Porrentruy.

BIBLIOGRAPHY: Gamper and Jurot 1999, pp. 69–72, and p. 31,
figs. 22, 23; Porrentruy 1999, pp. 34, 35, fig. 7.

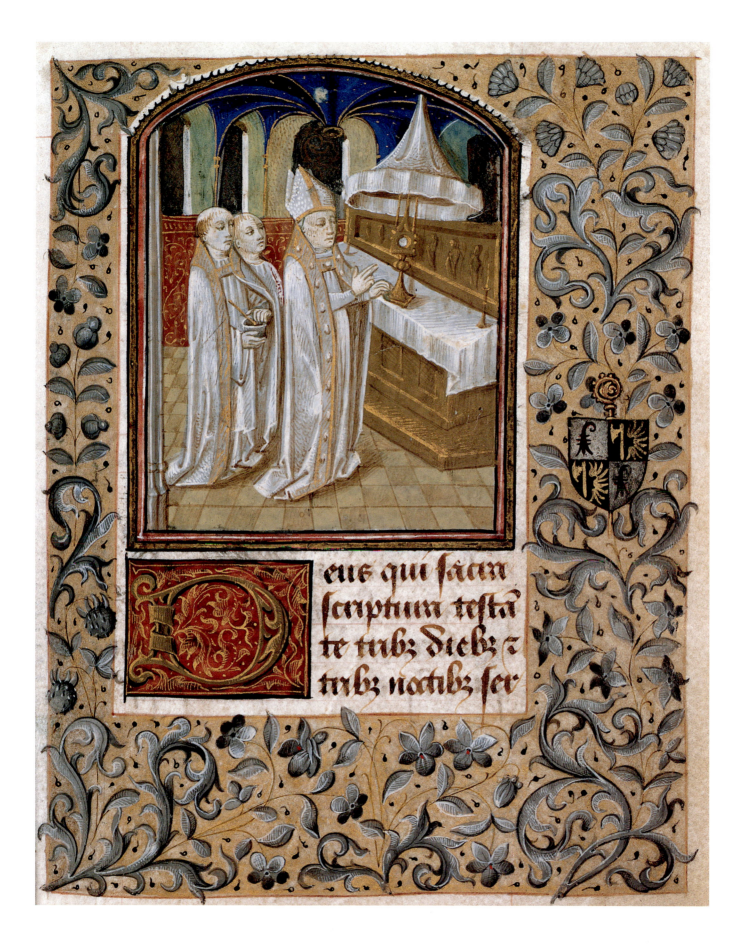

eus qui sacra
scriptum testa
te tribz diebz z
tribz noctibz ser

xi. *Breviary of Bishop Friedrich ze Rhin*

Basel, 1437–39. Illuminated manuscript on vellum: (475 folios), 22 x 15.8 cm.

Basel, Universitätsbibliothek, A. N. VIII 28.

A liturgical book, the Breviary contains the daily prayers according to the canonical hours: the Psalms, hymns, lessons, and the like, which were sung or recited in the Divine Office. Comprising two volumes—one for winter (the present manuscript) and the other for summer (*pars hiemalis, pars aestivalis*)—this Breviary was commissioned for Bishop Friedrich ze Rhin (r. 1437–51), whose coat of arms appears throughout. Compiled for Basel usage, the first volume commences with the calendar for the diocese, indicating the principal feast days, such as that of the sainted emperor Heinrich and of the consecration of the cathedral.

One of the earliest mentions of the Heinrich Cross (no. 4) occurs in this text. More sumptuous marginal treatments were reserved for particular sections, among them the Psalms, antiphons, hymns, and responses; these consist of twisting foliate and berry decoration and ornamented and historiated initials. In numerous instances, a *bas-de-page* angel supports the coat of arms of the bishop.

PROVENANCE: Auguste Quiquerez (1801–1882) collection, Jura; Antiquaire Band, Lausanne; since 1892, Universitätsbibliothek.

BIBLIOGRAPHY: Escher 1917, pp. 144–52.

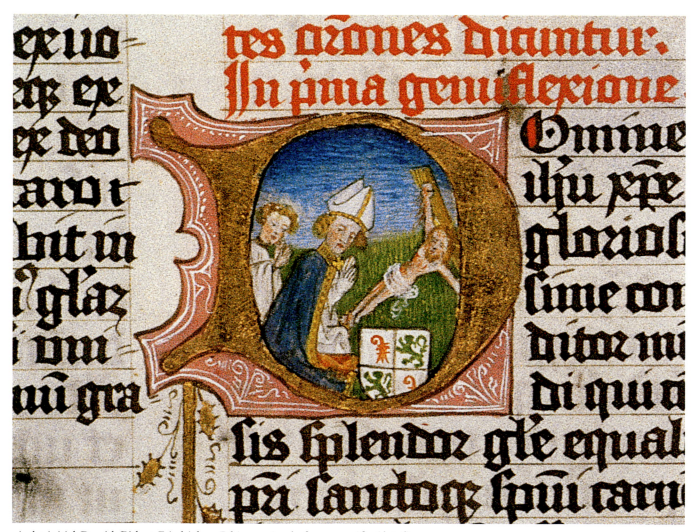

xi: the initial *D*, with Bishop Friedrich ze Rhin praying before a crucifix (detail)

Beatus vir qui non abiit in consilio impiorum et in via peccatorum non stetit: et in cathedra pestilencie non sedit.

Sed in lege domini voluntas eius: et in lege eius meditabitur die ac nocte.

Et erit tamquam lignum quod plantatum est secus decursus aquarum: quod fructum suum dabit in tempore suo. Et folium eius non defluet: et omnia quecumque faciet prosperabuntur.

Non sic impii non sic: sed tamquam pulvis: quem proicit ventus a facie terre.

Ideo non resurgunt impii in iudicio: neque peccatores in consilio iustorum. Quoniam novit dominus viam iustorum: et iter impiorum peribit.

Quare fremuerunt gentes: et populi meditati sunt inania.

Astiterunt reges terre et principes convenerunt in unum adversus dominum: et adversus christum eius. Dirumpamus vincula eorum: et proiciamus a nobis iugum ipsorum.

Qui habitat in celis irridebit eos: et dominus subsannabit eos. Tunc loquetur ad eos in ira sua: et in furore suo conturbabit eos. Ego autem constitutus sum rex ab eo super Syon montem sanctum eius: predicans preceptum eius. Dominus dixit ad me filius meus es tu: ego hodie genui te. Postula a me et dabo tibi gentes hereditatem tuam: et possessionem tuam terminos terre. Reges eos in virga ferrea: tamquam

xi: the initial *B*, with King David kneeling before God the Father

xii. *Missal of Bishop Johann von Venningen*

Basel, 1462–63. Illuminated manuscript on vellum:
(401 folios), 35.5 x 26.5 cm.
Porrentruy, Bibliothèque Cantonale Jurassienne, ms. 1.

A Missal is a liturgical book comprising all the texts, either spoken or sung, along with ceremonial directions, employed in the celebration of the Mass, and structured on a day-by-day basis in accordance with the temporal calendar. Containing numerous illuminations, including a full-page image of the Crucifixion and many inventively historiated initials—such as the *T* from the *Te igitur* incipit, rendered with the Brazen Serpent—this manuscript bears the coat of arms of Bishop Johann von Venningen (r. 1458–78). The style of illumination is identical to that of a pontifical, also commissioned by the bishop, which can be identified with a 1462 document of payment to a certain Hans von Ensingen.[1]

PROVENANCE: until 1478, Johann von Venningen; 1752, listed in the episcopal archives; 1795, inventoried; 19th century, library of the cantonal school, Porrentruy.

BIBLIOGRAPHY: Gamper and Jurot 1999, pp. 39–43, frontispiece, and p. 15, fig. 5; Porrentruy 1999, p. 24, and p. 3, fig. 1.

1. Gamper and Jurot 1999, p. 15.

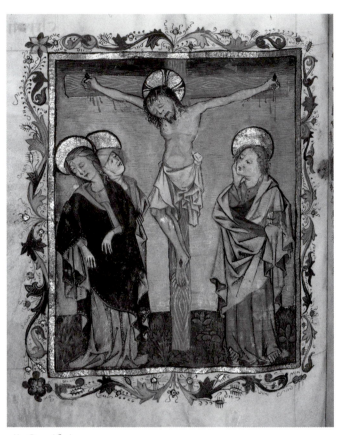

xii: Crucifixion

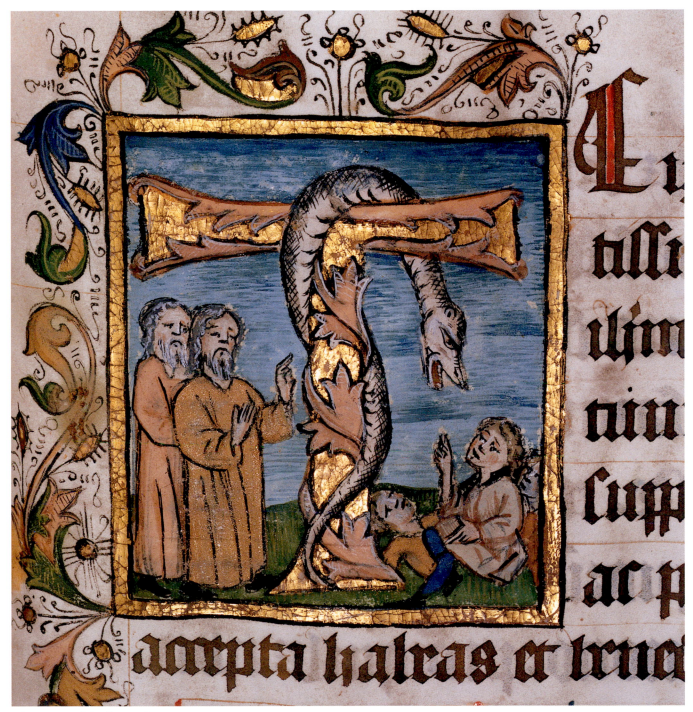

xii: Moses and the Brazen Serpent

16. *Censer*

Basel, before 1477. Raised and cast silver:
Height (with ring and chains), 83 cm; (vessel alone),
24.5 cm.
Marks: French import punches for 1838–64 and 1864–93.
New York, The Metropolitan Museum of Art. Gift of
J. Pierpont Morgan, 1917 (17.190.360).

xiii. *Drawing of a Censer*

Johann Jakob Neustück. Basel, 1834. Pencil on paper,
42.8 x 20.3 cm.
Historisches Museum Basel, 1957.30. Gift of Cécile
Singeisen.

xiv. *Copy of a Censer*

Upper Rhineland, Basel(?), 1836–42. Raised and cast silver:
Height (with ring and chains), 83 cm; (vessel alone), 24.5 cm.
New York, The Metropolitan Museum of Art. Gift of
J. Pierpont Morgan, 1917 (17.190.359).

Octagonal in section, this censer not only draws heavily on architectural vocabulary but also, in the upper section, imitates a Gothic structure such as a centrally planned oratory or baptistery. The lowest of the three elevations is composed of eight pairs of tall, double-lancet windows surmounted by quatrefoils and a crocketed gable. Arguing for local fabrication of the censer, similarly designed windows are a prominent feature of the west façade of Basel Cathedral.[1]

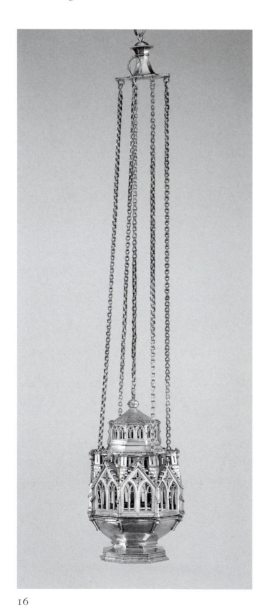

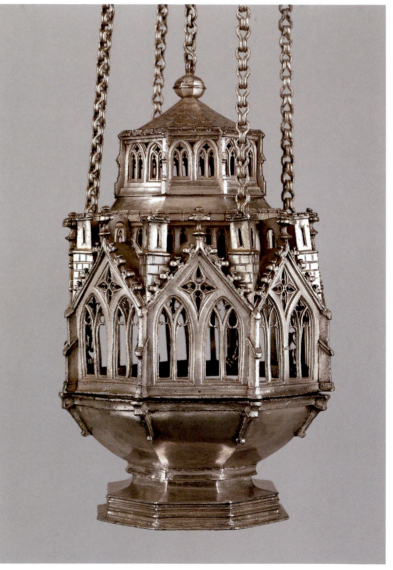

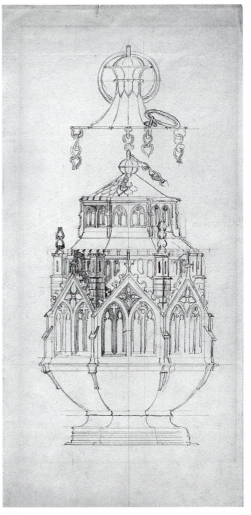

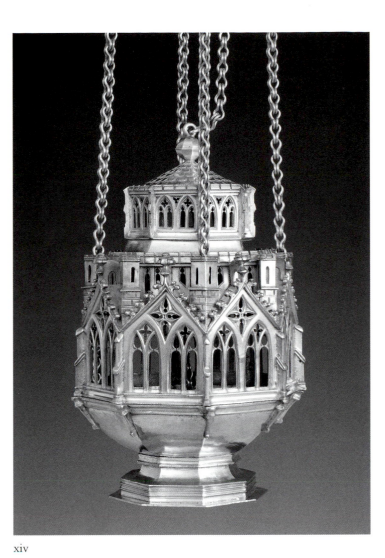

xiii xiv

The architectural conceit well suits the function of the object, as the generous fenestrations allow air to fire the incense coals while providing an escape for the perfuming smoke. The four chains threaded through every other tower support the vessel; raising the fifth chain by the ring lifts up the entire upper section, allowing for increased aeration and for smoke to escape while the censer is swung, as well as for the addition of incense. Unlike the thin-walled Romanesque censers (no. 7), which suffered from use, the unusually heavy-gauge sheet-silver construction here may, in large part, be credited with the censer's excellent state of preservation.

The difficulties of convincingly identifying documentary descriptions with a specific, extant object are dramatically underscored by this censer. A large silver censer is itemized in the Basel Treasury inventories of 1477 ("gross silberin rouchfass"), 1525 ("gût grosz sylberin rouchfasz"), and 1827

("ein grosses silbernes Rauchfass in gothischer Form"), as well as in the 1836 Liestal auction catalogue.[2] At some point shortly thereafter, such a censer was acquired by Colonel Jean-Jacques Ursin Victor Theubet, of Porrentruy, who, perhaps imitating the pair of Romanesque censers (no. 7), apparently had a copy made (no. xiv); one of the two was illustrated in his 1842 sale prospectus for the Golden Altar Frontal (no. 2).[3] The pair of censers reemerges in the 1861 sale catalogue of the Soltykoff collection, and both are illustrated in the 1890 sale catalogue of the Seillière collection. By the time Burckhardt was at work on his 1933 catalogue of the Treasury, the whereabouts of the censers was unknown. He observed, however, that the dimensions given in the Seillière catalogue did not correspond to those in the 1827 inventory, and, aware of Theubet's false assertion that both censers came from the Treasury when only one is mentioned in the inventories, Burckhardt was reluctant to

73

accept that either did. Thus, he concluded that the censer listed in the inventories was lost, and that the pair of censers belonging to Theubet was erroneously associated with the Treasury.

The first indication that one of the censers was, indeed, from the Treasury came with the discovery of a cursory sketch of the Basel censer made by Jacob Burckhardt at the time of the sale. Even more convincing evidence was provided by the rediscovery in 1957 of a precise rendering of the censer by the Basel painter Johann Jakob Neustück (no. xiii). Several years later, the actual whereabouts of the censer was discovered by pure accident. A Basler, resident in New York, was interested to read on a label in The Metropolitan Museum of Art that the Arm Reliquary of Saint Valentine (no. 43) had once been in the Basel Cathedral Treasury; helpfully, he took a photograph of the display case and sent it to the Historisches Museum. Burckhardt, who was still director of the Basel museum, had long known that the arm reliquary was in New York; what caught his eye, however, was a pair of censers in the same case, which, he

immediately recognized, matched those once owned by Theubet. He contacted the Metropolitan, and after subsequent study the original was distinguished from the copy. Thus, almost one and a quarter centuries after it was first sold, and nearly thirty years after he published his catalogue, Burckhardt assuredly had found the long-sought-after censer from the Basel Treasury.

PROVENANCE: 1834, allotted to Basel-Country; 1836, sold at auction in Liestal to J. Schaub, Oberdorf; 1842, acquired by Colonel Jean-Jacques Ursin Victor Theubet, Porrentruy; until 1861, Prince Peter Soltykoff, Paris; until 1890, Baron Achille Seillière collection, Paris; 1902, acquired by J. Pierpont Morgan; 1917, given to The Metropolitan Museum of Art.

BIBLIOGRAPHY: Burckhardt 1933, no. 71 and E, pp. 346–50, figs. 260–261; Reinhardt 1963, pp. 31–44; Fritz 1982, no. 306, p. 230; Frazer 1986, pp. 21–23, fig. 16; Basel 2001, no. 45.

1. Reinhardt 1963, p. 44.
2. Inventories 1477:53, 1525:176, and 1827:51, respectively; 1836 sale catalogue, no. 9.
3. Burckhardt 1933, pp. 346–47, fig. 260.

17. *Corporal Box*

Possibly Cologne, about 1460. Silk velvet and linen, on a wood support, with silk fringe, and tempera and gold paint on silk: 4 x 19.2 x 18.5 cm.
Historisches Museum Basel, 1905.3947.

18. *Corporal Box*

Basel, 15th century. Silk velvet and linen, on a wood support, with gilded-silver thread, gilded-silver sequins, and pearls, over wood balls: 4.3 x 21.5 x 21 cm.
Historisches Museum Basel, 1905.3948.

The corporal box was used, according to the descriptions in the inventories, to hold both the Eucharist and, more conventionally, a cloth, usually of fine linen, that was placed on the altar under and over the Eucharistic vessels. As the consecrated wine and bread became the blood and flesh of Christ, so the corporal came to symbolize Christ's shroud. These objects are among the very few in the Treasury not

made of precious metal. The inventories inform us, however, that numerous "*Corporalladen*" such as these, fashioned of costly materials, were kept in the new sacristy on the south side of the cathedral, but that all were sold at auction in 1532 following the Reformation.

The lid of the first, somewhat smaller of the two velvet-covered boxes is decorated around the edges with a red, white, and green silk fringe, but its distinction lies in the painting on silk attached to its inner surface, representing the Crucifixion: The Virgin and John the Evangelist appear on either side and Mary Magdalene kneels at the foot of the cross; all are set against a blue, star-studded background. The accomplished artist who painted this engaging devotional image, the underdrawing of which is quite visible, had access to the compositions of the famed Cologne painter Stephan Lochner (about 1400–1451), whose most famous work is the enormous Adoration Triptych—the so-called *Dombild*—now in the Cathedral of Cologne. Indeed, the figures of both the Virgin and Saint John are near quotations from other works by Lochner.

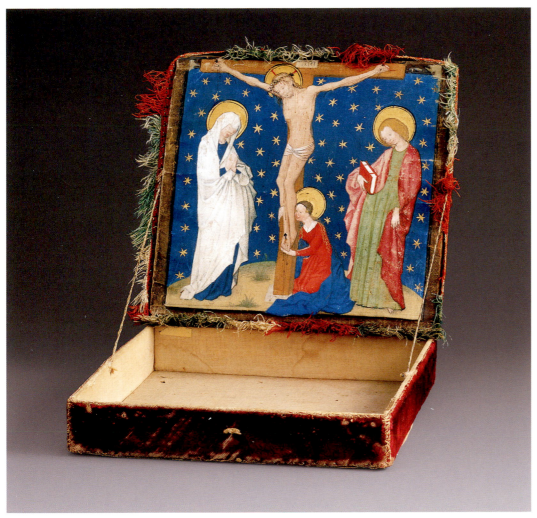

17

The second and plainer of the corporal boxes is decorated with five wood balls, one in each corner and one in the center, that have been covered in linen to which metallic sequins and tiny, perhaps freshwater, pearls have been stitched, giving each the appearance of an open pomegranate.

It is now thought that an entry in the 1525 inventory[1] citing a corporal box with a representation of the Savior and Mary Magdalene that was given to the cathedral by a certain Steffan von Utenheim, could refer to the first of the two present boxes.[2]

PROVENANCE: (17 and 18) 1834, allotted to Basel-City.

BIBLIOGRAPHY: (17) Burckhardt 1933, no. 57; Brand Philip 1959, pp. 223–26; Barth 1990, no. 20; Cologne 1993, no. 53, pp. 340–41; Basel 2001, no. 42, 2; (18) Burckhardt 1933, no. 58; Basel 2001, no. 42, 1.

1. Inventory 1525:140.
2. Vokner, in Basel 2001, no. 42, 2.

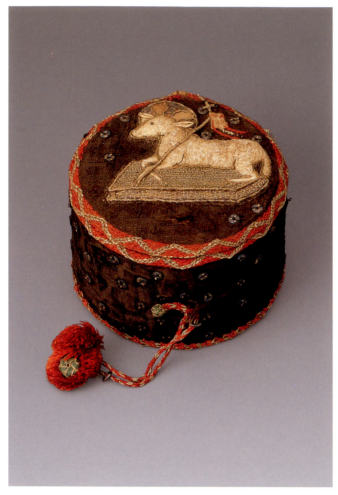

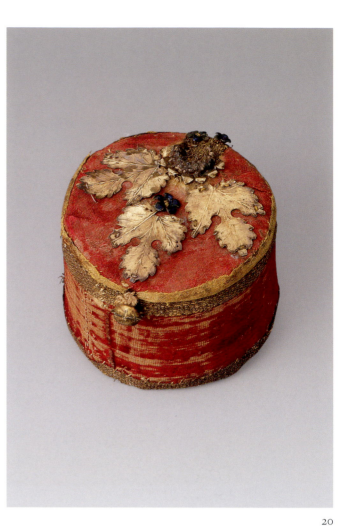

19

20

19. *Pyx*

Upper Rhineland, probably Basel, 15th century. Silk velvet,
linen, and gilded-silver thread, on a wood support, with
silver sequins and couched embroidery: Height, 6.5 cm.
Historisches Museum Basel, 1905.3949.

20. *Pyx*

Upper Rhineland, probably Basel, 15th century. Silk velvet
on a wood support, with attached and raised gilded-silver
leaves, and a bell: Height, 6.5 cm.
Historisches Museum Basel, 1905.3950.

These two containers for Eucharistic wafers,[1] along with the
two corporal boxes (nos. 17, 18), are among the few objects
remaining in the Treasury that are not goldsmiths' work,
although the gilded-silver attachments on the second example
qualify it as a hybrid of sorts. The bell recalls in miniature
the Bells for the Mass and the Handbells (nos. 25, 26). The
embroidered Lamb of God with the banner symbolizing
Christ's triumphal Resurrection alludes to the contents of
the pyx, for it is through Christ's flesh—the Eucharist—that
mankind is redeemed. The *Agnus Dei* is shown resting on
the Gospels, which reveal the meaning of Christ's sacrifice.

PROVENANCE: (19 and 20) by 1905, acquired by the Historisches
Museum Basel.

1. Although long thought to be part of the Treasury, this view is now
 questioned.

21. *Processional Staff for the Heinrich Cross*

Basel, 13th century. Raised and gilded silver, filigree, and gilded copper alloy (brass), over oak: Length, 157.7 cm. Staatliche Museen zu Berlin, Kunstgewerbemuseum, 1917,79.

The Heinrich Cross (no. 4), more than any other object in the Basel Treasury, was the focus of frequent public display, both ceremonial and processional (see pp. 16, 22). Supported by a cast-bronze foot (no. 5) while on the altar, the Heinrich Cross was held aloft by the present staff when it was borne in procession. Described in the 1525 inventory as a "silver staff for the festive cross" ("sylberin stecken fur festlich crutz"),[1] its identity is confirmed by the exact fit of the stem of the Heinrich Cross in the slot in the head of the staff. The granulated arcades set against the silver bands suggest a mid-thirteenth-century date. In 1945, the staff was separated from the Heinrich Cross and, since 1963, had been kept in Schloss Köpenick, Berlin. For the first time in over

fifty years, the staff and the cross it was intended to support are reunited in the Basel exhibition.[2]

PROVENANCE: 1834, allotted to Basel-Country; 1836, sold at auction in Liestal to the Berlin dealer Arnoldt, for Prince Karl of Prussia (1801–1883); Schlossmuseum, Berlin; 1917, acquired by the Kunstgewerbemuseum; during World War II, deposited at the Schlossmuseum; 1963, transferred to Schloss Köpenick, Berlin; after 1989, returned to the Kunstgewerbemuseum.

BIBLIOGRAPHY: Burckhardt 1933, no. 48; Reinhardt 1972, pp. 33–46; Arenhövel 1985; Jülich 1987, p. 171; Hildesheim 1993, vol. 2, no. II-46, pp. 104–6; Zuchold 1993, vol. 2, no. 86, p. 113; Basel 2001, no. 2.

1. Inventory 1525:42.
2. Lambacher, in Basel 2001, no. 2.

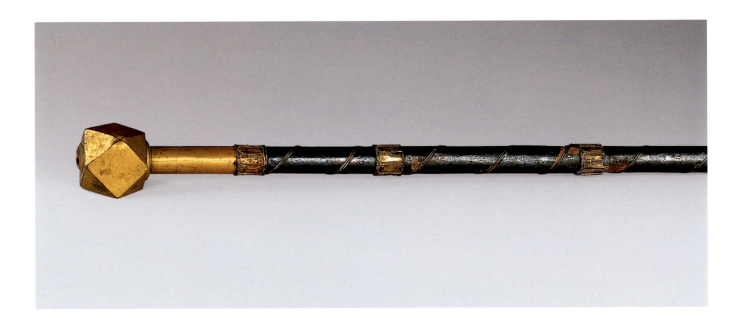

22. Small Processional Cross

Upper Rhineland, possibly Basel, about 1320, with later
alterations. Raised, engraved, and partially gilded silver,
with rock crystal and translucent and opaque *basse-taille*
enamel: Height, 27 cm.
Historisches Museum Basel, 1922.261. Gift of the Verein
des Historischen Museums Basel.

The arms of the cross radiate from a central, square reliquary
capsule on which is mounted an enameled plaque with the
bust of Christ on the obverse, and a circular rock-crystal
opening on the reverse; the latter provides a view into the
container that now houses an ornamental cutting from a
manuscript. The quatrefoil enameled plaques on the termini
of the obverse represent the Four Evangelists at their writ-
ing desks, accompanied by their zoomorphic symbols; on
the reverse, circular enameled plaques with saints and
prophets are mounted on engraved and gilded quatrefoils.
The structure of the cross and the sleevings at the termini
indicate that the arms were originally rock crystal, assembled
in a manner like those of the crystal Reliquary Cross
(no. 32). When viewed at a distance, the reflective value of
the silver simulates the brilliant effect of rock crystal. The
engraved patterns of flamboyant tracery on ungilded silver
are very similar in style and aesthetic to the ones on the
Hüglin, Heinrich, and Kunigunde Monstrances (nos. 75, 77,
78); it is possible that the alterations were made by the same
workshop that produced the monstrances, in the early six-
teenth century.

The inventories note the changes in the appearance of
the cross.[1] The 1478 inventory indicates that there was a sec-
ond small cross with a rock-crystal capsule ("zwey kleine
barillen crützlin"),[2] now lost but known through an ink-
and-watercolor drawing executed by Johann Friedrich II.
Burckhardt-Huber about 1836;[3] the inventory of 1511 notes
that, as indicated in the drawing, the crystal cover of the
capsule was removed and that the "little cross was altered
and made of silver" ("kreutzlin verendert und silberin
gemacht").[4] The 1525 inventory itemizes a silver staff that
supported the Basel cross as it was processed.[5] The diminu-
tive scale of the cross suggests that it was intended to be car-
ried in processions by a boy, as youths were an integral part
of ecclesiastical ceremony;[6] indeed, the loss of the original
rock-crystal arms may be attributed to the slip of small,
uncertain hands. The resultant restorations stand as yet
another reminder of the degree to which objects in the
Treasury were changed and altered by virtue of being part
of the fabric of daily life.

PROVENANCE: 1834, allotted to Basel-Country; 1836, sold at auction
in Liestal to Johann Friedrich II. Burckhardt-Huber; 1905, sold in the
auction of the Pannwitz collection, Munich; 1922, acquired from
Roman Abt, Lucerne, by the Historisches Museum Basel.

BIBLIOGRAPHY: Burckhardt 1923, pp. 32–43; Burckhardt 1933,
no. 18; Guth-Dreyfus 1954, pp. 52–54; Heuser 1974, pp. 104–7; Barth
1990, no. 7; Basel 2001, no. 53.

1. Kalinowski, in Basel 2001, no. 53.
2. Burckhardt 1933, p. 162, n. 2.
3. Now in the Historisches Museum Basel; see Burckhardt 1933,
 p. 162, fig. 119.
4. Ibid., no. 65, p. 333.
5. Inventory 1525:43.
6. Burckhardt 1933, p. 165.

22: reverse

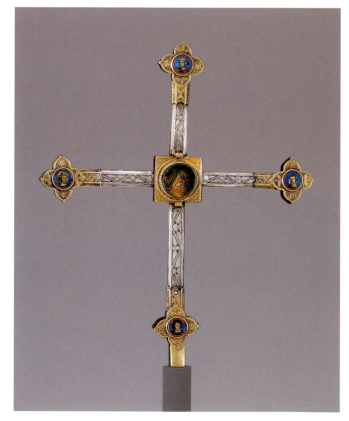

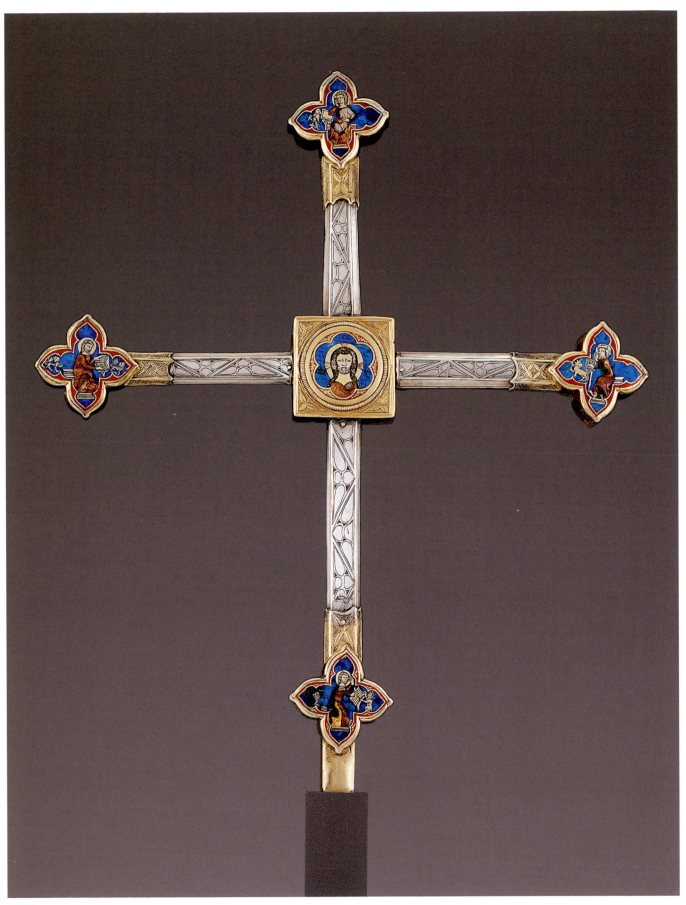

22: obverse

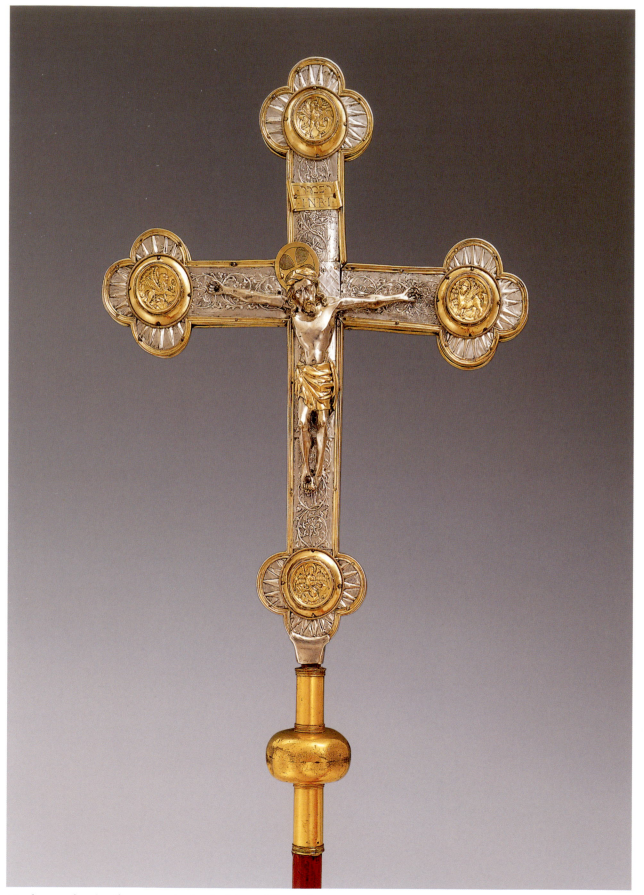

23: obverse, showing the cross and a detail of the staff (no. 24)

23. *Processional Cross*

Basel, 1425–50. Raised, stamped, engraved, and partially gilded silver, on a wood core: Height, 47.5 cm.
Historisches Museum Basel, 2000.190.1. On loan from the Römisch-Katholische Kirche Basel-Stadt (Sankt Clara).

24. *Staff for a Processional Cross*

Basel, 15th century. Painted wood, with gilded copper-alloy mount: Height, 173 cm.
Historisches Museum Basel, 2000.190.2. On loan from the Römisch-Katholische Kirche Basel-Stadt (Sankt Clara).

23: reverse

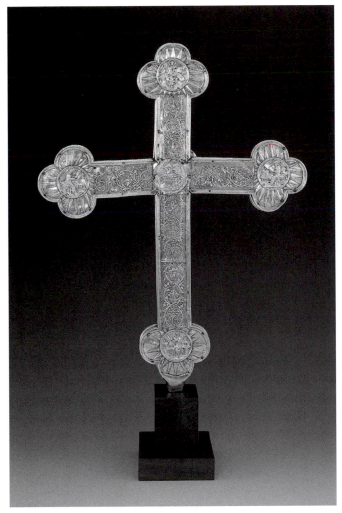

Both the obverse and the reverse of the cross are sheathed in silver stamped with a repeating vegetal motif; the trelobed termini of the arms are stamped with lines indicating rays of light that appear to emanate from raised circular plaques with the zoomorphic symbols of the Four Evangelists on one side and representations of the Evangelists at their writing desks on the other. A nimbed corpus with a *titulus* above is attached to the obverse, while a raised plaque with the Lamb of God is at the center, on the reverse. The edges are decorated with sheet silver stamped with a lozenge pattern. There are also inserted repairs.

This cross was paired with a nearly identical one whose whereabouts have been unknown since it was auctioned in Liestal in 1836, but whose appearance is recorded in a nineteenth-century pen-and-ink drawing.[1] It is possible that both crosses can be associated with an entry for the years 1436 and 1437 in the records of the cathedral fabric that mentions the execution of two partially gilded silver crosses, perhaps the work of a cathedral goldsmith named Heinrich Schwitzer.[2]

The 1525 inventory itemizes a red staff for the Sunday Cross with a copper knop ("ein rotter stecken zů dem sonteglichen crutz mit eynem kupfferin knopff").[3] While the description generally accords with that of the present staff, the latter is fitted to receive the present cross, not the Sunday Cross (no. 33).

PROVENANCE: (23 and 24) 1834, allotted to Basel-City, and given by the government of Basel-City to the Catholic community of Basel and deposited at the Church of Sankt Clara; 2000, placed on loan to the Historisches Museum Basel.

BIBLIOGRAPHY: (23) Burckhardt 1933, no. 35; Fritz 1966, no. 39, pp. 42, 448, fig. 18; Basel 2001, no. 55; (24) Basel 2001, no. 56.

1. Burckhardt 1933, pp. 334–35, figs. 248, 249.
2. Ibid., p. 242.
3. Inventory 1525:44.

25. *Four Bells for the Mass*

Germany (?), 1477–1511. Cast copper alloy, iron, and
leather: Diameters, 6.2 cm, 7.2 cm, 7.2 cm, 7.8 cm.
Historisches Museum Basel, 1870.623.1.-4.

26. *Four Handbells*

Nuremberg (bells) and Basel (mounts and handles), 1477–
1511. Cast copper alloy, copper alloy, tinned iron wire, and
painted wood: Length, 42.5 cm; 44.5 cm; 47.5 cm; and
47.5 cm.
Historisches Museum Basel, 1870.622.1.-4. Gift of the
Basel City Council, 1862.

The bells are listed in both the 1511 and 1525 inventories as "four little bells and six cymbals to herald the feast of Corpus Christi" ("vier cleyne glöcklin und sechs symblen, so mann an Unseres herren fronlichnamstag brucht").[1] The term *cymbal* (tintinnabulum) in sixteenth-century usage referred specifically to mounted "claw" bells like the four red-handled examples here.[2] These were given to the museum by the Basel city government in 1862, noting that they were leftovers from the Cathedral Treasury. In the 1836 auction, the bells apparently were assembled with the tin vessels, textiles, and other objects deemed to be of little or no worth, as they were not included in the sale catalogue. Because such ordinary objects were accorded so little value, the survival of the eight Basel bells is all the more extraordinary. While the inventories indicate that these bells played a particular role in the celebration of the Feast of Corpus Christi, chronicles document the use of handbells in all manner of Masses and processions; for example, two acolytes in copes, with bells in each hand, led the procession in the cathedral to the high altar at Vespers. Likewise, bells announced the commencement of highly orchestrated processions—embracing all ranks of society—through the city streets.[3]

PROVENANCE: (25 and 26) 1834, excluded from the allotments to Basel-City or Basel-Country; 1862, given by the government of Basel-City to the Medieval Collection; 1870, accessioned by the Historisches Museum Basel.

BIBLIOGRAPHY: (25 and 26) von Roda, in Basel 2001, no. 52, 5–8 and 1–4.

1. Inventory 1525:55.
2. von Roda, in Basel 2001, no. 52.
3. Ibid.

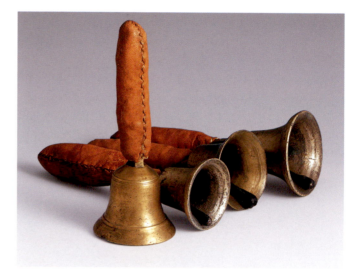

25

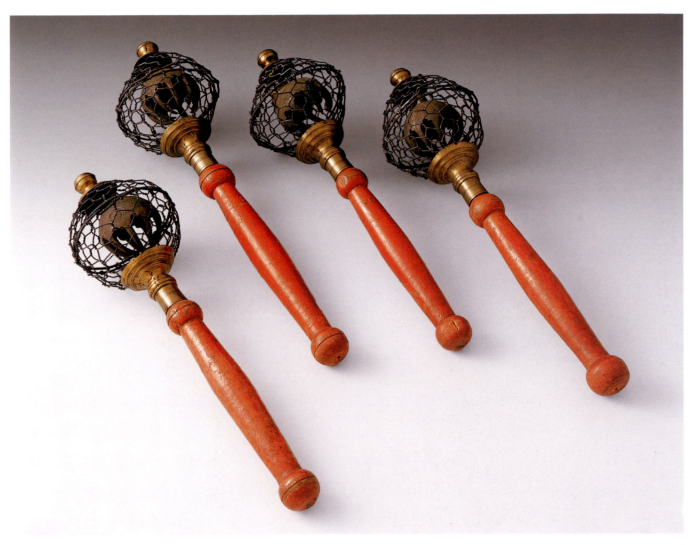

27. *Three Spouted Jugs*

Basel, 14th century. Cast and engraved pewter: Height
(each), 27 cm.
Inscribed: (respectively) s ◇ o ◇ ᴾvᴇʀoʀvᴍ; s oʟᴇvᴍ
Iɴꜰɪʀᴍoʀ ◇ ; s ᶜʀɪsᴍᴀ
Historisches Museum Basel, 1870.443.a.–c.

28. *Covered Container and a Lid*

Basel, 14th century. Cast and engraved pewter: Height
(vessel with lid), 28 cm.
Inscribed: (on the vessel) + o + ᴩvᴇʀoʀvᴍ + ; (on the lid)
+ o + p̆ + ; (on the spare lid); + o + ɪ +
Historisches Museum Basel, 1870.442 (vessel and lid),
1873.15 (lid).

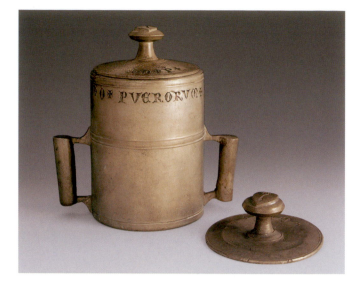

The 1525 inventory records three cylindrical, lidded containers and the three green glazed tiles that they stood on, as
well as three large spouted jugs for holy oil; of this group,
the present vessels alone survive.[1] Throughout the Middle
Ages, two types of oil figured in Church ritual: holy oil and
chrism (holy oil to which balsam had been added). Only a
bishop could consecrate the chrism, which was used in
administering the Seven Sacraments—particularly at baptisms, confirmations, and ordinations—as well as at the consecration of churches and altars. Holy oil was employed at
lesser rites—as, for example, for the unction of the sick. The
distinction is evident in the inscriptions on these vessels:
One of the large double-handled jugs is labeled ᴄʀɪsᴍᴀ, for
chrism, while all the others are marked o or oʟᴇvᴍ for holy
oil, which would be used in ministrations for children and
for the sick. Both lids are engraved with the head of a
crosier—the arms of the Bishopric of Basel. These vessels,
which were kept in the Romanesque sacristy, are mentioned in the Cathedral Ceremony Book in connection
with the annual rite of consecrating the oils.

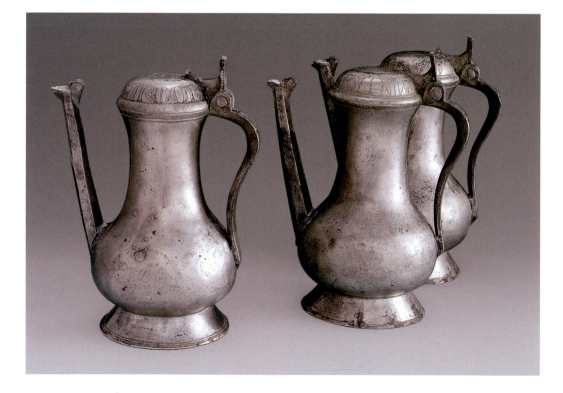

PROVENANCE: (jugs and container) 1834, excluded from the allotments to Basel-City and Basel-Country; 1862, given by the government of Basel-City to the Medieval Collection; 1870, accessioned by the Historisches Museum Basel; (spare lid) 1873, gift of S. Merian-Bischoff to the Historisches Museum Basel.

BIBLIOGRAPHY: (27) Burckhardt 1933, no. 22; Reinle 1988, p. 83, fig. 32; Basel 2001, no. 57, 1–3; (28) Basel 2001, no. 58, 1 and 2.

1. Inventory 1525:51-53.

29. *Ceremonial Staff*

Upper Rhineland (?), probably 15th century. Stamped and applied silver, gilded copper, rock crystal, and painted wood: Length, 121 cm.
Historisches Museum Basel, 1870.624.

A ribbon of silver stamped with a vegetal motif, much of it now missing, spirals around the length of the staff, which is capped by two rock-crystal elements set in gilded-copper mounts. In areas, an earlier surface of a slightly lighter green, with a pattern of white dots and horseshoe shapes, is visible. As it is itemized in both the 1511 and the 1525 inventories but not in that of 1477, this ceremonial staff may have entered the Treasury at some point in the intervening years. It is clearly described as "a staff with silver strokes around it, for the *Pedell*, or master of the ceremonies, in large processions" ("ein stock mit sylberen strychen umbwunden fur den pedellen inn den grossen umbgengen").[1] The *Pedell*, known in Basel Cathedral as the *Dormentarius*, held a priestly position that combined the role of "Sigrist," or guardian of order, with that of master of the ceremonies, in one person: He called the prelates to services, laid out the liturgical implements, led processions, controlled crowds, and issued important instructions during ceremonies. In more elaborate rites his specific task was distinguished by which of the two official staffs he carried: One was for ordinary occasions (*baculus ferialis*) and the other for more solemn events (*baculus solemnis*). The present staff served the latter function.[2]

PROVENANCE: 1834, excluded from the allotments to Basel-City and Basel-Country; 1870, accessioned by the Historisches Museum Basel.

BIBLIOGRAPHY: Burckhardt 1933, no. 49; Reinle 1988, p. 182; Basel 2001, no. 54.

1. Inventory 1525:45; see Egger, in Basel 2001, no. 54.
2. Ibid.

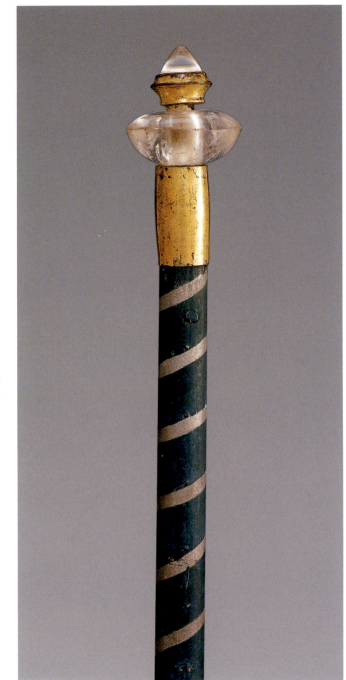

xv. *Investiture Book* (Lehenbuch)

Basel, 1437–39. Illuminated manuscript on vellum:
(195 folios), 46 x 32 cm.
Hausfideikommiß, Markgräflich Badische Hauptverwaltung
Salem; Generallandesarchiv Karlsruhe, Handschrift Nr. 133.

An investiture book records the ceremonies during which a lord bestowed fiefs on his vassals in return for honorable services. This manuscript documents the pretensions of the bishops of Basel as territorial rulers, although, in fact, their temporal powers had been greatly diminished by 1386, when Basel purchased the rank of "Free Imperial City" from Emperor Wenzel. Commissioned by Friedrich ze Rhin between 1437 and 1439, the Karlsruhe *Lehenbuch* details the fiefdoms granted by the bishops of Basel. The manuscript contains one full-page illumination representing the investiture in 1361 of the duke of Austria as the overlord of Pfirt in Alsace; the duke was the most prominent vassal of the bishops of Basel, and Pfirt was the most important fiefdom they had to confer. The scene is fictive, for the duke did not attend the ceremony. In the illumination, Bishop Johann Senn von Münsingen wears the cope purportedly given to the cathedral by Emperor Heinrich II in 1019; made of gold and silk and probably originating in Byzantium, the cope signified that the bishops of Basel derived their worldly powers directly from the sainted emperor. The manuscript, which was scribed by a Dominican monk from Basel named Nicholas, retains its original binding, with silver-and-enamel shields emblazoned with the coats of arms of Bishop Friedrich ze Rhin, made by the cathedral goldsmith Heinrich Schwitzer in 1445.[1]

PROVENANCE: until 1792, library of the bishops of Basel and after, princely library, Karlsruhe; on loan to the Generallandesarchiv Karlsruhe.

BIBLIOGRAPHY: Wackernagel 1888, pp. 267–70; Jurot, in Basel 2001, essay.

1. This information was kindly provided by Marie-Claire Berkemeier-Favre.

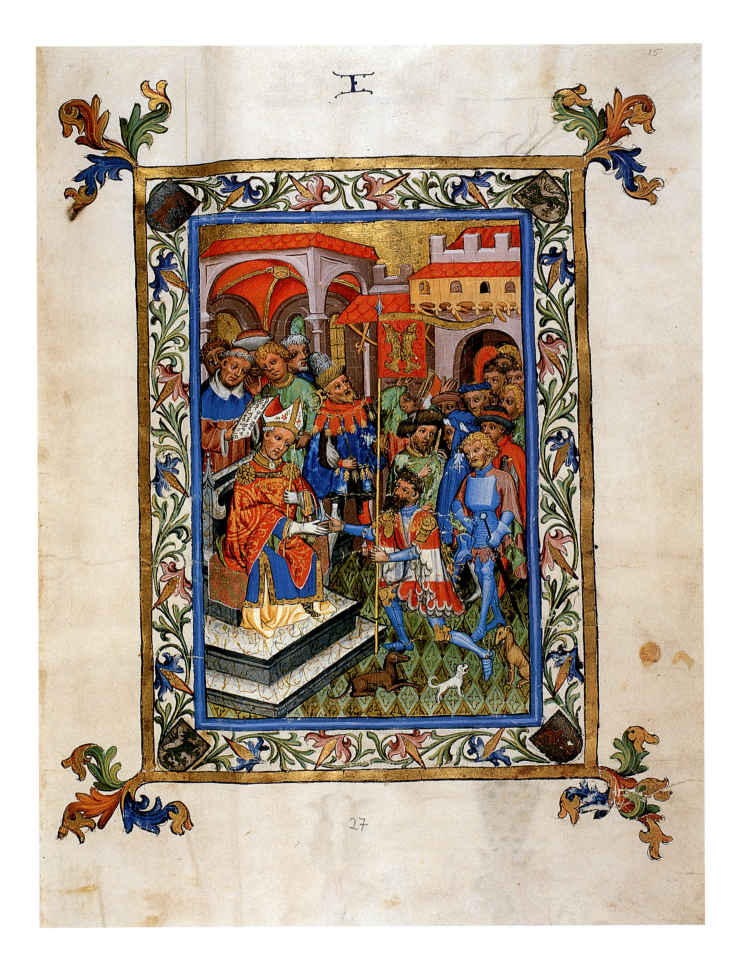

30. *Reliquary Casket*

Basel, 1380–1400. Stamped silver, and raised, cut, cast, and
gilded silver, on a wood core, with translucent *basse-taille*
enamel and amethysts: 35 x 39 x 31 cm.
Historisches Museum Basel, 1882.85.

The larger and earlier example of three (see also nos. 31, 34),
this footed reliquary shrine, first mentioned in the 1585
inventory,[1] is decorated with numerous square silver plaques
stamped with designs and attached to a wood core with
small nails—some of which still retain their rosette collars—
at the conjunction of the corners. The repertoire of stamped
designs includes the head of Christ, a lily, the *Agnus Dei*, and
the head of the Virgin; there appears to be no pattern in
their arrangement. Architectural reference comes in the
form of gilded crockets on the ridges of the roof and in the
tabernacles at each corner that house standing male figures.
Above each canopy, a hovering angel holds a semi-precious
stone. (One male figure and one angel are missing.) Access
to the shrine is by means of a two-paneled door, fitted with
a lock and pull and decorated with raised medallions rep-
resenting the Crucifixion and saints Catherine, John the
Baptist, and James the Greater. The wood interior surface is
painted in azurite, to which gilded stars have been attached.
A grotesque face outlined in red pigment is on the under-
side, and a blue translucent-enamel medallion depicting
the Virgin and Child, in reserve, is set into a gilded mount
on the front slope of the lid. Presumed to have housed
relics—as it is described as a "small reliquary house"
(". . . Reliquienhäuschen . . .")[2]—it is also possible that the
shrine served as a tabernacle or ciborium.

PROVENANCE: 1834, allotted to Basel-City.

BIBLIOGRAPHY: Burckhardt 1933, no. 25; Braun 1940, pp. 170, 174,
fig. 102; Barth 1990, no. 9; Basel 2001, no. 51.

1. Inventory 1585:45.
2. Inventory 1827:40.

30: casket (detail), with doors open

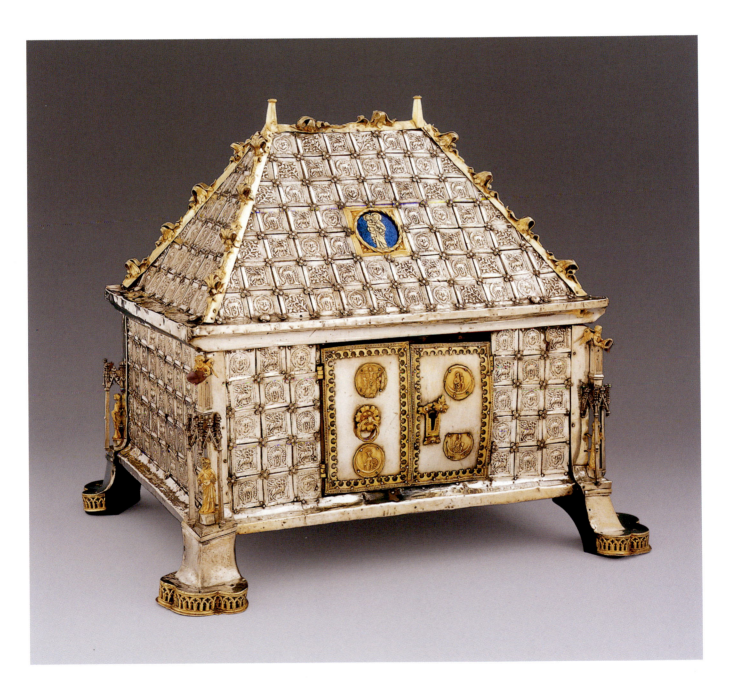

31. *Reliquary Casket*

Upper Rhineland, probably Basel, about 1450. Engraved, cut, and gilded copper, with blue painted paper: 19.8 x 20.2 x 14.6 cm.
Historisches Museum Basel, 1894.174. Gift of Sophie von Knosp-Schmid.

House shaped, with a pitched and imbricated roof and a projecting gable on each side, this reliquary shrine is formed of sheet copper without a wood core. On all four sides is an inset panel worked into intricate patterns of flamboyant tracery, most of which is pierced, although the smallest kites are engraved. The patterns of the opposing sides are similar but, in fact, are devised with subtle variations. The traceries are constructed, like the windows in the Gothic Censer (no. 16), out of three superimposed cut sheets of metal. The openwork is accented by papered panels colored with azurite. A lock and hasp are mounted on the front side.

The shrine is unusual in that its decorative program provides no indication of the intended function, and, in this regard, it is unique in the Treasury. The 1477 inventory lists only "a handsome gilded coffret made of copper" ("ein húbsch verguldt kistlin de cupero formatum"), and not until the 1525 inventory is there any mention of relics: "a handsome gilded coffret with the arm of Saint Philip the Apostle and relics of Verena" ("ein hupsch ubergult kystlin, ist kupfferin, mit sanct Philippen desz appostels arm und sanct Verenen heiltumb").[1] This would seem to imply that, originally designated for a secular purpose, the shrine was later converted into a reliquary. To the contrary, however, the fact that it is made of gilded copper suggests that it was designed to be used on the altar, for, according to medieval regulations, copper objects could be gilded only if they served in an ecclesiastical setting.[2] It is therefore presumed that relics, although not mentioned, were within the shrine at the earlier date.[3]

Saint Verena was already associated with the town of Zurzach in Canton Aargau by the ninth century, and was one of the most revered saints in the Upper Rhineland. Not only were the relics of these saints displayed on the high altar but the saints also were venerated elsewhere in the cathedral: A prebend was donated to honor Saint Verena in the Fröweler Chapel and an altar devoted to Saint Philip, along with Saint James, was installed in the Tegernau Chapel.[4]

PROVENANCE: 1834, allotted to Basel-Country; 1836, sold at auction in Liestal to Jakob Schmid-Ritter; 1894, given by his granddaughter Sophie von Knosp-Schmid, Stuttgart, to the Historisches Museum Basel.

BIBLIOGRAPHY: Burckhardt 1933, no. 38; Barth 1990, no. 14; Basel 2001, no. 5.

1. Inventories 1477:26 and 1525:24, respectively.
2. Fritz 1982, pp. 42, 66.
3. Häberli, in Basel 2001, no. 5.
4. Ibid.

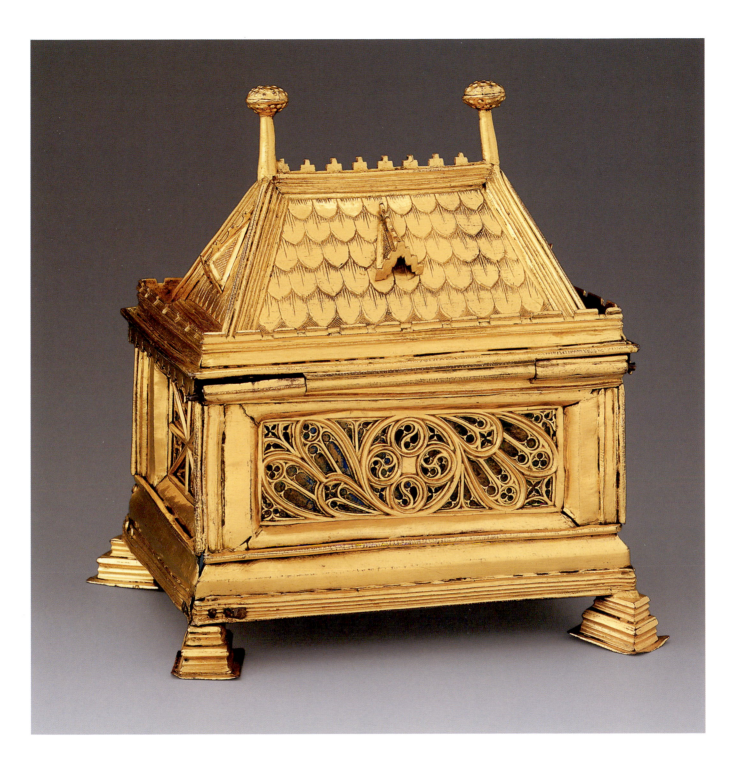

32. *Reliquary Cross*

Basel, 1430–60. Raised, cast, engraved, and gilded and
partially gilded silver, and rock crystal, over iron armatures,
with glass, intaglios, amethyst, quartz, and turquoise:
Height, 37 cm.
Historisches Museum Basel, 1882.86.

Unusual for the strict symmetry of its components and for
the truncated shafts of rock crystal in the arms, this reliquary
cross, nonetheless, is striking for both its precious materials
and its balanced composition. The arms end in generous
quatrelobes in the center of which, on the obverse, are
antique intaglios surrounded by a single stone in each lobe,
and, on the reverse, finely raised medallions with represen-
tations of the zoomorphic symbols of the Four Evangelists.
The gilded-silver cruciform mount at the crossing, on the
obverse, is engraved with a cross in reserve on a hatched
background, onto which the corpus is attached. The reverse
is engraved with a continuous meandering pattern of foliage.
At the center, also on the reverse, is a circular capsule with
a rock-crystal window affording a view of the relics identi-
fied by inscribed parchment strips as those of Saint Catherine
and of James the Greater. The intense colors of the stones;
the varied reflective values of the engraved, polished, and
raised surfaces; and the brilliant clarity of the rock crystal
combine to produce a dazzling display.

If correctly identified with this cross, an entry in the 1525
inventory indicates that an object described as of "rock crys-
tal with silver mounts, and relic" (". . . barillen glasz, ist inn
sylber gefasset, mit heiltumb . . .") was given by Wilhelm
Hemsberg, sacristan of the cathedral (". . . gab herr Wilhelm
Hemsperg, custor der styfft").[1] Shortly after it was trans-
ferred to Basel-City, the cross apparently was repaired by a
local goldsmith,[2] but it remains unclear to what extent this
may have altered its original appearance.

PROVENANCE: 1834, allotted to Basel-City.

BIBLIOGRAPHY: Burckhardt 1933, no. 33; Hahnloser and Brugger-
Koch 1985, no. 165, p. 134, fig. 165; Basel 2001, no. 22.

1. Inventory 1525:35.
2. Burckhardt 1933, p. 238.

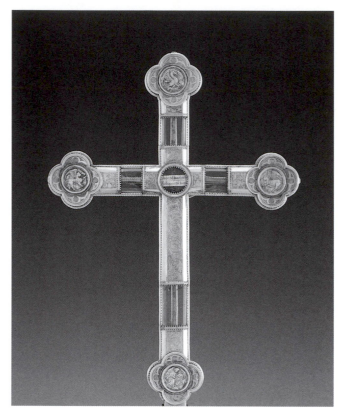

32: reverse

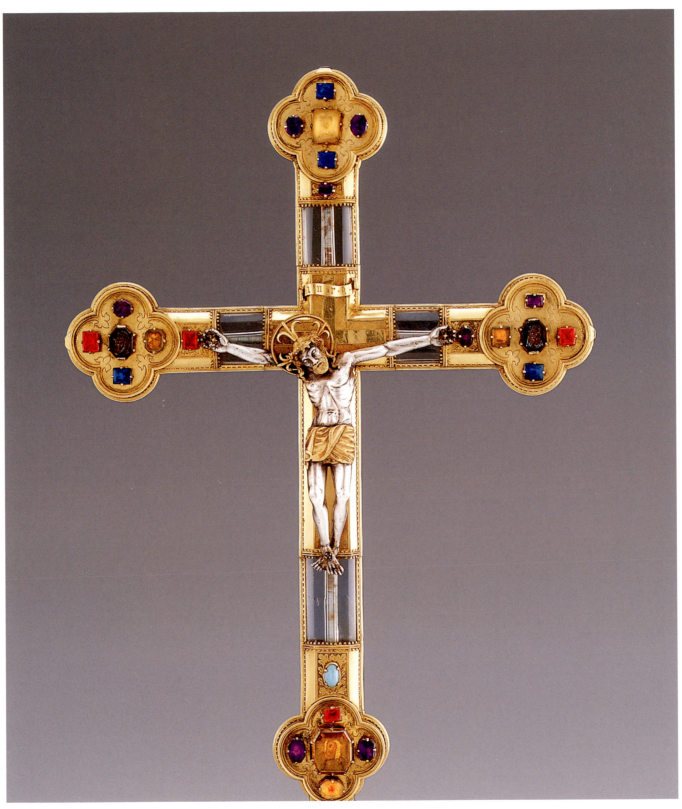

32: obverse

33. *Sunday Cross*

Basel, 1450–75. Raised, cast, chased, and gilded silver, with rock-crystal cabochons, glass, glass doublets with silver foil, and garnet, amethyst, sapphire, carnelian, fluorite, and citrine: Height, 49.8 cm.
Römisch-Katholische Kirche Basel-Stadt (Sankt Clara).

The appellation of this lavish cross is predicated on the terse associated descriptions in the 1477 and 1525 inventories: "crux dominicalis" and "das sonnenteglich crutz."[1] The combination of luxury materials and elaborate technique contributes to its arresting appearance. Five large, hemispherical rock-crystal cabochons, one in the center and one at the terminus of each arm, dominate the obverse. The interior fields are ornamented with fully dimensional foliate clusters at the center of which are a variety of glasses and stones. On the reverse, raised circular reliefs with the winged zoomorphic symbols of the Four Evangelists fill the corresponding positions of the cabochons. The termini are similarly embellished with curled, leafy attachments centered on and surrounded by various glass stones and gems. Against the unadorned center fields is a nimbed corpus with the *titulus* above. The edges of the cross are worked in a continual diamond pattern of alternating hatched and polished fields, a surface treatment that is found in almost identical form on the obverse of the Lamb of God or *Agnus Dei* Monstrance (no. 66). The brilliant colors of the gems, the limpid translucency of the crystal cabochons, the layers of adornment, and the varied surface treatments of the gilded silver combine to endow the cross with an exceptional volumetric presence and a shimmering play of light and shadow.

In addition to its glittering appearance, the Sunday Cross is most striking for its obvious dependence on the form of the Heinrich Cross (no. 4)—in particular, the circular expansions and the trapezoidal terminus of each arm. The multiple functions of the Heinrich Cross prompted numerous and continual alterations over the centuries, the most obvious of which was the addition of the corpus to the reverse, necessitating the removal of the medallion with the symbol of Saint Matthew on the terminus of the lower arm. The Sunday Cross, over four centuries later in date, codified many of these alterations and incorporated necessary adjustments: Designed to accommodate a corpus, for example, the lower arm was lengthened so that there would also be sufficient room for the circular relief of Saint Matthew, and, like the Heinrich Cross, the Sunday Cross assumed a variety of functions.

Relics preserved in tiny, red-silk sacks embroidered in gold thread, very similar to those found in the receptacle

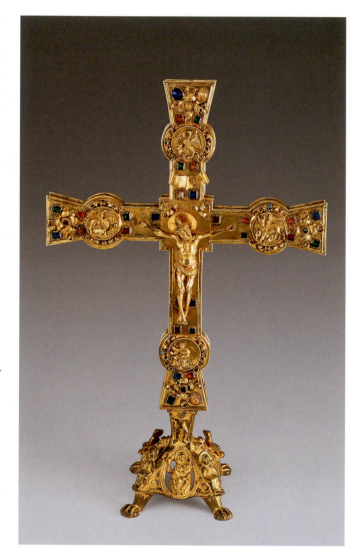

33: reverse, with base (no. 5)

under the upper cabochon of the Heinrich Cross, are housed beneath the analogous rock-crystal elements at the extremities of the present cross: Inscribed parchment strips identify their contents as relics of saints Peter, Paul, Thomas, and Andrew. With the exception of Andrew, relics of these same saints are preserved in the Heinrich Cross. Andrew's relics are prominently displayed in the upper arm, under a smoky rock crystal that differs in form from the other

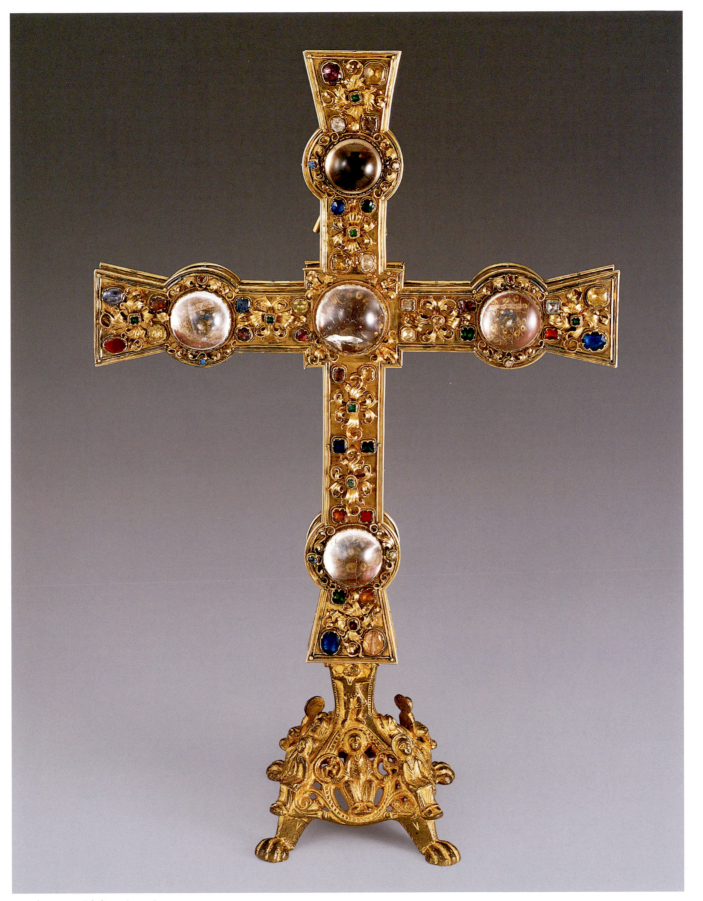

33: obverse, with base (no. 5)

cabochons; in fact, according to early-sixteenth-century chronicles, the Sunday Cross also was known as the Saint Andrew Cross.[2] A fragment of the True Cross apparently was housed under the central cabochon, as the underside is cut and polished in the pattern of a cross; the silk sack is damaged and the relic itself is missing, but it may be the fragment mentioned on the list of relics that were transferred to the Benedictine monastery at Mariastein in 1834.

The Heinrich Cross, like the Sunday Cross, was provided with a processional staff, according to the 1525 inventory, which itemizes a red staff with a copper knop ("ein rotter stecken zů dem sonteglichen crutz mit eynem kupfferin knopff"; see nos. 23, 24).[3] The Sunday Cross similarly was equipped with a base to support it on the altar, but the base with which it is associated today (no. 5) also can support the Heinrich Cross. The inventories list a base for the Heinrich Cross ("ein vergült fuss pro bona cruce")[4] as well as one for the Sunday Cross ("ein vergultter fůsz zů dem sonteglichen crutz");[5] whether these are two separate bases or one and the same cannot be determined. The Sunday Cross also was fitted with a plainer base ("ein schlechter fuss pro Cruce dominicali");[6] this cannot, however, be the base described in number 6 above, as the latter is neither large enough nor sufficiently heavy to support the Sunday Cross. Additionally, a late-fifteenth-century document mentions a silk cloth that was draped over the Sunday Cross during Lent.

Like so many objects in the Treasury, the Sunday Cross—its unified and coherent appearance notwithstanding—has undergone many repairs and restorations over the course of its history. Perhaps most interesting is a notation in the 1511 inventory stating that a leaf that had broken off the Golden Rose Branch (no. 55) was used to regild the Sunday Cross.[7] Although the Sunday Cross was allotted to Basel-City, the government decided that this cross, as well as a processional cross (no. 23), a processional staff (no. 24), and a base (no. 5) would be given to the Catholic community of Basel. Thus, after nearly three hundred years in dormancy storage, these objects once again were invested with the spiritual values that inspired their creation.

PROVENANCE: 1834, allotted to Basel-City, then given to the Catholic community of Basel and deposited at the Church of Sankt Clara.

BIBLIOGRAPHY: Burckhardt 1933, no. 36; Karlsruhe 1970, no. 211, pp. 251–52, fig. 190; Fritz 1982, no. 710, p. 284, fig. 710; Basel 2001, no. 20.

1. Inventories 1477:17 and 1525:7, respectively.
2. The information in this entry is drawn largely from Berkemeier-Favre, in Basel 2001, no. 20.
3. Inventory 1525:44.
4. Burckhardt 1933, no. 63, p. 362.
5. Inventory 1525:54.
6. Inventory 1511:55; see Berkemeier-Favre, in Basel 2001, no. 20.
7. Burckhardt 1933, p. 247, and n. 3.

34. *Hallwyl Reliquary*

Strasbourg, before 1470. Mathias Frischmut, 1470
(base). Raised, cast, engraved, punched, and chased gold,
with diamonds and a ruby (Crucifixion group); raised, cast,
engraved, cut, and gilded silver, with opaque *champlevé*
enamel, a sapphire, and a sardonyx cameo (reliquary); and
gilded lindenwood (base): Height (overall), 58.7 cm.
Inscribed (in enamel, twice): HALWIL
Historisches Museum Basel, 1882.83.

The Hallwyl Reliquary is composed of three distinct ele-
ments: the shrine, the Crucifixion group above, and the base
on which the ensemble sits. At the core is the reliquary
shrine, certainly the finest of the three in the Treasury (see
also nos. 30, 31). Raised on pier-like supports, the shrine is
conceived as a miniature building with a steeply pitched,
imbricated roof surrounded by a lace-like network of pen-
dentive flamboyant Gothic tracery and crocketed pinnacles.
Along the sides, between buttresses, are engraved double-
lancet windows. Atop the highest pinnacles at the corners
are angels—some censing, others holding candles. At the
ridge line of the roof are two enameled shields, each with
the name HALWIL inscribed above corresponding identical
coats of arms, and between which are a cameo of a lion and,
in the same position on the opposite side, a sapphire.

While the shrine is made of gilded silver, the Crucifixion
group mounted on the roof of the shrine is wrought from
gold. The mourning Virgin and John the Evangelist stand
on brackets, whereas the cross is attached directly to the roof.
The cross is elaborately worked with numerous projecting
stubs of branches and careful patterning to resemble bark;
elements of the figures' costumes are textured to suggest
different fabrics or materials. The *titulus* over Christ's head
is rendered in three languages. Exceptionally, the head of
each of the three nails in Christ's hands and feet is set with a
diamond and a ruby marks the wound in his side. Although
the gold Crucifixion group may appear visually out of scale
with the shrine upon which it stands, recent examination
reveals, however, that the interior mounts are in large part
original, indicating that the shrine was designed to support
a sculptural group. The ensemble stands on a rectangular,
gilded lindenwood base, its openwork panels pierced with
varying patterns of Gothic tracery; aediculae at the corners
and at the center on the front once must have accommo-
dated small figures. This base, made in 1470 by Mathias
Frischmut, a master joiner in the employ of the cathedral
from 1470 to 1479, was used to display the Hallwyl shrine on

the high altar, and, quite probably, was conceived to pro-
vide the ensemble with greater prominence and visibility.

The 1477 inventory, in the longest single entry for any
object in the Treasury, makes it clear that the ensemble
functioned as a reliquary: ". . . In qua habentur reliquie de
Sancta Cruce et de Sagnome miraculoso"[1] Thus, the
Heinrich Cross (no. 4) and the Hallwyl Reliquary, two of
the most precious objects in the Treasury, held the most
venerable relics: fragments of the True Cross and the mirac-
ulous blood of the Savior. Like the other reliquary shrines in
the Treasury, the Hallwyl Reliquary was intended to house,
not to display, relics, but its contents were easily accessible
through a trapdoor in the bottom.[2] However, relics were
displayed on appropriate feast days, and it is thought that the
two ampuls of Holy Blood (see no. 47), now in the Bene-
dictine monastery at Mariastein, were housed in the Hallwyl
shrine. Furthermore, it appears that these were the ampuls
that were suspended from the arms of the Heinrich Cross on
the annual observance of the "miraculous holy blood of our
Lord Jesus Christ."[3]

The two shields on the front of the shrine, as noted, are
each emblazoned with the arms of the ennobled Hallwyl;
one of these may be identified with Rudolf V. von Hallwyl
(1405–1473), from whom the Cathedral Chapter acquired
the reliquary shrine on April 6, 1480, for 280 gulden. A
contribution of one hundred gulden toward the purchase
was made by a certain Agnes von Efringen, and other dona-
tions were proffered by Peter zem Luft, Niklaus von Grü-
nenberg, and Burkhard Hanffstengel. Rudolf V. von
Hallwyl married the wealthy Ursula von Laufen in 1436,
and the couple lived in the Engelhof on the Nadelberg, a
house that she had inherited from her first husband. His
wife's money and family standing together with his aristo-
cratic background enabled Rudolf to rise to the high posi-
tions in which he served over a long career—longer, in fact,
than the successive tenures of the bishops Friedrich ze Rhin,
Arnold von Rotberg, and Johann von Venningen. In 1465,
by imperial privilege, Rudolf received from Friedrich III the
lordship over lands in Canton Aargau. Recent research has
revealed that the second coat of arms on the shrine belonged
to Rudolf's cousin the knight Thüring III. von Hallwyl.[4]

The base of the shrine bears the punch marks of Stras-
bourg goldsmiths who were members of the guild "zur
Stelz," leaving no doubt as to its place of origin. There are no
identifying marks on the Crucifixion group, but stylistically it
can be closely linked to the Upper Rhineland and almost cer-
tainly to Strasbourg itself. There are formal correspondences

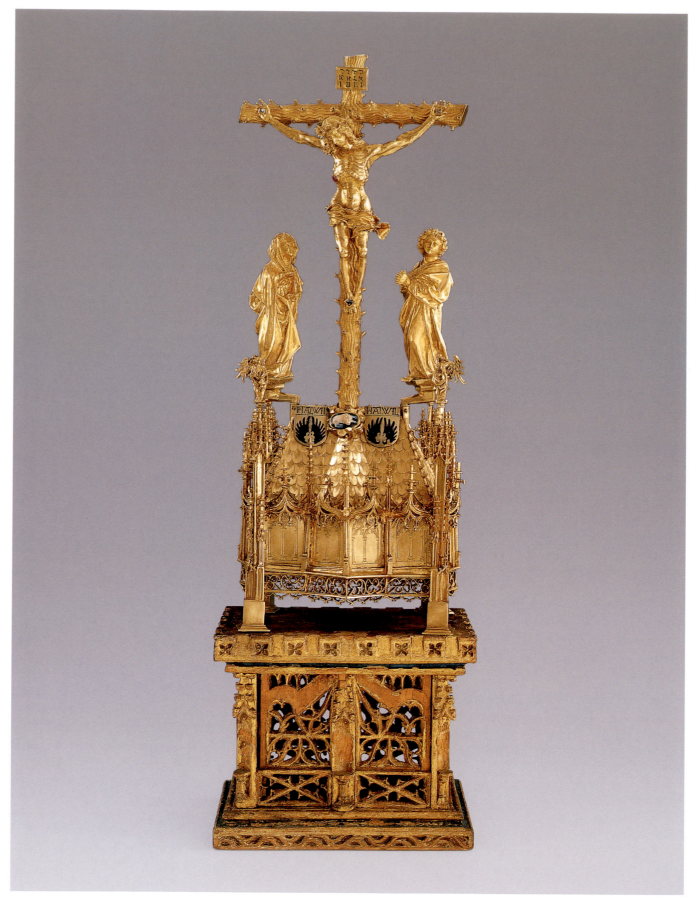

34: obverse

with the engraved versions of the subject by both the Master E.S. and Martin Schongauer, which, in turn, are indebted to the compositions of the Netherlandish painter Rogier van der Weyden. The strongest comparisons, however, can be made with the sculpture of Niclaus Gerhaert von Leiden, a seminal artist presumably trained in the Netherlands and active in Strasbourg in the 1460s. Differences in scale notwithstanding, the stylistic similarities between the Hallwyl Crucifixion and the monumental version Gerhaert executed in 1467 in Baden-Baden are striking, especially in Christ's serene but psychologically intense facial expression that contrasts with the carefully observed anatomy of his tortuously stretched and drawn body. Notable, too, are the analogies of such details as the fluttering loincloth about the dead weight of the body, the three-language *titulus*, and the naturalistic treatment of the wood of the cross (see fig. 3). The group also can be compared with the Crucifixion by Niclaus Gerhaert in Nördlingen, particularly with the dramatically charged figures of the Virgin and John the Evangelist; sculpturally coherent from all angles, both Basel figures express tension, their spiraling movement accentuated by the fluent, enveloping drapery passages. The Hallwyl Crucifixion group constitutes not only the finest sculptural ensemble in the Treasury but it also may be numbered among the greatest masterpieces of goldsmiths' work to have come down to us from the Late Middle Ages.

PROVENANCE: 1834, allotted to Basel-City.

BIBLIOGRAPHY: Burckhardt 1933, no. 39; Karlsruhe 1970, no. 210, pp. 249–51, fig. 197; Fritz 1972, no. 210, p. 170, fig. 210; Fritz 1982, no. XIII, pp. 183–84; Lüdke 1983, vol. 1, fig. 209; vol. 2, no. 289, pp. 667–69; Barth 1990, no. 15; Basel 2001, no. 25.

1. Inventory 1477:5.
2. I am grateful to Martin Sauter for clarifying the structural details of the shrine.
3. The information in this entry is drawn largely from Häberli, in Basel 2001, no. 25.
4. Ibid.

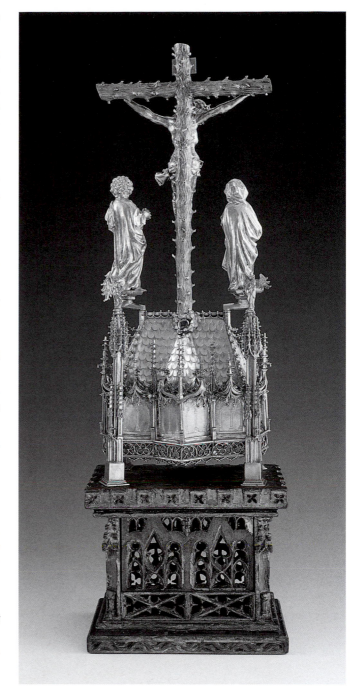

34: reverse

35. *Statuette of King David*

Upper Rhineland, possibly Constance, about 1280 (Virgin and Child, incorporating a cameo of about 1150); about 1290–1310 (figure of David, incorporating an antique cameo of the 2nd or 3rd century A.D.); about 1320 or shortly thereafter (reliquary group); 15th century (crown and base). Raised, cast, and cut gold, with a sardonyx cameo, glass, and garnet (David and the Virgin); raised, cast, and gilded silver, with translucent *basse-taille* enamel, glass, and gemstones (crown and lower section); and gilded wood (base): Height (overall), 21.6 cm.

Inscribed (on the banderole): + DAVID ✳ REX ✳ MANV ✳ FORTIS ✳ ASPECTV ✳ DESIDERABILIS ✳ ECCE ✳ STIRPS ✳ MEA ✳ ET ✳ SAL' ✳ MV̄DI ✳ QVĀ ✳ DIVINIT' ✳ p̄PHAVI

Historisches Museum Basel, 1882.80a.

This gold statuette of King David is one of the more eccentric objects to have survived from the Late Middle Ages. The half-length figure is garbed in a habit-like robe, cinched around the waist with a rope. David, whose countenance is an antique cameo of a Gorgon's head, appears to gaze out from under the gold cowl upon which a crown rests (see fig. 13). In distorted hands, the figure holds an inscribed and enameled banderole, above which, atop a cameo of a lion that appears to hover in space, stands a diminutive gold Virgin and Child. The figure of David appears to rise out of a tower-like structure that, in turn, is supported by a hexagonal base with gabled sides, each of which frames, within an arched opening, an enameled plaque representing a prophet. The entire ensemble rests on a gilded-wood base that appears to be a reused element, adapted from some altogether different object.

Annual records establish that the figure of David was a gift to the cathedral from a certain Master Johannes, who was the physician to Duke Leopold I of Austria (about 1290–1326), the son of the Habsburg king Albert I and husband of Catherine of Savoy. Additionally, Johannes gave the sum of thirty shillings to endow an annual Mass to pray for his soul. The annual records also indicate that Johannes was closely aligned to the mendicant orders, and was buried in the Dominican church, where his tomb slab is preserved. The Dominicans in Basel had long enjoyed considerable esteem through their close connections with the Habsburgs.[1]

The gold statuette of David is the result of at least three different campaigns. The figure itself and the standing Virgin and Child most probably date to the end of the thirteenth century. Following *The Golden Legend* of Jacobus de Voragine, David was conceived as a hagiolatrous cult image; in a typological context, he was regarded as one of Christ's forebears, and the lion symbolized the tribe of Judah—the ancestors of Christ. It has been suggested that originally David balanced the Virgin and Child in one hand and the lion in the other—thus, holding the Old and the New Testament in a parallel gesture.[2] This reading is underscored by the words of the inscription: "King David, of strong hands, and fortuitous vision [declares] 'Behold my descendant, the Savior of the world, whom, with divine inspiration I have prophesized.'" The figure was much altered early in the fourteenth century—probably about 1320, soon after it entered the Treasury. The hands may have been re-formed to hold the banderole, and the figure was incorporated into the tower structure, underneath which is an opening with a spring-lock mechanism, added at this time, marking the conversion of the statuette into a reliquary. The enamels are likely of Basel origin, but the influence of Constance also has been noted.[3] The wood base and the crown are both fifteenth-century additions.

PROVENANCE: 1834, allotted to Basel-City.

BIBLIOGRAPHY: Burckhardt 1933, no. 19; Guth-Dreyfus 1954, pp. 57–58; Heuser 1974, pp. 103–4; Ackermann 1981; Fritz 1982, no. 230, p. 216, fig. 230; Barth 1990, no. 8; Basel 2001, no. 8.

1. The information in this entry is based largely on Ackermann 1981, and Eggenberger-Billerbeck, in Basel 2001, no. 8.
2. Heuser 1974, p. 103.
3. Ackermann 1981, p. 23.

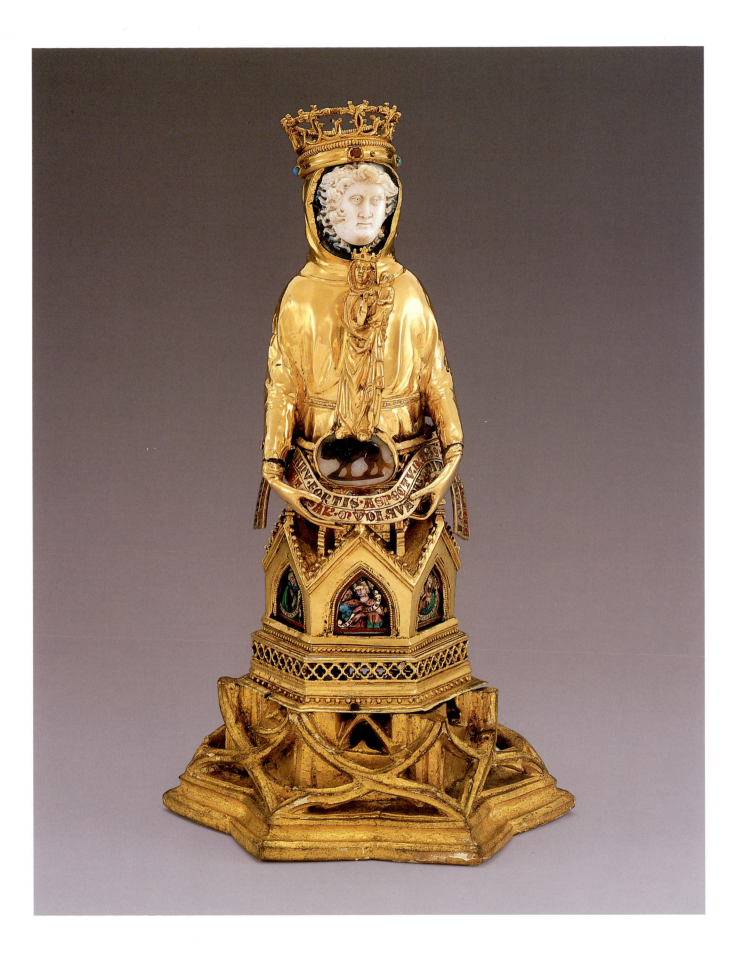

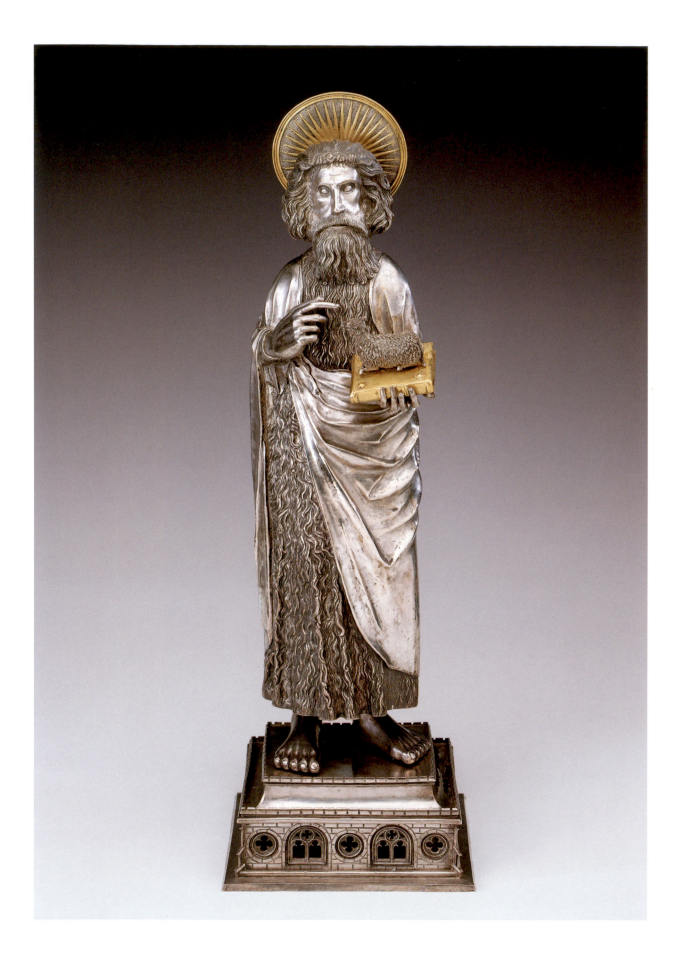

36. Statuette of Saint John the Baptist

Basel, 1400–1425. Raised, pierced, engraved, and partially
gilded silver: Height, 54.5 cm.
Saint Petersburg, The State Hermitage Museum, F-138.

Although of a different date and style, the present work was
paired with the Statuette of Saint Christopher (no. 37) when
both were in the Cathedral Treasury, and on high feast days
they were set out on the high altar symmetrically flanking
the Golden Altar Frontal (plate 4, fig. 5, and no. 2). Full
figures, these reliquaries represent the saint himself, rather
than the part of the body that corresponds to the enclosed
relic.[1] Like reliquary caskets, the statuettes were not intended
to display relics; indeed, only the small aperture secured with
a hinged and hasped closure at the back of each figure indi-
cates that they were made as reliquaries rather than as cult
images. This figure of John the Baptist held a finger of the
saint that had been given to the cathedral in the early thir-
teenth century by a certain Gertrudis and her husband. It is
possible that part of this relic was later removed and placed
in the Hüglin Monstrance (see nos. 75, 76).[2]

John the Baptist was venerated both as the last prophet
to foretell the coming of the Messiah and as the first Christ-
ian martyr. In his youth, he retreated to the wilderness
and clothed himself in the pelt of a camel. As an itinerant
preacher, he admonished his followers to repent, for the
Kingdom of Heaven was at hand, and he washed, in the
River Jordan, all those who confessed their sins. When
Christ came to him, John baptized him; upon their next
encounter, John pointed to Christ and said: "Behold the
Lamb of God . . . who taketh away the sin of the world"
(John 1: 29). These words are given form in the present rep-
resentation of the saint.

The insistent frontality, outsized proportions of the hands
and feet, and rather vacant gaze give the figure a somewhat
static and ungainly appearance. Indeed, this statuette was, for
a period, considered a rather coarse copy of a lost original; a
watercolor rendering by Johann Friedrich II. Burckhardt-
Huber in which he recorded the figure shortly after he
acquired it in the 1836 Liestal auction corrected this misap-
prehension. The Saint John the Baptist reliquary, according
to the 1477 inventory,[3] was the gift of Konrad Zyfer, a
chaplain and master of the cathedral fabric, whose tenure
can be placed in the second decade of the fifteenth century.[4]

PROVENANCE: 1834, allotted to Basel-Country; 1836, sold at auction
in Liestal to Johann Friedrich II. Burckhardt-Huber; before 1870,
Alexander P. Basilevsky, Paris; 1884, acquired by Tsar Alexander III
with the Basilevsky collection; 1885, entered the collections of the
Hermitage.

BIBLIOGRAPHY: Burckhardt 1933, no. 24; Lüdke 1983, vol. 2, no. 39,
pp. 353–54; Basel 2001, no. 6.

1. It should be noted that the form of a reliquary and its contents do
 not have to agree anatomically; that is, an arm reliquary does not
 necessarily contain an arm bone. See Hahn 1997, p. 21.
2. This is suggested by Marie-Claire Berkemeier-Favre, who notes
 that the inventory at Mariastein includes two relics of Saint John
 the Baptist.
3. Inventory 1477:30.
4. Kryzanovskaya, in Basel 2001, no. 6.

37. *Statuette of Saint Christopher*

Upper Rhineland, probably Basel, 1425–50. Raised, cast, engraved, punched, and partially gilded silver: Height, 44.2 cm.
Inscribed (on the scabbard of the knife): IHESUS
Historisches Museum Basel, 1933.160. On loan from the Gottfried Keller Foundation.

Like the Statuette of Saint John the Baptist (no. 36), this reliquary figure of Saint Christopher supporting the Christ Child is raised from sheet silver without the wood core that is often found in Romanesque figural reliquaries, such as the Reliquary Head of Saint Eustace (no. 9); only the hands and feet of the child and the twisted band around the saint's head are cast. With virtuoso skill, the goldsmith brought exceptional sculptural presence to this image. Seemingly arrested in motion, the massive figure of the saint pauses, rotating his head toward the child on his shoulder, as though he is noticing the weight of his small charge for the first time. Soft folds of drapery convincingly envelope the underlying anatomy of

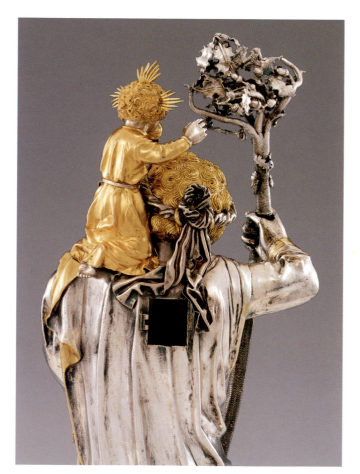

the saint while defining its mass. Thus the physical reality of the sculpture group is charged with spiritual intensity. Meticulous attention to detail—the careful delineation of the hair and beard, the surface treatment of the tree-like staff, and the articulation of the water rushing about the saint's feet—adds to the compelling sense of drama with which the figures are imbued. The forthright naturalism of the style has been compared to that of the painter Konrad Witz (about 1400–1445/47), who spent thirteen years working in Basel.

The execution of this reliquary group imparts the crux of the legend to eminent effect. Christopher (the name derives from the Greek, meaning one who carries Christ), a man of considerable stature, sought to serve the most powerful king but did not know how to find him. On the advice of a hermit, he settled by a ford and carried pilgrims across the river. One night, a small child asked to be taken to the other side; placing the child on his shoulders, Christopher started to ford the river. Midstream, Christopher paused, suddenly realizing his diminutive passenger had become so heavy that he feared he could not make it to the far bank. The child then revealed that Christopher was carrying not only the weight of the whole world but also that of the one who ruled it, for the child was Christ, the king whom Christopher had been seeking.

The inventory of 1477 states that the Saint Christopher reliquary was donated by Ludwig Mog,[1] an *Assisius*, or one of the four senior chaplains of the cathedral. It has been suggested that the reliquary may have been given to the cathedral in the wake of an outbreak of the plague in 1439, during the Council of Basel (1432–48); likewise, it might have been the gift of the secretary of Pope Eugenius IV, Cristoforo da Treviso, in honor of his patron saint.[2]

PROVENANCE: 1834, allotted to Basel-Country; 1836, sold at auction in Liestal to Johann Friedrich II. Burckhardt-Huber; until 1861, Prince Peter Soltykoff, Paris; before 1874, Alexander P. Basilevsky, Paris; 1884, acquired by Tsar Alexander III with the Basilevsky collection; 1885, entered the collections of the Hermitage; 1932, purchased by the dealer Theodor Fischer; 1933, acquired by the Gottfried Keller Foundation, Winterthur, and placed on loan in the Historisches Museum Basel.

BIBLIOGRAPHY: Burckhardt 1933, no. 27; Braun 1940, pp. 437, 445, fig. 514; Karlsruhe 1970, no. 218, p. 256, fig. 199; Fritz 1982, no. 574, p. 268, fig. 574; Lüdke 1983, vol. 1, fig. 126, vol. 2, no. 8, p. 311–12; Reinle 1988, p. 132; Barth 1990, no. 11; Basel 2001, no. 7.

1. Inventory 1477:19.
2. Berkemeier-Favre, in Basel 2001, no. 7.

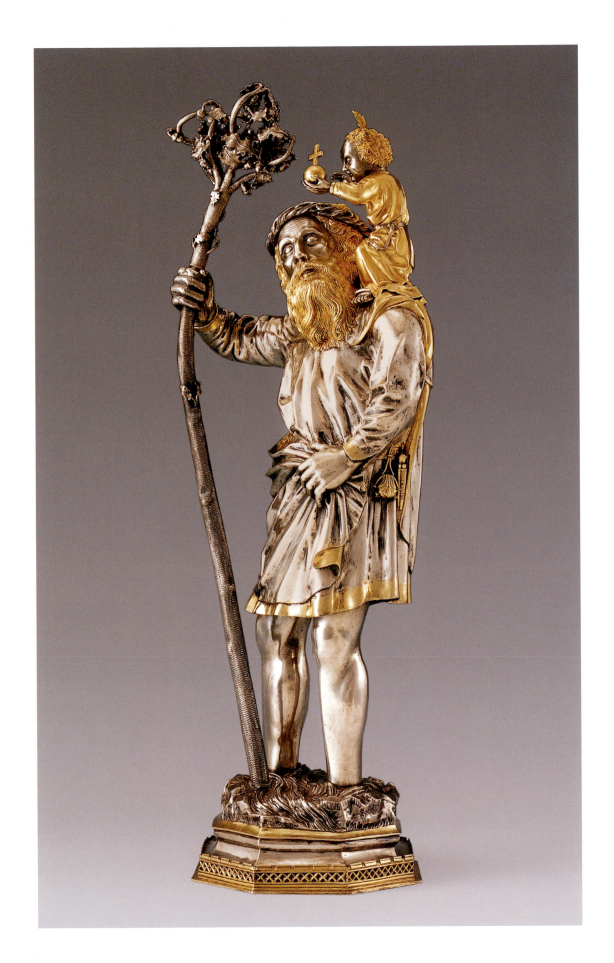

38. *Dorothy Reliquary Monstrance*

Upper Rhineland, possibly Constance, 1417–20 (shrine); Basel, about 1440 (base, stem, and crockets and finial above). Raised, engraved, pounced, and partially gilded silver, with glass, translucent and opaque *champlevé* enamel, and a chalcedony intaglio, agate cameo, amethyst, garnet, sapphire, and spinel ruby: Height, 55 cm.
Historisches Museum Basel, 1882.81.

The Dorothy Monstrance is composed of two distinct elements: the mandorla-shaped reliquary shrine and the octafoil base and stem upon which it stands. The shrine, encircled by radiating, leafy crockets and crowned with a similarly worked finial, centers on the high-relief figure of Saint Dorothy holding the hand of the Christ Child, who, in turn, holds the basket of flowers, the attribute of the saint. On the reverse is a small hinged and clasped aperture with two circular crystal windows, which would have allowed the viewing of the relics that the monstrance once housed; attached below is a shield with the coat of arms of the Offenburg family of Basel.

The legend of Dorothy tells of a maiden in Cappadocia who was arrested by Diocletian for her Christian beliefs. She was handed over to two apostate women, who were instructed to pervert the young captive but instead ended up being converted themselves. For this trangression, Dorothy was sentenced to beheading. As she was led to her execution, a lawyer named Theophilus mockingly asked her to send him flowers from the heavenly gardens. Miraculously, a small child later brought Theophilus a basket of flowers and apples, occasioning the tormentor's own conversion.

The reliquary capsule was made for Henman Offenburg (1379–1459), who belonged to a rich family of apothecaries, members of which had been citizens of Basel prior to the 1356 earthquake. Henman undertook numerous diplomatic missions for the city of Basel and earned the favor and confidence of King Sigismund (1368–1437)—to such an extent that he was elevated to the status of "familiaris" in 1413 and subsequently was granted the right to a coat of arms. During the Council of Constance, so great was Sigismund's trust in Henman that the king had him ensconced in his own bedroom. The king enhanced Henman's coat of arms in 1429, and in 1433, after his coronation as Holy Roman Emperor, Sigismund knighted Henman in Rome.[1] Henman traveled to Jerusalem in 1437, and it is possible that he acquired the relics of Dorothy on this trip.

The reliquary capsule of the Dorothy Monstrance has been dated as late as 1450 and the stand as early as 1350–75;[2]

it also has been proposed that the monstrance was presented to the Treasury by one of Henman's sons, either Franz (1405–1452), who was a canon of the cathedral, or Peterman (1408–1474), who had two daughters baptized Dorothy.[3] Current scholarship, however, favors the dates given here and holds that the reliquary capsule, intended for Henman's own private devotion, probably was commissioned by him shortly after 1417, when he was attending the Council of Constance.[4] Only at a later date, perhaps as an act of piety in the wake of the devastating outbreak of the plague in 1439, was the capsule given to the Cathedral Treasury; subsequently, the capsule was joined, somewhat clumsily, to its stand, so that it could be displayed on the high altar, and the crockets and finial were added to give a more balanced and uniform appearance to the whole. The origin of the capsule itself remains an open question; the proposed earlier dating of the stand and the somewhat later dating of the conjoining of the several elements are not untenable.

PROVENANCE: 1834, allotted to Basel-City.

BIBLIOGRAPHY: Burckhardt 1933, no. 26; Braun 1940, pp. 289–90, 293–94, fig. 279; Fritz 1982, no. 304, p. 230, fig. 304; Barth 1990, no. 10; Basel 2001, no. 9.

1. Eggenberger-Billerbeck, in Basel 2001, no. 9.
2. Fritz 1982, p. 230.
3. Burckhardt 1933, p. 199.
4. Eggenberger-Billerbeck, in Basel 2001, no. 9.

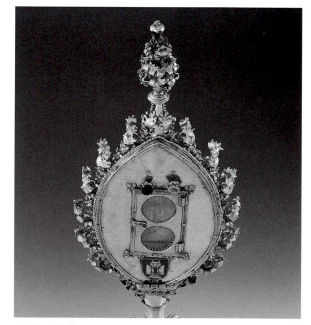

38: detail of reverse

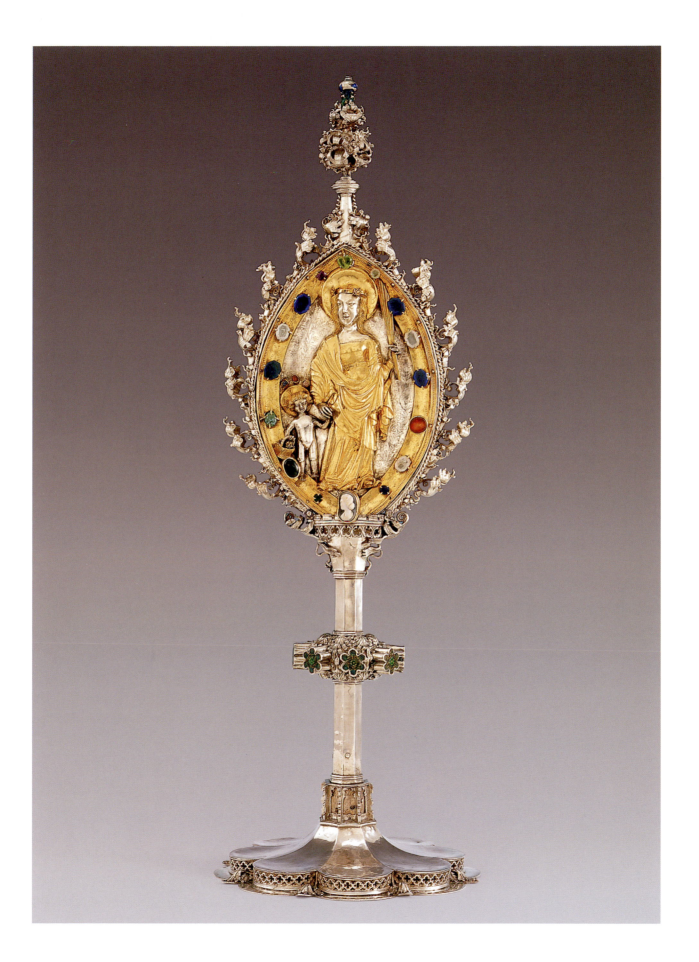

39. *Reliquary Bust of Saint Pantalus*

Upper Rhineland, possibly Basel, after 1270. Raised and
gilded silver, paint, and glass, with a garnet, pearls, and a
carnelian, amethyst, and chrysoprase (bust); raised and
gilded copper and cast and gilded copper alloy, with glass
and semi-precious stones (base and lappets): Height, 49 cm.
Historisches Museum Basel, 1882.87.

According to legend, Pantalus was the first bishop of Basel,
and is believed to have accompanied Saint Ursula (no. 41)
and the 11,000 Virgins on their pilgrimage to Rome and
then to Cologne, where they all were martyred. This legend
seems to have originated in the visions of the Benedictine
nun Elizabeth of Schönau (1129–1164): In 1106, a Roman
burial field was uncovered in Cologne, and the female bones
were presumed to belong to the 11,000 Virgins while the

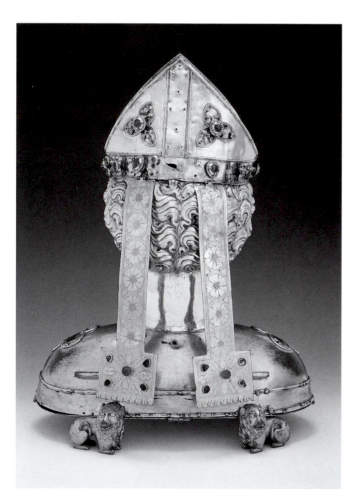

men's and children's bones, as revealed to Elizabeth, were
thought to be those of additional and heretofore unmen-
tioned pilgrimage companions of Saint Ursula. Between
1155 and 1164, the remains were taken to the abbey at
nearby Deutz, and the events were recorded in a manu-
script.[1] Concurrently, the legend of Pantalus first emerged.
In 1270, the city of Cologne presented the bishop of Basel,
Henri III de Neuchâtel, with the skull of Pantalus; the trans-
lation of this relic to Basel amid considerable ceremony may
have occasioned an expanded account of the saint's legend
written by Konrad von Würzburg. The veneration of Pan-
talus flourished to such a degree that, soon after the arrival
of his presumed relics, he was elevated to the status—
enjoyed only by the Virgin Mary and subsequently by Hein-
rich—of cathedral patron.

Pantalus is represented with a broad face, a knitted brow,
and a prominent nose, all encircled by the curls of his hair
and beard; the oversized dark eyes transfix the viewer and
endow the legendary saint with an arresting physical pres-
ence. The similarity in style suggests that the bust may have
been inspired by the heads in the archivolt above the main
portal of the cathedral.[2] Concealed by the trefoil with a
green chrysoprase at its center, in the middle of the miter
border, is a clasp that releases the miter and allows the relic
within to be viewed. According to the records of the Bene-
dictine monastery of Mariastein, the head was cleaned in
1495 by Konrad Hüglin.[3]

PROVENANCE: 1834, allotted to Basel-City.

BIBLIOGRAPHY: Burckhardt 1933, no. 9; Braun 1940, pp. 418, 430,
fig. 484; Heuser 1974, pp. 101–2, 109; Fritz 1982, no. 61, p. 192,
fig. 61; Reinle 1988, p. 134; Barth 1990, no. 3; Falk 1993, no. 53,
pp. 209–11; Basel 2001, no. 14.

1. Zutter, in Basel 2001, no. 14.
2. Basel 1956, no. 9, p. 18.
3. Zutter, in Basel 2001, no. 14.

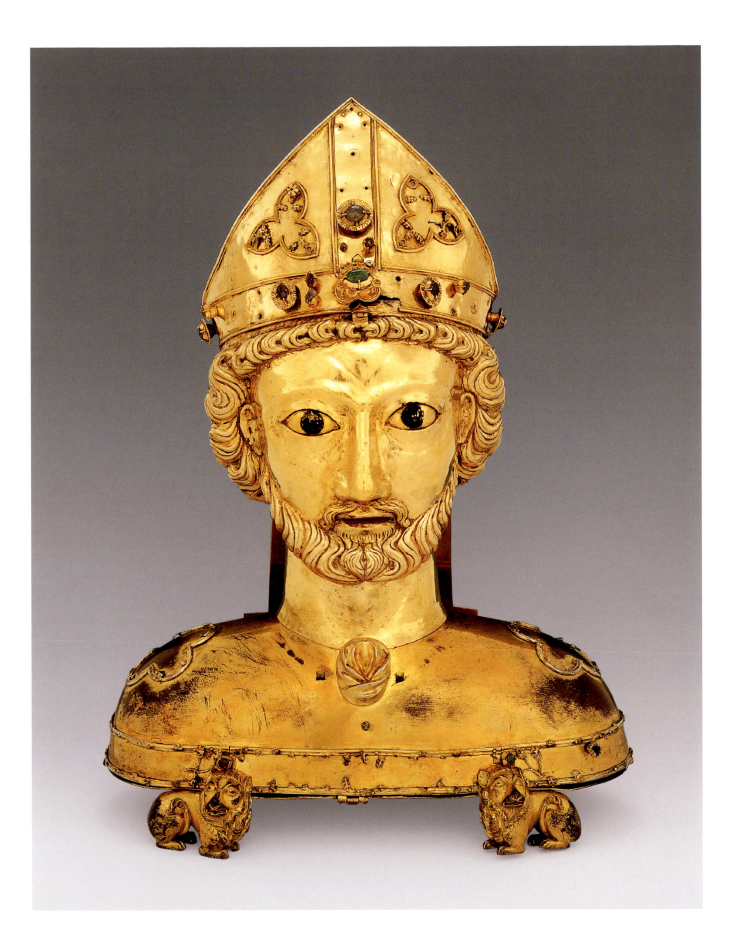

40. *Reliquary Bust of Saint Thecla*

Upper Rhineland, 1290–1300 (bust); 1325–50 (base). Raised and gilded silver, with opaque *champlevé* enamel and glass stones (head); raised and gilded copper (base): Height, 31.2 cm. Amsterdam, Rijksmuseum, RBK 16997.

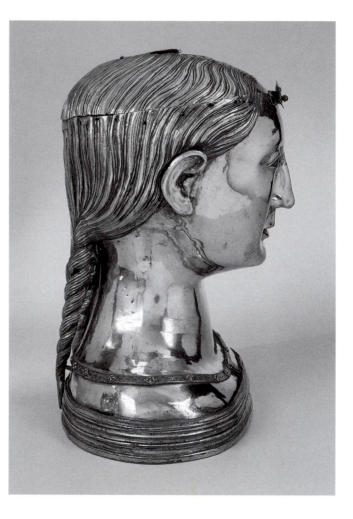

Among the oldest of female patronesses, Saint Thecla, martyred in the first century, refused marriage because she had devoted herself to Christ. Much persecuted for her beliefs, and after persistent attempts to kill her with fire and wild animals, she retreated to a cave in the wilderness where she lived for many years. Others became jealous of her healing abilities and she was again attacked in her old age, but she escaped her tormentors when the rock of her cave miraculously swallowed her up. The legend of Saint Thecla is based on the writings of Saint Paul the Apostle, of whom she was an early follower; her cult was established in Cologne by the third century, and it spread rapidly throughout the Germanic world.

The saint is represented here as a young maiden without the headdress signifying a married woman, but, rather, with her hair parted in the middle and falling in two braids at the back. The remains of a gold fillet with gem-studded florets that encircles her hair once concealed the join of the skull-cap to the rest of the head, while an enameled collar with a single, unidentified heraldic shield rests at the base of her neck. A small, hinged door at the top of the head provides access to the relics. On her feast day, the Bust of Saint Thecla was displayed on a high base articulated with a series of double-lancet arcades capped by leafy finials, all made of gilded wood;[1] the present gilded-copper base is a later addition.[2]

Remarkable are the eyes of the saint, almond shaped, with incised lids left ungilded. The central part of each eye is made of a separate, circular, inset piece of silver whose center has been cut away, the whole supporting purple enamel; because of differences in depth, the iris is lighter and thus distinguishable from the darker pupil. The resultant illusion of natural eyes further blurs the border between the reality of the relic and the fictive representation of the head that houses it; it is almost as though the goldsmith attempted to put flesh and hair back on the skull.

PROVENANCE: 1834, allotted to Basel-City; 1837, exchanged along with the Golden Rose Branch (no. 55) and the Arm Reliquary of Saint Valentine (no. 43) for the Hüglin Monstrance (no. 75), which had been allotted to Basel-Country, was sold at auction in Liestal, and subsequently was acquired by the Academic Society of Basel; 1838, sold to Colonel Jean-Jacques Ursin Victor Theubet, Porrentruy; by 1843, on the London art market and sold to Alexander P. Basilevsky,

Paris; 1884, acquired by Tsar Alexander III with the Basilevsky collection; 1885, entered the collections of the Hermitage; 1932–33, sold by the Hermitage and acquired by Dr. Fritz Mannheimer (d. 1939), Amsterdam; 1941, apparently acquired by Hans Posse, through Kajetan Mühlmann, for the planned Führermuseum in Linz; after the capitulation of the Nazis, recovered from the Altaussee depot; sent by the Allies to the Central Collecting Point, Munich; 1946, on loan to the State Office for Dispersed Works of Art, The Hague; 1953, acquired by the Rijksmuseum.

BIBLIOGRAPHY: Burckhardt 1933, no. 11; Heuser 1974, p. 102; Fritz 1982, no. 215, p. 214, fig. 215; Reinle 1988, p. 134; Falk 1993, no. 55, pp. 213–14; de Jongh 2000, pp. 32–34; Basel 2001, no. 15.

1. Burckhardt 1933, p. 96, fig. 59, and p. 98.
2. Falk, in Basel 2001, no. 15.

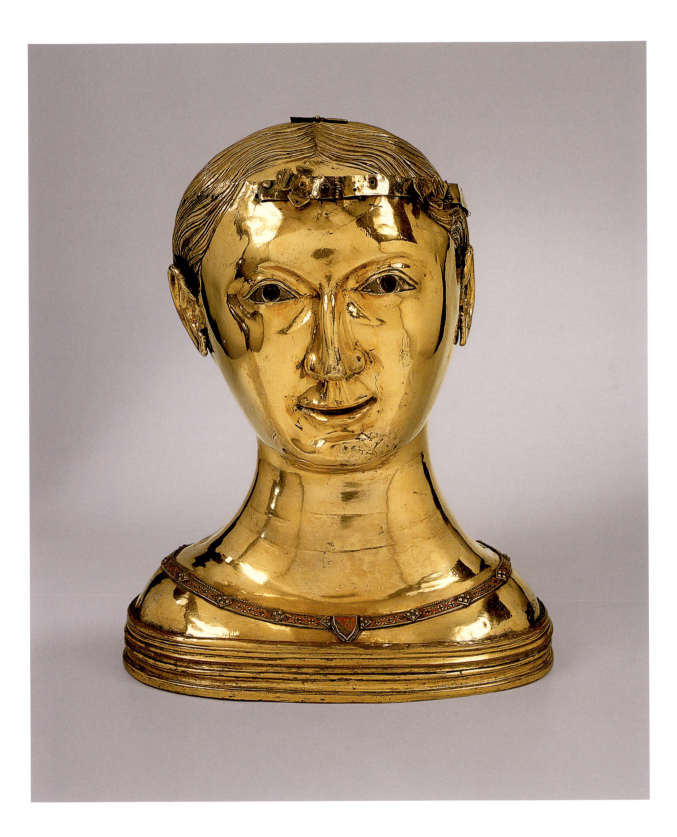

III

41. *Reliquary Bust of Saint Ursula*

Upper Rhineland, probably Basel, 1300–1320 (bust); 1325–50
(supporting collar). Raised, engraved, cast, chased, and gilded
silver, with translucent and opaque *basse-taille* enamel,
translucent *cloisonné* enamel (*émail de plique*), and glass, all set
on a raised and gilded-copper collar: Height, 35.5 cm.
Historisches Museum Basel, 1955.207. Purchased with
contributions from the People of Basel ("Ursula-Spende"),
the Verein des Historischen Museums Basel, and a subvention
from the Swiss Confederation.

42. *Base for the Bust of Saint Ursula*

Upper Rhineland, probably Basel, 1325–50. Raised, cast,
and gilded copper, with glass or semi-precious stones:
Height, 29 cm.
Saint Petersburg, The State Hermitage Museum, F-118.

The remarkably naturalistic bust representing Saint Ursula is
close in both style and technique to that of Saint Thecla
(no. 40), although Ursula's features are rather fuller, softer,
and rounder. The wavy, loosely plaited hair, dimpled chin,
and upturned corners of the mouth all contribute to a
warmer countenance. Her neckline, from which a richly
decorative openwork brooch or pendant is suspended, is set
with enameled lozenges alternating with glass stones, while
her diadem is studded with similar glass stones alternating
with raised gold and translucent *émaux de plique* that likely
were produced in Paris about 1300. Like those of Saint
Thecla, the eyes of Saint Ursula are made from separate
sheets of silver, with irises of dark green enamel and pupils
of brown enamel, producing an arresting, life-like appear-
ance. In this regard, the figure served as an interlocutor
between the devout and the divine.

In 1254, the dean and chapter of Cologne Cathedral gave
to Basel Cathedral, then under the rule of Bishop Berthold
II. von Pfirt, and to several monastic churches in the city, a
complete head, two arm bones and other relics of the 11,000
Virgins, who, accompanying Saint Ursula, were martyred in
Cologne in the fifth century. (Ursula's multitudinous atten-
dants may derive from the misreading of the name of one of
her companions: Ximilia = XI thousand). By the later
fifteenth century, however, these remains became identified
with Ursula herself, for the inventory of 1477 refers to the
reliquary bust as the "head of Saint Ursula" ("caput sancte
ursule").[1] As with the Reliquary Bust of Saint Thecla, a
small door in the skullcap of Saint Ursula can be raised to
reveal the relics housed within.

The date of the Bust of Saint Ursula is uncertain, but the
stylistic affinity to the sculpture on the west portal of the
cathedral, executed about 1290—particularly the faces of the
Foolish Virgins and, even more so, the head of Heinrich (see
frontispiece)—supports a date in the early fourteenth cen-
tury. The reliquary probably was placed in the Gebwiler
Chapel, also known as the Chapel of the 11,000 Virgins.
Documentary evidence indicates that the bust was cleaned
in 1495, along with that of Saint Pantalus, by Konrad
Hüglin.[2] The concave copper band around the bottom of
the reliquary head was intended to fit into the eight-sided
base, raised on four feet in the form of lions' heads (no. 42);
the bust was separated from its base when it was sold in
1932–33 and the base remained in the collections of the
Hermitage in Saint Petersburg.

According to legend, Saint Ursula sailed up the Rhine
from Cologne to Basel, where she disembarked and contin-
ued her pilgrimage to Rome on foot. When the Bust of
Saint Ursula was acquired by the Historisches Museum in
1955, this trip on the Rhine was re-created; the reliquary
arrived in Basel to great festivity and ceremony and was
transported to the museum in an open carriage, where it was
greeted by, among others, 426 girls and young women from
Basel and the surrounding canton, all of whom were named
Ursula (see figs. 10, 11, and pp. 28, 29, 31, 32).[3]

PROVENANCE: (41) 1834, allotted to Basel-Country; 1836, sold at
auction in Liestal and acquired by the Berlin dealer Oppenheim; 1860,
acquired by Prince Peter Soltykoff; sold at auction with the Löwen-
stein collection, Christie's, London; 1862, acquired at auction by
Alexander P. Basilevsky, Paris; 1884, acquired by Tsar Alexander III

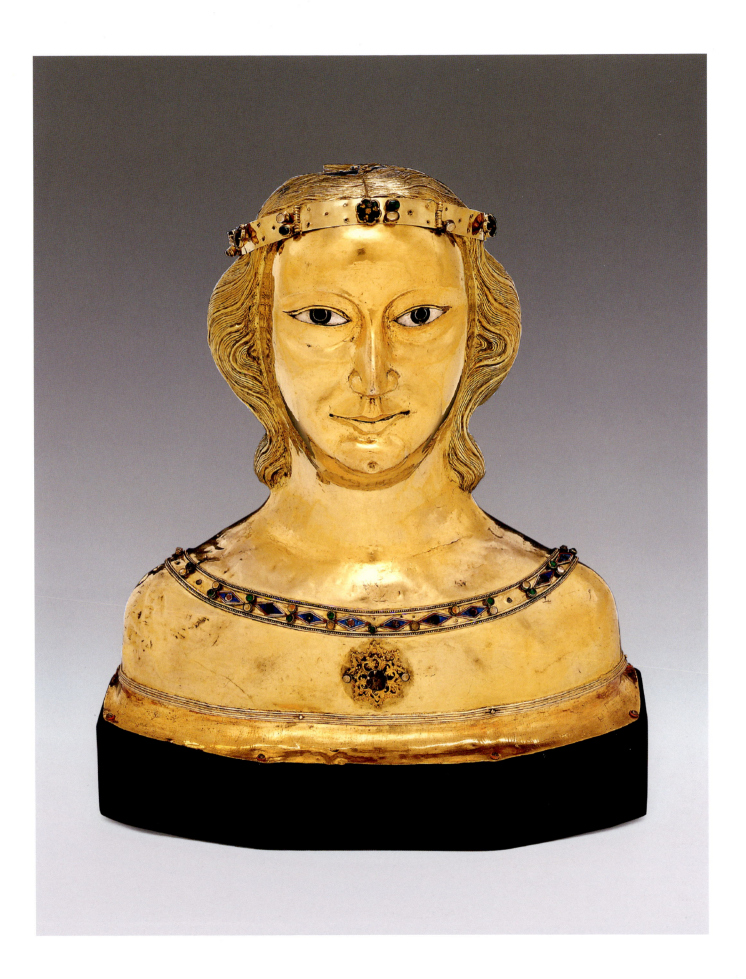

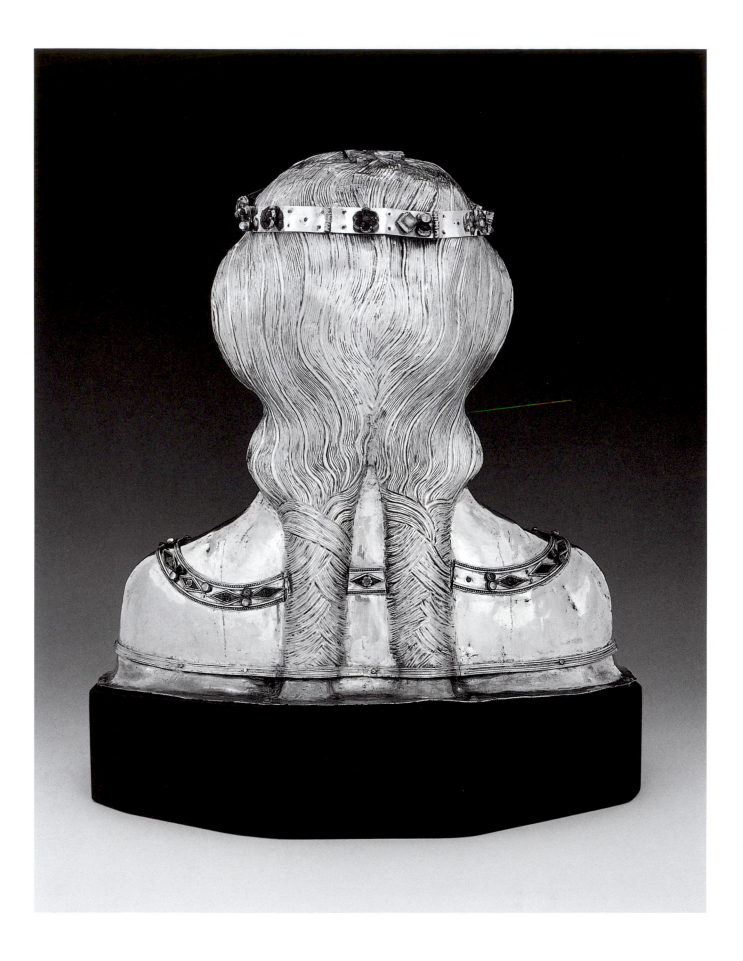

with the Basilevsky collection; 1885, entered the collections of the Hermitage; 1932–33, sold by the Hermitage and acquired, along with the Reliquary Bust of Saint Thecla (no. 40), by Dr. Fritz Mannheimer (d. 1939), Amsterdam; 1941, apparently acquired by Hans Posse, through Kajetan Mühlmann, for the planned Führermuseum in Linz; after the capitulation of the Nazis, recovered from the Altaussee depot; sent by the Allies to the Central Collecting Point, Munich; 1946, on loan to the State Office for Dispersed Works of Art, The Hague; 1953, acquired by the Rijksmuseum; 1955, sold by the Rijksmuseum to the Historisches Museum Basel; (42) same as above, but separated from the bust in 1932–33 and retained by the Hermitage.

BIBLIOGRAPHY: (41) Burckhardt 1933, no. 12; Reinhardt 1956, pp. 26–36; Heuser 1974, pp. 102, 107 n. 281; Falk 1993, no. 56, pp. 214–16; Barth 1990, no. 4; Basel 2001, no. 16, 1 (42) Basel 2001, no. 16, 2.

1. Inventory 1477:23.
2. Zutter, in Basel 2001, no. 16.
3. Ibid.

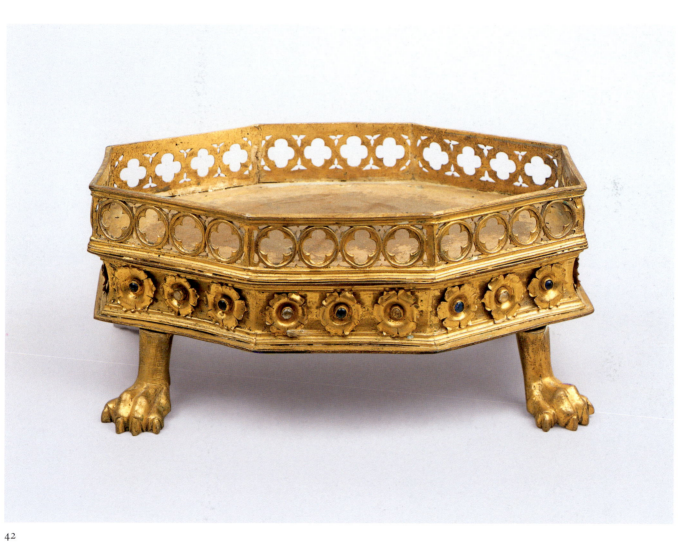

42

43. *Arm Reliquary of Saint Valentine*

Upper Rhineland, possibly Basel, 1380–1400. Raised, cut, and partially gilded silver, with a sapphire and traces of translucent enamel: Height, 55 cm.
New York, The Metropolitan Museum of Art. Gift of J. Pierpont Morgan, 1917 (17.190.351).

This reliquary originally housed a fragment of the arm bone of Saint Valentine, whose feast day is February 14; little is known of this saint, but he is thought to have been a priest or bishop in or near Rome, who was martyred during the reign of Claudius II, about 269. The present reliquary is exceptional for the striking, if somewhat eccentric, manner in which its component parts are harmoniously merged. The simple but stout base provides a visually secure footing for the vertical vessel it supports, the mass being relieved by the pierced trefoil work of the central zone. The architectural vocabulary is extended into the arm itself by the

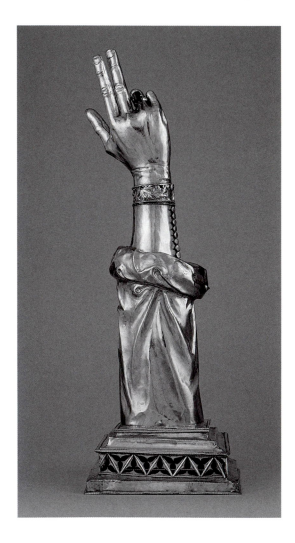

gate-like aperture of the relic housing, and compositional cohesion is enhanced by the repeated play of void and solid. With the rolled cuff as a visual divider, the naturalistically rendered hand emerges from the arm-like shape of the lower, functional portion of the reliquary. Thus, the fictive hand of the living saint becomes one with the true arm bone of the martyred saint; the real and the illusionary merge.

Evidently, the Arm Reliquary of Saint Valentine was conceived as a pendant to the earlier Arm Reliquary of Saint Walpert (no. 10) and, therefore, almost certainly was fabricated in Basel.[1] This supposition is supported by the fact that the trefoil openwork balustrade of the cathedral choir screen (see no. vi), which was erected in 1381, is replicated with remarkable similarity on the base of the Saint Valentine reliquary. The fashioning of the aperture of the relic's receptacle niche as an arched gateway with an open portcullis is an unusual design for an arm reliquary, and the only close comparisons all date to the last years of the fourteenth century.[2] As a consequence, such a date seems justified for this work.

Made of particularly thin sheet silver and without a core, this arm reliquary has suffered considerable distortion and reshaping, and has been clumsily repaired. The openwork band around the wrist has been reattached with rivets, resulting in the almost complete loss of the underlying translucent blue enamel. If Johann Friedrich II. Burckhardt-Huber's drawing of about 1838 (no. xviii) accurately records the reliquary's appearance then, the inset relic niche has since lost the point of its arch; the height of the portcullis has been reduced, with a fragment illogically attached at the foot of the opening; and the trefoil openwork panel on the front has been reset upside down.

PROVENANCE: 1834, allotted to Basel-City; 1837, exchanged, along with the Golden Rose Branch (no. 55) and the Reliquary Bust of Saint Thecla (no. 40), for the Hüglin Monstrance (no. 75), which had been allotted to Basel-Country, sold at auction in Liestal, and subsequently acquired by the Academic Society of Basel; 1838, sold to Johann Friedrich II. Burckhardt-Huber; before 1842, sold to Colonel Jean-Jacques Ursin Victor Theubet, Porrentruy; 1893, sold with the Frédéric Spitzer collection, Paris; until 1913, J. Pierpont Morgan, London and New York; 1917, given to The Metropolitan Museum of Art.

BIBLIOGRAPHY: Burckhardt 1933, no. 23; Braun 1940, pp. 393, 404, fig. 467; Hahnloser 1971, p. 170, n. 5; Fritz 1982, no. 305, p. 230, fig. 305; Reinle 1988, p. 139; Boston 1995, no. 19, pp. 24–25; Basel 2001, no. 18.

1. Burckhardt 1933, p. 179.
2. Hahnloser 1971, p. 170.

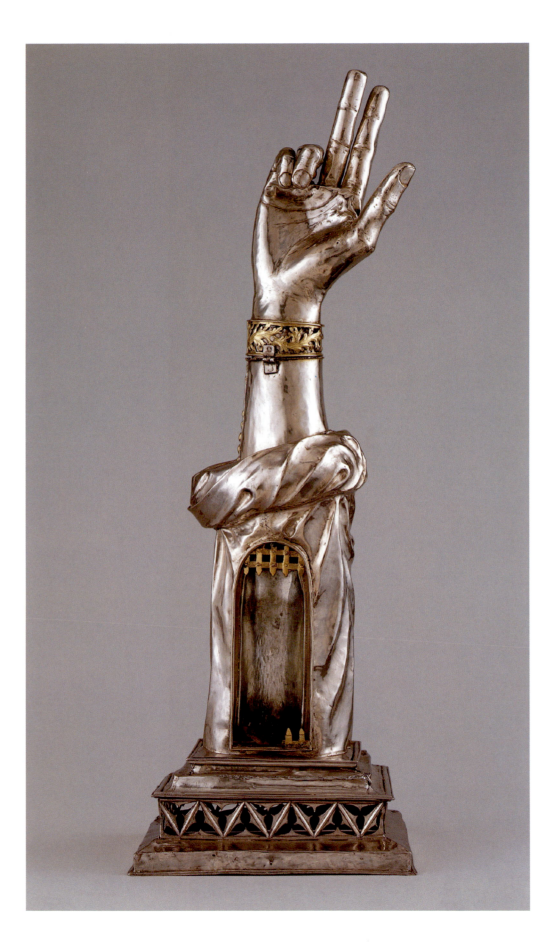

44. *Foot Reliquary*

Basel, dated 1450. Raised, stamped, cast, and partially
gilded silver, and engraved and gilded copper, all on a
wood core, with translucent *émaux de plique*, rock crystal,
glass stones, and pearls, a garnet, and a mother-of-pearl
relief: Height, 14.2 cm; length, 23.5 cm.
Inscribed: (on the outer face of the sole) integer pes / de
innocentibus / Sanctus columb/anus / dedit; (on the inner
side of the sole) osualdus fecit / hoc opus de / uoluntate /
dey / 1450 iar
Zürich, Schweizerisches Landesmuseum, 184.

This highly unusual reliquary actually takes the form of a
foot in an open-toed, ankle-high shoe or boot. The shoe is
richly decorated with applied and gilded rosette-headed
studs, numerous glass stones and gemstones—some mounted
singly and others in simulated bands—filigree work, two
applied translucent *émail-de-plique* medallions encircled by
pearls, and a mother-of-pearl plaque representing the Pre-
sentation in the Temple. On the bridge of the foot, a raised
circular aperture affords a view into the leather-lined cavity
that once contained the relics. The inscription on the sole of
the foot is engraved to resemble a parchment document, the
corners of which curl over, as though it were a certificate of
authentication: The inscription can be rendered, "the whole
foot of the innocents; Saint Columban gave [the relic]." The
inscription on the inner side declares that "Oswald by the
grace of God made this in the year 1450."

Close examination reveals that both the conception of
the foot and its applied decorative elements are heteroge-
neous. The treatment of the foot itself is somewhat *retar-
dataire*, reflecting an aesthetic closer to the Romanesque
than to the Gothic, especially in the filigree work on the
ankle. The *émaux de plique* are almost certainly of Parisian
origin, from about 1300, but the mother-of-pearl relief dates
to the first half of the fifteenth century, while the engraved
inscription and the circular, leafy frieze at the top are Late
Gothic in character. This has led some scholars to conclude
that either an older reliquary was reworked or, at the least,
used as a model, and elements of disparate sources were re-
employed to create a new, if somewhat eclectic, one.[1] The
creation of a new reliquary based on an older model also
occurred in the case of the Sunday Cross (no. 33), which was
inspired largely by the Heinrich Cross (no. 4).

The 1827 inventory of the Treasury mentions that five
of the stones on the reliquary were intaglio cut ("tief-
geschnittene"), and the sale catalogue of 1836 likewise

alludes to gemstones with antique engraving ("mit antiker
Gravierung").[2] These descriptions are confirmed by the 1836
watercolor of the object by Johann Friedrich II. Burckhardt-
Huber,[3] but the antique intaglio gems are no longer to be
found on the foot reliquary. An 1851 illustration shows the
foot without the intaglios and as it looks today, and the
accompanying text explains that the valuable stones had
been removed and replaced with glass ones. The added claim
that the originals had been sold back to the cathedral does
not, however, appear to be true.[4]

The identification of the Oswald in the inscription is not
certain. On the assumption that the reference is to the gold-
smith who made the reliquary, it was thought that the latter

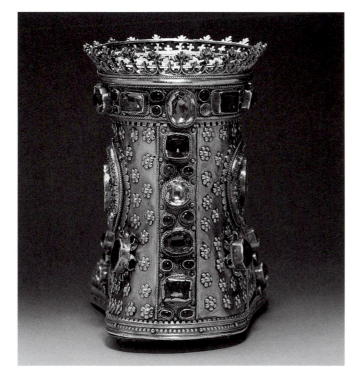

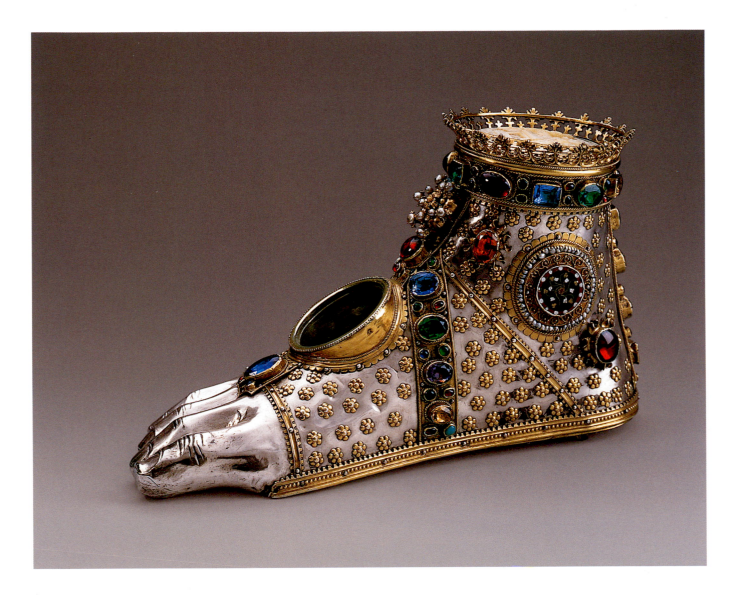

might be Oswald Überlinger, the sole documented Basel goldsmith of that name.[5] However, it is now known that Überlinger died between 1445 and 1446. If, on the other hand, the name refers to the donor or to the individual who commissioned the work, Oswald Walter, or Walcher, the cathedral chaplain and master of the cathedral fabric in 1450, emerges as the most likely candidate.[6]

PROVENANCE: 1834, allotted to Basel-Country; 1836, sold at auction in Liestal and acquired by the Basel goldsmith Johann Friedrich II. Burckhardt-Huber; 1839, acquired by Hollingsworth Magniac, Bedford; 1892, sold at auction, Christie's, London, and acquired by Dr. Heinrich Angst for the Landesmuseum.

BIBLIOGRAPHY: Burckhardt 1933, no. 28; Braun 1940, p. 382, fig. 436; Fritz 1972, p. 187; Fritz 1982, no. 604, p. 272, fig. 604; Basel 2001, no. 19.

1. Fritz 1982, p. 272.
2. Inventory 1827:30; see sale catalogue 1836:39 (Burckhardt 1933, p. 381).
3. Historisches Museum Basel, 1922.163.
4. Büttner, in Basel 2001, no. 19.
5. Burckhardt 1933, pp. 218–20.
6. Barth 1990, p. 13; Büttner, in Basel 2001, no. 19.

45. *Two Woven Fragments*

Persia or Central Asia, early 14th century. Silk, linen, and
gold on leather (lampas): (a) 48.5 x 14.5 cm; (b) 35.5 x 23 cm.
(a) Benediktinerkloster Mariastein.
(b) Historisches Museum Basel, 1907.83.

46. *Two Woven Fragments*

Syria or Egypt, 8th century (a); Persia, 8th–9th century (b).
Silk (samite): (a) 10 x 13.4 cm; (b) 11 x 10.5 cm.
(a and b) Benediktinerkloster Mariastein.

Luxury textiles from the Near and Far East were highly
prized in the West throughout the Middle Ages and were
among the most valuable holdings in treasuries. Expensive
silk weavings and velvets were used for the ecclesiastical vest-
ments of the high clergy; smaller fragments were employed
to line book boxes and containers for liturgical items and
served extensively as protective coverings for relics (see
no. 9). The quality and variety of these textiles are known,
in large part, only through the many fragments of relic
wrappings that have survived. Following the transfer of the
Treasury fom the cathedral to the Town Hall in 1827, the
relics were removed from their reliquaries and often the

45a

45b

46 a and b

coverings were separated from their contents. While it is not certain which reliquaries many relics were housed in, some of the textile wrappings have retained their identifying parchment labels, although these are not always reliable. That associated with one of the lampas pieces (no. 45 a), for example, erroneously states that it is a fragment of the stole of Himerius, a local saint, but this is not possible, as Himerius apparently lived in the Jura in the seventh century.[1] Likewise, the two samite fragments (no. 46 a and b) traditionally have been said to come from the chasuble in which Saint Theodulus was buried, but the two are very different in ori-

gin and postdate the death of the saint by centuries. In any event, it is clear that these four fragments were not wrappings for relics but were perceived as relics in and of themselves.

PROVENANCE: 1833, removed with relics from the reliquaries; 1834, transferred to the Benedictine monastery at Mariastein except for 45 (b), which, in 1907, was retained by the Historisches Museum Basel.

BIBLIOGRAPHY: (45 a and b) Burckhardt 1933, no. 14; Schmedding 1978, no. 119, pp. 149–50; Basel 2001, no. 3; (46) Schmedding 1978, no. 118 a, b, pp. 147–49; Basel 2001, no. 4.

1. Schorta, in Basel 2001, no. 3.

xvi. *Reliquary Pouch (Bursa)*

Syria or Byzantium, 11th century. Silk weaving (samite):
17.5 x 30.5 cm.
Beromünster, Chorherrenstift Sankt Michael.

This textile fragment was originally folded in half (the crease is still visible) and stitched together to form a small reliquary pouch. The weave is in an overall pattern of bands describing hexagonal fields filled with plant motifs; a close variation of the pattern is found on the leggings of Pope Clement II (r. 1046–47), now in the Cathedral of Bamberg. It was customary throughout the Middle Ages to place relics within the altar at the time of its consecration. During the iconoclastic uprising of February 1529, a theology student named Kaspar Schufelbühl removed the relics that had been placed in the high altar of the cathedral to prevent their destruction. The following month, he registered at the university in Freiburg-im-Breisgau, and later moved to Beromünster, near Lucerne, where he served as canon and custodian of the Monastery of Saint Michael until 1561. According to records dating from 1529, it was in this pouch that he found the relics in the high altar.[1] Indeed, this may be the very pouch that contained the relics given by Heinrich II at the consecration of the rebuilt cathedral.

PROVENANCE: found by 1529; transferred to Beromünster.

BIBLIOGRAPHY: Schmedding 1978, no. 16, p. 32.

1. Marie-Claire Berkemeier-Favre kindly provided this information.

47. *Three Assemblages of Relics*

Arranged and mounted in 1903 by the sisters at the
Convent of the Visitation, Solothurn.
Benediktinerkloster Mariastein.

In 1827, after having been stored in the upper sacristy of the
cathedral for nearly three centuries, the Treasury, by order
of the city government, was transferred to the Town Hall.
The relics were to be removed from their reliquaries and

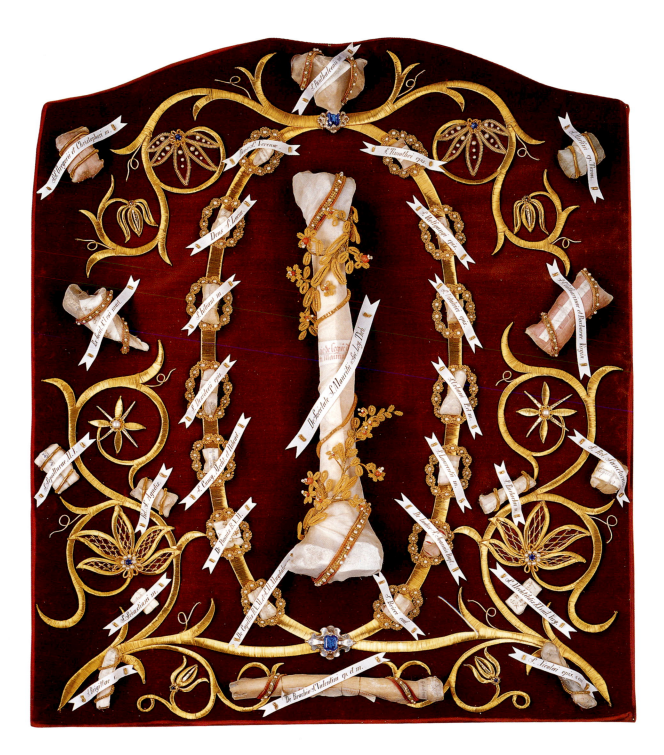

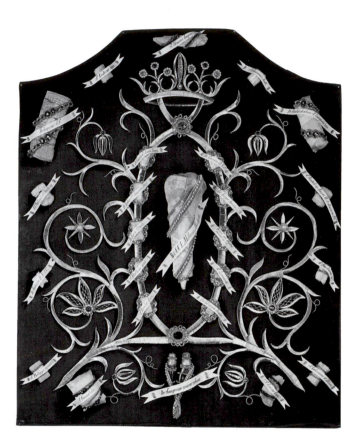

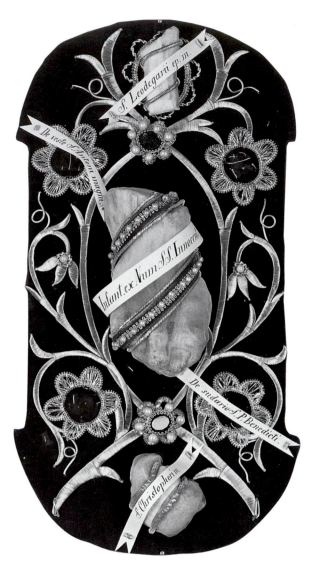

monstrances and then transferred to the Basel archivist Johann Krug, who was instructed to burn them or to throw them into the Rhine. Acutely aware of both the spiritual and historical importance invested in the relics, Krug could not bring himself to effect such a wanton act. Rather, at the request of Placidus Ackermann, abbot of the Benedictine monastery at Mariastein, Krug arranged for them to be deeded to the monastery in 1834. After every item was identified and a careful inventory compiled, the relics—101 in all—were translated to Mariastein on March 5, 1835.[1] Subsequently, the relics were wrapped with their earlier identifying parchment labels, mounted with new labels on fabric-covered boards, elaborately ornamented with gold thread and semi-precious stones, and then housed in rococo-style shrines. The relics included those of saints Barbara, Benedict, Christopher, John the Baptist, John the Evangelist, Lawrence, Lucy, Martin of Tours, Nicholas, Philip, Timothy, Valentine, and Wolfgang, as well as of the Holy Innocents and the 11,000 Virgins, along with two vials of the Holy Blood, which may have been the ones said to have been displayed on the Heinrich Cross.[2]

1. Roth 1911, pp. 186–88.
2. Burckhardt 1933, p. 46.

48. *Burial Crown of Queen Anna*

Probably Vienna, 1281. Cut and gilded silver, with glass and a pearl: Height, 14 cm; diameter, 17.6 cm.
Staatliche Museen zu Berlin, Kunstgewerbemuseum, K3874.

Anna von Hohenberg, the wife of Rudolf von Habsburg, died in Vienna on February 23, 1281, and her earthly remains were translated to Basel, where she was buried in the cathedral on March 19, 1281. Her tomb was opened in 1510 and contemporary accounts relate that a golden crown was in place upon her head. Many of the gems originally mounted on the fleurs-de-lis and all the pearls but one that were set at the points of the petals have been lost. The remaining stones and their settings were all reused finger rings, the stones and their bezels cut off and then riveted to the crown. Many of the claw mounts that hold the stones in place are broken, perhaps either because they had to be opened and the stones removed in order to mount the bezel, or they may have been pried open to substitute glass for the real gems. The forms of the bezels indicate that the cannibalized rings dated largely from the late twelfth and early thirteenth centuries. The recycling of earlier rings and the possible removal of the gemstones before the bezels were mounted on the crown are in keeping with the medieval practice of replacing genuine materials with imitations when royal regalia were used for burial purposes.[1]

PROVENANCE: 1834, allotted to Basel-Country; 1836, sold at auction in Liestal possibly to the dealer Oppenheim, Berlin; Schlossmuseum (?), Berlin; transferred to the Kunstgewerbemuseum.

BIBLIOGRAPHY: Burckhardt 1933, no. 10; Basel 2001, no. 59; Schramm and Fillitz 1978, no. 2, pp. 50–51, fig. 2, p. 111.

1. See Meier, in Basel 2001, no. 59.

xvii. *Head of a Bishop*

Basel, after 1422. Sandstone: Height, 39 cm.

Basel, Museum Kleines Klingental, 12289.

This head of a bishop, with its elaborately ornamented miter, came from the tomb monument of Hartmann III. Münch (r. 1418–22), which had been installed in the Chapel of Saint Nicholas—a separate structure alongside the southeast bay of the cathedral choir. In 1529, iconoclasts destroyed the bishop's effigy along with most of the sculpture throughout the cathedral. Subsequently used as masonry fill, the head was rediscovered in the course of repairs to the cathedral fabric in 1947. Although the face has been disfigured, the sculpture nonetheless convincingly portrays an aged countenance in serene repose. The high quality of the carving evident in this isolated fragment is a poignant reminder of the incalculable destruction wrought by the religious upheavals.

PROVENANCE: 1947, transferred from the cathedral to the Stadt- und Münstermuseum, later the Museum Kleines Klingental.

BIBLIOGRAPHY: Schwinn Schürmann 1998, p. 64.

49. *Pontifical Ring*

Upper Rhineland, possibly Basel, 1300–1350. Raised, cast,
and gilded silver, with glass: Diameter (inner), 2.1 cm;
length (stone), 2.7 cm.
Historisches Museum Basel, 1905.5684.

50. *Head of a Crosier*

Limoges, 1230–50. Raised, engraved, and gilded copper,
with opaque *champlevé* enamel: Height, 17 cm.
Historisches Museum Basel, 1870.330.

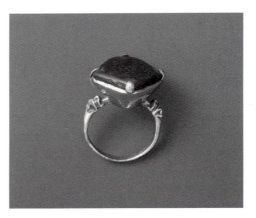

In his will, the energetic bishop of Basel Johann von Ven-
ningen, who died on December 20, 1478, directed that he
be buried with bishop's gloves and a ring on the third finger
of his right hand and a crosier in his left hand (". . . darnach
die Henschen und den Pontificalringk an den finger by
dem cleyn finger an der rechtten Hand . . . darnach den
Bischoffsstab in die linke hand . . .").[1] When the bishop's
tomb near the choir screen in the cathedral was opened in
1820, both a ring and a crosier head were found. Subsequent
uncertainty notwithstanding, it is now thought that the pre-
sent objects were those disinterred, the corroded condition
of both the glass and the enamel being consistent with long
burial. The ring does not appear to be a pontifical ring,
however, for not only is it made of a modest material but
more usually precious ceremonial rings were turned over to
the Treasury after their owner's death; it seems, rather, to be
a personal ring that was substituted for the pontifical one for
purposes of burial. Likewise, the Limoges crosier head,
which, by the time of Johann von Venningen, would have
been long out of fashion, was exchanged for the one used by
the bishop in his lifetime.[2]

PROVENANCE: (49 and 50) 1820, removed from the tomb of Johann
von Venningen; 1834, excluded from the Treasury allotment.

BIBLIOGRAPHY: (49) Basel 2001, no. 60; (50) Burckhardt 1933,
no. 46; Basel 2001, no. 61.

1. Burckhardt 1933, p. 298.
2. Ochsner, in Basel 2001, nos. 60, 61.

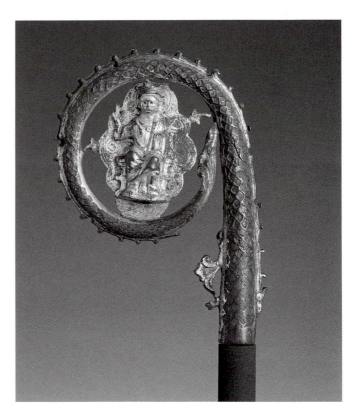

51. *Bracelet*

Probably Upper Rhineland, about 1500. Raised and gilded
silver, coral, and amber: Length, 22.3 cm.
Historisches Museum Basel, 1905.3944.

xviii. *Drawing of the Arm Reliquary of Saint Valentine, with a Bracelet*

Johann Friedrich II. Burckhardt-Huber (1784–1844). Basel,
about 1838. Pencil, with pen and ink and watercolor: 64.8 x
50 cm.
Historisches Museum Basel, 1922.170.

Gifts of jewelry often were presented by the devout to adorn
images of holy figures or vessels containing their relics—
particularly, of the Virgin, Christ, and any of the pantheon
of saints whose intercession was being invoked. The present
bracelet of amber, coral, and gilded silver beads, which may
originally have formed part of a string of prayer beads or a
rosary, has no documented connection with the Treasury
other than the fact that it appears to have adorned the wrist
of the Arm Reliquary of Saint Valentine (no. 43), as recorded
by Johann Friedrich II. Burckhardt-Huber, suggesting that
just such a pious gift had been made prior to 1529.

PROVENANCE: (51) 1834, allotted to Basel-City; (xviii) 1894, pur-
chased from Samuel Burckhardt-Kern by the Historisches Museum
Basel; 1922, accessioned by the museum.

BIBLIOGRAPHY: (51) Basel 2001, no. 38; (xviii) Burckhardt 1933,
p. 185.

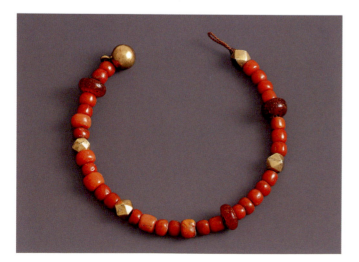

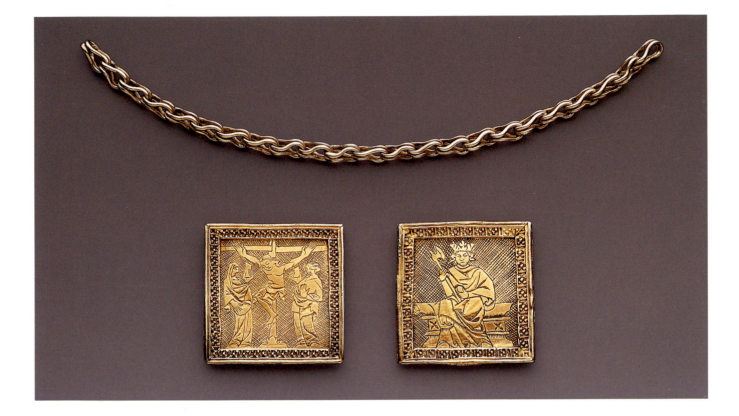

52. *Two Plaques and a Chain from a Pectoral Cross*

Scandinavia (?), 1350–1400. Engraved, punched, and gilded
silver, with remnants of solder and silver chain: Plaques
(each), 4.2 x 4.2 cm; length of chain, 19.4 cm.
Historisches Museum Basel, 1882.96.

The pendant is constructed of two sheets of silver that origi-
nally formed a reliquary capsule, one engraved with a scene
of the Crucifixion flanked by the Virgin and Saint John and
the other with a seated king. The victim of vandalism at the
hands of thieves in 1937, the arms of the cross, with fleur-
de-lis termini, were crudely removed. On the basis of the
unusual attribute of a battle-ax, the seated king is believed
to be the Norwegian national saint, Olaf, and the crowned
female saint engraved on the now-lost arms has tentatively
been identified as Saint Bridget of Sweden,[1] whose revela-
tions became widely circulated by the end of the fourteenth
century and influenced devotional practice throughout
Europe. The Scandinavian attribution, therefore, depends in
large part on the correct reading of the iconography.

It is unclear when or under what circumstances this pec-
toral cross entered the Treasury. However, many Scandina-
vians traveled through Basel for commerce and on their way
to the Holy Land, and, as Saint Bridget was the patroness of
pilgrims, one of them may have made an offering of the
cross in hopes of protection during the continuation of the
pilgrimage. There may have been some connection with the
Council of Basel as well. Burckhardt believed that this pec-
toral was the object mentioned in the 1525 inventory as
hanging from the Heinrich Cross (no. 4) by a silver chain
("...daran hangendt an eyner sylbern kettenen...").[2]

PROVENANCE: 1834, allotted to Basel-City.

BIBLIOGRAPHY: Burckhardt 1933, no. 20; Basel 2001, no. 35.

1. Burckhardt 1933, pp. 169–70, n. 1.
2. Ibid., p. 170; Inventory 1525:6.

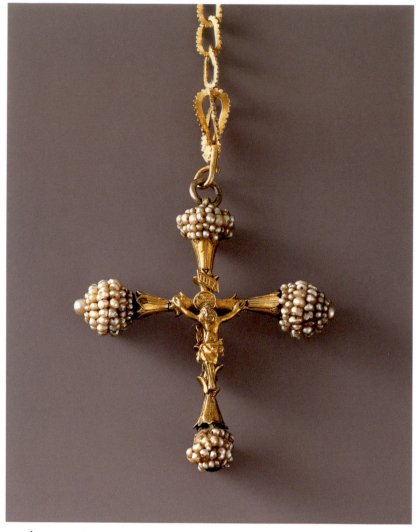

53: obverse

54

53. *Pendant Cross*

Upper Rhineland, probably Basel, 1380–1400. Raised, cast, engraved, and gilded silver, with seed pearls: Height, 6.3 cm.
Inscribed (on the *titulus*): inri
Historisches Museum Basel, 1882.100.

54. *Pendant Cross*

Germany, 15th century. Mother-of-pearl, with gilded-silver mount and suspension loop: Height (overall), 4.3 cm.
Historisches Museum Basel, 1905.5298.

The Treasury inventory of 1827 lists fifteen pendant crosses and reliquaries that, like the preceding fragmentary pendant, were most likely private gifts of supplication to particular saints. Of exceptional refinement is the gilded-silver cross with clusters of seed pearls attached to the termini that is suspended from a section of chain (no. 53); in miniature, on the obverse, is an image of the crucified Christ and, on the reverse, of a standing Virgin and Child. In the 1477 inventory, the Reliquary Bust of Saint Ursula (no. 41) is described as being adorned with this cross (". . . und daran so hangt ein Krútzlin mit vier berlechten knỏpffen . . .").[1] The mother-of-pearl patonce cross (no. 54) may well be the "berlinmutterzeichen" that the 1511 inventory describes as also suspended from the Bust of Saint Ursula.[2]

PROVENANCE: (53 and 54) 1834, allotted to Basel-City.

BIBLIOGRAPHY: (53) Burckhardt 1933, no. 50; Basel 2001, no. 36; (54) Burckhardt 1933, no. 51; Basel 2001, no. 37.

1. Inventory 1477:23.
2. Burckhardt 1933, p. 304.

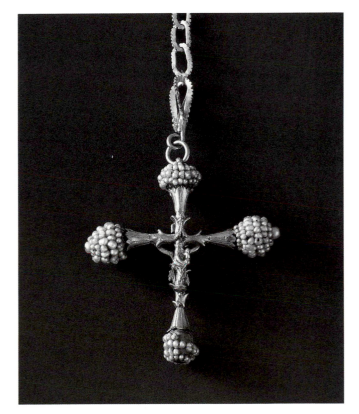

53: reverse

55. *Golden Rose Branch*

Minucchio da Siena. Avignon, about 1330 (rose branch);
Basel, about 1200–1225 (knop); Basel, about 1330–40
(shields, holder, and base). Cut and raised gold, with glass
stones (rose branch); raised and gilded silver, with filigree
and opaque *champlevé* enamel (holder); and gilded wood
(base): Height (overall), 84 cm.
Paris, Musée National du Moyen-Âge, Thermes & Hôtel de
Cluny, Cl 2351.

Composed of a central stem and five leafy branches, each terminating in a rose either in bud or in full blossom and centered on a colored-glass cabochon (see fig. 8), the Golden Rose Branch from the Musée de Cluny combines two distinct elements: the gold rose branch itself and the slightly later silver-gilt stand with a filigree knop. The rose was intended to be held in the hand, between the two spherical elements. Such roses were papal commissions and each was designed specifically for use in the liturgical celebration of the fourth Sunday in Lent: The pope held the rose, sprinkled with balsam, while delivering his sermon, and then, after the Mass, he carried it back to the papal residence where he personally bestowed it upon an individual he wished to honor. The Cluny Golden Rose Branch almost certainly can be identified with an Avignon document, which itemizes for February 14, 1330—a date during the reign of Pope John XXII—a golden rose made by the Sienese goldsmith Minucchio that was to be presented to the count of Neuchâtel. The latter most probably was Rodolphe III de Nidau, who received the rose as a gift and subsequently had the display stand fabricated and decorated with his coat of arms and the earlier filigree knop. The knop is very similar to that found on the Eptingen Chalice (no. 8) and must be more or less contemporaneous. It is not known how it came into the count's possession, nor are the circumstances under which the rose and its later stand entered the Treasury clear. Close political ties between the *seigneurs* of Nidau and Basel, however, are well established, and the Golden Rose Branch with its display stand must have been given to the cathedral before the count's death in 1339 or, as a bequest, shortly thereafter.

PROVENANCE: 1834, allotted to Basel-City; 1837, exchanged, along with the Reliquary Bust of Saint Thecla (no. 40) and the Arm Reliquary of Saint Valentine (no. 43), for the Hüglin Monstrance (no. 75), which had been allotted to Basel-Country, sold at auction in Liestal, and then acquired by the Academic Society of Basel, which subsequently sold all three objects; by 1842, sold to Colonel Jean-Jacques Ursin Victor Theubet, Porrentruy; 1854, in gratitude for its having purchased the Golden Altar Frontal (no. 2), given to the Musée de Cluny.

BIBLIOGRAPHY: Burckhardt 1933, no. 13; Taburet-Delahaye 1989, no. 63, pp. 166–69.

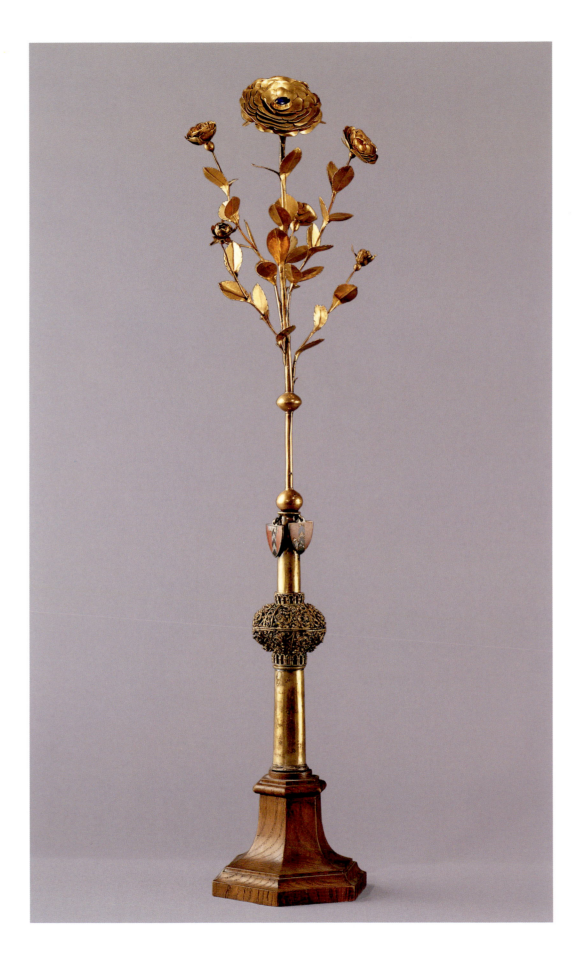

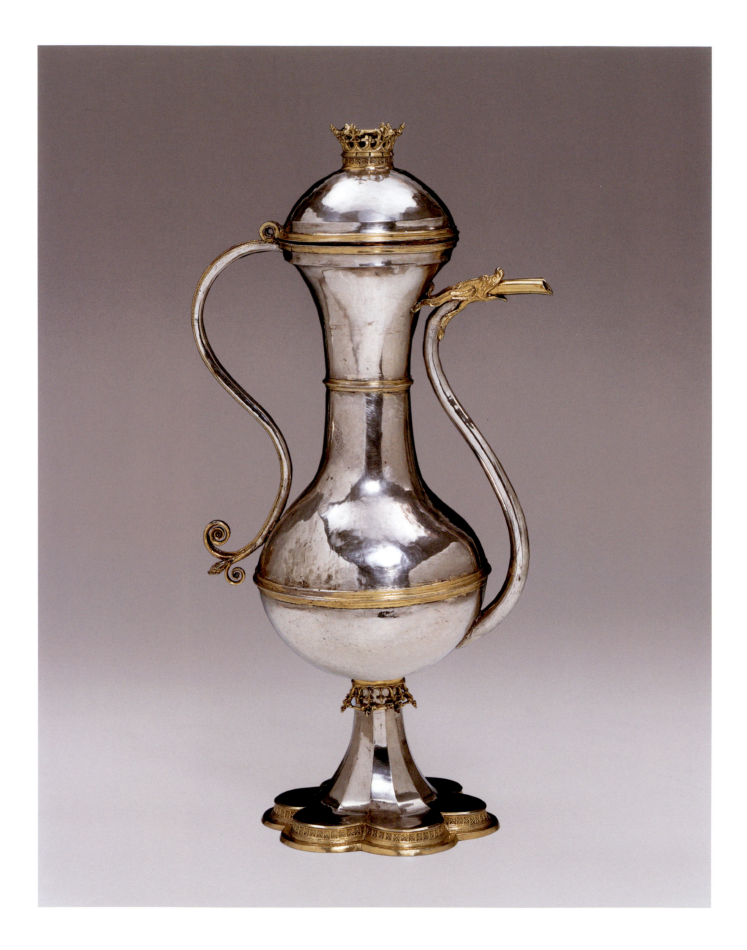

56. *Ewer*

Germany, about 1350, with 15th- and 19th-century
alterations. Raised, cast, stamped, chased, and partially
gilded silver: Height, 28.7 cm.
London, Victoria and Albert Museum, 7914–1862.

The London ewer can be grouped with several tall, spherical-bodied vessels all dating to the first half of the fourteenth century; the dragon-headed spout, on the other hand, is nearly identical to that found on a number of other vessels that appear to be of northern German origin and date slightly later.[1] The fact that the usual wine and water marks—such as those visible on the Victoria and Albert Museum cruets (see nos. 11, xix) or on a cruet now lost but recorded in an 1836 watercolor by Johann Friedrich II. Burckhardt-Huber[2]—are not in evidence strongly suggests that the ewer was intended for secular not liturgical use. It is, therefore, very likely that it was a personal gift, the date and circumstances of which are entirely unknown. Once in the possession of the cathedral, the vessel may well have served a sacramental function, and, indeed, in the 1827 inventory, it is listed among six silver cruets for the Mass ("sechs silberne Messkännchen . . .").[3] Another watercolor by Burckhardt-Huber records the appearance of the ewer in 1836 and clearly establishes that it was subsequently altered,

most notably in the reshaping of the foot and lid and in the replacement of both the finial and the ornament at the join of the stemmed foot to the vessel with crown-like open-work enhanced by fleurs-de-lis.[4]

PROVENANCE: 1834, allotted to Basel-Country; 1836, sold at auction in Liestal to the Basel goldsmith Johann Friedrich II. Burckhardt-Huber; until 1848, Sommesson collection, Paris; until 1861, Prince Peter Soltykoff, Paris, when it was sold at auction, along with the Covered Beaker of Eucharius Vol (no. 57), to van Cuyck; 1862, acquired by the South Kensington Museum, London, later the Victoria and Albert Museum.

BIBLIOGRAPHY: Burckhardt 1933, no. 59; Karlsruhe 1970, no. 241, p. 272, fig. 221; Fritz 1982, no. 648, p. 277, fig. 648; Basel 2001, no. 41.

1. Fritz 1982, p. 277, prefers a date of 1400–1425.
2. Burckhardt 1933, p. 340, fig. 254.
3. Inventory 1827:41; see Burckhardt 1933, p. 377.
4. Burckhardt 1933, p. 310, fig. 239, p. 312.

57. Covered Beaker of Eucharius Vol

Upper Rhineland, probably Basel, 1450–1500. Raised,
cast, stamped, engraved, and partially gilded silver, with
translucent enamel: Height, 30 cm.
Inscribed (on the banderole on the finial): h. d. g.
London, Victoria and Albert Museum, 7941-1882.

This covered drinking vessel was given to the Treasury
sometime between 1477 and 1511, when it first appears in
the inventory. Like many secular vessels of the type, this
exceptional example was altered so that the lid could be
fixed securely to the beaker, which would then serve as a
reliquary. The elaborate vessel is supported by three wild
men, while a fourth nestles among the leaves and flowers of
the finial. The inscribed initials are thought to stand for
"God help you" ("helf dir Gott").[1] The inventories of 1511
and 1525 indicate that this skillfully wrought object was the
gift of the cathedral chaplain Eucharius Vol, who was buried
in the cathedral cloister.[2] It ranks among the finest Late
Gothic secular vessels to have survived from an ecclesiastical
treasury.

PROVENANCE: 1834, allotted to Basel-Country; 1836, sold at auction
in Liestal to the Basel goldsmith Johann Friedrich II. Burckhardt-
Huber; until 1848, Sommesson collection, Paris; until 1861, Prince
Peter Soltykoff, Paris, when it was sold at auction, along with the
Ewer (no. 56), to van Cuyck; 1862, acquired by the South Kensing-
ton Museum, London, later the Victoria and Albert Museum.

BIBLIOGRAPHY: Burckhardt 1933, no. 60; Karlsruhe 1970, no. 234,
p. 269, fig. 214; Fritz 1982, no. 625, p. 274, fig. 625; Basel 2001,
no. 40.

1. Burckhardt 1933, p. 315.
2. Inventory 1525:37; see Burckhardt 1933, p. 316.

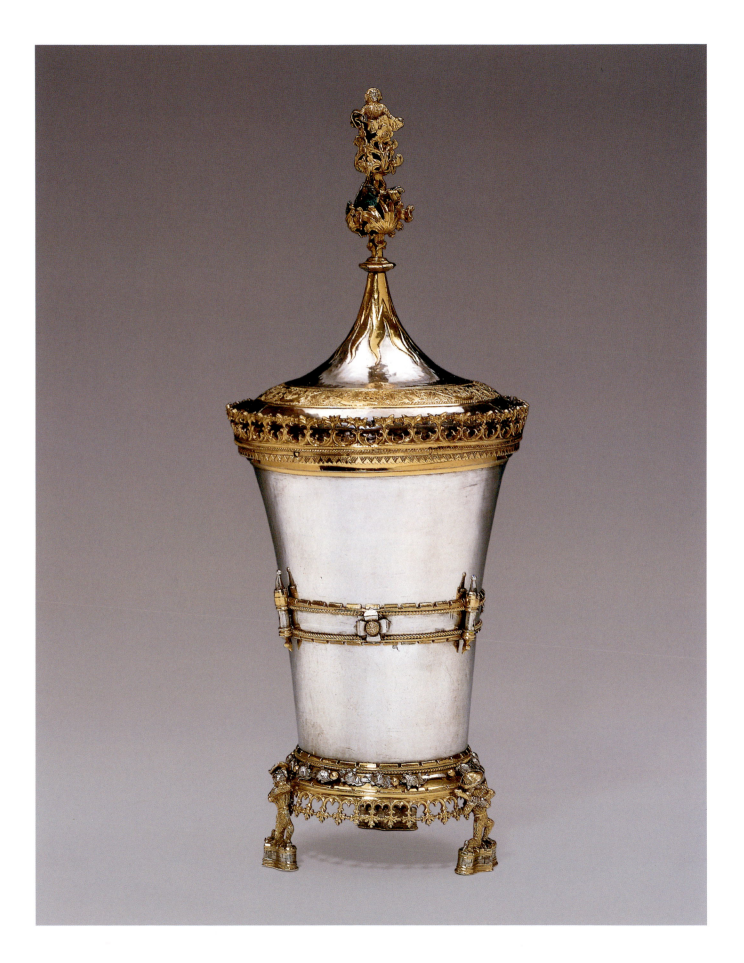

58. *Reliquary Cross with the Virgin, Saint John the Evangelist, and Two Angels*

Upper Rhineland, possibly Basel, about 1330. Raised, cast, and gilded silver, with translucent *basse-taille* enamel and rock crystal: Height, 68 cm.
Staatliche Museen zu Berlin, Kunstgewerbemuseum, K 3861 (lost or destroyed, 1945).

Of all the losses from the Basel Treasury none is more lamentable than that of the Reliquary Cross known as the Chapel Cross (*Kapellenkreuz*). Curving branches supporting the Crucifix and the flanking figures of the Virgin and Saint John the Evangelist rise out of the diminutive chapel articulated with delicate, attenuated Gothic tracery; this formal concept was revisited in the Hallwyl Reliquary (no. 34) nearly a century and a half later. Supported by a raised platform encrusted with brilliantly colored translucent enamels, the chapel and the Crucifixion group are flanked by two angels, each holding a crystal reliquary cylinder. The overall balance and proportion of the ensemble, the grace and expressive value of the individual figures, the refinement of detail and construction, and the richness of material all mark this reliquary as a masterpiece of Gothic goldsmiths' work.

During World War II, the Chapel Reliquary Cross was stored in a bunker in the Friedrichshain district of Berlin. There is apparently reason to believe that the Reliquary Cross was still there in May 1945 and that, contrary to the generally held assumption, it had not yet been destroyed.[1]

PROVENANCE: 1834, allotted to Basel-Country; 1836, sold at auction in Liestal and acquired by the Berlin dealer Arnoldt; 1838, acquired for the Kunstkammer of the Schlossmuseum, Berlin, then part of the royal museums; 1875, with the dissolution of the Kunstkammer, transferred to the Kunstgewerbemuseum.

BIBLIOGRAPHY: Burckhardt 1933, no. 17; Braun 1940, pp. 465, 478, 487, 491, fig. 554; Guth-Dreyfus 1954, pp. 54–56; Heuser 1974, p. 107; Cologne 1978, vol. 1, p. 199; Fritz 1982, no. 214, pp. 213–14, fig. 214; Lüdke 1983, vol. 1, fig. 199, vol. 2, no. 290, pp. 669–73; Reinle 1988, p. 100.

1. This information was kindly provided by Lothar Lambacher.

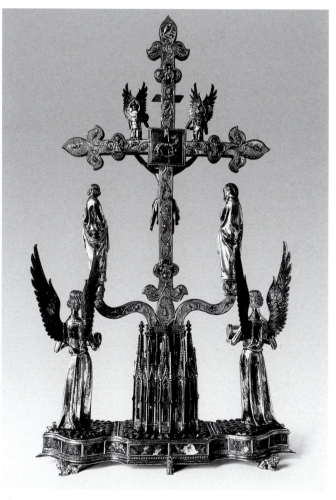

58: reverse

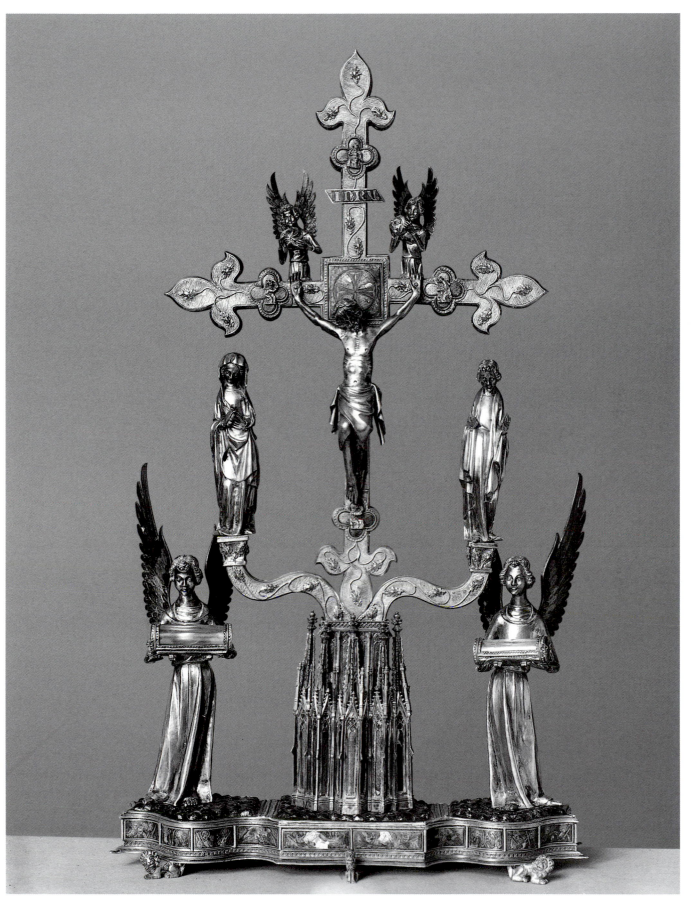

58: obverse

xix. *Watercolor of a Pair of Altar Cruets and a Reliquary Capsule*

Johann Friedrich II. Burckhardt-Huber (1784–1844).
Basel, about 1836. Pencil, pen and ink, and watercolor:
50 x 64.8 cm.
Historisches Museum Basel, 1922.164.

The Basel goldsmith Johann Friedrich II. Burckhardt-Huber acquired a number of objects from the Basel Treasury in the auction at Liestal in 1836 and subsequently made full-scale watercolor renderings of them. The altar cruets depicted in the present watercolor are today in the Victoria and Albert Museum, London (no. 11). The pendant reliquary capsule, on the other hand, is one of several works that have been lost since their dispersal after the Liestal sale; it was, according to the 1827 inventory, among fourteen small items contained in a corporal box covered in red-and-white damask.[1] Said to have been made of gilded silver, it was set with precious or semi-precious stones; the Crucifixion was repre-

sented on one side and Christ Enthroned on the other. This capsule may well be one of the five jewel-like objects that, according to the 1511 inventory, were suspended from the Heinrich Cross (no. 4).[2] It is by no means impossible that the reliquary as well as other objects from the Treasury that were scattered in the nineteenth century may surface one day.

PROVENANCE: 1894, purchased from Samuel Burckhardt-Kern by the Historisches Museum Basel; 1922, accessioned by the museum.

BIBLIOGRAPHY: Burckhardt 1933, no. 70.

1. Inventory 1827:46a; see Burckhardt 1933, no. 70.
2. Ibid., p. 341.

59. *Ewer*

Venice or Paris, 1350–75 (rock crystal); Basel, 1350–75
(mounts). Rock crystal, with raised, cast, stamped,
engraved, and gilded-silver mounts: Height, 22.2 cm.
Vienna, Kunsthistorisches Museum, Kunstkammer, 9051.

Several objects dispersed after the 1836 auction in Liestal
eventually ended up in public collections, yet were not
identified as having come from the Treasury for many years.
The large Gothic Censer (no. 16) is a notable instance:
Given to The Metropolitan Museum of Art in 1917, its
provenance was not rediscovered until 1960. The present
ewer is certainly another such example. Although it had
been in the Kunsthistorisches Museum since 1932, only in
1957[1] was it identified with "... a small crystal ewer given
by bishop Hartmann Münch" ("... ein parillen kenlin dedit
dominus episcopus Hartmannus Munch"), itemized in the
1477 inventory.[2]

Rare and exceptionally refined in its composition and
detail, this secular vessel was a gift to the Treasury, as indi-
cated by the inventory entry, from Hartmann III. Münch,
who was the bishop of Basel from 1418 until 1422 (see no.
xvii). As the vessel, on a stylistic basis, must be dated to no
later than about 1375, a probable original owner was Hart-
mann's father, Konrad VIII. Münch, who is documented in
1337 and again in 1371.[3] The high neck with the attached
spout was an expedient means of avoiding the difficulty
and risk of boring through the rock-crystal wall of the
vessel. The figure of the kneeling monk on the lid is a

visual play on the family name. Because the palmette frieze
and pearled borders of the mounts are nearly identical
to those on the Imperial Couple Monstrance (no. 65), the
metalwork in both instances is thought to have been pro-
duced in Basel and, almost certainly, in the same goldsmith's
workshop.[4] The crystal vessel itself was undoubtedly an
import from either Venice or Paris, known centers for
workshops specializing in the cutting, boring, and polishing
of rock crystal.

PROVENANCE: 1834, allotted to Basel-Country; 1836, sold at auction
in Liestal to the dealer Oppenheim; 1847, Debruges-Duménil collec-
tion, Paris; 1910, Maurice Kann collection, Paris; 1911 or after,
acquired by Gustav von Benda, Vienna; 1932, bequeathed by Gustav
von Benda to the Kunsthistorisches Museum.

BIBLIOGRAPHY: Lanz 1957, pp. 29–35; Fritz 1982, no. 359, p. 236,
fig. 359; Hahnloser and Brugger-Koch 1985, no. 464, pp. 221–22,
fig. 464; Darmstadt 1992, no. 45, p. 151; Basel 2001, no. 39.

1. Lanz 1957, pp. 29–30.
2. Inventory 1477:13.
3. Distelberger, in Basel 2001, no. 39.
4. Lanz 1957, pp. 32–33; Distelberger, in Basel 2000, no. 39.

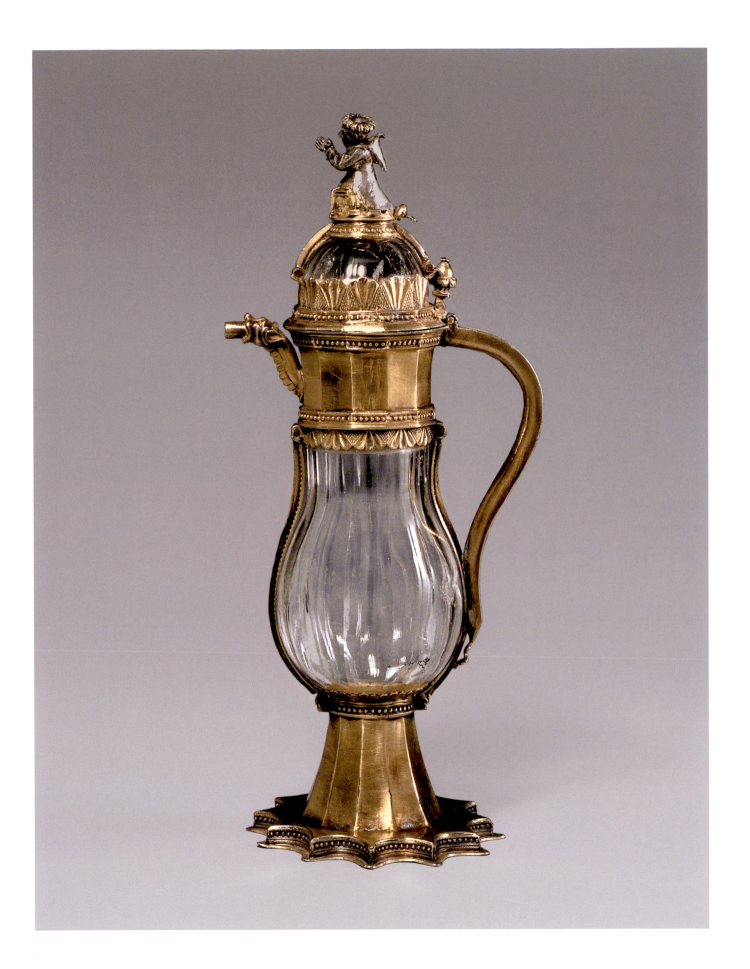

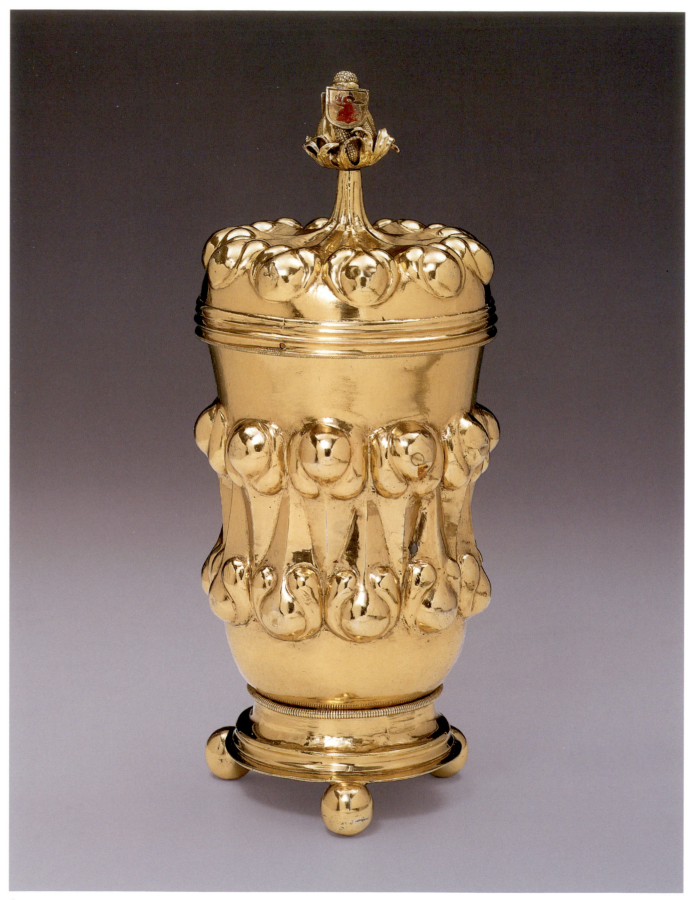

60. *Covered Beaker of Ulrich zem Luft-Eberler*

Purportedly Upper Rhineland, probably Basel, 1470–90.
Cast and gilded silver with opaque *champlevé* enamel:
Height, 22.5 cm.
London, Victoria and Albert Museum, 2112–1855.

xx. *Copy of the Covered Beaker of Ulrich zem Luft-Eberler*

London (?), presumably 1911–13. Gilded-silver electrotype,
with opaque *champlevé* enamel: Height, 22.5 cm.
Historisches Museum Basel, 1913.3.

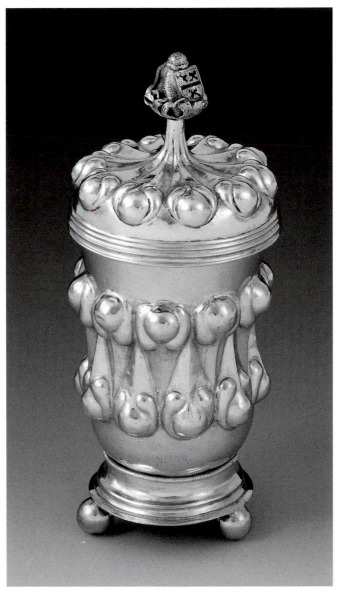

The first of these two covered beakers, with raised globular, or "fish-bladder," decoration, and resting on three spherical feet, was long thought to be the original from the Basel Treasury. According to the 1511 and 1525 inventories,[1] the vessel was the gift of the city councillor Ulrich zem Luft (1429–1490), whose coat of arms and that of his wife, Anna Magdalena Eberler zum Grünenzwig, are surrounded by the berry-like fruit and curly leaves of the finial; the earlier inventory mentions that the beaker was given to the cathedral by the son of Ulrich, Dr. Arnold zem Luft.[2] According to the 1585 inventory, the beaker stood on a gilt-work base placed on the high altar, and presumably then served as a reliquary.[3] The highly original form of this vessel, of robust but balanced proportions, contrasts with the elegant attenuation and refined details of the Vol Beaker (no. 57).

When it entered the collections of the Victoria and Albert Museum, the provenance of this vessel was unknown, and only in 1911 did Rudolf Burckhardt identify it as having come from the Treasury of Basel Cathedral. Shortly afterward, the Victoria and Albert commissioned an electrotype replica (no. xx), which was presented in 1913 to the Historisches Museum Basel; it is now displayed there in the introductory section to the new installation of the Treasury objects. However, in the course of preparing this publication it was discovered that the London vessel is made not of raised but of cast silver, and, therefore, cannot be the original.[4] The question remains as to whether the Victoria and Albert originally acquired a copy of the Luft-Eberler Beaker or whether the goldsmith who provided the replica for Basel produced one, unsolicited, for the London museum as well.

PROVENANCE: (60) 1834, allotted to Basel-Country; 1836, sold at auction in Liestal; thereafter, uncertain; 1855, included in the Ralph Bernal sale, Christie's, London, and entered the collections of Marlborough House, which, in 1878, were incorporated into the South Kensington Museum, later the Victoria and Albert Museum.

BIBLIOGRAPHY: Burckhardt 1933, no. 61.

1. Inventories 1511:39 and 1525:38, respectively.
2. Burckhardt 1933, p. 320.
3. Ibid., p. 323.
4. I am grateful to Martin Sauter for providing this information.

61. *Replica of the Chain of the Order of Our Lady of the Swan*

Berlin, 1887 or slightly earlier. Gilded-copper electrotype:
Length, 74 cm.
Staatliche Museen zu Berlin, Kunstgewerbemuseum,
1888,546.

The Order of Our Lady of the Swan was founded in 1440 by the elector Friedrich II of Brandenburg and its insignia was bestowed on the Society of the Knights of Brandenburg.[1] The chain is formed of eighteen links, each of which consists of a heart pressed between two saw blades that represent the tools of martyrdom; the heart symbolizes the mortification of the flesh suffered by the saints. Suspended from the chain is the device of the order, a bust-length image of the Virgin holding the Christ Child, supported by a crescent moon and surrounded by the rays of the sun; from this pendant hangs a second one with a swan encircled by a miraculous cloth. The swan, which foresees its own death, is a reminder of the transitory nature of life, while the cloth is a symbol of chastity. Hanging from chains suspended from the cloth are six tiny bells that remind the wearer to be ever vigilant against the wages of evil and to behave charitably. The order was revived in 1834 by King Friedrich Wilhelm III of Prussia for eleemosynary purposes.

The original chain was bestowed upon Peter Rot, who was the mayor of Basel in 1455 and was a member of the order in 1464; he fought against Charles the Bold, Duke of Burgundy, at Grandson and at Murten in 1476, and died in 1487. The chain was given to the cathedral in 1506 by his widow and second wife, Ursula von Efringen. Apparently intended as a gift to her patron saint, the chain, as noted in the 1511 inventory, was suspended from the neck of the Reliquary Bust of Saint Ursula (no. 41).[2]

Several objects from the Basel Treasury were replicated in the nineteenth century for various reasons: The Victoria and Albert Museum, for example, presented the Historisches Museum Basel with a copy of the Ulrich zem Luft-Eberler Beaker (see nos. 60, xx) out of gratitude for information given concerning the origins of the beaker, and Colonel Theubet, whose motives are less clear, had an exact replica made of the large Gothic Censer (no. 16) in raised silver (no. xiv). The present copy, likewise produced for an uncertain purpose, was given by Emperor Friedrich to the Kunstgewerbemuseum in 1888. Its fabrication proved to be fortuitous: In 1899, the original was in the Prussian Crown Treasury and later in the Hohenzollernmuseum; the only medieval example to have survived, the chain disappeared during War War II. The Berlin replica preserves the appearance of the original and is thereby a document of historical importance.

PROVENANCE (for the original): 1834, allotted to Basel-Country; 1836, sold at auction in Liestal and bought by the Berlin dealer Oppenheim for King Friedrich Wilhelm III; 1899, in the Prussian Crown Treasury and later in the Hohenzollernmuseum; 1945, disappeared.

BIBLIOGRAPHY: (for the original) Burckhardt 1933, no. 62; Steingräber 1956, p. 71, fig. 100; Fritz 1982, pp. 98, 319; Lightbown 1992, p. 262, fig. 136; Berlin 1999, no. 2.31, pp. 225–26.

1. The information in this entry was provided by Lothar Lambacher.
2. Inventory 1511:23; see Burckhardt 1933, no. 62.

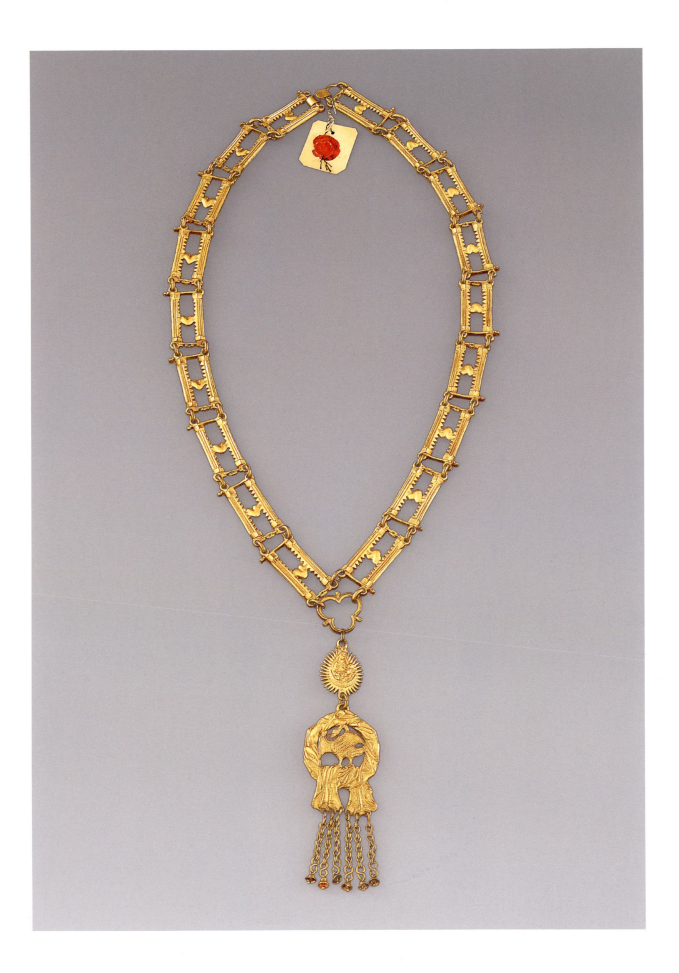

62. *After Cast of the Golden Altar Frontal*

Heinrich Baumgartner and Gregor Mahrer, after a 19th-
century cast by Johann Heinrich Neustück and
M. G. (Matthias Grell?), Basel, 2000. Gilded and painted
composite: 120 x 177.5 x 13 cm.
Augsburg, Haus der Bayerischen Geschichte.

Subsequent to his purchase of the Golden Altar Frontal (no. 2) from the Basel goldsmith Johann Jakob III. Handmann (see pp. 28, 30–31), Colonel Jean-Jacques Ursin Victor Theubet had two plaster casts of it made, one gilded (illustrated here) and the other not. Theubet donated the ungilded version to the museum in the Augustinergasse, Basel (it is now in the Museum Kleines Klingental), and the gilded cast was bequeathed by his heirs in 1904 to the Historisches Museum Basel, where it remains on exhibition. Because of their fragility, neither nineteenth-century cast could travel to New York for the exhibition at the Metropolitan Museum in 2001, and the present after cast was fabricated as a substitute. This, the most recent of the replicas of the Golden Altar Frontal, eventually will be displayed in Bamberg Cathedral; thus, a modern copy replaces the original that many believe left for Basel almost one thousand years ago.

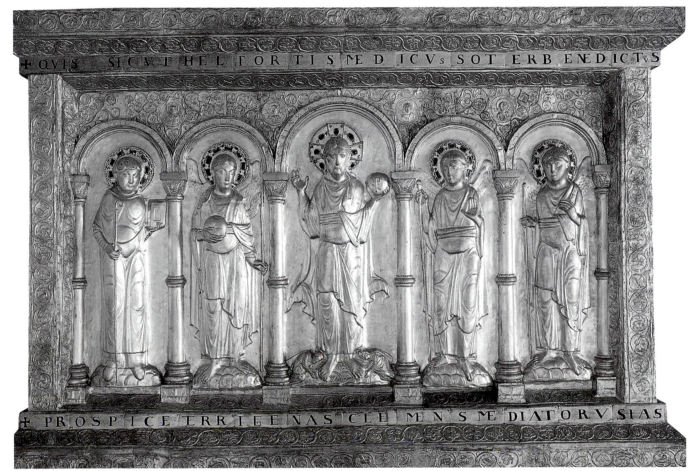

Cast of the Golden Altar Frontal. Before 1849. Historisches Museum Basel, 1904.369.

63. *Small Knight*

Upper Rhineland, probably Basel, 1440–60. Cast, raised, and gilded silver: Height, 5.3 cm (knight); Ulrich Sauter, Basel, 1917. Raised and gilded silver: Height (covered beaker overall), 23.1 cm.
Historisches Museum Basel, 1979.336.

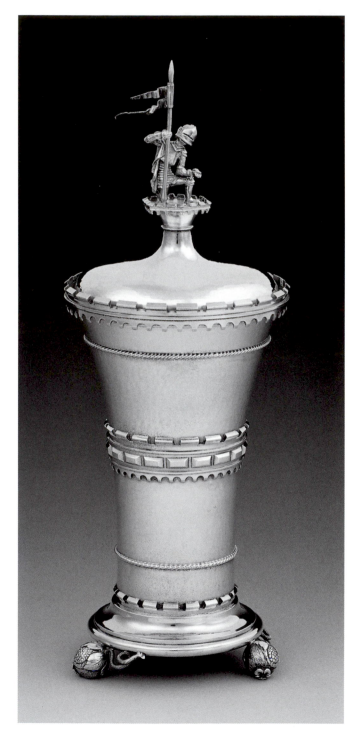

Atop an eight-sided crenellated platform, a knight, on bended knee and wearing full armor, clasps a bannered lance in his right hand; in his left hand he once held a shield (now missing). The small cloth draped over his right shoulder signifies a love token from his lady, whose honor he must defend in a joust; it may be in deference to her that he assumes this chivalrous pose.

Although there is no clear reference to this small figure in any of the inventories, it can be linked to the Basel Treasury with some assurance. The town councillor Emanuel Burckhardt (1776–1844) was, through his second wife, a brother-in-law of the Basel goldsmith Johann Jakob III. Handmann, one of the three evaluators of the Basel Treasury and the purchaser of the Golden Altar Frontal (no. 2). While attending the 1836 auction in Liestal with Handmann, Burckhardt noted that the last item sold was a little knight, which a proprietor from Bubendorf named Matthias Flubacher acquired for fifty francs; attracting derision from all, Flubacher paraded about with the figure attached to the fob of his pocket watch. It appears that he became dispirited, lost interest in his purchase, and sold it to Wilhelm Oser, who, in turn, sold it—along with the Rotberg Chalice (no. 12)—to the mayor of Basel Felix Sarasin-Brunner (1797–1862).[1] The Rotberg Chalice was given by Sarasin's widow to the Historisches Museum Basel when the museum relocated to the Barfüsserkirche in 1894, while the small knight remained in the Sarasin family. In 1917, the figure, undoubtedly in a return to its intended function, was attached as a finial to the cover of a silver beaker made by Ulrich Sauter.

PROVENANCE: 1836, sold at auction in Liestal to Matthias Flubacher, and then acquired by Wilhelm Oser; until 1862, Felix Sarasin-Brunner, Basel, and then Jakob R. Sarasin-Schlumberger, Basel; 1917, attached to the cover of a commissioned beaker; until 1979, Hans J. Sarasin, then Historisches Museum Basel.

BIBLIOGRAPHY: Burckhardt 1952, pp. 25–28; Barth 1990, pp. 8–9; Basel 2001, no. 62.

1. Burckhardt 1952, p. 28.

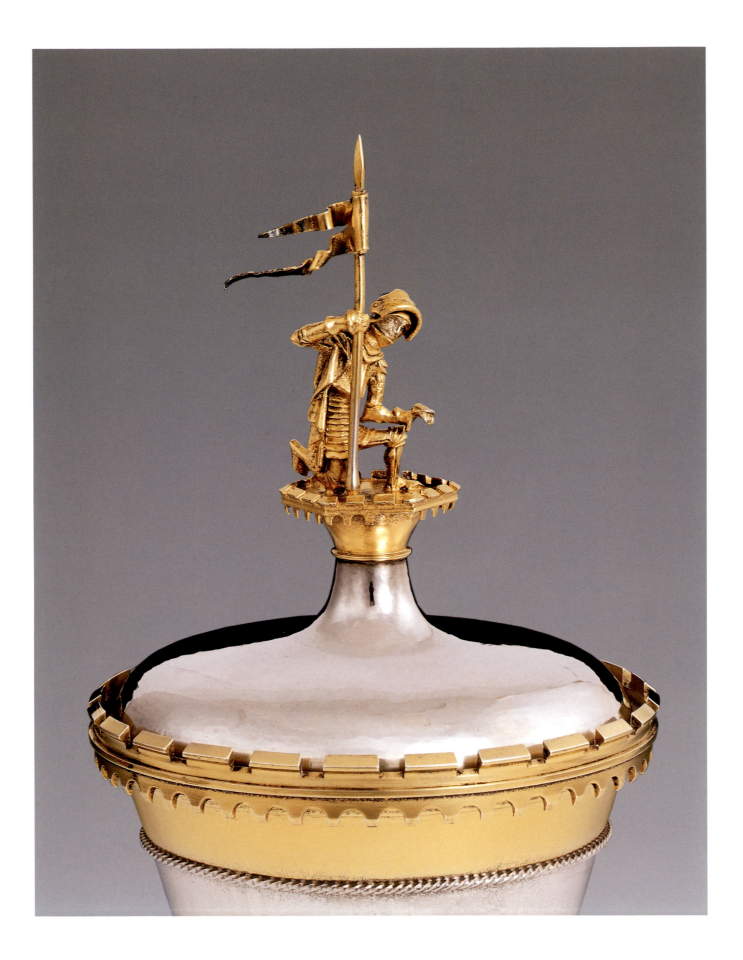

MONSTRANCES

xxi. *Charter Documenting the Acquisition of Relics by Bishop Johann Senn von Münsingen*

Basel, 1360. Pen and ink, and watercolor, on vellum, with five wax seals: 40 x 52 cm.
Staatsarchiv des Kantons Basel-Stadt (Domstift Urkunde 119).

On October 18, 1356, a violent earthquake struck Basel, devastating the cathedral and many of the houses in the city. Intent on comforting his people as well as on rebuilding his church, Bishop Johann Senn von Münsingen (r. 1335–65) petitioned Rome for relics. The present charter, dated April 25, 1360, registers the acquisition of remains of saints Paul, Cecilia, Pancras, Fabian, Sebastian, Agnes, Dorothy, Urban, Petronella, George, and Lucy, as well as of the Holy Innocents and the 10,000 Martyrs. These relics attracted numerous donations to be used for the reconstruction of the cathedral, and Bishop Johann consecrated the high altar in the new choir on June 25, 1363.

The historiated initial *I* shows Johann Senn von Münsingen kneeling between Saint Paul and the Virgin and Child. The apostle hands over his unnaturally large tooth to the bishop, who offers it, mounted in a tower-shaped monstrance (compare with no. 65), to the Virgin Mary, patroness of the cathedral. Bishop Johann is thus depicted as a benefactor of the Treasury. The miniature illustrates the medieval belief that the possession of a relic ensures that those in its presence will be protected by the holy person from whom it comes, since the relic is a fragment of the latter's body. Attached to the document are two texts—one of May 23, 1360, and the other of January 19, 1361—each rewarding the veneration of the relics with a forty-day indulgence (the remission of temporal punishment in purgatory).

PROVENANCE: 1529, municipal archives, Basel.

BIBLIOGRAPHY: Stückelberg 1907, caption to pl. 17; Escher 1917, no. 359, p. 249; Burckhardt 1933, p. 9, fig. 4, p. 11.

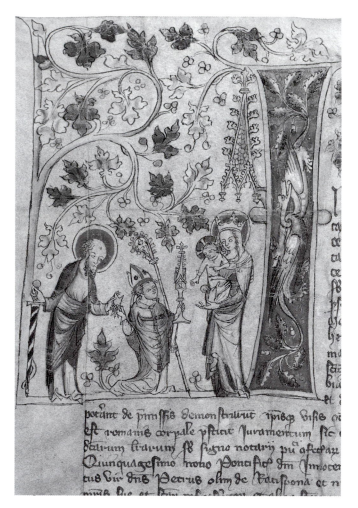

64. *Apostles Monstrance*

Basel, 1330–40, with 15th-century alterations. Raised, cast,
engraved, punched, and gilded silver, with translucent
basse-taille enamel and rock crystal: Height, 74.2 cm.
Inscribed: (on the foot) ·s·COLLVNBANVS/AVE GRACIA PLENA
DOM; (on the banderole held by the engraved angel) O GLORIA
Historisches Museum Basel, 1933.159. Purchased with
public and private contributions.

One of the masterpieces of the Basel Treasury, this excep-
tional monstrance is centered on a disk-shaped vessel sur-
rounded by sixteen circular translucent *basse-taille* enameled
plaques. Surmounting the central section is an ornate crock-
eted gable of tracery flanked by two slender towers, all of
which are capped with finials of enameled buds emerging
from leafy surrounds. The whole is supported by a tall stem
with an architectural knop resting on a hexalobe foot. The
enameled plaques on the foot depict Saint Columban, along
with five scenes from the Infancy of Christ: the Annuncia-
tion, Nativity, Adoration of the Magi, Massacre of the Inno-
cents, and Flight into Egypt. The enamels around the central
disk represent: at the top, Christ and the Virgin; at the bot-
tom, two angels; and, in between, six on each side, the
Twelve Apostles, who reappear as standing figures on the
arcaded knop. The foot is further elaborated with a raised
leaf-and-tendril pattern against a punched ground.

A monstrance, from the Latin *monstrare* (to show)—alter-
nately known as an ostensory, or ostensorium, from the
Latin *ostendere* (also, to show)—in the earlier Middle Ages
generally denoted a vessel with a crystal cylinder or disk
intended for the display of either the Host or a relic. In the
mid-thirteenth century, with the institution of a feast day in
honor of the Host, the term increasingly connoted a vessel
of dedicated function, and, as its shape more closely corre-
sponded to its contents, the disk variety eventually prevailed.
This evolution was propelled by the pietistic belief that the
viewing (*visio*) held apotropaic value; merely glancing at the
Host in the morning, for example, protected the faithful
from dying unprepared that day.

The intended function of this vessel has been much
debated. The inclusion of Saint Columban side by side with
the Massacre of the Innocents led to the earlier belief that
the monstrance originally held the foot of one of the Holy
Innocents (see nos. 44, 47). The issue is complicated by the
fact that, like so many sacred vessels, this one was altered or
adapted in the course of its medieval history: At the very
least, the sun's rays and the plaque engraved with an angel
were added to the back in the later part of the fifteenth cen-

tury (see fig. 12), and possibly more extensive changes were
occasioned as well.

The circular format of the rock crystal and the limited
depth of the flat, frontal vessel seem, on the other hand,
to preclude its use as a foot reliquary. It has been argued,
therefore, that the Apostles Monstrance originally was
intended to display the Host—and, in fact, it is the earliest
surviving example of the gabled type of Eucharistic mon-
strance.[1] Its currently accepted date places the fabrication
shortly after the introduction in Basel of the Feast of Corpus
Christi in the 1320s.[2] The apostles are shown on the arcaded
knop both as individuals who spread the word of Christ
throughout the world and, more importantly, as the disci-
ples who accompanied Christ at the Last Supper. In the lat-
ter role, the apostles in the circular medallions gaze upon or
gesture toward the Eucharistic vessel that held the flesh of
Christ, underscoring his place as Redeemer of mankind.
The monstrance may have served a secondary function as an
apostolic reliquary as well, for the knop is constructed as a
container. Indeed, both the 1477 and 1525 inventories refer
to it as large and beautiful and also indicate that it was
known as the apostles monstrance ("genannt de apostolis"
and "genant von den Zwœlffbotten").[3]

The purpose of the fifteenth-century alterations is unclear:
The fact that the 1525 inventory describes the monstrance as
having relics (". . . mit kœstlichem heiltum") must be signi-
ficant, but the iconography of the angel and plaque shed little
light on the matter (see fig. 12). The sun's rays—associated
with Saint Bernardino of Siena's cult of Christ's monogram—
appear, however, to enhance the display of Christ's flesh.[4]

Notwithstanding the perplexing alterations to the Apostles
Monstrance, it remains a remarkable example of goldsmiths'
work, exceptional for its clarity of composition and form,
richness of detail, accomplished execution, and quality of
enameled decoration. The palpable influence of Strasbourg
has been observed: The star-like tracery in the central circle
of the gable, so fine and delicate in its detail that it resembles
a snowflake, is a miniaturization of that in the gable over the
north portal on the western façade of the Cathedral of

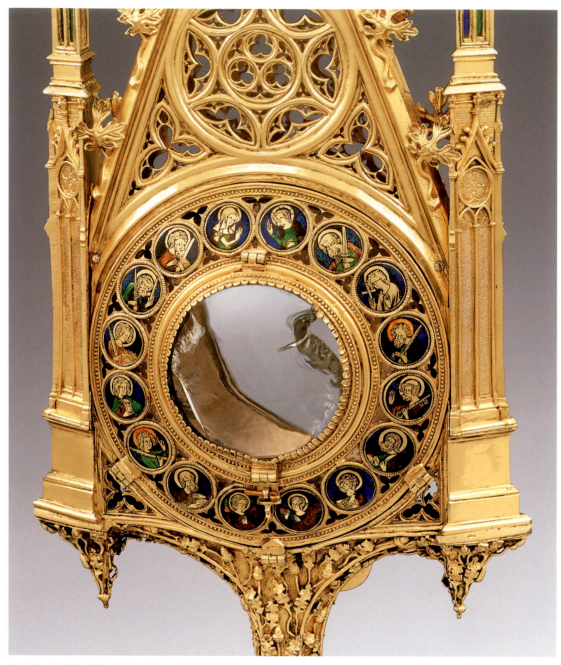

64: obverse (detail)

Strasbourg,[5] once again underscoring the seminal influence of this center of artistic creativity (see no. 34).

PROVENANCE: 1834, allotted to Basel-Country; until 1864, housed with the Imperial Couple Monstrance (no. 65) and the Münch Monstrance (no. 72) in the Liestal Town Hall; 1864, sold with the Imperial Couple Monstrance to the Paris art dealer Löwengard; 1867, both monstrances sold to Alexander P. Basilevsky; 1885, both monstrances purchased by Tsar Alexander III and deposited in the Hermitage; 1932–33, both sold through the dealer Theodor Fischer to the Historisches Museum Basel.

BIBLIOGRAPHY: Burckhardt 1933, no. 16; Braun 1940, pp. 343, 344, 346, 352, fig. 392; Guth-Dreyfus 1954, pp. 49–52; Heuser 1974, pp. 105–7; Fritz 1982, no. VII, pp. 181–82, pl. VII; Hahnloser and Brugger-Koch 1985, no. 175, pp. 136–37, fig. 175; Reinle 1988, p. 130; Barth 1990, no. 6; Guster 1999, pp. 63–71; Basel 2001, no. 11.

1. Fritz 1982, pp. 181–82.
2. Büttner, in Basel 2001, no. 11.
3. Inventories 1477:7 and 1525:9, respectively.
4. Guster 1999, p. 67.
5. Ibid., pp. 68–69, fig. 13.

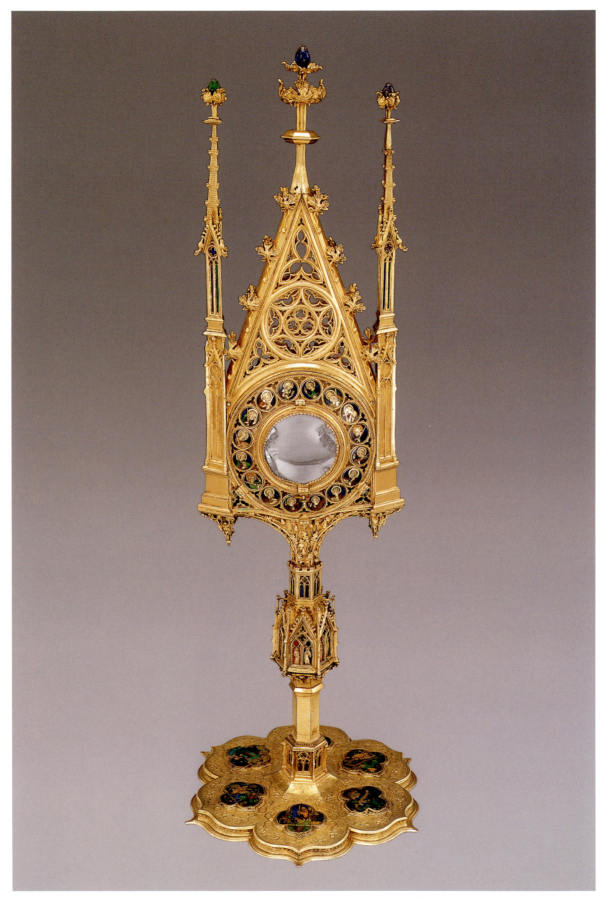

65. *Reliquary Monstrance of the Imperial Couple*

Basel, 1347–56. Raised, cast, punched, and gilded silver, with translucent *basse-taille* enamel and rock crystal: Height, 67 cm.

Inscribed: (on the banderole of Heinrich) ·S·HEĪR·ĪP̄ATOR·ET·CŌF'; (on the banderole of Kunigunde) S·K'VNIGV̄D'·ĪP̄ATX·V̇GO·; (on the enameled plaque below the spire, on the angel's banderole) AVE MARIA·GREIA; (on the foot) + HEINRICVS○CESAR○PRESENS○ TEMPLVM⊕REPARAVIT○; + PORTAVIT⊕CR⊕CRVCEM⊕ KV̇NIGVNDIS⊕CESARIS⊕VXOR; + REGINE⊕RADIVS⊕SOLIS⊕ SVMPSIT⊕CYROTHECAM; + NEPTIS⊕MAXILLA⊕FERT○ICTVS⊕ PVBLICA⊕SIGNA⊕; + ARPENTES⊕VOMERES⊕NON⊕REGINE⊕ NOEVERVNT/S'KVNIGV̄D'; + DVCITVR:AD⊕CELVM⊕CESAR⊕ MEDIANTE⊕CATHINO⊕/S'LAVRĒNT; + VT⊕VIDIT⊕POST⊕SEX○ ANNOS○DVX○EFFICITVR○RCX○/POST SEX; + CALCVLVS○AD○ PALMAM○REGIS○DATVR○A BENEDICTO

Historisches Museum Basel, 1933.158. Purchased with public and private contributions.

In recognition of the exalted role Heinrich II had played in the life of the city and of the cathedral, Bishop Johann Senn von Münsingen, on July 28, 1347, elevated the 13th of July to a holy feast day in honor of the emperor. In connection with this new feast day, the bishop, dean, and chapter of the cathedral, along with the mayor and city council, formally requested of the city and diocese of Bamberg, where Heinrich and Kunigunde were buried, relics of the sainted imperial couple. Bamberg consented, sending to Basel elements of the right arms of both saints, which were received amid much ceremony on November 4, 1347. The altar required for the saints was mostly donated by the subcustos of the cathedral, Johannes, the rector of Landser in Alsace, who became the first chaplain. The altar was established in the east walk of the cathedral cloister and was dedicated to Heinrich and Kunigunde on April 2, 1348; it was endowed with relics of the Virgin and of the imperial couple, as well as of Peter and Paul, Philip and James the Greater, Pantaleon, Valentine, Ambrose, Benedict, and Scholastica. On July 13, 1348, the feast day of Heinrich was celebrated for the first time.[1]

Although there is no documentation concerning the donor, date, or maker of the Imperial Couple Monstrance, the need for a new reliquary must have been satisfied at some point upon or shortly after the establishment of the feast day and the subsequent arrival of the relics of Heinrich and Kunigunde, probably before the 1356 earthquake. The intended function of the monstrance is clear: Standing on top of the two buttresses supported by angels and enhanced with blind lancets and tracery are statuettes of the imperial couple holding their identifying attributes and banderoles, and, in one of the earliest and most extensive narrative cycles, episodes of their legends are depicted and explicated in the medallions on the foot. Among the events included are: Saint Benedict miraculously removing a stone and healing Heinrich; Saint Wolfgang, bearing an inscription reading "post sex," appearing in a dream to Heinrich when he was still a duke, six years before he would become a king; devils weighing the soul of the deceased emperor, as Saint Lawrence tosses on the scales a chalice that Heinrich had donated to the Church of Saint Lawrence in Merseburg, thus tipping the balance in the emperor's favor; a ray of the sun miraculously returning a glove to Kunigunde, who retired to a nunnery after her husband died; Kunigunde slapping the face of her niece, the abbess, for the latter's profane behavior, with the sting mark remaining permanently on her face as a constant reminder to live piously; and Kunigunde, accused of infidelity in her childless marriage to Heinrich, walking across red-hot plowshares unharmed to prove her chastity.

PROVENANCE: 1834, allotted to Basel-Country; until 1864, housed with the Apostles Monstrance (no. 64) and the Münch Monstrance (no. 72) in the Liestal Town Hall; 1864, sold with the Apostles Monstrance to the Paris art dealer Löwengard; 1867, both monstrances sold to Alexander P. Basilevsky; 1885, both monstrances purchased by Tsar Alexander III and deposited in the Hermitage; 1932–33, both monstrances sold through the dealer Theodor Fischer to the Historisches Museum Basel.

BIBLIOGRAPHY: Burckhardt 1933, no. 15; Braun 1940, pp. 342, 346, 348, 351, 376–77, fig. 387; Guth-Dreyfus 1954, pp. 47–49; Grimme 1972, pp. 156–57; Heuser 1974, pp. 105–7; Fritz 1982, no. VII, pp. 181–82, pl. VII; Hahnloser and Brugger-Koch 1985, no. 250, p. 156, fig. 250; Guth 1986, no. 15, pp. 90, 92–96; Reinle 1988, p. 130; Barth 1990, no. 5; Basel 2001, no. 10.

1. This information is drawn from Büttner, in Basel 2001, no. 10.

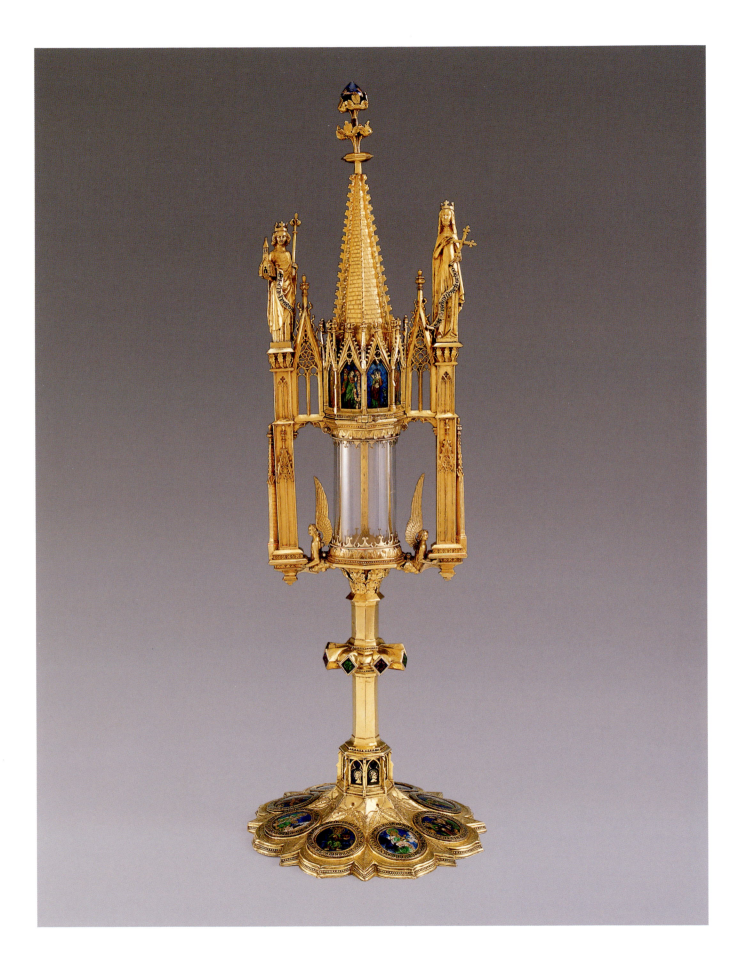

66. *Lamb of God or* Agnus Dei *Monstrance*

Basel, 1460–66. Raised, cast, engraved, punched, and partially gilded silver, with a rock quartz, tourmaline, garnet, aquamarine, topaz, and sapphire, and traces of enamel: Height, 60.2 cm.

Inscribed (on the reverse): Maximus + antistes + magna + pietat / e + secundus + Hunc + pius + agnellum + dei + / sacraverat + ipse + Quam + tibi + pro + magno + / celebris + basilea + decore + Mittit + et + ex + veteri + q / ua + te + sub +corde + benigno + Claudit + amicicia + veni / as + superaddidit + ultro + Magnas + ad + edem + sa / ncta + hanc + qui + crimine + fasso + / Acceserat + tristes + exponens +/pectore + culpas + / Divesq + soluetur +celi + rem / eabit in + ortus + / Donat + tibi + eneas + pius + hec / basilea + secundus + / m° cccc° lx°
Staatliche Museen zu Berlin, Kunstgewerbemuseum, K 3862.

This richly worked and jewel-beset object assumes the general form of a Late Medieval monstrance, but, properly speaking, it is not a monstrance, as its contents cannot be seen and it was never intended to display the Host. Instead, within a corona of golden tendrils, gemstones, and fully dimensional thistle leaves is the capsule that once contained an *Agnus Dei*. Rather than a crystal disk that would have allowed a view into the interior, the contents are indicated by the image of the nimbed Lamb of God, which once held a banner with the cross (lost between 1945 and 1953), signifying Christ's triumph. Resembling the Host, the *Agnus Dei* is a wafer made from the wax of Easter candles by archdeacons in the Lateran basilica in Rome on Good Friday and displayed to the congregation on the first Sunday after Easter. Since the early fifteenth century, the *Agnus Dei* was blessed by the pope on Maundy Thursday—initially, on an annual basis and later only in the first and seventh years of each pontificate. After 1471, the consecration of the *Agnus Dei* became the sole right of the pope.[1]

The reverse of the monstrance is engraved with an extended inscription in Gothic minuscule and a representation of a kneeling pope identifiable by his coat of arms surmounted by the papal tiara and the keys of Saint Peter as Pius II. The coat of arms is repeated three dimensionally on the obverse. The inscription, in paraphrased form, states that Pope Pius II consecrated the *Agnus Dei* with great piety and gave it to Basel out of deep friendship . . . along with other great favors . . . those who go in haste to the cathedral and repent their sins and transgressions will be redeemed and gain the heavenly kingdom. The date 1460 follows. Elected

66: reverse

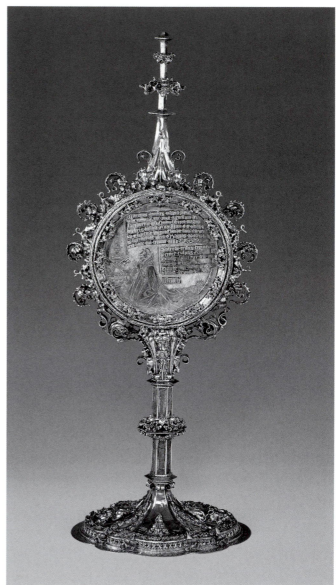

to the papacy in 1458, Pius II (1405–1464) was born Aeneas Silvius Piccolomini; as secretary and deputy, he spent some years in Basel during the Council of Basel (1431–48), occasioning his professed friendship toward the city. A man of great literary flair, he founded the University of Basel, through a papal bull of 1459.

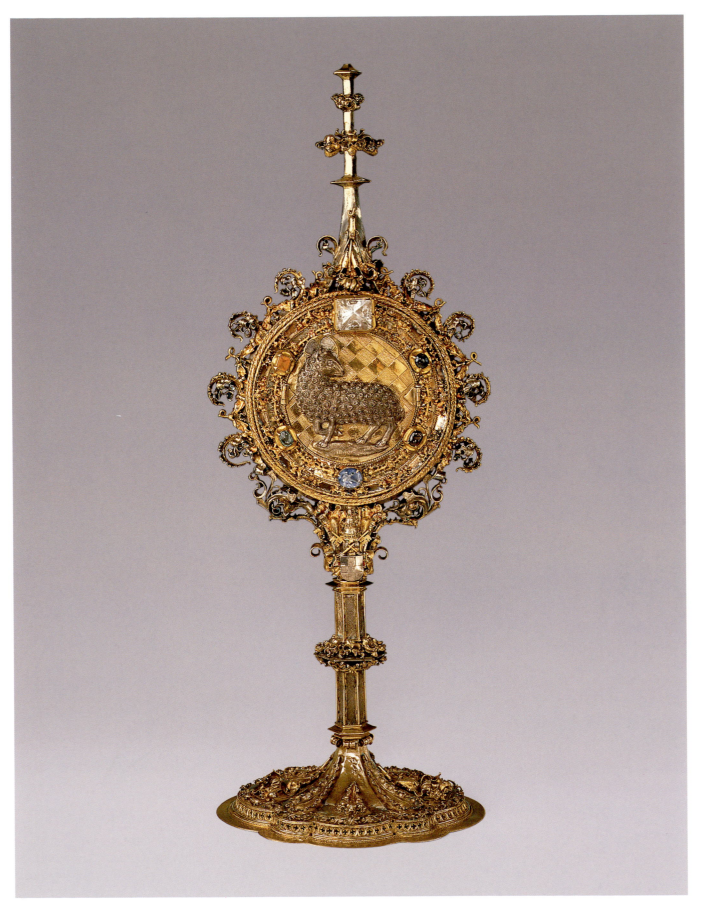

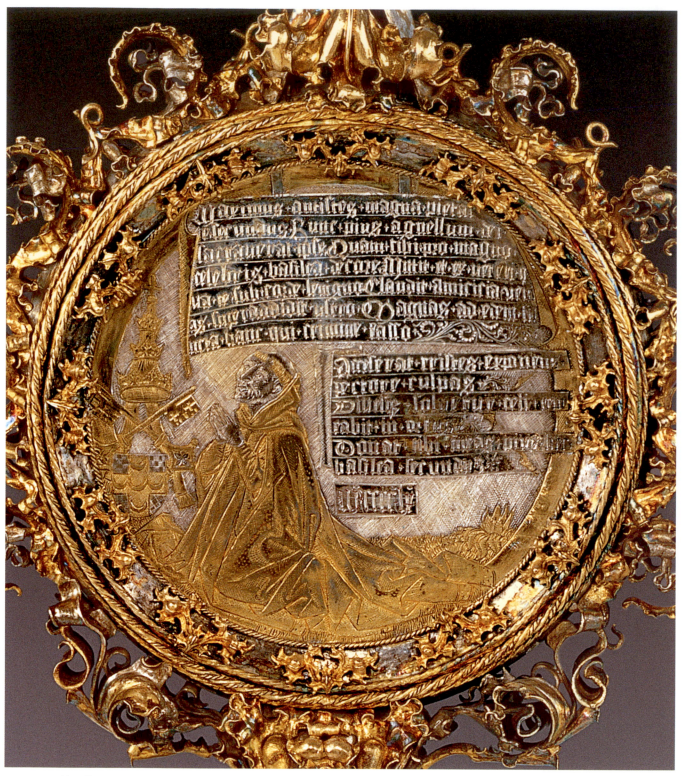

66: reverse (detail)

160

The inventory of 1477 informs us that the receipt of funds from the indulgences of 1460 (the "great favors" mentioned in the inscription), along with donated gemstones, enabled the cathedral deacon Johann Werner von Flachslanden to commission a new monstrance for the *Agnus Dei* (". . . ein núwe silberin monstrantz miz einem agnus dei");[2] as von Flachslanden became provost in 1466, it seems probable that the monstrance was ordered between 1460, when he gave the *Agnus Dei* to the cathedral, and the year of his elevation.[3]

The *Agnus Dei* Monstrance, assuredly of local manufacture, long has been attributed to the goldsmith Hans Rutenzwig on the basis of circumstantial evidence. Rutenzwig, who is first documented in Basel in 1453 and died there before 1489, thus was active at the time of the commission.[4] Furthermore, in 1471–72 he was described as the cathedral goldsmith ("aurifabro fabrice"), and in 1477 he was mentioned in connection with a large monstrance, now lost, that the cathedral had ordered.[5] The closest stylistic parallel to the *Agnus Dei* Monstrance in form and detail is the earlier Dorothy Monstrance (no. 38): Particularly striking are the likenesses in shape and scale; the enclosed central capsule,

with its identifying relief, corona of gemstones, and generously dimensional leaf decoration; and the selective use of gilding.[6] Undoubtedly, it was for reasons beyond mere coincidence that the two were displayed as pendants on the high altar on major feast days (see fig. 5).[7]

PROVENANCE: 1834, allotted to Basel-Country; 1836, sold at auction in Liestal to the Berlin dealer Arnoldt, who offered it to Basel on terms that were not met; 1838, entered the Kunstkammer, Königliche Museen, Berlin; 1875, transferred to the Kunstgewerbemuseum; evacuated during World War II; 1953, returned to the Kunstgewerbemuseum.

BIBLIOGRAPHY: Burckhardt 1933, no. 31; Braun 1940, pp. 289, 293–94, fig. 278; Fritz 1966, pp. 49–51, fig. 28, no. 70, pp. 453–54; Karlsruhe 1970, no. 199, pp. 243–44, fig. 167, pl. 5; Fritz 1982, no. 521, p. 260, figs. 521, 522; Schreiber 1985; Basel 2001, no. 12.

1. Lambacher, in Basel 2001, no. 12.
2. Inventory 1477:32.
3. Lambacher, in Basel 2001, no. 12.
4. Barth 1989, vol. 3, p. 12.
5. Lambacher, in Basel 2001, no. 12; see Burckhardt 1933, no. 63, p. 274.
6. Burckhardt 1933, p. 232; Lambacher, in Basel 2001, no. 12.
7. Burckhardt 1933, p. 353.

67. *Reliquary Pendant Capsule*

Probably Upper Rhineland, 15th century. Rock crystal
with raised, engraved, and gilded silver: Height, 6.1 cm.
Historisches Museum Basel, 1878.41.

This small reliquary pendant capsule was intended to be
hung around the neck or worn otherwise as personal adorn-
ment. Essentially serving as a private monstrance, the bored
crystal, which displays a splinter of wood (a fragment of the
True Cross?) and what appear to be fragments of silk textile,
functioned on a small, individual scale in the same manner
as the large tower reliquary monstrances (nos. 72, 74, 75,
77–78) did in public. Merely looking at the relic was
deemed, in Late Medieval devotional practice, to have
specific apotropaic value; additionally, the relic was tangible
evidence of the holy personage, whose physical proximity
provided an immediate focus for spiritual contemplation and
private devotion.

PROVENANCE: 1834, allotted to Basel-City.

BIBLIOGRAPHY: Burckhardt 1933, no. 56; Basel 2001, no. 28, 3.

68. *Reliquary Pendant with the Nativity and the Lamb of God*

Upper Rhineland, 1475–1500. Raised, engraved, swaged, and partially gilded silver, with traces of *basse-taille* enamel: Diameter, 6.1 cm.
Historisches Museum Basel, 1882.97.

69. *Reliquary Pendant with the Coronation of the Virgin and the Virgin and Child on a Crescent Moon*

Probably Upper Rhineland, 1475–1500. Raised, engraved, swaged, and gilded silver, with reverse-glass painting and gold leaf on rock crystal: Diameter, 5.5 cm.
Historisches Museum Basel, 1878.40.

70. *Reliquary Pendant with the Man of Sorrows and the Annunciation*

Probably Upper Rhineland, 1475–1500. Raised, engraved, swaged, and gilded silver, with mother-of-pearl: Diameter, 5.4 cm.
Historisches Museum Basel, 1882.112.

71. *Reliquary Pendant with Saint Veronica and the Lamb of God*

Probably Upper Rhineland, late 15th century. Raised, engraved, swaged, and gilded silver: Diameter, 4.1 cm.
Historisches Museum Basel, 1878.39.

These pendant capsules, intended to be worn as items of personal adornment, served as individual "blind" monstrances or reliquaries, as their contents could not be seen without opening the capsule. One pendant (no. 68) is an *Agnus Dei* capsule, and another (no. 71) is an *Agnus Dei* in image only, as it has no compartment to hold the wax wafer. The other two are reliquary pendant capsules whose contents probably were alluded to by their external images. Rare is the pendant of rock crystal with painting and gilding on the obverse or interior surface (no. 69); the engravings on the reverse sides, like numerous examples from this period, were heavily dependant on prints by leading Upper Rhenish masters, particularly the Master E.S. and Martin Schongauer. Iconographically poignant is the mother-of-pearl representation of the Man of Sorrows supported in the tomb by the Virgin and Saint John the Evangelist (no. 70). An ornament, often amuletic, originally hung from a lower loop on these reliquaries.

The circumstances under which the reliquary pendants entered the Treasury is unknown, but many such individual gifts were used to embellish the images of saints (see nos. 51–54); the mother-of-pearl pendant (no. 70), for example, could be the "mother-of-pearl badge" (". . . berlinmutter zeychen") mentioned in the 1525 inventory as an adornment on the Reliquary Bust of Saint Ursula (no. 41).[1]

PROVENANCE: (68–71) 1834, allotted to Basel-City.

BIBLIOGRAPHY: (68) Burckhardt 1933, no. 52; Basel 2001, no. 31; (69) Burckhardt 1933, no. 55; Fritz 1966, p. 53, fig. 30, no. 41, p. 449; Karlsruhe 1970, no. 204, p. 247; Murnau 1995, no. F 11; Basel 2001, no. 34; (70) Burckhardt 1933, no. 54; Fritz 1966, p. 52, fig. 29, no. 42, p. 449; Basel 2001, no. 33; (71) Burckhardt 1933, no. 53; Fritz 1966, p. 55, fig. 33, no. 43, p. 449; Basel 2001, no. 32.

1. Husemann, in Basel 2001, no. 33.

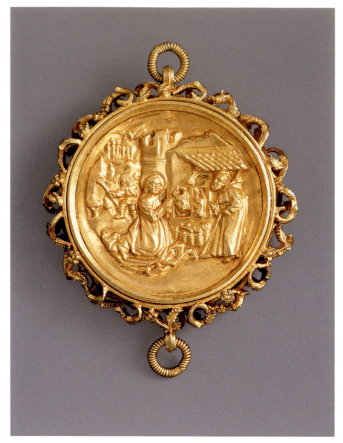

68: obverse

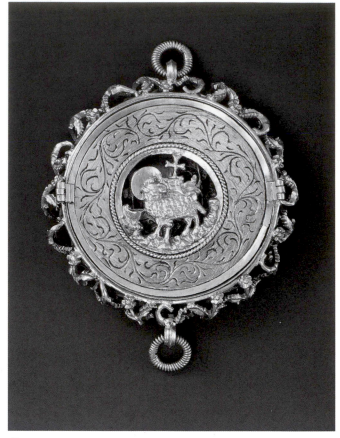

68: reverse

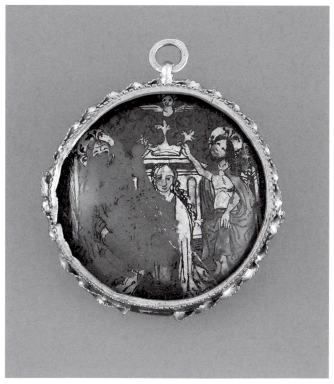

69: obverse

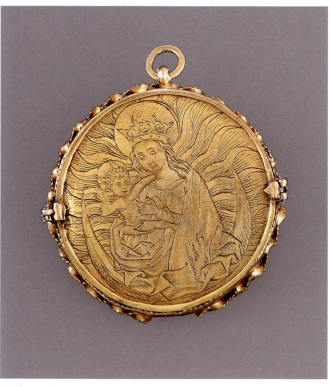

69: reverse

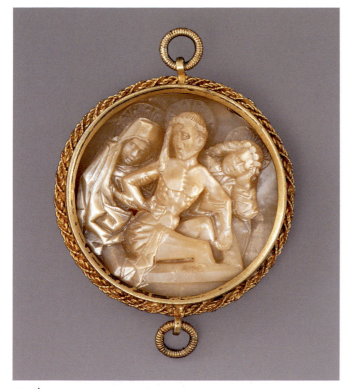

70: obverse

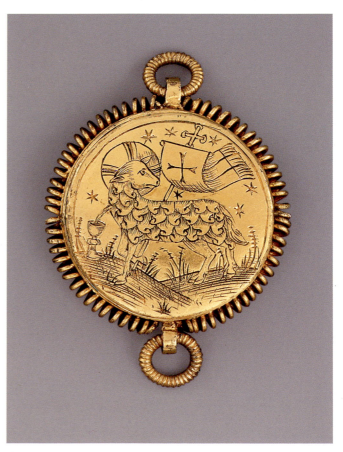

70: reverse

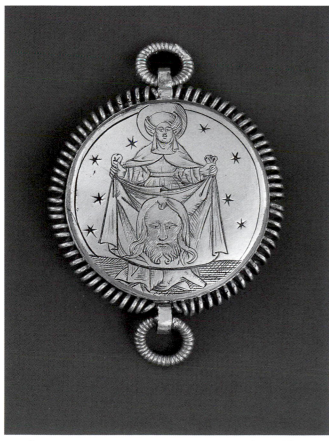

71: obverse

71: reverse

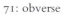

72. *Münch Monstrance*

Attributed to Jörg Schongauer (documented 1482–94).
Basel, 1490–94. Raised, cast, swaged, chased, and engraved
silver, with a diamond, garnet, opaque *champlevé* enamel,
and modern glass: Height, 108.8 cm.
Historisches Museum Basel, 1955.330. Gift of the
Government of Canton Basel-Country.

73. *Lunula*

Attributed to Hans Rutenzwig. Basel, 1471. Raised, engraved,
worked, and gilded silver: Height (with base), 9 cm.
Historisches Museum Basel, 1955.330.

The earliest and most elaborate of the tower reliquaries,
the Münch Monstrance is a masterpiece of Late Gothic
goldsmiths' work. The architectonic structure, virtuoso
technique, complex but thoroughly coherent overall com-
position, and richness of detail are combined in an object
of exceptional grace, balance, and visual appeal. The com-
ponents are analogous to those of contemporary carved
retables: the central shrine, with a clearly defined front and
back, but now devoid of the relics that constituted its pri-
mary focal point; the footed stand; and the towering super-
structure (*Gesprenge*) of buttresses, colonnettes, pinnacles,
and crocketed gables filled with lace-like tracery. The hexa-
lobe form of the foot, with its punched ground, raised fleur-
de-lis cusping, and groin webbing for strength to support
the towering structure, is continued in section throughout.
A shield with the coat of arms of the Münch family is
attached to the front side. The small figures in the arcades of
the knop represent Christ and saints Thomas, James the
Greater, Stephen, Agnes, and Bridget; in the superstructure
are saints Heinrich and Kunigunde and the Virgin (see fig. 4).
All the figures were cast and extensively chased after they were
removed from the molds, giving them a crisp and sculptural
appearance. The architectural elements are constructed of
both cast and hollow sheet work to reduce the weight and
stress of the exceptionally large structure; generally, the
raised elements are polished while those that are cast are left
with a matte surface, creating a modulated play of light.

The monstrance is first mentioned about 1500 as "con-
taining the relics of Heinrich" (". . . darinn keiser Heinrichs
heilthumb ligt"), for which a "fine crystal glass" (". . . ein

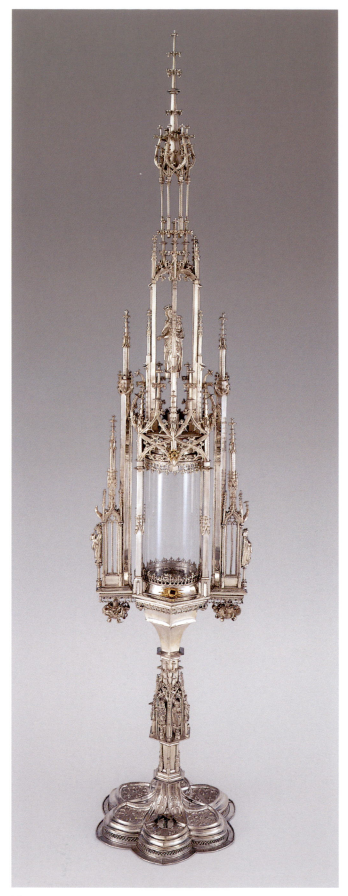

schön christallin glasz") was made in Venice.[1] These relics, which were translated to Basel in 1347 and originally kept in the Imperial Couple Monstrance (no. 65), were transferred to the Benedictine monastery at Mariastein in 1834. The heraldic shield on the foot allows an unequivocal identification with entries in the 1511 and 1525 inventories. The Münch Monstrance probably was made to replace an earlier one, itemized in the 1477 inventory,[2] which held relics translated from Bamberg in 1347.[3] The attribution to Jörg Schongauer, the younger brother of Martin, is based on close stylistic similarities with documented works by this goldsmith.[4] The figure of Saint Stephen, for example, is cast from the same mold as that made for a monstrance in Porrentruy by Jörg Schongauer in 1487–88.[5]

The lunula is in the form of a priest—wearing an alb, chasuble, and maniple—in whose raised hands is a crescent-shaped holder for the Eucharist or Host. This lunula originally belonged to a large monstrance that, according to the inventories, was made in 1471 by Hans Rutenzwig, a cathedral goldsmith, and for which the joiner Mathias Frischmut made a "reservaculum," or special container.[6] The 1827 inventory informs us that this lost monstrance—described in 1477 as "new and large" ("núwe und gross")—was one-and-a-quarter meters high, and further notes that it was mounted with a ruby, sapphire, and pearls, and was similar in form to the Hallwyl Monstrance (no. 74).[7] This monstrance and the Münch Monstrance were allotted to Basel-Country, which chose to keep the Münch Monstrance but sold the other in the 1836 auction; it is probable that the lunula was removed from the now-lost monstrance at this time as a substitute for the one missing. (The 1836 watercolor by Johann Jakob Neustück shows the lunula in the Münch Monstrance.)

The Münch Monstrance was the model for the one made in 1842–43 by Reimund Hotz (d. 1888) to replace the example stolen from the Hofkirche in Lucerne. The foot of this later monstrance was subsequently repaired, strengthened, and inscribed by Johann Jakob III. Handmann, who, along with Johann Jakob Pfaff and Bernhard Schnyder, had been charged earlier with dividing the Basel Treasury into equal parts.[8]

PROVENANCE: (72) 1834, allotted to Basel-Country but not sold in the auction of 1836; 1893, placed on loan to the Historisches Museum Basel; 1955, given by Basel-Country to the Historisches Museum Basel on the occasion of the return of the Reliquary Bust of Saint Ursula (cat. no. 41) to Basel; (73) 1834, allotted to Basel-Country; 1836, probably removed from the large monstrance that was sold at auction in Liestal and subsequently was lost.

BIBLIOGRAPHY: (72) Burckhardt 1933, no. 40; Basel 1956, no. 38, pp. 40–41; Karlsruhe 1970, no. 194, pp. 240–41, fig. 175; Fritz 1982, no. 690, pp. 122, 282, figs. 690, 691; Barth 1990, no. 16; Basel 2001, no. 26; (73) Burckhardt 1933, p. 274; Basel 2001, no. 43.

1. Burckhardt 1933, p. 276, n. 3.
2. Inventory 1477:3.
3. Schubiger, in Basel 2001, no. 26.
4. Ibid.
5. Fritz 1982, p. 282.
6. Burckhardt 1933, pp. 274–76, 331–32.
7. Inventory 1827:1.
8. Schubiger, in Basel 2001, no. 26.

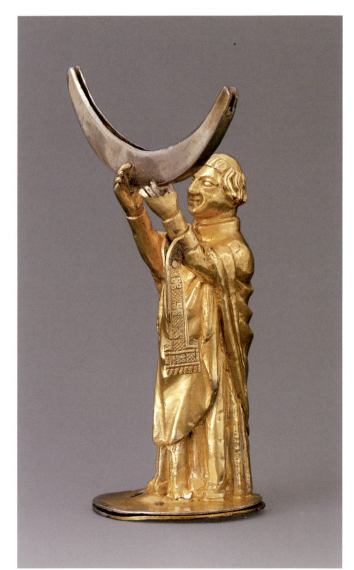

73

74. Hallwyl Monstrance

Attributed to Jörg Schongauer (documented 1482–94).
Basel, 1490–1500. Raised, cast, swaged, and chased silver,
with opaque *champlevé* enamel on gilded silver, and modern
glass: Height, 113.2 cm.
Historisches Museum Basel, 1882.80.

The Hallwyl Monstrance is not only the most imposing one in the Treasury but also among the largest examples to have come down to us from the Late Middle Ages. The towering structure is counterbalanced by restrained ornamentation; the lack of gilding and engraving lets the eye focus on its delicate but soaring architecture. The unornamented surfaces, which still retain their planishing marks, create a variety of reflective values that contrast with the surface treatment of the other tower monstrances in the Treasury. The section of eight is repeated throughout the vertical composition, to which the rhythm of alternating right angles provides some horizontal counterpoint. The conceit of colonnettes transformed into entwining branches with symmetrically arching finials appears contemporaneously on the superstructures (*Gesprenge*) of carved altarpieces and on the canopies of stained-glass windows. Exceptional is the proportionate weight devoted to the central vessel and its crowning spires. Pomegranates anchor the four corners, above which are delicate colonnettes supporting four small but crisply cast figures representing the Virgin and Child, the warrior saint Maurice, and the bishop saints Theodulus and Pantalus.

The monstrance originally displayed relics of saints Maurice and Theodulus that were given to Basel by the cathedral chaplain of Sion in 1490;[1] it probably was fabricated shortly thereafter and apparently was also furnished with a crystal cylinder made in Venice and donated by a certain Hans Bär.[2] Similarities between this example and a documented monstrance in Porrentruy have led some to attribute the Hallwyl Monstrance to the local goldsmith Hans Rutenzwig.[3] However, Jörg Schongauer replaced the Porrentruy monstrance in 1487–88, reusing the earlier Rutenzwig figures; the resemblance of the Hallwyl Monstrance in form and overall composition to the one in Porrentruy suggests, therefore, that Schongauer, not Rutenzwig, was the maker of the present example. The donor was very likely Hartmann von Hallwyl (d. 1506), dean of the cathedral and provost (1481–85), whose family coat of arms is emblazoned on the shield attached to the vessel's foot.[4] The gift may be related to the Altar of the Holy Cross, which, in 1493, was reconsecrated as the Altar of the Fraternity of the Virgin of the Cathedral Works.[5] In 1489, Hartmann von Hallwyl and the head of the cathedral works, Konrad Hüglin (see no. 75), laid the first stone in the rebuilding of the Tower of Saint Martin on the south side of the west façade of the cathedral.

PROVENANCE: 1834, allotted to Basel-City.

BIBLIOGRAPHY: Burckhardt 1933, no. 41; Basel 1956, no. 39, p. 42; Barth 1990, no. 17; Basel 2001, no. 27.

1. Schubiger, in Basel 2001, no. 27.
2. Burckhardt 1933, pp. 278–82.
3. Ibid., p. 282.
4. Schubiger, in Basel 2001, no. 27.
5. Barth 1990, p. 66.

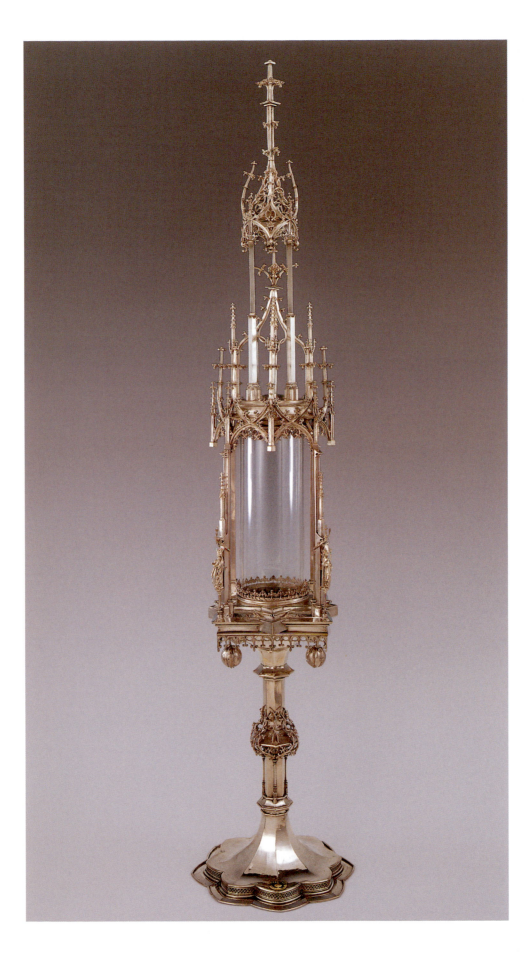

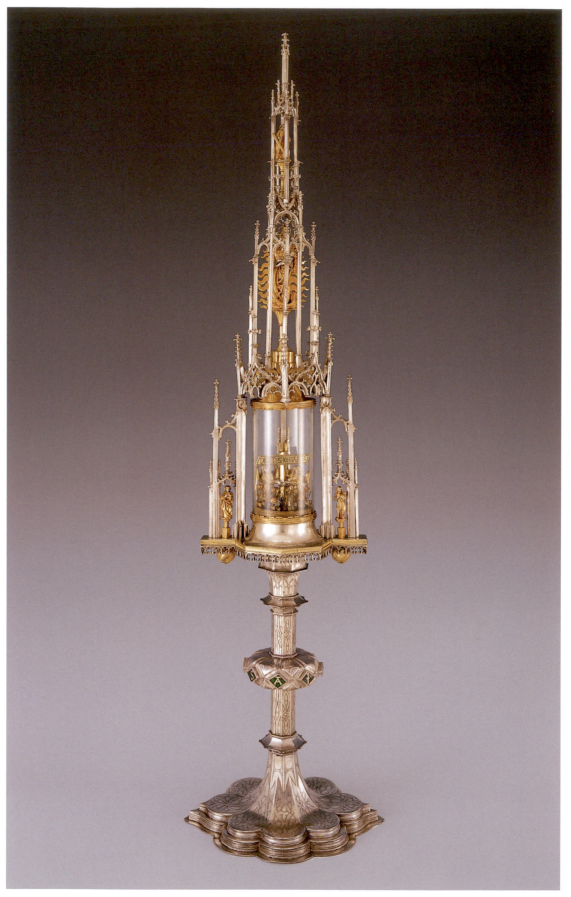

75. *Hüglin Monstrance*

Attributed to Simon Nachbur (d. 1513). Basel, about 1502. Raised, cast, swaged, chased, engraved, and partially gilded silver, with translucent *basse-taille* enamel and modern blown glass: Height, 88.7 cm.
Inscribed: (on the ends of the knop projections) M / A / H / I / R / S / A / I; (on the base of the relic plate) CVNRADVS HÜGLIN CAPPELAN' HṀ KAĹIE DONARVT
Historisches Museum Basel, 1882.79. Acquired from the Academic Society by exchange.

76. *"Little Garden of Paradise"* (Paradiesgärtlein) *Relic Holder*

Basel, about 1502. Raised, cast, swaged, and partially gilded silver, with translucent *basse-taille* enamel, gilded copper wire, silk thread, and glass beads: Height, 7 cm.
Inscribed (on the *titulus*): DIGITO :S: IOH: BABTIST
Historisches Museum Basel, 1882.79.

76

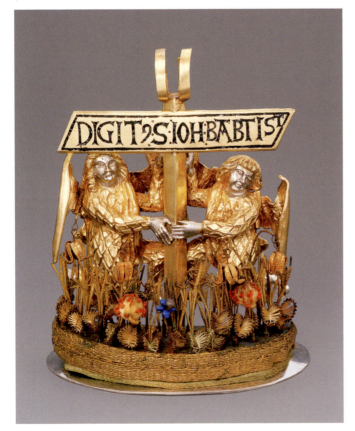

The Hüglin Monstrance in both appearance and execution is a more modest achievement than either the Münch or Hallwyl monstrances (nos. 72, 74). Yet, the slender but towering proportions, the unusual triangular section, and the crisp engraved decoration endow it with grace and a special presence. The Hüglin Monstrance is the only one of the Basel tower reliquaries enhanced with gilded accents. On the middle stage of the present work are the figures of saints John the Baptist and John the Evangelist; saints Barbara and Andrew occupy the upper stage; and on the pinnacle is the Virgin. This distribution of the somewhat coarsely cast figures imparts a slight sense of disunity. In its design and execution, the Hüglin Monstrance is very close—if more elaborate—to those of Heinrich and of Kunigunde (nos. 77, 78).

The "Little Garden of Paradise" originally was placed in the base of the cylinder, and the angels held the relic of the finger of Saint John the Baptist; the relic was given to the Benedictine monastery at Mariastein in 1834, and, in more recent history, it was replaced by the crystal Reliquary Pendant Capsule (no. 67).[1]

The inscription below the angels that once held the finger relic of John the Baptist indicates that the monstrance was given to the cathedral by Konrad Hüglin, head of the cathedral works (*Bauhütte*), and this corresponds precisely to the entries in both the 1511 and 1525 inventories, which list a "new monstrance that Konrad Hüglin, architect, had made containing the finger of Saint John the Baptist" ("... ein nuwe monstrantz, liesz herr Conrat Huglin, der buwmeister, machen, darinn sannct Johanns des tœuffers finger").[2] Documented in 1489 and again in 1502—about the time the monstrance most likely was made[3]—Hüglin died in 1509.

PROVENANCE: (75 and 76) 1834, allotted to Basel-Country; 1836, sold at auction in Liestal to the Basel goldsmith Johann Friedrich II. Burckhardt-Huber; 1836, sold to the Academic Society; 1837, acquired by Basel-City, in exchange for the Reliquary Bust of Saint Thecla (no. 40), the Arm Reliquary of Saint Valentine (no. 43), and the Golden Rose Branch (no. 55).

BIBLIOGRAPHY: (75) Burckhardt 1933, no. 42; Basel 1956, no. 40, pp. 41–42; Barth 1990, no. 19; Basel 2001, no. 28, 1; (76) Burckhardt 1933, pp. 283–88; Basel 2001, no. 28, 3.

1. Burckhardt 1933, fig. 236; see Husemann, in Basel 2001, no. 28, 2.
2. Inventory 1525:13.
3. Schubiger, in Basel 2001, no. 28, 1.

77. *Heinrich Monstrance*

Attributed to Simon Nachbur (d. 1513). Basel, before 1511.
Raised, cast, swaged, chased, and partially gilded silver,
with translucent *basse-taille* enamel and free-blown glass:
Height, 73.6 cm.
Inscribed (on the ends of the knop projections): J / H / S /
M / A / R
Staatliche Museen zu Berlin, Kunstgewerbemuseum,
K 3867.

78. *Kunigunde Monstrance*

Attributed to Simon Nachbur (d. 1513). Basel, before 1511.
Raised, cast, swaged, chased, and partially gilded silver,
with translucent *basse-taille* enamel and free-blown glass:
Height, 75.5 cm.
Inscribed (on the ends of the knop projections): R / A / M /
S / H / J
Historisches Museum Basel, 1882.78.

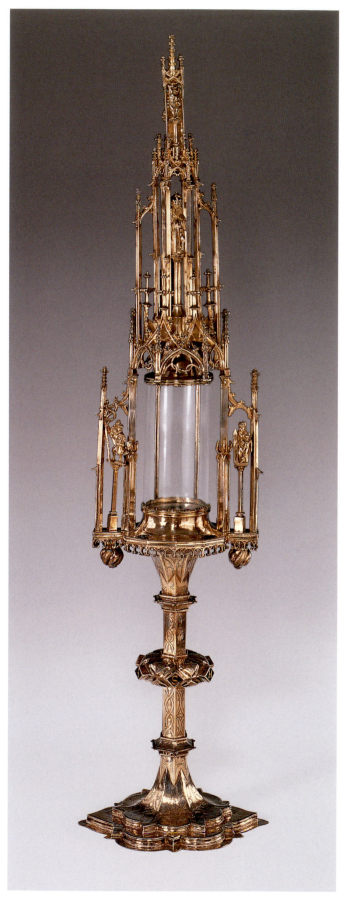

Executed as a pair, these nearly identical monstrances vary
only in the saints who inhabit their architectural constructs:
The apse-like space above the relic holder, which establishes
a distinct frontality, houses a figure of Heinrich with his
imperial crown, in the first instance, and Kunigunde with
her crown and cross, in the second. Heinrich is accompa-
nied by saints Christopher and Barbara, and above, in
niches, are smaller figures of saints Sebastian, George, and an
unidentified saint. Kunigunde is joined by Saint Matthias
and a bishop, probably Saint Pantalus; above are the Virgin
and Child, Saint Aegidius, and another unidentified saint.
Although somewhat smaller, conceptually simplified, and
architecturally more airy, these two monstrances are so close
in design, structure, and sensibility to the Hüglin Mon-
strance (no. 75) that, in all probability, the three were made
in the same workshop. Like the Hüglin Monstrance, the
present pair is also constructed of hollow verticals, one
sleeving over another, thereby allowing for easier assembly
and cleaning, as well as reducing the weight and consequent
stress on the towering structure. The cast figures, likewise,
share a common source: Saint Matthias, for example, on the
Kunigunde Monstrance is based on the same model as the
figure of Saint Andrew on the Hüglin Monstrance.

The Heinrich and Kunigunde monstrances were almost
certainly the last important objects intended for use on the
high altar to enter the Treasury.[1] They must postdate both
the Münch and Hallwyl Monstrances (nos. 72, 74), as they

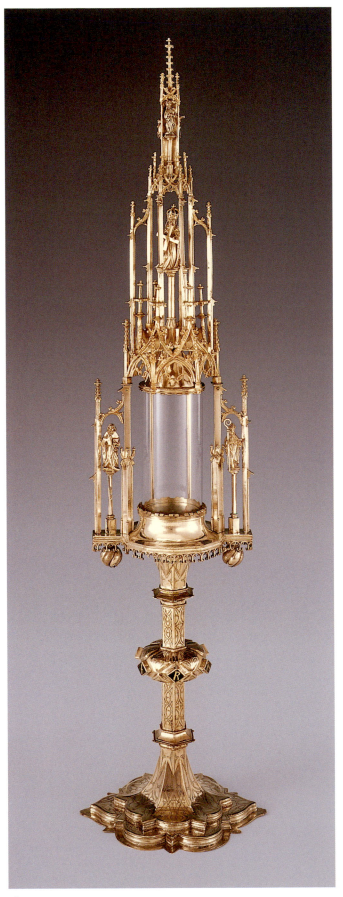

are not included in the display scheme for the high altar set down about 1500 (see fig. 5),[2] and they are first mentioned only in the inventory of 1511. These monstrances may well be the pair described in both the 1511 and 1525 inventories as "two crystal monstrances . . . melted down and two new ones made of them" ("zwo barillen monstrantzen . . . sind geschweltzet und zwo nuw darusz gemacht").[3]

PROVENANCE: (77) 1834, allotted to Basel-Country; 1836, sold at auction in Liestal to the Berlin dealer Arnoldt; 1836, entered the Kunstkammer, Berlin; 1876, transferred to the Kunstgewerbemuseum; (78) 1834, allotted to Basel-City.

BIBLIOGRAPHY: (77) Burckhardt 1933, no. 43; Basel 1956, no. 41, pp. 43–44; Karlsruhe 1970, no. 197, pp. 242–243, fig. 172; Fritz 1972, no. 197, pp. 166–67; Basel 2001, no. 29; (78) Burckhardt 1933, no. 44; Basel 1956, no. 42, pp. 43–44; Barth 1990, no. 18; Basel 2001, no. 30.

1. Schubiger, in Basel 2001, nos. 29, 30.
2. Burckhardt 1933, pp. 289, 353.
3. Inventory 1525:12; see Burckhardt 1933, p. 289.

Bibliography

Ackermann 1981
Hans Christoph Ackermann, *Das goldene Davidsbild*, Basler Kostbarkeiten 2, Basel, 1981.

Alioth, Barth, and Huber 1981
Martin Alioth, Ulrich Barth, and Dorothea Huber, *Basler Stadtgeschichte 2: vom Brückenschlag 1225 bis zur Gegenwart*, Historisches Museum Basel, 1981.

Arenhövel 1985
Willmuth Arenhövel, "Das 'Heinrichskreuz' aus dem Basler Münsterschatz," Staatliche Museen Preussischer Kulturbesitz Berlin, Kunstgewerbemuseum, Führungsblatt no. 1416, 1985.

Augsburg 1973
Suevia Sacra, Frühe Kunst in Schwaben (exhib. cat.), Augsburg, Rathaus, 1973.

d'Aujourd'hui 1986
Rolf d'Aujourd'hui, *Die Entwicklung Basels vom keltischen Oppidum zur hochmittelalterlichen Stadt*, Basel, 1986.

Barth 1978
Ulrich Barth, "Zur Geschichte des Basler Goldschmiedehandwerks (1261–1820)," Ph.D. dissertation, Basel University, 1978.

Barth 1990
Ulrich Barth, *Erlesenes aus dem Basler Münsterschatz*, Schriften des Historischen Museums Basel 11, Basel, 1990.

Basel 1956
Der Basler Münsterschatz (exhib. cat.), Historisches Museum Basel, 1956.

Basel 1989
Ulrich Barth, *Schätze der Basler Goldschmiedekunst 1400–1989: 700 Jahre E.E. Zunft zu Hausgenossen* (exhib. cat.), Historisches Museum Basel, 1989.

Basel 1990
Die Münsterbauhütte Basel 1985–1990 (exhib. cat.), Stadt- und Münstermuseum Basel, 1990–91.

Basel 1999
Daniel Grütter, *Basler Münster Bilder*

(exhib. cat.), Basel, Museum Kleines Klingental, 1999.

Basel 2001
Der Basler Münsterschatz (exhib. cat.), Historisches Museum Basel, 2001.

Beck et al. 1982
Andreas Theodor Beck, François Maurer-Kuhn, and Hans Rudolf Sennhauser et al., *Das Basler Münster*, Basel, 1982.

Berlin 1999
Bayern & Preußen & Bayerns Preußen, Schlaglichter auf eine historische Beziehung (exhib. cat.), Berlin, Haus der Bayerischen Vertretung, 1999.

Bonjour 1959
Edgar Bonjour, ed., *Basel in einigen alten Stadtbildern und in den beiden berühmten Beschreibungen des Aeneas Sylvius Piccolomini*, Basel, 1959.

Boston 1995
Memory and the Middle Ages (exhib. cat.), Boston College Museum of Art, 1995.

Brand Philip 1959
Lotte Brand Philip, "Eine kölnische Kreuzigung im Historischen Museum zu Basel," *Wallraf-Richartz-Jahrbuch* 21 (1959), pp. 223–26.

Braun 1940
Joseph Braun, *Die Reliquiare des christlichen Kultes und ihre Entwicklung*, Freiburg-im-Breisgau, 1940.

Bruckner 1972
Albert Bruckner, ed., *Helvetia Sacra*, vol. 1, part 1, Bern, 1972.

Burckhardt 1923
Rudolf F. Burckhardt, "Ein silbernes Fahnenkreuz des 14. Jh. mit Tiefschnittschmelz aus dem Basler Münsterschatz," *Historisches Museum Basel, Jahresberichte und Rechnungen* 1922 (1923), pp. 32–43.

Burckhardt 1933
Rudolf F. Burckhardt, *Die Kunstdenkmäler des Kantons Basel-Stadt 2, Der Basler Münsterschatz*, Basel, 1933.

Burckhardt 1952
Rudolf F. Burckhardt, "Der kleine Ritter aus dem Basler Münsterschatz," *Historisches Museum Basel, Jahresberichte und Rechnungen* 1951 (1952), pp. 25–28.

Caillet 1985
Jean-Pierre Caillet, *L'antiquité classique, le haut moyen âge et Byzance au Musée de Cluny*, Paris, 1985.

***Catalogue des Manuscrits* 1969**
Catalogue général des Manuscrits des Bibliothèques publiques de France 56, Colmar, Paris, 1969.

Cologne 1972
Rhein und Maas, Kunst und Kultur 800–1400 (exhib. cat.), Cologne, Joseph-Haubrich-Kunsthalle, 1972.

Cologne 1978
Die Parler und der schöne Stil 1350–1400, Europäische Kunst unter den Luxemburgern (exhib. cat.), vol. 1, Cologne, Joseph-Haubrich-Kunsthalle, 1978.

Cologne 1985
Ornamenta Ecclesiae: Kunst und Künstler der Romanik (exhib. cat.), Cologne, Joseph-Haubrich-Kunsthalle, 1985.

Cologne 1993
Stefan Lochner Meister zu Köln. Herkunft-Werke-Wirkung (exhib. cat.), Cologne, Wallraf-Richartz-Museum, 1993.

Darmstadt 1992
Faszination Edelstein (exhib. cat.), Darmstadt, Hessisches Landesmuseum, 1985.

Egger 1991
Eugen Egger, "Basel, Universität," *Schweizer Lexikon*, vol. 1, Lucerne, 1991, pp. 414–15.

Escher 1917
Konrad Escher, *Die Miniaturen in den Basler Bibliotheken, Museen und Archiven*, Basel, 1917.

Falk 1993
Brigitta Falk, "Bildnisreliquiare: Zur Entstehung und Entwicklung der metallenen Kopf-, Büsten- und Halbfigurenreliquiare im Mittelalter,"

Aachener Kunstblätter 59 (1991–93), pp. 99–238.

Fellmann 1981
Rudolf Fellmann, *Das römische Basel*, Basel, 1981.

Frazer 1986
Margaret English Frazer, "Medieval Church Treasuries," *The Metropolitan Museum of Art Bulletin* 43, no. 3, (Winter 1985–86), pp. 1–56.

Fritz 1966
Johann Michael Fritz, *Gestochene Bilder: Gravierungen auf deutschen Goldschmiedearbeiten der Spätgotik*, Beihefte der Bonner Jahrbücher 20, Cologne and Graz, 1966.

Fritz 1972
Johann Michael Fritz, "Goldschmiedekunst," *Jahrbuch der Staatlichen Kunstsammlungen in Baden-Württemberg* 9 (1972), pp. 159–95.

Fritz 1982
Johann Michael Fritz, *Goldschmiedekunst der Gotik in Mitteleuropa*, Munich, 1982.

Gamper and Jurot 1999
Rudolf Gamper and Romain Jurot, *Catalogue des manuscrits médiévaux conservés à Porrentruy et dans le canton du Jura*, Dietikon-Zürich, 1999.

Gasser 1978
Helmi Gasser, *Clarakirche Basel*, Schweizerische Kunstführer, Gesellschaft für Schweizerische Kunstgeschichte, Basel, 1978.

Grimme 1972
Ernst Günther Grimme, *Goldschmiedekunst im Mittelalter, Form und Bedeutung des Reliquiars von 800 bis 1500*, Schauberg, 1972.

Guster 1999
Holger Guster, "Die Apostelmonstranz des Basler Münsters," *Historisches Museum Basel, Jahresbericht 1998* (1999), pp. 63–71.

Guth 1986
Klaus Guth, *Die heiligen Heinrich und Kunigunde, Leben, Legende, Kult und Kunst*, Bamberg, 1986.

Guth-Dreyfus 1954
Kathia Guth-Dreyfus, *Transluzides Email in der esten Hälfte des 14. Jahrhunderts am Ober-, Mittel-, und Niederrhein*, Basler Studien zur Kunstgeschichte 9, Basel, 1954.

Hahn 1997
Cynthia Hahn, "The Voices of the Saints: Speaking Reliquaries," *Gesta* 36, no. 1 (1997), pp. 20–31.

Hahnloser 1971
Hans R. Hahnloser, *Il Tesoro di San Marco*, vol. 2, *Il Tesoro e il Museo*, Florence, 1971.

Hahnloser and Brugger-Koch 1985
Hans R. Hahnloser and Susanne Brugger-Koch, *Corpus der Hartsteinschliffe des 12–15. Jahrhunderts*, Berlin, 1985.

Heuser 1974
Hans-Jörgen Heuser, *Oberrheinische Goldschmiedekunst im Hochmittelalter*, Berlin, 1974.

Hieronimus 1938
Konrad W. Hieronimus, *Das Hochstift Basel im ausgehenden Mittelalter, Quellen und Forschungen*, Basel, 1938.

Hildesheim 1993
Bernward von Hildesheim und das Zeitalter der Ottonen (exhib. cat.), Hildesheim, Dom- und Diözesanmuseum, 1993.

de Jongh 2000
E. de Jongh, *"Een heilig leeg hoofd,"* *Openbaar Kunstbezit, Kunstschrift* 3 (2000), pp. 32–34.

Jülich 1987
Theo Jülich, "Gemmenkreuze: Die Farbigkeit ihres Edelsteinbesatzes bis zum 12. Jahrhundert," *Aachener Kunstblätter* 54/55 (1986–87), pp. 99–258.

Karlsruhe 1970
Spätgotik am Oberrhein. Meisterwerke der Plastik und des Kunsthandwerks 1450–1530 (exhib. cat.), Badisches Landesmuseum Karlsruhe, 1970.

Lanz 1957
Hans Lanz, "Ein wieder aufgefundenes Bergkristall-Kännchen aus dem Basler Münsterschatz," *Historisches Museum Basel, Jahresberichte und Rechnungen 1956* (1957), pp. 29–35.

Lasko 1994
Peter Lasko, *Ars Sacra: 800–1200*, 2nd ed., New Haven and London, 1994.

Legner 1995
Anton Legner, *Reliquien in Kunst und Kult zwischen Antike und Aufklärung*, Darmstadt, 1995.

Lightbown 1992
Ronald W. Lightbown, *Mediaeval European Jewellery with a catalogue of the collection in the Victoria & Albert Museum*, London, 1992.

Lüdke 1983
Dietmar Lüdke, *Die Statuetten der gotischen Goldschmiede, Studien zu den "autonomen" und vollrunden Bildwerken der Goldschmiedeplastik und den Statuettenreliquiaren in Europa zwischen 1230 und 1530*, 2 vols., Munich, 1983.

Luginbühl 1909
Rudolf Luginbühl, *Die Basler Reformation 1528–1529*, Basel, 1909.

Maurer-Kuhn 1984
François Maurer-Kuhn, *Das Basler Münster*, Schweizerische Kunstführer, Bern, 1984.

Meyer-Hofmann 1973
Werner Meyer-Hofmann, "Das 'Lob der rheinischen Städte'—ein Preisgedicht auf Basel aus dem 13. Jahrhundert," *Basler Zeitschrift für Geschichte und Altertumskunde* 73 (1973), pp. 23–35.

"Münsterschatzschrankes" 2000
"Die Restaurierung des Münsterschatzschrankes (1904.375)," *Historisches Museum Basel, Jahresbericht 1999* (2000), pp. 133–36.

Murnau 1995
Frieder Ryser and Brigitte Salmen, *"Amalierte Stuck uff Glas / Hinder Glas gemalte Historien und Gemäld,"* Hinterglaskunst von der Antike bis zur Neuzeit (exhib. cat.), Schlossmuseum Murnau, 1995.

Pfaff 1963
Carl Pfaff, *Kaiser Heinrich II. Sein Nachleben und sein Kult im mittelalterlichen Basel*, Basel and Stuttgart, 1963.

Porrentruy 1999
Trésors du Patrimoine intellectuel du Moyen Âge jurassien: Les Manuscrits du Fonds ancien de la Bibliothèque cantonale à Porrentruy, Porrentruy, 1999.

Reinhardt 1956
Hans Reinhardt, "Das Ursula-Haupt aus dem Basler Münsterschatz," *Historisches Museum Basel, Jahresberichte und Rechnungen 1955* (1956), pp. 26–36.

Reinhardt 1963
Hans Reinhardt, "Bemerkungen zur Goldenen Altartafel und ein wiedergefundenes Stück des Basler Münsterschatzes: das große silberne Rauchfaß," *Historisches Museum Basel, Jahresberichte und Rechnungen 1962* (1963), pp. 31–44.

Reinhardt 1976
Hans Reinhardt, "Das Heinrichskreuz

aus dem Münsterschatz," *Historisches Museum Basel, Jahresberichte und Rechnungen 1972* (1976), pp. 33–46.

Reinle 1988
Adolf Reinle, *Die Ausstattung deutscher Kirchen im Mittelalter: Eine Einführung,* Darmstadt, 1988.

von Roda 1999
Burkard von Roda, *Die Goldene Altartafel,* Basler Kostbarkeiten 20, Basel, 1999.

Roth 1911
Carl Roth, "Akten der Überführung des Reliquienschatzes des Domstiftes Basel nach dem Kloster Mariastein im Jahre 1834," *Basler Zeitschrift für Geschichte und Altertumskunde* 10 (1911), pp. 186–95.

Ryff, in *Basler Chroniken* I, 1872
"Die Chronik des Fridolin Ryff 1514–1541," *Basler Chroniken,* vol. 1, ed., Historische Gesellschaft in Basel, Leipzig, 1872.

Schmedding 1978
Brigitta Schmedding, *Mittelalterliche Textilien in Kirchen und Klöstern der Schweiz,* Bern, 1978.

Schramm and Fillitz 1978
Percy Ernst Schramm and Hermann Fillitz, *Denkmale der deutschen Könige und Kaiser, II. Ein Beitrag zur Herrschergeschichte von Rudolf I. bis Maximilian I., 1273–1519,* Munich, 1978.

Schramm and Mütherich 1962
Percy Ernst Schramm and Florentine Mütherich, *Denkmale der deutschen Könige und Kaiser, Ein Beitrag zur Herrschergeschichte von Karl dem Großen bis Friedrich II., 768–1250,* Munich, 1962.

Schreiber 1985
Christa Schreiber, "Das Agnus Dei-Ostensorium aus dem Basler Münsterschatz," Staatliche Museen Preussischer Kulturbesitz Berlin, Kunstgewerbemuseum, Führungsblatt no. 1417, 1985.

Schwinn Schürmann 1998
Dorothea Schwinn Schürmann, *Skulpturen des Basler Münsters, Museum Kleines Klingental, Austellungsführer,* vol. 1, Basel, 1998.

Schwinn Schürmann 2000
Dorothea Schwinn Schürmann, *Das Basler Münster,* Schweizerische Kunstführer, Bern, 2000.

Springer 1981
Peter Springer, *Ikonographie und Typologie eines hochmittelalterlichen Gerätes, Bronzegeräte des Mittelalters,* vol. 3, Berlin, 1981.

Steingräber 1956
Erich Steingräber, *Alter Schmuck. Die Kunst des europäischen Schmuckes,* Munich, 1956.

Stückelberg 1907
Ernst Alfred Stückelberg, *Denkmäler zur Basler Geschichte,* Basel, 1907.

Stückelberg 1922
Ernst Alfred Stückelberg, "Die spätromanische Schatzkammer des Basler Münsters," *Anzeiger für schweizerische Altertumskunde,* n.s. 24 (1922), pp. 58–60.

Suckale-Redlefsen 1995
Gude Suckale-Redlefsen, "Eine kaiserliche Goldschmiedewerkstatt in Bamberg zur Zeit Heinrichs II., *Berichte des Historischen Vereins Bamberg* 131 (1995), pp. 129–75.

Taburet-Delahaye 1989
Élisabeth Taburet-Delahaye, *L'Orfèvrerie Gothique (XIIIe–début XVe siècle) au Musée de Cluny,* Paris, 1989.

Teuteberg 1988
René Teuteberg, *Basler Geschichte,* Basel, 1988.

Wackernagel 1924
Rudolf Wackernagel, *Geschichte der Stadt Basel,* 4 vols., Basel, 1907–24.

Wollasch 1980
Joachim Wollasch, "Bemerkungen zur Goldenen Altartafel von Basel," *Text und Bild. Aspekte des Zusammenwirkens zweier Künste im Mittelalter und früher Neuzeit,* Wiesbaden, 1980.

Zuchold 1993
Gerd-H. Zuchold, *Der "Klosterhof" des Prinzen Karl von Preussen im Park von Schloss Glienicke in Berlin,* 2 vols., Die Bauwerke und Kunstdenkmäler von Berlin, Supplement 20/21, Berlin, 1993.

Index

179

21

Sacramentale
pont primus

Passionale

Sacramentale

Passionale